CONCERT PHOTOGRAPHY

HOW TO SHOOT
AND SELL
MUSIC-BUSINESS
PHOTOGRAPHS

BY JON SIEVERT

humble press

San Francisco

Cover and interior design by Richard Leeds

Edited by Tom Wheeler and Tom Mulhern

Quality Books Cataloging-in-Publication Data

Sievert, Jon.
 Concert photography: how to shoot and sell music-business
photographs / by Jon Sievert.
 p. cm.
 Includes bibliographical references and index.
 Preassigned LCCN: 96-77712
 ISBN 0-9647009-1-3

 1. Photography—Vocational guidance. I. Title.

TR154.S54 1997 770.2'32
 QB196-40329

First Printing

00 99 98 97 5 4 3 2 1

For Hank, Helen, and humble

Good luck in
all you choose
to do.
 Love,
 Teague

Until one is committed,
there is hesitancy,
the chance to draw back,
always ineffectiveness.

Concerning all acts of initiative
there is one elementary truth,
the ignorance of which kills
countless ideas and endless plans:
That the moment one definitely commits oneself,
then providence moves, too.

All sorts of things occur to help one
that would never otherwise have occurred.
A whole stream of events issues from the decision,
raising in one's favor all manner of
unforeseen incidents and meetings and
material assistance which no man
could have dreamed would come his way.

Whatever you can do or
dream you can, begin it!
Boldness has genius, power,
and magic in it.

— Johann Wolfgang von Goethe

TABLE OF CONTENTS

ILLUSTRATIONS

All photographs are by the author unless otherwise noted.
Equipment photos are courtesy of the manufacturers.

This book represents the fruits of more than 25 years of personal experience and the shared knowledge of some extremely talented music-business photographers. If you're the kind who reads photo credits in music magazines and books and on CD covers, many of their names will be instantly recognizable: Robert Altman, Joel Bernstein, Jay Blakesberg, Stuart Brinin, Clayton Call, William Claxton, Tom Copi, Ron Delaney, Alison Dyer, Ken Friedman, Lynn Goldsmith, William Gottlieb, Ross Halfin, Steve Jennings, Dennis Kleiman, Dawn Laureen, Mark Leialoha, Herman Leonard, Jim Marshall, Paul Natkin, Ray Olson, Ebet Roberts, Chuck Stewart, and Neil Zlozower. Some are quoted more than others, some are not quoted at all, but all were invaluable for their insights. I am deeply grateful for their assistance.

Other helpful folks who contributed interviews and editorial input include Kirk Anspach, Eric Auerbach, Terri Berg, Tad Crawford, Herb DeCordova, Laura Eveleigh, Julie Graham, Chris Gulker, Andy Harrell, Tom Kunhardt, Michael Ochs, Maria Ragusa, and David Spindler.

I am particularly indebted to Jim Crockett, former publisher of *Guitar Player*, *Keyboard*, and *Frets* magazines. If he had not made me the staff photographer for those publications, I'd never have been able to gather the knowledge or produce the photos contained herein. And I might never have met my talented editors Tom Wheeler and Tom Mulhern, or my exceptional art director Richard Leeds. Their contributions are appreciated more than they realize. Thanks also to the editors and art directors I was privileged to work with during my long association with the magazines, particularly Don Menn, Steve Caraway, Carla Carlberg, Tom Darter, Rick Eberly, Jim Ferguson, Joe Gore, Paul Haggard, Jim Hatlo, Phil Hood, Dominic Milano, Jas Obrecht, Peggy Shea, and Lachlan Throndson. I'm proud to call them my friends.

Without the cooperation of all the musicians, promoters, public relations people, stage managers, lighting directors, and club owners, there would be no photos. Thanks to all whom I've had the honor of working with, especially Jesse Colin Young, David Grisman, Mimi Fariña, Tom Mazzolini, Ernie

Beyl, and the people who helped at Bill Graham Presents (particularly Sherry Wasserman, Colleen Kennedy, Dawn Holliday, and Peter Barsotti). Special thanks to the past and present staffs of San Francisco's Great American Music Hall, including Tom Bradshaw, Jeanne Rizzo, Lee Brenkman, Gilbert Johnson, Claire Pister, Luther Manning, and Annie O'Toole. After all these years it's still my favorite music venue.

Friends I'd like to thank for encouragement and support at crucial moments along the way include Q.V. "Duke" Browning, Alec Dubro, Paul Grushkin, Ray Meyers, Brian Richards, Marc Silber, Boston Woodard, and the wise and talented authors and publishers I've met through the Publishers Marketing Association Listserv, the Marin Small Publishers Association, and COSMEP.

Finally, my warmest thanks and gratitude to my wife Wendy and daughter Melinda for their loving patience and support throughout this project.

I t's not unusual to want to photograph musicians. If cave drawings are any indication, artists have been intent on capturing images of musicians as long as they've had the tools to do so. Photographers have been doing it literally since the medium advanced far enough to make portraits possible. According to most photo histories, that was in October 1839. And, indeed, a daguerreotype exists of the most famous musician of the time, Italian violin virtuoso Nicólo Paganini, who died in May 1840. And who's to say he was the first? Maybe he was just the most famous.

Over the course of photography's history, thousands of amateur and professional photographers (including many of the great artists such as Matthew Brady, W. Eugene Smith, Henri Cartier-Bresson, Ernst Haas, Alfred Stieglitz, and Ansel Adams) have followed the same urge. It's as if they feel they can somehow preserve or get closer to the music by photographing the musician. In their wake they have left a vast, rich archive of the ongoing parade of famous and not-so-famous musicians over the past 150 years. Now, you want to make *your* contribution to history's archives, see your photos and byline in print, and maybe make a few bucks as well.

You've picked a good time to start. Thanks to the astounding growth of record and instrument sales that began with the early-'60s folk movement, there are more musicians performing more kinds of music at a wider variety of venues than at any other time in history. The corresponding exponential growth of the media has created an unprecedented demand for photographs of musicians practicing all manner of musical idioms. Potential markets include magazines, record companies, books, newspapers, television, online media, and the brave new world of multimedia. Additionally, there are more bands and performers than ever needing good publicity shots. And, because of the nature of the music business, you don't have to live in New York, Chicago, San Francisco, or Los Angeles to participate. If you live in a good-sized city, metropolitan area, or college town, you'll find any number of homegrown bands and solo artists who will appreciate your attentions. In addition, many of your favorite recording artists

will come to your hometown to perform. In fact, your chances are probably better outside the major cities, where there are fewer photographers vying for position and clearances.

Furthermore, this is an equal-opportunity business. It doesn't matter if you're male or female; have black, white, red, or green skin; or practice Christianity, Buddhism, or Animism. Lots of photographers are already getting a piece of the action. Some do it for money, while others do it for the thrill of having their photos published. Still others do it just for the sheer pleasure of combining a love of photography with a love of music, which is the best way. In general, music-business photography is *not* the road to fame and fortune. The field is extremely competitive, particularly at the higher levels, and only the most talented, tenacious, and lucky make a decent living at it. But that doesn't mean you can't get your little piece.

For continuity, the book is divided into two parts. Part I (Chapters 1 through 9) covers the details of getting started, getting established, securing credentials, shooting on- and offstage, protecting your rights, and selling your photos. Part II (Chapters 10 through 14) is devoted to choosing and buying the equipment that meets the specific demands of concert photography. By the time you've finished, you will not only know what it takes to create outstanding music-business photos, but also how and where to sell them and/or get them published.

I invite you to keep in touch. Your feedback and questions are welcome. Write to P.O. Box 4322, Daly City, CA 94016, leave some e-mail for *jon@humblepress.com*, or visit our web site (*http://www.humblepress.com*). In the meantime, enjoy the music and the musicians, and keep your head down.

Taking the First Step

I f you already own a camera and a lens or two, getting started is as easy as photographing a street musician, a free concert in the park, your sister practicing in her bedroom, or any public performance you might encounter. In many cases, you can take your camera to a show for which you've bought a ticket. Just don't count on starting out with Pearl Jam unless you have some very special connections. You have to be properly certified and credentialed to work those kinds of shows. The subject of photo credentials is covered in Chapter 3. There *was* a time (prior to the 1980s) when you could bring your camera to almost any concert, and in fact that's how many of the most successful photographers started. However, that was before the advent of multi-million-dollar merchandising contracts and $40 concert tickets. The big acts claim they need total control to protect their image and to stifle bootleg merchandise.

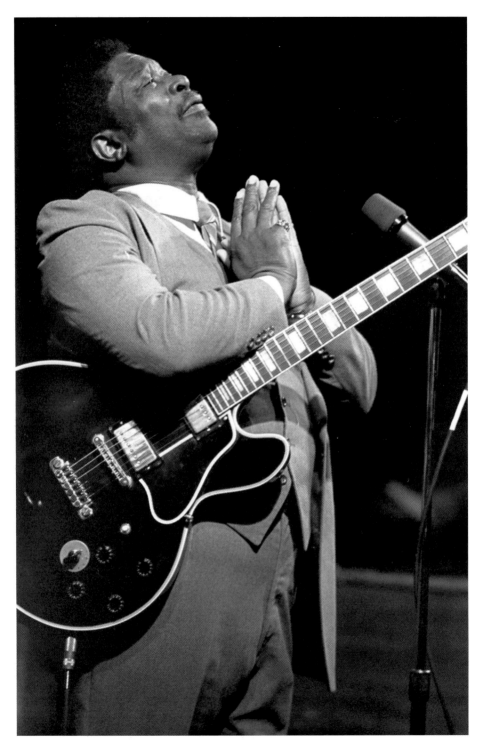

B.B. KING, 1982

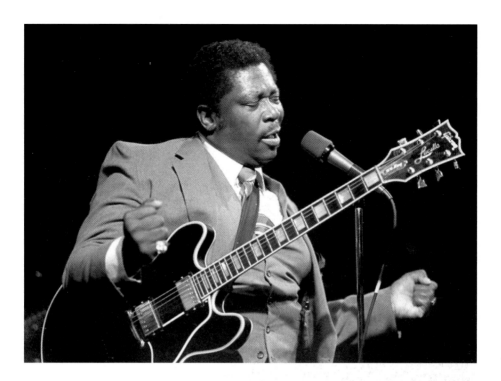

In widely varying degrees, performers of all styles often reflect the emotional aspects of their music with facial expressions and body gestures. Learn to recognize how these gestures and looks present opportunities to capture the drama, movement, and emotional intensity of the music. The more you shoot, the better you'll get at capturing those moments. Of course, there's nothing like having a master showman like B.B. King to improve your chances. On any given night he provides many such opportunities.

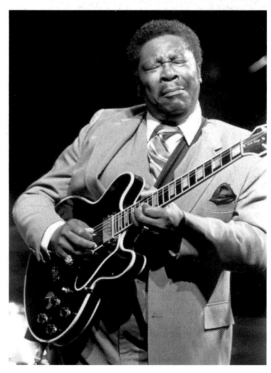

But don't be discouraged if you can't immediately photograph your favorite rock star. Chances are, you're not ready for prime time anyway. Concert photography is not prohibitively difficult, but it does often require you to work at the limits of your equipment and film. Lighting is usually problematic, and working conditions can be tense, demanding, and hurried. Shooting in concert requires quick reactions and the ability to adjust your focus and aperture with speed and accuracy. It also demands a certain degree of conditioning and flexibility, because you are constantly stooping, bending, kneeling, crawling, and stretching to get into position. If your body or dignity can't take that kind of manipulation, then you're going to severely limit your shooting angles and opportunities. Exercises that strengthen your back, shoulders, legs, and abdominal muscles are helpful. Carrying a 25-lb. camera bag around for several hours takes a heavy toll on your back and shoulders; trips to the chiropractor are a routine part of life for many pro photographers.

And take heart: not every successful act believes its fans are out to rip them off. The Grateful Dead, arguably the world's most successful touring band before Jerry Garcia's death, not only permitted cameras during its 30-year existence, but tape recorders as well. The organization believed that the resulting exposure only helped build the band's fan base. With virtually every show a stadium sell-out, annual ticket sales around 40 million dollars, and several fanzines devoted solely to the band, it looks like they were on to something. And country music stars have always allowed fans to bring cameras to shows. (So far, anyway. Merchandising has also invaded country in a big way as it has become America's new pop music.) The music world is spotted with other big-name artists who permit cameras, but even then their generosity can be thwarted by promoters who impose their own house restrictions. Fortunately, the actual number of bands and musicians with the power and will to exercise the kind of censorship power described here is relatively small compared to the big picture. It's just that they're the most visible. Except for a core group of superstars, however, this is a revolving cast. This year's new "star" can just as easily be next year's has-been that you'll be able to shoot in a 300-seat club.

Look beyond the charts

Finding musicians to photograph is not difficult; you simply have to think beyond the *Billboard* charts. Top record sellers represent a mere fingertip on the body of live music. For every artist or band on that list, there are hundreds

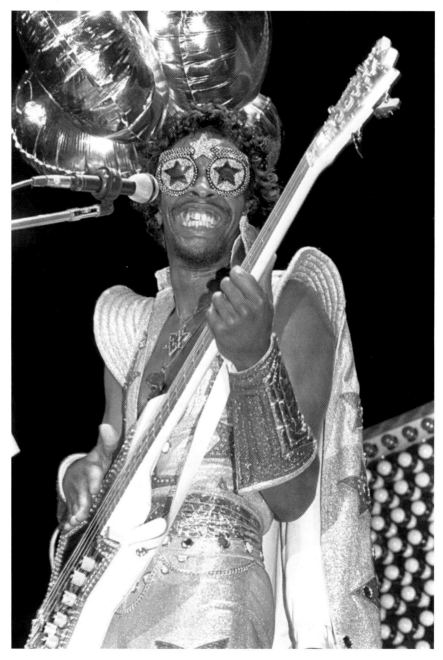

BOOTSY COLLINS, 1978

Electronic flash looks artificial and is seldom pleasing. But combined
with fortuitous concert lighting and a particularly suitable subject, it can
make the picture. Still, it's Bootsy's infectious funk, outrageous sense of
humor, and glittering fashion that make this image jump off the page.

more playing all kinds of music in venues more accessible to a photographer. The spectacular growth of the music industry in the past three decades has created a thriving performance market for a multitude of musical idioms. Besides the more obvious genres of pop, rock, country, blues, jazz, rap, and hip-hop, there's also bluegrass, Irish, flamenco, salsa, folk, Christian, gospel, klezmer, classical, and zydeco, to name a few. And that barely touches on the different kinds of ethnic music and instruments. The range is astounding. All you need is the interest and willingness to search them out and pay some dues. It takes time to learn how to do it right, and doing it professionally takes a substantial investment in equipment. It's best to learn your craft and build a portfolio under less critical conditions at shows where there is no specific demand to produce.

So, how do you actually find situations that permit you to learn the principles of photographing musicians without a lot of pressure or security people? If you don't have immediate access to a band or club, start by assessing your local music scene.

Community settings

Look around you—live music is everywhere. Not just in obvious places like clubs, theaters, arenas, and stadiums; it's also at parties and in parks, restaurants, churches, schools, streets, living rooms, malls, stores, garages, and even libraries. These performances can take just about any form—a piano player in a mall, a free concert in the park, a school orchestra performance, a singer/guitarist in a church basement, a band rocking out at a party. A good place to start is to pick something or someone close to your personal experience. Does your father, sister, brother, aunt, or another relative play an instrument? Do you have a friend who plays in a garage band? Branch out from there by identifying performances where you know the performer or the person staging the event. That will help alleviate anxiety and build confidence. Any organization or institution that you're a part of (school, church, club, fraternity, etc.) is a good possi-

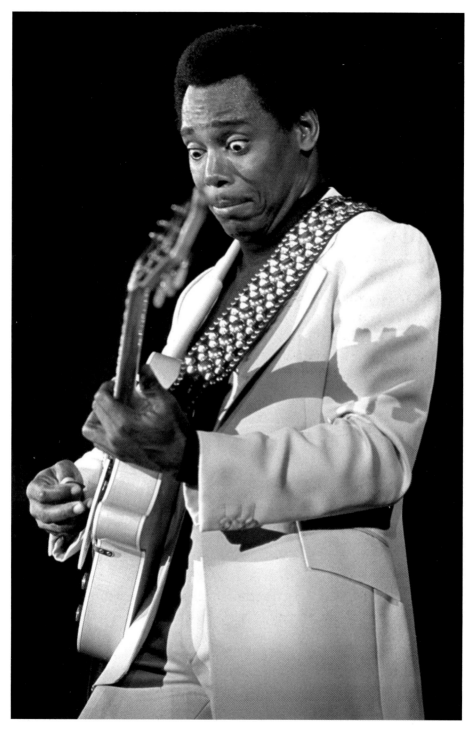

GEORGE BENSON, 1979

bility. It doesn't necessarily have to be a concert, either. Most of the ideas and techniques discussed here are equally relevant if you're shooting a school play, a stand-up comedian, or a poetry reading.

When you're ready to venture into the unknown, you can find plenty of free or self-produced concerts by scouring regional newspapers and bulletin boards in music stores, libraries, schools, churches, grocery stores, and Laundromats. You'll be amazed to discover just how many there are and how few require special permission to shoot. It doesn't really matter what instrument or what kind of music it is, though it helps if you like the music. You can learn basic camera skills and the fundamental principles of composition, lighting, focusing, and exposure by photographing anyone.

Take your camera to some of the shows that interest you or offer the most promising conditions; in most cases, you'll find little or no resistance if you don't disturb the show. If you have any doubts, or just want to pave the way, call ahead or get there early enough to ask permission of the artist or someone involved in the show's production. Diplomacy and sensitivity are paramount; you'll discover early on that your chance of success depends largely on your ability to deal with people who work in the business. In many cases, you'll find that the artists or promoters are delighted by your interest. If they ask for anything, it will probably be a print or two. That's pretty cheap tuition. This approach is a great way to build relationships with local musicians and get a feel for the mechanics of working a show. But remember, your performance will be watched carefully. Your camera does not grant special privilege to disrupt the show in your pursuit of good photos. If your actions are disrespectful to the audience or artist, you won't be welcome again. Work quietly and unobtrusively, and you'll be appreciated by all.

These kinds of performances also offer more than just the opportunity to build your skills. They also provide opportunity to establish contacts and sell some photos. Every working musician and band needs publicity photos, and they all like to see shots of themselves performing, especially if they make them look good. Maybe you'll sell a few prints. If they really like your work, it could lead to a productive working relationship.

Bars and clubs

Perhaps the best places for novice shooters to gain experience are the thousands of nightclubs and bars across the country that present live music. There

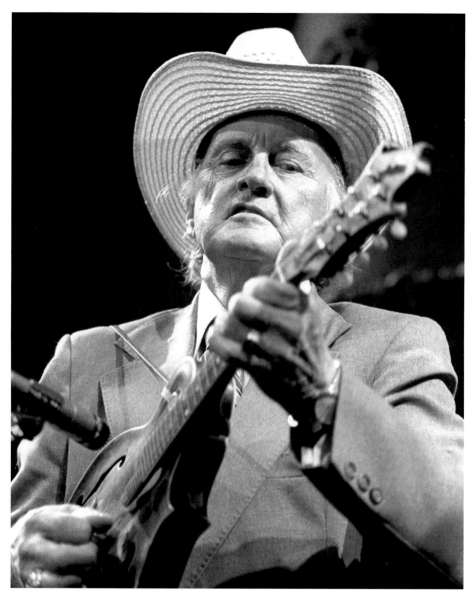

BILL MONROE, 1977

are few cities or towns without at least one such place. Clubs and bars are the nurturing ground of popular music. That's where you'll find the stars of the future working on their craft, the great masters of the past, and a lot of very talented people who never get famous outside their own circle of friends. (And,

A musician doesn't have to be famous to merit your attention. If you're lucky, someday you'll meet a character like Abner Jay. My *Guitar Player* pal Jas Obrecht found him at the San Jose flea market, knocking down $300 a day in tips singing pre-Civil War gospel tunes, while blowing harmonica and playing a huge Ernie Ball Earthwood acoustic guitar.

At 72, Abner had been around and knew how to attract attention. His booth was covered with posters and handbills of gigs, as well as homemade albums and album cover art. When Jas found him, he had been staked out at the flea market for more than a year, living rent-free in his small but comfortable trailer behind a Chevron gas station. Abner's gone on now, but there are still unique musical souls like him who need to be documented.

of course, you'll hear a lot that aren't so good, too.)

Nightclubs and bars provide a measure of intimacy between musician and audience not possible in larger venues. Just about every successful musician has had to pay club dues at one time or another. In fact, many successful recording artists *still* play clubs. In certain musical idioms (blues, bluegrass, and folk, for instance) that's often the top rung of the ladder. Venues can run the gamut from a 10-seat, no-cover bar featuring a local synthesizer player to a 2,000-seat nightclub headlining top-name acts. Obviously, you're most likely to run into opposition at the fancier clubs headlining the bigger names, but not always. You might also find opposition in places that feature solo or acoustic acts easily disturbed by noise or movement. In most cases, the venue manager or owner controls access, which again entails diplomacy on your part. Check out the clubs, bars, and restaurants in town that offer live entertainment and find out if they have a policy on cameras. If they do, it will usually be posted at the door or mentioned in their advertising. Find one that you know doesn't care and start there. They're great places for a baptism of fire. However, regular club work requires a lifestyle commitment. It can be a tough gig if you don't function particularly well with late hours, cigarette smoke, and drunks.

Festivals and fairs

If you're a fan of bluegrass, folk, blues, or jazz, don't neglect festivals if they're within your geographical reach. They are a great way to build a portfolio quickly because of the large number of acts on a typical bill. Most bluegrass, folk, and

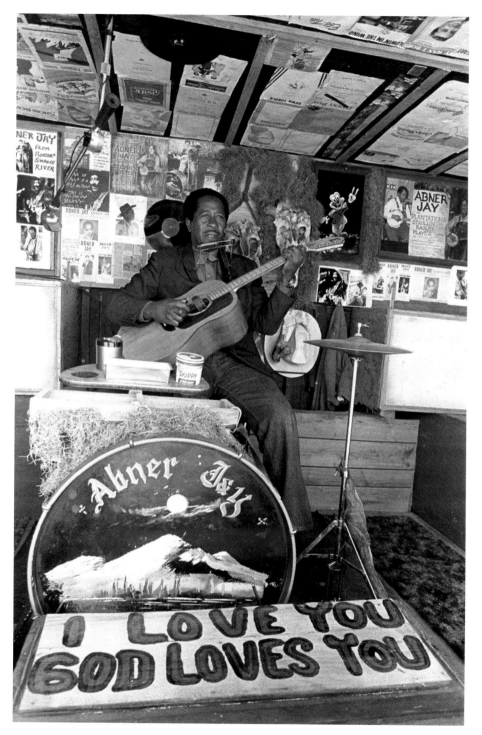

ABNER JAY, 1982

blues festivals I've attended have open seating on a first-come, first-served basis. Few restrict the use of cameras, although access in front of the stage is often controlled. (Jazz festivals are another story; they're usually more upscale and more tightly regulated.) Festivals can be particularly rewarding to shoot. Security is generally less oppressive than at rock and pop events, and performers are more accessible and less paranoid about being photographed. Even if you don't have access to the pit area in front of the stage, you can usually get close enough to fill your frame if you're willing to get in line early outside the gate or are adept at slipping through a crowd. Also, many of these events take place, at least partially, during daylight hours, which reduces lighting problems. You can find out when and where these kinds of events take place by watching local media or consulting magazines such as *Living Blues, Sing Out!,* and *Bluegrass Unlimited.*

Other surprisingly good possibilities are state and county fairs, which now routinely bring in big-name concert acts of all idioms. Many of these venues are outside and shows happen at just about any time of the day. Sometimes the price of the concert is even part of the fair's entrance fee. And because people sometimes bring cameras to fairs, there are often no restrictions on taking them into the show. It usually depends on how much money the promoter has spent on security or how particular the artist is about his or her image. Get there early and scope out the venue. You'll find that you're often dealing with temporary stages set up to take advantage of grandstand seating, leading to some strange configurations. If you have a ticket with an assigned seat number, find out if you're close enough to shoot from your seat. In many cases, however, you'll discover that these types of events feature "festival seating." This is a fanciful term coined by promoters that means there are *no* seats, just a big, wide-open area where everybody stands. Turn this to your advantage by arriving early enough to establish a place at the front of the pack.

Find a back door

Despite the difficulty of getting clearances to shoot rock and pop stars, some people have started by finding jobs at major concert venues. These jobs can involve working for a band or artist, for the venue itself, or for a crew that provides logistical support, such as lighting, sound, or film companies. Two photographers who launched successful careers this way are Mark Leialoha and Lynn Goldsmith. Leialoha, a prominent hard rock/heavy metal photographer, was

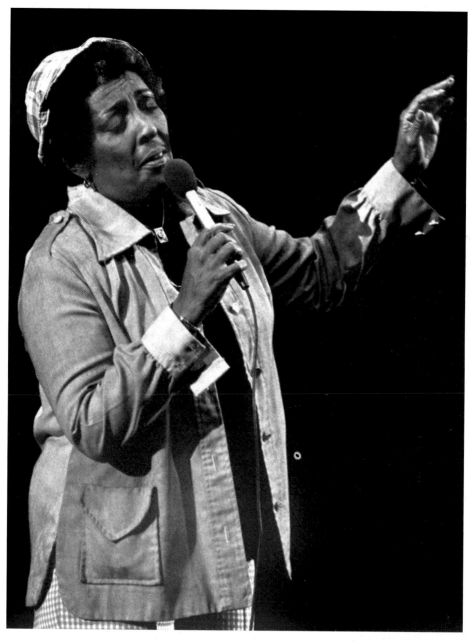

CARMEN McRAE, 1975

One of my most important tests when judging a concert shot is how well I can "hear" the music. Gestures and body language are key contributors to that. I'll always hear Carmen bringing her low, throaty voice to a whisper, balancing musical space with her left hand.

a stagehand at San Francisco's Cow Palace when he realized he had opportunities to learn his way around the stage that were not afforded everyone. He started buying tickets and taking his cameras to shows he wasn't working, at a time when it was still possible to do that. Eventually, he started leasing his photos for reproduction, which led to a strong working relationship with a couple of music magazines. Now, he spends much of his life traveling the world on assignment for magazines, bands, and record companies.

Goldsmith already had professional photography credits when, in the early '70s, she was hired to direct camera changes for Joshua Television, the first company to introduce big-screen video magnification for concerts. When ABC decided there was a place on late-night TV for rock and roll, it hired Joshua Television to create the shows, and Goldsmith became the first director for *ABC in Concert*. Determined to succeed, she began taking her cameras to shows to photograph the bands before they were scheduled to appear on television. "I wanted to know when certain things happened in the show so I'd be ready," she says. "Being a musician, I always had a pretty good sense when the guitar solo was going to happen, for instance. I didn't have to wait for someone to start playing to know that's where I was supposed to be. I'd take pictures and create a storyboard so I could plan my camera changes. One day an art director looked over my shoulder and saw my storyboard and asked if he could buy the pictures. I said, 'How much?' and he said '$1,000.' I said, 'How about $1,500?' and he agreed. That was more than I got paid for directing the show, which took two weeks and a lot of long, boring meetings. I decided it was time for a career change." Her work has since appeared in virtually every major magazine and on numerous album covers. In addition, she has created several photo books and started LGI, a very successful stock photo agency that serves the music and celebrity media.

Finally, don't overlook the possibility of starting out as an assistant to an established music-business photographer, if you're lucky enough to know of any in your hometown. You'll be required to schlep equipment, keep cameras loaded, go for coffee, clean the studio, and perform a host of other chores that the photographer doesn't want to be bothered with. If you have a good background in photo and lighting techniques, a few days on the job will provide enormous insight into the workings of the music business and that particular photographer's style and work ethic. You should also be paid about $10 an hour or $100 a day, if the photographer embraces standard assistant rates.

The examples of Goldsmith and Leialoha represent what can happen if you're

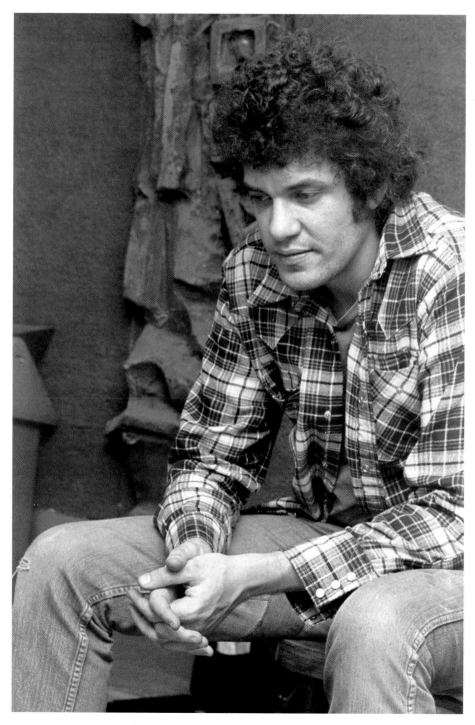

MICHAEL BLOOMFIELD, 1977

in the right place at the right time with the right skills. The point is to begin thinking about ways you can create access opportunities on your own.

Caring for your photos

Once you start producing negatives and slides, it's important to store, label, and catalog them properly so they can be located when you need them. I've found that it's not uncommon for many photographers, even experienced ones, to simply shove their cut negatives into a hastily marked sleeve and dump them into a drawer with boxes of unedited, unmarked transparencies. Your wonderful photographs are useless if the slide or negative is damaged or you can't quickly locate a specific image when someone makes a request.

Negatives and slides must be stored in archivally safe plastic sleeves. Glassine sleeves are less desirable because there is evidence the glue that seals them has a detrimental effect on film emulsion over time. For negatives, I prefer clear pages that hold seven strips of five 35mm negatives each, because the entire roll can be proofed on an 8x10 piece of printing paper. For those who can't bear to surrender a frame from a 36-exposure roll, they are also available in a six-by-six configuration. Transparencies are effectively stored in pages with pockets for 20 mounted slides. Both negative and transparency pages are punched to fit in a three-ring notebook. You can find these pages in virtually any camera store marketed under brand names such as Vue-All, Print File, and Qualide. Be sure that they are certified archivally safe. If you prefer to store your negatives and slides in boxes, there are systems available to meet just about any preference. All, however, are based around archivally safe media.

Cataloging

Don't wait to set up a system for cataloging your negatives and transparencies. You may think that your memory will retain relevant details of the shoot and help you locate a photo when needed, but a short pencil is much better than a long memory. Assign a unique number to every roll of film or transparency that you shoot and start a log. Minimally, this log will list an identifying number, the date of the shoot, the name of the band or musician, and the venue. You may also wish to list additional information, such as the event, the names of all the musicians in the band, and whether it was a concert, backstage, or studio session. Think of yourself as a historian. Pho-

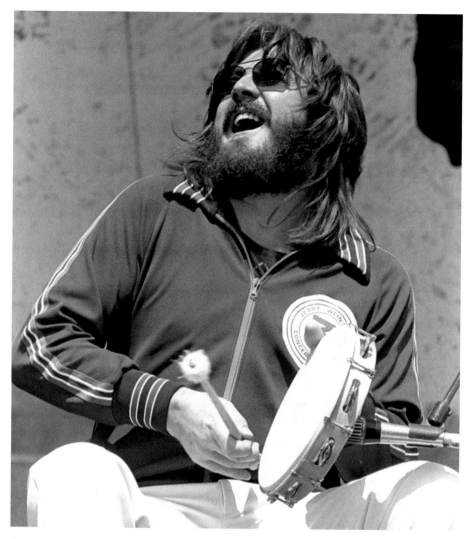

JOHN BONHAM, 1977

Drummers are especially tough to shoot because they're usually at the back of the stage, buried behind a wall of snares, bass drums, toms, and cymbals. You can aim into the middle to pick up the drummer and his sticks, but you'll need a long telephoto. Bonzo obliged by coming to the front of the stage for this shot.

tographing musicians captures them at very specific moments in their careers, and detailed information could prove crucial later. Because I've recorded this information, I've been able to quickly fill requests for photos of artists taken at specific venues or in specific years. You never know what

information an editor or art director will consider important to the image. Today's photos quickly become tomorrow's archives.

The method you use to record this information can take any form, as long as it is logical and leaves room for expansion. You can log it by hand in a notebook or put it into a computer. I have more than 3,000 rolls of black & white negatives logged into a word processor with a search function that allows me to find any artist name or venue. If I were starting over, I'd probably put them into a database, which allows for more flexible search and reporting possibilities. If you already own a database program, it's simple enough to create your own photo database to help you keep track of your files. It's also possible to buy powerful stand-alone programs dedicated to this task, such as Photo Management System from Perfect Niche Software. It not only offers a database that allows you to search by many criteria but also creates invoices and delivery memos. Whatever method you choose, keep your log in order and up to date. It will pay off when, ten years later, an art director comes looking for that photograph that only you have in your files.

Marking your photos

This is a good place to drive home a cardinal rule of music-business photography: *Never* release a print or slide that's not marked with, at least, your copyright notice and a phone number. Did you get that? ***Never* release a print or slide that's not marked with, at least, your copyright notice and a phone number.** The importance of this rule cannot be overstated, though the most recent changes in the copyright law protect your image even if it is not marked. Suppose, however, you give a print to an artist or her manager at a show and six months later she decides to use your shot for publicity or an album cover. How is she going to know whom to credit and pay if you haven't provided that information?

The proper form for marking your photo is: ©year of first publication, your name. All Rights Reserved (e.g., **©19— Frieda Fotographer. All Rights Reserved**). Get a rubber stamp made and use it religiously. For more information on copyright, see Chapter 8.

Building a portfolio

Start building a portfolio as soon as possible. Much of the art of securing assignments or credentials is based on your ability to persuade someone that you

are capable of producing quality photographs under pressure. A good portfolio demonstrates that you have already done so. Compiling and updating it also forces you to constantly evaluate your work from a critical standpoint.

As you begin to assemble your portfolio, remember that more is not necessarily better. In fact, one of the most common mistakes made by novice photographers is showing everything they've ever shot without considering the relative strength of the images. Be very selective; show only your best work. It is far better to show a portfolio with 12 powerful images than one with 12 strong images and 12 mediocre ones. Displaying your mistakes to a potential client is unwise; it only dilutes your appeal.

The kind of work you show will determine the kind of work you get. If your portfolio consists solely of a dozen knockout performance shots, then you're telling the world that's all you can do. Don't wait for someone to give you an assignment—assign yourself. Work out a deal with a favorite local band and fire up your imagination. In building a portfolio, the subjects of your photos are ultimately less important than the ideas and lighting and shooting techniques you demonstrate. An art director must assume that you can apply the same techniques no matter who is before the lens.

There is no prescribed way to present the work in your portfolio. Some photographers employ a combination of tear sheets and prints in a book, while others prefer to photograph everything on transparencies and take a Carousel tray with them for projection. I've also seen video tapes with soundtracks and a collection of scanned images on a floppy disk that can be viewed on a computer. Whatever method you choose, it should be nicely presented, but don't go overboard. The work will be noticed, not the packaging. A good art director won't be fooled by flash. It's the message that counts.

The darkroom edge

When you're starting out, you need every edge you can get. If you can develop and print black & white film, you've got one. Many of the smaller publications you'll be targeting at first (and indeed many of the larger ones) predominantly use black & white photos. If you have a darkroom available, and the skills to use it, you can produce prints in a matter of hours if necessary. While it's true that color slides and negatives can be converted to black & white, neither can match the tonal scale of the real thing, and the process takes extra time and expense. Developing and printing your own film and photos keeps quali-

ty control in your hands and provides a jump on the competition.

If you don't have access to a darkroom, consider building one. Printing is a skill that takes practice to master, and the easier your access to a darkroom, the better. You don't need a lot of space. I've seen quality prints made in closets without running water. All you need is a relatively uncluttered space that can be made light-tight. There are several fine books devoted to building a darkroom, including *Build Your Own Home Darkroom* by Lista Duran and Will McDonald, *Building a Home Darkroom* (Kodak), and *How to Build a Home Black & White Darkroom*, an inexpensive 20-page report from *Shutterbug* magazine.

Beyond the camera

Whether you're just starting out in photography or already have some experience, you must understand your equipment and its limitations before you put yourself in a high-pressure situation where someone has granted access. But mechanical competence is only part of the picture. You also need to understand the aesthetics of photography. The elements of a good photo are always the same—subject matter, lighting, emotional content, composition, and technical quality, to name the more important ones. Look carefully at the photographs that bombard you daily in magazines, newspapers, and books, and on television, and ask yourself why one works especially well while another is merely adequate. Get to the library and bookstore and study the work of the acknowledged masters in all kinds of photographic disciplines.

When you see a photo that moves or impresses you, try to break down the elements that make it work. Identify the light sources and where they're coming from, because they give shape, form, and *being* to the photograph. Wherever you go, be aware of how the light falls on faces, objects, and landscapes. Note the contrast between shadows and light. This kind of constant awareness translates directly into better photos on your part.

Immerse yourself in the immense amount of literature on photography. There are hundreds of books, each of which can provide a different insight on techniques and aesthetics. Read magazines such as *Shutterbug, PDN News, Popular Photography, Petersen's Photographic, Darkroom Photography*, and *American Photo*. They'll not only keep you abreast of the latest equipment advances, but will also expose you to a constant barrage of photographs and stoke your creative fires.

You'll also be richly rewarded if you study the origins of the kind of music

you love. Don't limit yourself to MTV and radio. All musicians, no matter how original they seem, are influenced by *someone*. If you're a rock and roller, then take a good look at rock's roots in blues, R&B, and country. If jazz is your choice, start with great New Orleans artists and follow the evolving history through swing, bebop, cool, and fusion. The advent of the compact disc has resulted in a tremendous wealth of reissues of classic records that encompass the history of popular music. Open your ears. As you start to learn the names and become familiar with the music of the pioneers, you'll be astonished to discover that some are still alive and performing, often in tiny clubs or festival venues that offer photographic opportunities.

Finally, get involved in the digital revolution as soon as you can. It's the now and future of photography. The ability to reduce photos to bits and bytes has fundamentally changed the publishing industry and created new markets. Buy a computer and start working with your scanned photos. And get a modem and begin exploring the Internet. It will prepare you to compete on equal footing.

Most important, take lots of pictures. All the reading in the world will only give you an intellectual understanding of the process. You must expose film, evaluate the results, and correct your mistakes. So what are you waiting for?

Getting
Established

Now you've actually shot a few performances. Are you happy with the results? Unless you're already a seasoned photographer accustomed to working in difficult circumstances, chances are you'll find there's plenty of room for improvement. That will come with experience. The more performance work you do, the more comfortable you'll become with its unique demands. Staying active in the game is also important to help establish you as a valid player. Therefore, you must find a situation that permits you to shoot on a regular basis. There are several possibilities once you're able to produce technically competent photos.

Pick a band or artist with potential

One of the easiest and most effective ways is to latch on to a local band or artist that you feel has potential. It could just be a band you like, or one that includes someone you know. If you know someone in the band, or close to it, gaining inside access is obviously easier. In general, you'll find that most beginning or unknown bands and solo artists work in venues that don't require special clearances. Just show up and start shooting. Anonymity allows you to work and learn without the pressure of living up to someone else's expectations.

The time to share the results comes when you get something good. Poor pho-

tos only hurt your cause. Most musicians love to see photos of themselves performing, and chances are they'll be delighted that someone cares enough to make the effort. I've been amazed to discover that many bands—even some that have been together long enough to have a press kit and promo photos—have never seen good shots of themselves in concert. That means you have an excellent chance to make a good impression. Once you've gained respect, doors will open to rehearsals, backstage, and posed shots. The better your photos, the more likely they will lead to paid promo or album cover sessions. With the dramatic drop in recording costs over the past few years and the explosion of independently produced albums, an album cover session is now within reach of just about anybody with the right skills and connections.

The experience you gain from working with a band that gives you free rein can be invaluable. After all, a guitar player by any other name is still a guitar player. From a technical standpoint, it really doesn't matter if it's Eric Clapton or Joe Blow you're shooting. Most of the elements at play in the performance of a big star are also present in the performance of any relatively experienced working band. You'll learn the best angles to get clear action shots, how to compose and expose properly, and what lenses are necessary to fill the frame of your viewfinder. You'll also learn the harsh realities of working crowded clubs and the fickle mysteries of concert lighting. And by working with a band on a regular basis, you'll learn the characteristic stage gestures of each member and how to anticipate good shots. At the same time, you can use your connection with the band to develop contacts with club managers, promoters, and other local bands.

Tying your allegiance to talented but unknown artists can be particularly fortuitous if your instincts are good and you get lucky. If they hit big, you just might get to go along for the ride. And if they get *really* big you may even end up with a book archiving their early years somewhere down the line. More likely, however, the band will not survive, no matter how good they are. That's just the reality of bands. Conflicting goals, musical directions, talents, attitudes, and work ethics serve to splinter 99% of all bands before they succeed. Still, the more talented members usually move on to other bands, which widens your circle of possibilities.

Case in point: JOEL BERNSTEIN

Joel Bernstein was a 15-year-old Philadelphia high school student in 1967 when he was mesmerized by a coffeehouse performance of a young, relatively unknown

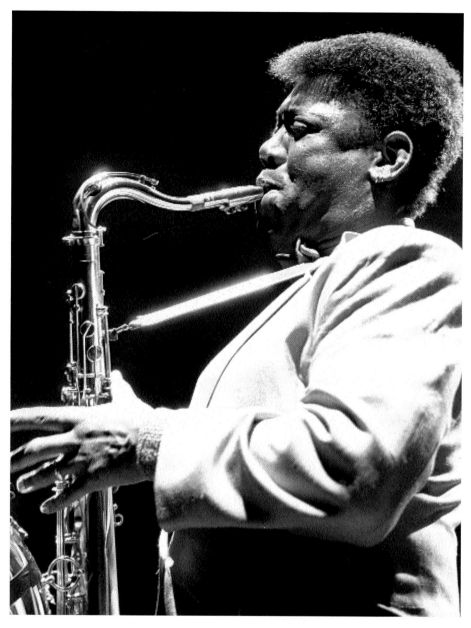

CLARENCE CLEMONS, 1984

Light is the giver of all things photographic. That's the cardi-
nal rule. Sometimes it all comes together and you get that
blessed combination of front and back light that chisels out
features and imparts three-dimensional qualities. Playing with
Bruce Springsteen's E Street Band, Clarence was the canvas.

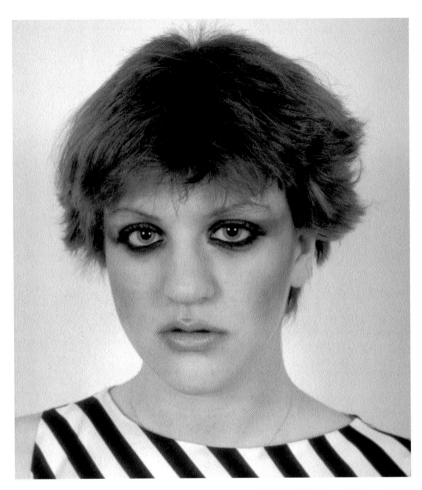

COURTNEY LOVE, 1981

When you hang out your shingle as a music photographer, you never know
who will walk in your door. If you've got a small studio where you can photo-
graph artists and bands, you can shoot promotion photos. There are a lot of
young bands hungering for a shot at the big time, and promotion photos are
essential in the quest. If you get lucky, you might even end up with shots of
an unknown artist or band who later makes it big.

 An acquaintance asked me to photograph his 16-year-old daughter Court-
ney and her girlfriend in my small dining-room studio. He didn't offer to pay,
but I was intrigued by his description of the girls. Courtney and her friend
Robin spent an hour or so flirting and posturing for my camera in a thor-
oughly enjoyable session. I liked both for their sense of humor and deadly
insightful young/old wisdom. Courtney and her father left town shortly there-
after, before I showed them the slides and proof sheets. It was 12 years be-
fore I rediscovered them in my files and put two and two together. Four are
reproduced here for the first time.

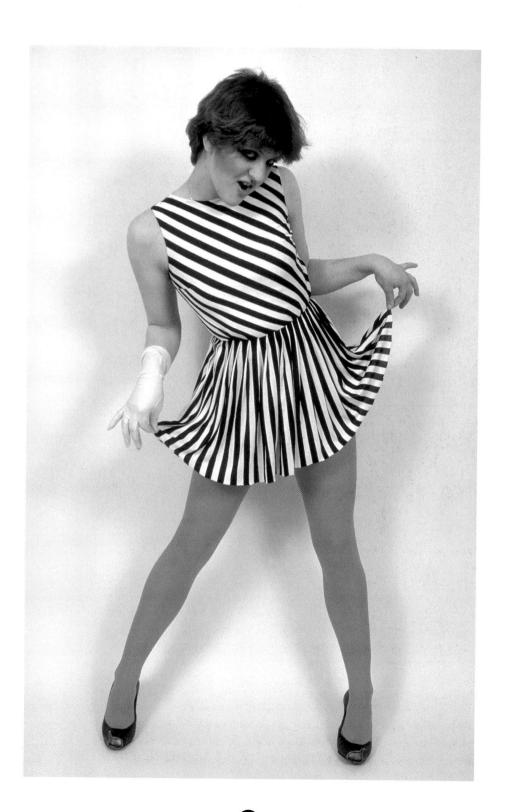

COURTNEY LOVE AND ROBIN, 1981

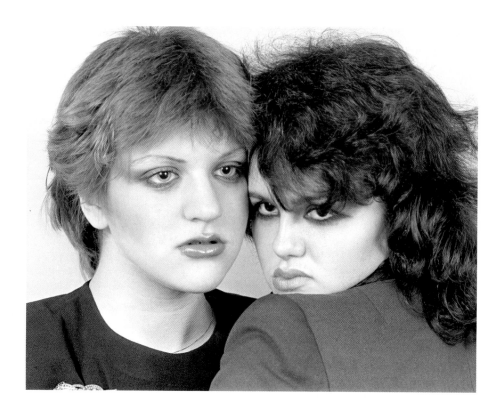

Canadian singer/songwriter/guitarist. "I'd been playing guitar since I was eight," he recalls, "but I'd never heard anyone play in open tunings the way she did. I was fascinated." A fledgling photographer, Joel decided to bring his camera the next night. The film from that night was the first he ever processed and proofed himself. By his own admission the shots weren't very good, but they hooked him on photography. Over the next year his skill improved and he photographed the singer on several more occasions. "Eventually, I did a shot of her in the fall of 1968 that I can still look at and say, 'That's a good picture.'" It was good enough, in fact, that Joni Mitchell asked Joel to become her personal photographer.

Soon he was meeting and photographing her musical friends, including Laura Nyro, Leonard Cohen, David Crosby, Stephen Stills, Graham Nash, and Neil Young. His byline began appearing in magazines and song books and on album covers. In June 1970, one week before he was graduated from high school, he shot the cover and inside photos for Young's classic LP *After the Gold Rush*. Shortly thereafter he shot the photos for Crosby, Stills, Nash, and Young's *4-Way Street*.

Both album sessions, he points out, were shot "on spec," meaning he didn't get paid unless the photos were used. With the results he was achieving, however, it wasn't long before record companies began hiring him for sessions. Subsequent album photo credits include some of rock's biggest names, including Jackson Browne, Bob Dylan, Bruce Springsteen, and Prince. Despite his success and talent, however, photography has always been only a part of his working identity. Among other jobs, he has toured with Bob Dylan and Prince as their guitar technician and has a long, successful history as a recording engineer. He has spent the better part of the past five years listening, choosing, mixing, and engineering three decades' worth of material for Neil Young's long-awaited boxed set.

"The path I took is still open," says Joel. "I encourage young photographers to find a band that's not already playing arenas and get attached. Even if you take a really good concert shot of a big-name band and somehow get it to them backstage, it might end up buried under a mountain of things that they're getting in the dressing room that night—most of which are terrible. The chances of sending a photo backstage and having somebody publish it are pretty small. It would be much more to the point to find a band who you can shoot in a more intimate setting like a club or theater. If you can, take them a portfolio and say, "Hey, I have this one idea for a group shot. Could I just take one shot of you outside?" Any shot that's not in a concert situation is going to be worth more because, when all is said and done, the best concert photograph is still just a concert photograph.

"Andy Warhol used to say that his idea of a great photograph was a famous person doing ordinary things. There is something to be said for that. I think my pictures of Joni in her kitchen or in an off-guard moment are much more to the point than something I might do of her in the studio. In my own photography, I've tended to avoid studio setups. The first one I ever did was for Prince. He loved it and used 50 things from one session, so it sort of succeeded in that sense. But it's not the kind of thing that I like to do or include in my portfolio."

Case in point: MARK LEIALOHA

Mark Leialoha had already been shooting concert photos on his own for some time when he chanced upon a young, struggling band from the San Francisco Bay Area called Faith No More while on assignment for *Artist* magazine. Though there was little or no photo demand for them at the time, Leialoha persisted because he liked their music and felt they had a shot at making it.

MARY TRAVERS AND PETER YARROW, 1979

**Not all of the best shots happen centerstage, so don't get lost in the
tunnel vision of your lens. Mary Travers and Peter Yarrow (of Peter,
Paul and Mary) were standing in the wings watching Paul Stookey
perform a solo piece when I saw this shot. I liked the way it revealed
the warm, easy affection of two old partners and friends.**

Sure enough, when their time came, Mark had established a solid working re-
lationship with the band and was ready to meet the sudden demand for pho-
tos. He became the band's tour photographer, and dozens of his photos have
been published in books and magazines throughout the world. "I've pho-
tographed Faith No More on more than 50 occasions," he says. "One good thing
about shooting a band many times is that you don't have to try to be every-
where at once. A lot of times I'll go to the show with one idea, and I'll do noth-
ing but concentrate on that. For instance, another band I've shot a lot is Slay-
er. One night I decided to only shoot the drummer. Naturally, the drummer
loved it and I came up with some great drum shots, which isn't easy to do. Af-
ter that, anytime somebody needed individual live shots of the whole band
I pretty much had all the drum shots locked up, because everybody else was
concentrating on the lead singer and guitarist. I've done the same thing with

Familiarity with a band's stage act allows you to be in position when you know something graphically interesting is going to happen. Leialoha has photographed Faith No More on numerous occasions and knew that lead vocalist Mike Patton would take a mouthful of water and spray it up in the air at a certain point in the show. Leialoha was ready, and the shot has been published at least a dozen times throughout the world.

keyboard players and bassists."

These days Leialoha routinely works with the biggest names in hard rock, but he's never forgotten the lesson he learned from Faith No More. He continues to seek out sessions with young, unsigned local bands, even when it means little or no money. "I like doing sessions with young bands because they are fun to work with. You do a photo session with a big-name band or artist you don't know and get maybe five or ten minutes with them, because that's what the time slot allows. With a younger band, they want you there as much as you want to be there, and you can feel free to experiment. Some of my best ideas were worked out in sessions with young, unknown bands and later used for magazine or album cover sessions for more famous ones. And if their time finally comes, and a record company is ready to spend some money, you hope they'll remember your interest and call. The hard aspect of starting with an unknown band is that you usually end up doing stuff for free or next to nothing while they are developing. When they get rich, sometimes they can't get away from the idea that you should still be working with them for free. As your business grows, you tend to charge old clients old prices and newer clients new prices, which means you have to continually keep moving on to new bands."

Establish yourself as a house photographer

Another effective way to build your portfolio and gain credibility is to strike an agreement with a club manager or owner to be a house photographer. There aren't many that wouldn't love to have shots of musicians performing in their club, either for display or their personal collections. The problem is that not many are willing (or able) to pay for the privilege. You can turn this to your advantage if you're willing to initially pay for film, processing, and printing in ex-

MIKE PATTON, 1989. PHOTO BY MARK LEIALOHA

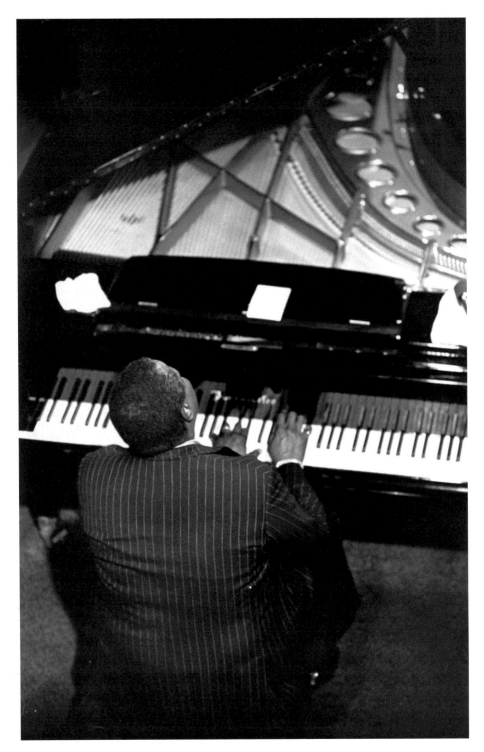

OSCAR PETERSON, 1977

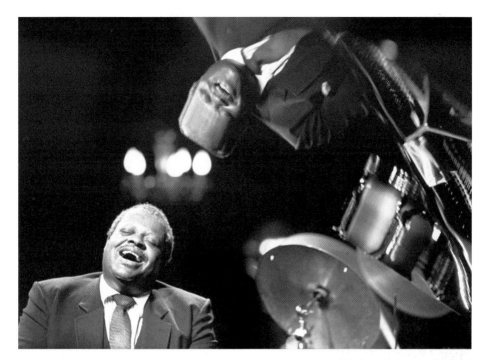

1981

The value of working often at one venue is that you learn the best shooting spots in the house. The ideal venue affords a clear shot from several angles, none of which disturb the paying customers. Unfortunately, few venues are ideal, but you can learn how to maximize the best possibilities of any given situation. These photos of jazz piano master Oscar Peterson were taken at San Francisco's Great American Music Hall between 1977 and 1981. Peterson, incidentally, is himself a talented photographer who speaks knowledgeably on the subject.

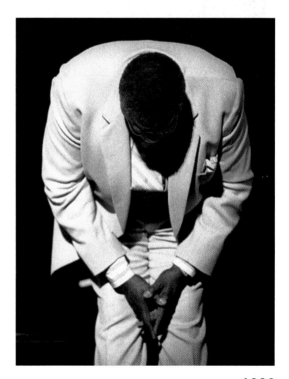

1980

change for access, to prove yourself. This is no small expense if you're shooting transparency film and getting prints made from the slides. But if you like the kind of music presented in the club and feel that there's a reasonable possibility you can recover your costs by publishing your photos or establishing working relationships with the bands, you might find it's worth it to gain a foothold.

As a house photographer you'll have the cooperation and good will of the club's employees, including the person running the lights. This can be a tremendous advantage, especially if the house has a good lighting system. After a couple of gigs you'll also become intimately aware of the best camera angles in the house and be able to position yourself accordingly ahead of time. Furthermore, your official status may also provide backstage access to performers, although they will ultimately decide when and where you can photograph them.

Establishing this kind of relationship with a club has its potential pitfalls, however. Primarily, you don't want to end up feeling exploited. When you approach the manager or owner with your proposal, try to present a professional attitude, especially if you already have a quality portfolio to show. Don't promise the moon. Offer to provide a couple of prints of your own choosing and be very specific about how they can used. Copyright control must be retained by you, although you may want to allow the owner to use a shot for a publicity release or advertisement. It is certainly in your best interest to allow the club to display them. Just be sure to stipulate that your photo credit be conspicuous. After you've established yourself, you might even get the club to help defray your expenses. If you're good enough, and the owner needs more than a couple of shots of each act and has uses beyond displaying them at the club, it's even possible to turn it into a paying job. It's not unusual for venues, particularly those that present big-name acts, to retain a photographer on a regular basis with a guaranteed minimum purchase for each shoot.

Case in point: TOM COPI

By the time Tom Copi moved to San Francisco in the early '70s, he had already built a portfolio of rock and jazz performance photos as a photographer for the *Michigan Daily* and the *Detroit Free Press*. Uninterested in pursuing a career as a news photographer in California, he tried selling mounted prints of his music photos for five dollars apiece on the streets of San Francisco's North Beach and Fisherman's Wharf tourist districts.

Despite his low prices, he met with little success until the night he set up his

display in front of Keystone Korner, then the city's premier jazz club. "I was used to people occasionally buying a print or just blowing by my stand altogether," says Tom. "But this guy walked up and bought 12 photos, and that sure got my attention." The buyer was the club's owner, Todd Barkan, who asked Tom if he was interested in documenting the acts that passed through the club. Because jazz was his first love, Copi quickly agreed and a deal was struck.

"I worked there two or three nights a week for eight years, but I was never on the payroll. We had an informal agreement where I sold him promo photos he could use in his other roles as a promoter and an agent. Plus, he was a big collector. He papered the walls with photos, magazine articles, posters, and sheet music. I didn't charge him much, but what I got helped pay for film, paper, and chemicals. And by being there for so many years, I struck up acquaintances with the musicians who came back year after year and was able to do some business with them. Still, there wasn't a lot of money involved. This was jazz, performed by people dedicated to pure art. Not many of them make much money."

The primary benefit, he says, was the access. As his file of musicians grew, he became a steady contributor to *Down Beat*, a leading jazz publication since the 1930s, and several other music magazines. That, in turn, gave him access to the other jazz clubs in the Bay Area. As part of the Keystone family, he was given a free hand as long as he didn't upset the artists or audience. Lighting, he says, was invariably a problem. "The club was always a hand-to-mouth operation because it was so small. There wasn't any money for high-tech lighting. There was one bank of lights above the stage that were way too high and straight overhead, so everybody had 'raccoon eyes' from the shadows. When I first started, the only lighting control was this potentiometer right next to the stage. I'd get on it and very slowly start bringing the lights up—so slowly that nobody would notice it. But after a few minutes the lights were really bright and I'd fire away like crazy until the artist would notice and signal for someone to turn the lights down. I had these grandiose plans to redesign the system, but I was always broke. I *did* put two battery-operated slaves up in the corners of the stage that I could trigger with my on-camera flash when I got the artist's permission to use them. Some would let me use the lights for one song, some didn't care at all how much I used them, and some would say, 'No way.' I got all kinds of different responses. Those slaves were great until somebody stole them; I never had the money to replace them.

"Those eight years were a great experience. Bebop was the heart and soul of Keystone Korner, and a lot of great artists played there. There was a lot of great

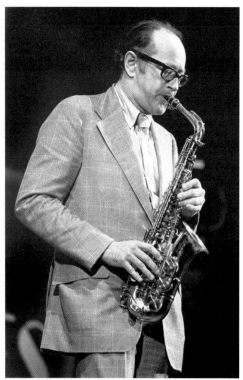

Learning to wait for and recognize an extraordinary shot might be the most important attribute you need to become an outstanding music photographer. The shot on the left of the late Paul Desmond stands on its own as an acceptable, publishable photograph. The composition is basically good, the lighting is excellent, it's sharp, and he has a pleasant-enough facial expression. By waiting a split second for him to put new wind and his body into the horn, however, you get new insight into the musician and his music. Use the instrument and the musician's body gestures to create graphically pleasing shapes that imply movement.

PAUL DESMOND, 1975

hanging out after hours, and I got some great backstage shots of many of my musical heroes. I'm still selling the photos I got during those years."

Build a working relationship with a newspaper or magazine

Perhaps the most visible result of the desktop publishing revolution is the unprecedented proliferation of small, independently published community newspapers and magazines, many of which are distributed for free. Though the contents and primary target audiences of these publications vary greatly, the one thing most seem to have in common is a page or section devoted to local entertainment. The content can take the form of concert reviews, record reviews, entertainment listings, or full-blown editorial coverage of local and visiting musicians. These publications offer the novice photographer the opportunity to get his or her work published, as well as photo access to concerts. The catch is

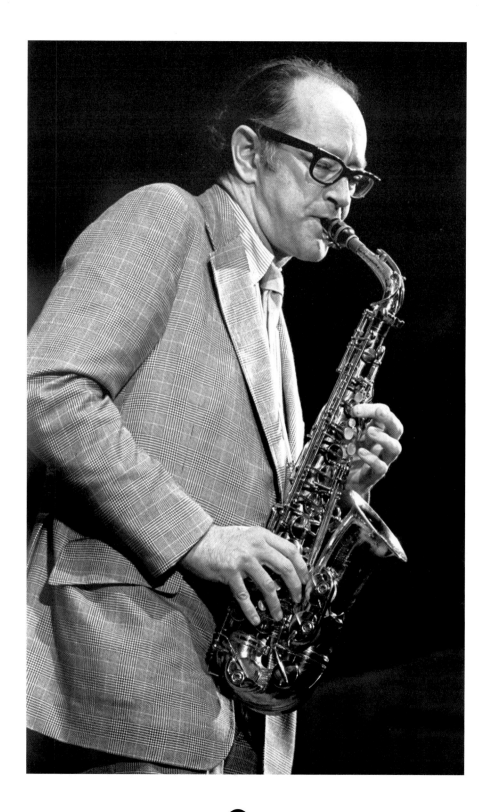

that there's very little money involved. This is seldom a matter of the publisher pocketing all the dough (although they usually get what little there is) while the writers and photographers get burned; a large percentage of these publications operate week-to-week or month-to-month on a nonexistent budget and often disappear overnight. Nevertheless, some of them *do* survive and grow into healthy publications because they've found writers and photographers who are willing to take a chance on their success in exchange for a showcase for their work. If you can demonstrate a talent and agree to work for peanuts, most of these publications are eager to give you a chance.

Target the ones that appeal to you and make an appointment to show your portfolio. After you've demonstrated that you can deliver the goods on time, they might even add you to the masthead as a staff photographer. Some of them list up to a dozen. Though it probably means little in terms of cold, hard cash, it will enhance your ability to negotiate photo clearances. Don't end up feeling like a chump, however. Even if you're working for little or no money, you should act like a professional and ask to be treated like one. If you work for a struggling young publication on a regular basis, it's not unreasonable to expect help with film and processing expenses, at the very least. And when the magazine or newspaper starts to make money, *you* should make money. There are more than a few publishers who will gladly exploit you, if you give them a chance.

In the same vein, there are dozens of national and international publications operating on that same shoestring, targeting specific musical idioms without the mass appeal of rock and pop, such as blues, bluegrass, gospel, folk, Christian, zydeco, etc. If your interests fall into one of these categories, try to establish a working relationship with a relevant publication. Again, if they like your work, you could end up on the masthead as a staff photographer with exclusive assignments in your geographical region.

College newspapers can be especially good because of the large number of campus concerts currently booked by big-name acts. You have the advantage of working for the "home" newspaper, which *can* give you an edge with the campus promoters and security people.

Case in point: ROSS HALFIN

For more than two decades, Ross Halfin has been *the* international heavy-metal and hard-rock photographer. Armed with his Nikons and a caustic wit, the wry Englishman has literally blanketed the globe photographing headbangers

Sometimes the little details surrounding an event can add meaningful information and provide another salable image. This set list was taped to guitarist Ed King's amp for a Nashville date on the hugely successful 1988 Lynyrd Skynyrd Tribute tour. Any Skynyrd fan can instantly identify the songs by their sketchy titles.

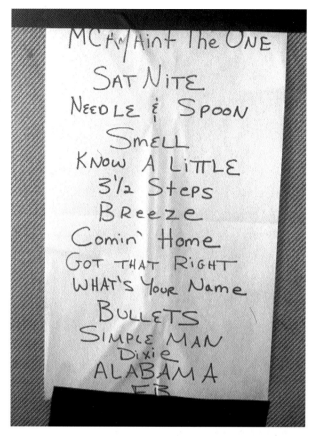

LYNYRD SKYNYRD SET LIST, 1988

for dozens of international publications. His roots in the business, though, are quite humble. An art college dropout, he was working in a guitar store when he started taking his camera to concerts. "That was when you could still do that at big shows," he recalls. "I was a big fan of the Who, and I figured the best way to get up front was to become a photographer." One of the first bands he shot was the Canadian rock trio Rush. Though he admits he didn't know much about photography, Halfin got a couple of shots published in a small black & white newspaper called *Sounds*. The paper's concert review editor liked them and started setting Ross up for other shows.

Within a year, he'd quit his job at the guitar store and become the *Sounds* staff photographer, shooting a wide variety of music. His identity was sealed when the editor suggested they collaborate on a book on heavy rock. "This was

during the period when bands like Black Sabbath and UFO were really big," says Ross. "The problem was he didn't have the money to do a book and I didn't have many color photos. So I scraped together some pictures of ZZ Top, Styx, and Motörhead, and we put out a thousand copies of a magazine called *Kerrang!*, named for the sound of a big, crashing, metal open guitar chord. It sold out immediately, so he did another one. Pretty soon it became a monthly magazine and I was suddenly getting $100 a picture instead of $30, because it was color. I still work for *Kerrang!*, sort of as a staff freelancer. I get first pick of the jobs. That's how I became stereotyped as a heavy rock photographer. I sort of like it, but I also sort of resent it. I wanted to shoot Prince a few years ago and rang up the Warner Brothers press office. They wouldn't give me a photo pass because of the type of music I typically shoot. Sometimes I feel I'd like to do something else besides hard rock, but I can't make as much money."

Ross says he gets flown all over the world to shoot for European rock magazines because they are more powerful than their U.S. counterparts. "In the States, MTV is first, and then radio, for selling records and tours. Magazines are the lowest rung of the ladder, and that's why record companies and bands treat them so badly. In Europe, there is no hard rock radio and MTV is still kind of new and not at all like it is in the States. Magazines sell tours over there, and that's why they're so powerful. Bands that tour will do sessions because they want to be on the covers of European magazines. In the late '70s, I started getting flown to America almost every other week to shoot covers, and the photographers here couldn't work out why. I still come here quite often."

Develop a working relationship with a freelance writer

Another pathway to publication is to hook up with a writer working on a story. If the writer is a freelancer, he or she will understand that the chances for publication are enhanced if the piece is accompanied by good, current photos. In fact, if the photos are good enough, an editor will sometimes go to great lengths to rescue weak text. Surprisingly, perhaps, a team often evokes more cooperation from the artist or band. Maybe it's because they get a better understanding of how the photos are going to be used, or maybe they're just flattered by the attention of two people. Whatever the reason, I've often found it helpful to work directly with a writer. Photographing while the interview is taking place offers a particularly fine opportunity to get relaxed and animated can-

dids of the subject or subjects. Working with a writer led to my first pu~~b~~~~lica~~tion in a music magazine and my first album cover. A friend, Alec Dubro, assigned to write a piece on the Youngbloods for *Rolling Stone* in 1970 and invited me along to shoot some photos. Several ended up being used, and the band members liked them well enough that I was asked to shoot what turned out to be their final album cover.

Better yet, if you have the skills, do both the writing and photography yourself. Editors find it very appealing and convenient if they can count on you to deliver both story and photos. If your questions are intelligent and relevant, the rapport you develop with the artist will serve you well when you start taking photographs. A 1972 interview/photo session with the late John Cipollina, of Quicksilver Messenger Service, became a *Guitar Player* cover story that led directly to my 19-year relationship with the magazine as a writer, staff photographer, and editor.

Freelance, using all of the above tactics and more

Nearly every successful music-business photographer got that way by using all of the tactics we've discussed thus far. If you feel you don't have any particular edge right now, create one. Keep shooting regardless of whether you have any immediate hope of being paid or published for it, making contacts any way you can while developing your craft. Give out a lot of prints, and make a lot of friends along the way. You never know when or how it will come back to you.

Case in point: JAY BLAKESBERG

With an average of 20 to 25 shoots each month, few music-business photographers can match the schedule of Jay Blakesberg. His photos appear regularly in dozens of magazines and newspapers, on compact disc packaging, in many prominent (and budding) musicians' promo packages, and just about anywhere else that photos of musicians are found.

Obviously, art directors and musicians didn't just start calling him one day. Jay built his standing step by step, starting by taking his father's Nikon to shows in the late '70s while still in high school. "The original reason I started taking pictures of musicians had nothing to do with making money," he says. "I really thought I was documenting a part of history and creating a personal archive

that was important to me."

In 1985, after a brief flirtation with college where he continued to shoot occasional shows, Jay moved to the San Francisco Bay Area and began photographing musicians in earnest. With no standing to acquire photo passes, he started with small clubs, coming back time and again to cultivate relationships with owners and local musicians. Unable to afford the services of a professional printer, he set up a small home darkroom to develop film and generate prints for his portfolio and for promos.

Photos in hand, Blakesberg began haunting local entertainment newspapers and magazines to get his work published and to solicit photo passes. When he met rejection, he was doggedly persistent and kept coming back. He also understood the power of promotion and turned it to his advantage: "When I was first starting out, I'd make 25 to 30 5 x 7 prints and turn them into postcards, just to get the attention of editors and art directors for publications that I wanted to work with. It's very important to make those connections, and mailers can be very effective. I don't know how compelling they are in terms of getting an art director to pick up the phone right now and give you a job, but it does remind people that you're still out there producing new work."

By 1987, Jay's perseverance and performance began to pay off. He became the house photographer for the I-Beam, a popular San Francisco night club that showcased up-and-coming alternative bands, just as alternative music started hitting the charts. His photos of hot new bands such as the Pixies, Throwing Muses, and 10,000 Maniacs were suddenly in demand. That same year, his persistent promotional mailings paid off when *Rolling Stone* called him at the last minute to shoot a surprise U2 performance in San Francisco's Justin Herman Plaza. Three weeks later the magazine called again for a Los Angeles shoot, and Jay has been *Rolling Stone*'s first-call photographer for Northern California assignments since. Shortly thereafter he hooked up with Retna, an agency specializing in entertainment photography (see Chapter 9), and his byline began to spread throughout the world. Art directors, publicists, and record companies began calling and haven't let up since. Blakesberg now maintains a 2,300-square-foot studio.

Part of his success can be attributed to versatility; there is no single Jay Blakesberg "look." He works in 35mm, 2-1/4 square, and 4x5 formats in both color and black & white. He is equally adept in the studio, on location, and in concert. Sharp focus, soft focus, cross-processing of color materials, and a whole library of other looks are all part of his repertoire. The choice depends on the

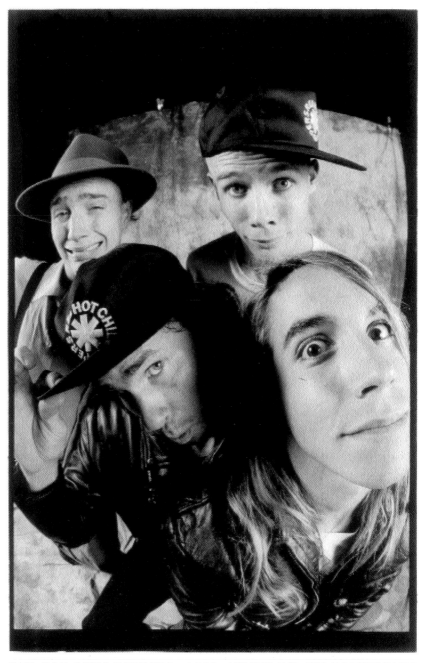

RED HOT CHILI PEPPERS, 1989. PHOTO BY JAY BLAKESBERG

Conventional photographic wisdom says that you don't distort someone's
face when you're shooting portraits. But, hey, this is rock and roll.
Blakesberg used a 16mm fisheye for this unusual shot of an unusual group.

artist, the situation, client needs, and whim. He is quick to point out that his knowledge was very limited when he started out. "When I look at some of my early stuff, I see how weak it is compared to what I can do now. But I believed in myself and had faith that I would succeed if I kept growing as a photographer and learned more about the business."

Despite his current visibility, Jay has never cut back on his promotional efforts. His database of artists, managers, publicists, product managers, and art directors now includes nearly 1,500 names, and he does several 4-color postcard mailings annually to about half the list. "It's definitely important to promote yourself or you can easily get lost in the shuffle," he says. "This year I'm also taking a two-page ad in *The Alternative Pick*, a sourcebook that is distributed to art directors, designers, and other people in the entertainment business who buy photography. It's a big expense, but it does put your work in front of the right people." (See Chapter 9 for more about sourcebooks.)

Securing
Credentials

A cquiring photo credentials is the most formidable obstacle facing photographers who want to shoot best-selling musicians in theaters, arenas, and coliseums. Though these artists actually represent just a small percentage of the total number of working musicians, they are the most visible. As such, their photos are the most marketable—a primary reason that photo access is so tightly controlled. With a few notable exceptions, it's safe to generalize that the bigger the act, the more restricted the access. It's not unusual to go to a mega-show these days and see one or maybe two photographers the whole night. For much of Barbra Streisand's 1994 comeback tour, *no* still photographers were permitted in the house. In truth, musicians who can afford to exercise that kind of control don't need to generate publicity. Artists with the stature of Streisand, Michael Jackson, Madonna, and the Rolling Stones tour so seldom that they create an massive overdose of hype without even trying.

Fortunately, mere mortal musicians must court the press to call attention to their latest album and tour. That's why artists and record companies have publicists whose primary task is to provoke media coverage. Musicians and publicity people understand that it's in their best interest to grant interviews, dole out free tickets to writers and reviewers, and provide access to photographers. They just want to be sure they're getting something back for their efforts. It's

Introducing the audience into your shot helps bridge the gap between it and the performer. It can be one-to-one, like George Thorogood at San Francisco's Warfield Theater, or one-to-many à la Ronnie Montrose at the Oakland Coliseum.

GEORGE THOROGOOD, 1981

simple, really; if you want to get credentials to shoot a show, you're going to have to convince somebody that it's in their best interest to give them to you.

Identifying recipients

To help you determine where you might fit into the picture, let's take a look at the photographers wearing photo passes and lining the stage at the shows you paid $30 a ticket to see. They are likely to come from several sources.

Magazine and newspaper photographers

The majority are on assignment for a magazine or newspaper, including staff photographers and freelancers representing national and international publications, local daily newspapers, and local entertainment weeklies. In terms of sheer numerical possibilities, this is probably the easiest way to score a pass. Arrangements are frequently made by the publication on behalf of the photographer, although well-established freelancers often have direct connections with record companies and band management.

Venue photographers

These are professionals who are hired to record all events that take place at

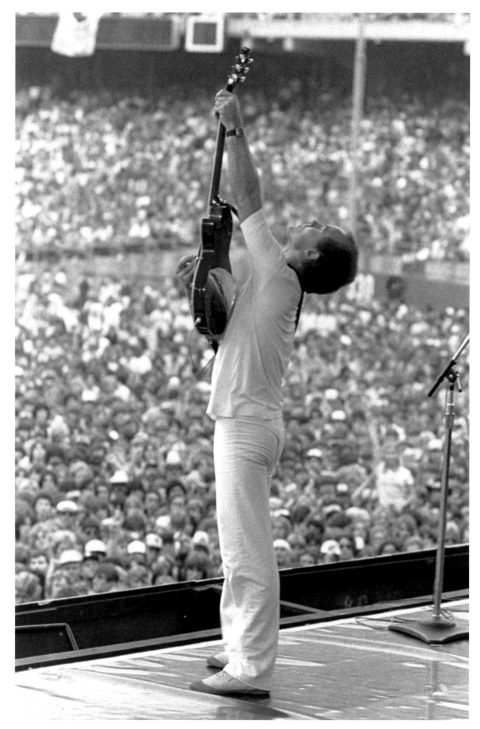

RONNIE MONTROSE, 1981

a particular venue. Sometimes there are two photographers who fit into this category—one hired by the promoter, the other by venue management. Depending on the band's photo policy, they are often granted better access than press photographers. And even if the band is being difficult about photo access, the venue photographer can often find ways to circumvent restrictions because he or she has the advantage of knowing the nooks and crannies of the hall and the personnel running it.

People associated with the band

This group includes people who are friends, family, or employees of the band. Most of them are just looking to get a few shots for the scrapbook, although a few take photography seriously and may provide photos for the band's album covers or tour books. I've even met a few who are professional photographers in other disciplines, such as fashion, sports, or advertising, and just happen to be friends of the band. The edge this group has is that they're sometimes permitted to shoot in places that are off-limits to strangers and working media, including backstage, in hotels, or on tour buses.

Official tour photographers

This is probably the best music photographer's gig there is. The tour photographer is hired by a band's management or record company to travel with the band and produce photos suitable for publicity and merchandising purposes. In most cases, these guys are well-seasoned pros and veteran road warriors who are known and trusted by the people who hire them. Discretion is essential for this type of work. In theory, tour photographers have complete access to the band both on- and offstage, and sometimes they actually do. Some of the more experienced members of this coterie include Neal Preston, Ross Halfin, Neil Zlozower, Paul Natkin, Mark Leialoha, and Lynn Goldsmith.

Freelancers

This catch-all category includes photographers hired or granted photo rights by various entities with some kind of professional connection to the band. They include, but aren't limited to, public relations agencies, record companies, sound and lighting companies, merchandisers, advertising agencies, and mu-

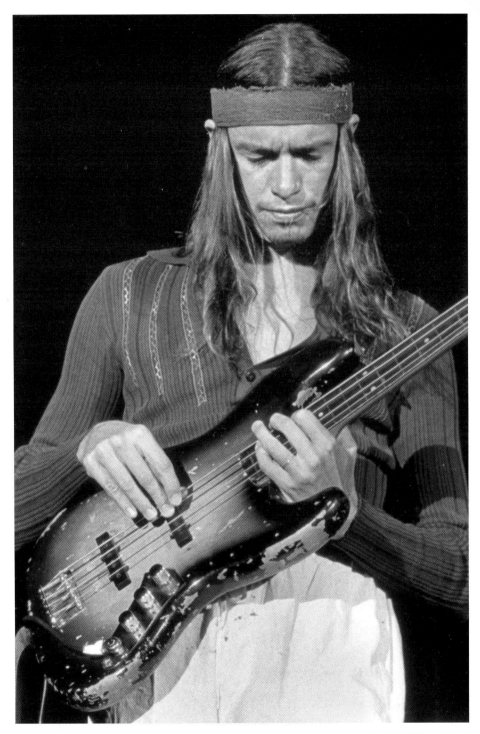

JACO PASTORIUS, 1979

THE BOREDOMS, 1996. PHOTOS BY DENNIS KLEIMAN

Combining electronic flash with ambient light helps impart motion to your images. One of the more creative practitioners of this technique is Dennis Kleiman, chief photographer for *Smug*, a well-written and well-designed free newsprint magazine that covers the New York alternative music scene. Much of his performance work is in small clubs where the music is loud, the crowd is rowdy, and the use of flash is seldom an issue.

"I try to freeze the subject with the flash and keep the shutter open long enough to get a wash of colors and shapes in the background," says Kleiman. "Sometimes you get 'trails' off the musicians as they move around, but that's usually a happy accident. When you get lucky, it captures the energy of the performance, and it looks different with each frame."

He uses Fuji RDP (ISO 100) film rated at ISO 80, a Nikon F3, and a non-dedicated flash unit. Exposure is determined by years of trial and error. "Generally, I shoot somewhere between f/2.8 and f/4 at 1/4th, 1/8th, or 1/15th of a second, depending on how much 'blur' I want. I'm familiar with most of the clubs here, so if I'm shooting at CBGB, I know it'll be dark and I'll need to shoot at 1/8th or slower to soak up some of the existing stage lights. At some of the bigger clubs with better lighting, I can shoot at 1/15th or 1/30th. Sometimes I'll shake or spin the camera to produce an effect similar to the subject's movement.

"These techniques work well when the subject is primarily backlit, because the flash freezes the subject and there is little existing light on him. Then I can shoot at even slower speeds up to one second, and the background and subject exposures are almost the same."

SPILTH, 1995

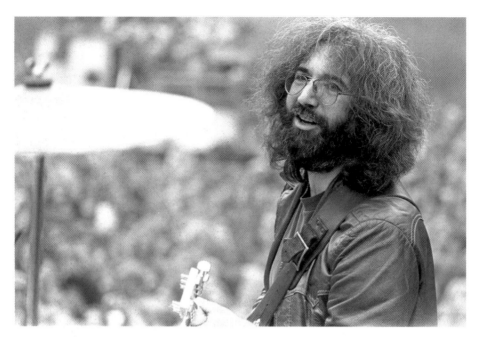

JERRY GARCIA, 1975

Though it's always best to frame your shot precisely in the viewfinder, don't be afraid to crop an image in the darkroom or computer if you can make it stronger. I was in position to get this shot for less than two minutes (kneeling on a big amp or speaker cabinet, as I recall). My camera was fitted with a 105mm f/2.5 lens, and it was horizontal when Jerry turned his head in my direction. There was no time to reframe, which left waste space. But because I had captured enough of the guitar's headstock and his hand, and it was well exposed and sharp, I was able to crop the shot vertically and present a stronger image.

sic equipment manufacturers who have endorsement deals with the band.

Establishing contacts

By studying the photographers who get passes, you get a pretty good idea of who has the power to grant them. Most powerful are the band's management and publicist, followed by the record company publicist, the promoter, and venue management. Intermediary entities who can arrange passes include magazines, newspapers, public relations agencies, merchandisers, advertis-

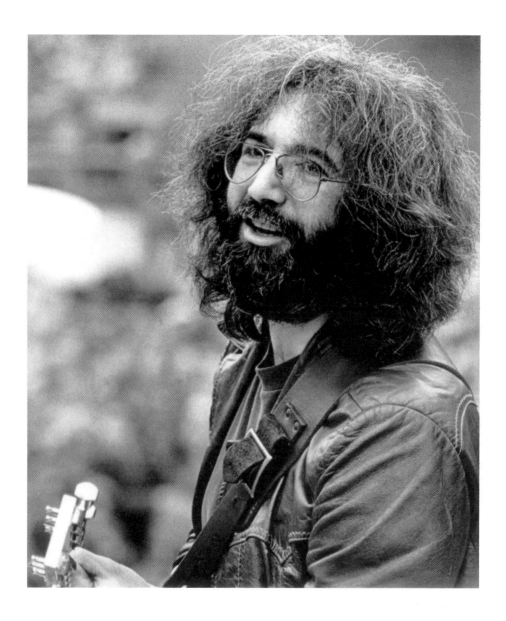

ing agencies, and music equipment manufacturers. These are the people you must impress if you want permission to shoot; you're either going to need a portfolio that shows you're capable of delivering the goods or have a powerful ally (like the lead singer or guitarist) intercede on your behalf.

Building relationships and contacts that lead to photo passes is a gradual, ongoing process that demands persistence and diplomacy. Convincing

CHEECH & CHONG, 1972

people that they should give you a photo pass requires a combination of finely tuned interpersonal skills, including aggressiveness, amenity, patience, respectfulness, charm, and self-confidence. Furthermore, you need the insight to balance these qualities in just the right measure, depending on whom you're dealing with. The music industry is a powerful magnet for talented, intelli-

gent people. Many are friendly and helpful, but some have egos equal to or greater than the artists themselves. Don't be discouraged if you feel like you're being blown off because you can't speak directly to the head man or woman to plead your case. The secretary or assistant you speak to today could well be in charge tomorrow, and he or she usually remembers who treated them with civility and respect when they were starting. No matter how righteous you think your cause, copping an attitude will only endanger any future possibilities for cooperation.

Try to arrange interviews to show your portfolio to anyone who has the power to provide access to the artists you would like to photograph. No matter what the outcome of your initial meeting, keep in contact by phone, fax, or mail so they remember who you are. If your work is good and you maintain a cordial, professional demeanor, the contacts will eventually start to click. Persistence is the key word here. Don't be a pest, though. If you start to sense hostility, back off.

Who ya gonna call?

An important part of the process is knowing precisely who to call. You may know a band's record company, but who's the head of publicity and what's her phone number? How do you find out who manages or books the band? Who handles publicity for the local college venues? Because people in the music business need to know these things, too, there are several directories and publications that provide this kind of information. These extremely powerful tools must be used with discretion. The people listed in them are there to facilitate business contacts. They are not for fans looking for a way to contact their favorite musician for an autograph.

With that in mind, here's a summary of available resources. Although every attempt is made by the publishers to keep their information up to date, the music business is volatile. Turnover is brisk, as people get promoted or change companies. If you prefer to make contact by mail or fax, call first to confirm the name. People are much more receptive if you get their name right, especially if they are new in the job.

Billboard Directories

Well known to the music trade and general public for its weekly charts of the best-selling singles and albums, *Billboard* magazine has been part of the

entertainment industry for more than five decades. In addition to its weekly magazine, *Billboard* annually publishes eight directories targeting specific aspects of the industry. Most relevant to our needs is the *International Talent & Touring Directory*, which lists individual information on nearly 9,000 U.S. and international artists and bands, including musical category, current record label, booking agent, personal manager, public relations representative, and business management. In another section, addresses, telephone numbers, and the names of key personnel are provided for nearly 3,000 U.S. and international booking agents, personal managers, and business management firms. Also included is a comprehensive state-by-state listing of concert promoters, facilities (auditoriums, arenas, theaters, clubs, etc.), sound and lighting services, musical instrument rental and sales outlets, rehearsal studios, security services, and hotels. In separate sections, much of the same type of information is provided for more than 40 other countries. The listings are tiny and there aren't any fancy full-page color ads, but for the sheer volume of information this publication is tough to beat. The *International Talent & Touring Directory* is published annually in October and currently costs $99.

If you're interested in country or Latin American music, *Billboard* also offers directories aimed specifically at those markets. *Nashville 615/Country Music Sourcebook* ($55), updated each May, has two different sets of listings. The *Nashville 615* listings provide comprehensive data on entertainment-related companies and services in the Nashville area, while the *Country Music Sourcebook* supplies U.S. and Canadian listings of personal managers, booking agencies, performing artists, record companies, music publishers, and radio stations devoted to country music. The *International Latin Music Buyer's Guide* ($65), published in August, supplies Latin music contacts in the U.S., Mexico, Central America, South America, Spain, and Portugal. **Billboard *Directories, P.O. Box 2016, Lakewood, NJ 08701; Phone: (800) 344-7119; Fax: (908) 363-0338.***

Bluegrass Unlimited

Bluegrass Unlimited magazine offers two annual directories. The January issue provides a comprehensive listing of dates, locations, and contact people for the upcoming year's bluegrass festivals, contests, and conventions. Each October, a significant part of the issue is devoted to a bluegrass talent directory, which provides the names, addresses, and phone numbers of management for more than 900 bands. Back issues are usually available throughout

Getting permission to shoot a live performance of almost any classical musician is nearly impossible. The decorum demanded in most concert halls all but forbids the intrusion of still photographers. And what decorum doesn't cover, the stage union does. Rehearsals are your best alternative. Classical performers generally tour by themselves, guesting with local orchestras. These collaborations require at least one rehearsal. If you're properly connected—say with a local newspaper, classical music publication, or promoter—you can sometimes get permission to shoot these rehearsals. This photo of Van Cliburn rehearsing with the Fresno Orchestra was shot on assignment for *Keyboard* magazine.

the year. **Bluegrass Unlimited,** *Box 111, Broad Run, VA 22014; Phone: (540) 349-8181; Fax: (540) 341-0011.*

Performance

Performance magazine has provided concert-business news and information for more than 25 years. Published weekly, a typical issue contains tour itiner-

aries, hot industry news, box office concert reports, artist management signings, booking agency signings, top-grossing charts, profiles of industry decision-makers, and international market trends. A one-year subscription costs $259, which includes ten comprehensive directories, each targeting a specific segment of the concert industry. Titles include *Talent/Personal Managers; Promoters/Clubs; International; Booking Agencies; Concert Venues/Concert Production;* and *Country Talent/Variety.* Each can be purchased separately for $35. *Talent/Personal Managers* is a particularly good bargain, providing names, addresses, and rosters of more than 1,200 management firms, as well as the personal management, booking agencies, and record companies of nearly 15,000 bands and artists. Also included are the names, addresses, phone numbers, and contact people for more than 200 music publications and 150 publicity companies. The other directories are equally comprehensive. **Performance, *1101 University Dr., Ste. 108, Fort Worth, TX 76107; Phone: (817) 338-9444; Fax: (817) 877-4273.***

Pollstar

Pollstar is a weekly magazine that targets much the same audience as *Performance*. It includes box office summaries; tour schedules for artists of all musical genres; charts listing top-grossing concert artists; album sales and radio airplay; artist and executive profiles; and insider news. A one-year subscription costs $295, which includes five directories—*Agency Rosters, Record Company Rosters, Talent Buyers & Clubs, Concert Venues,* and *Concert Support Services.* The directories are published twice a year, which keeps the information up to date. All address their subject matters in depth, making it possible to identify and locate just about anybody in power in the music business, except for personal management. That information is provided in a directory called *Artist Management Rosters,* which is sold only to "select concert industry professionals." You don't have to subscribe to the magazine to get the other directories. Each can be ordered separately for $37.50. **Pollstar, *4697 W. Jacquelyn Ave., Fresno, CA 93722; Phone: (209) 271-7900; Fax: (209) 271-7971.***

Recording Industry Sourcebook

Introduced in 1990, this single-source, 400-page, spiral-bound publication combines 55 categories of free listings with glitzy, full-page, 4-color ads. Divided into 12 chapters, it provides a comprehensive survey of who's who and

what's what in the U.S. recording industry. Most relevant to our needs are the listings of major and independent record labels and distributors, artist management, business management, booking agencies, music media, publicity and public relations firms, concert promoters, and music-business photographers and designers. In between you'll also find exhaustive listings of U.S. recording studios, mastering facilities, record producers and engineers, recording equipment manufacturers, CD manufacturers, and much more. The book is $80.

If you prefer your information in electronic form, a much-expanded version is provided in a database called *Sourcebase*. It is bundled with the book and ACT! Contact Management, a combination database/word processing/time management software package that provides instant information with a few keystrokes. *Sourcebase* costs $295, and is available for Macintosh and Windows. A CD-ROM version is only $95, but it excludes the book and ACT! software. **Mix *Bookshelf, 6400 Hollis St., #12, Emeryville, CA 94608; Phone: (800) 233-9604; Fax: (510) 653-5142.***

The Yellow Pages of Rock

The Yellow Pages of Rock is a 400-page, spiral-bound publication that began as a guide to U.S. rock radio stations. Radio is still the primary focus, but it has since expanded to include listings of major-label and independent record companies, artist-management companies, press and public relations people, and music publications, as well as music retail outlets, 24-track recording studios, music publishers, and CD manufacturing companies. Though the focus is narrower than other publications mentioned here, the listings are very thorough. Published annually, *The Yellow Pages of Rock* costs $100 and includes two smaller publications in the price. *Junior* is a spiral-bound book that includes 200 pages of travel information for North America's most popular destinations, while *Spot* is a directory of the most important fax numbers from the parent publication. ***The Album Network, 120 North Victory Blvd., Burbank, CA 91502; Phone: (818) 955-4000; Fax: (818) 955-8048.***

The Music Address Book

For a less expensive but more fan-oriented publication, check your local bookstore for *The Music Address Book*, compiled by Michael Levine, a highly respected

Los Angeles-based publicist. It costs $12 and contains 3,000 up-to-date (as of 1996) addresses for bands and artists, managers, record companies, agents, music publications, and critics. It's published by HarperPerennial Books.

You got the pass. Now what?

Your persistence has paid off and the publicist has called to tell you that you've been cleared to shoot the show. Now what can you expect? Before you hang up the phone, try to get the name of a contact person traveling with the band, preferably the road manager. No matter how sincere and reassuring the publicist is that your pass will be waiting for you at Will Call, you can anticipate a dropped ball on somebody's part at least 20% of the time. For one reason or another, your name simply does not appear on the band's or record company's guest list, and you're left standing outside feeling foolish. With the right name, your chances of getting in improve dramatically. Ask the person at the Will Call window to call backstage and check on your pass. If they refuse, head for the backstage door area, where the band's buses and trucks are parked, and look for somebody wearing an all-access laminated pass. If you have the right name, a courteous request to check with your contact person will usually do the trick, provided you were legitimately cleared in the first place. Make sure you have business cards with you.

Dealing with contracts

Before you are given the pass, however, you may be presented with a contract to sign. Demands can run the gamut from the reasonable (assuring that the photos will be used for editorial purposes only) to the draconian (granting full copyright control of the images to the band). Barely less odious mandates include guarantees that the photos will be used only in the publication for which they were initially shot, artist/management approval of any images used, and free use of selected images for merchandising materials such as T-shirts and posters. Naturally, these demands do not sit well with working pros, many of whom may be shooting "on spec" at their own expense. Fortunately, their objections and resistance have helped reduce the incidence of being forced to sign away rights before receiving a photo credential.

Many pros now refuse to sign such agreements. Paul Natkin says he has walked away from several shows where he was presented contracts, even though he was

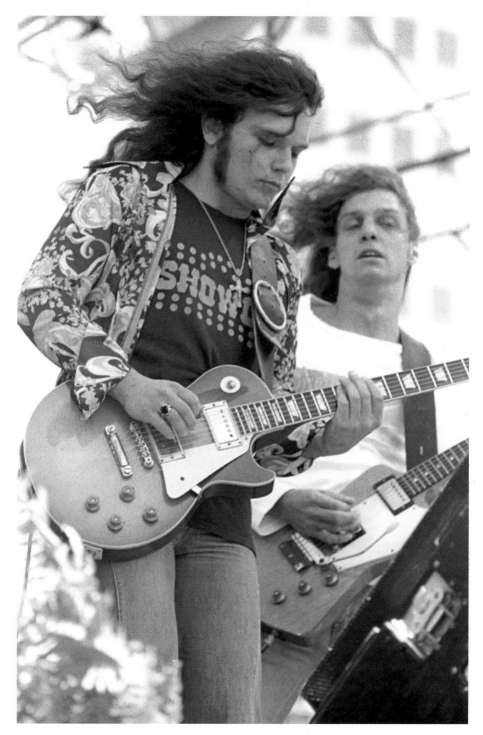

GARY ROSSINGTON & ALLEN COLLINS (LYNYRD SKYNYRD), 1977

on assignment for publications like *Rolling Stone* and *People*. "I'm more than happy to sign a contract that says the photos will be used for editorial purposes only," he says. "But when they try to steal my copyright, dictate where I can sell them, or expect me to provide free merchandising photos, I draw the line. There is plenty of question as to whether these bogus contracts would hold up anyway, since there is no negotiation process involved. My attorney tells me that no contract is valid unless both parties sit down and negotiate in good faith. That's a basic canon of law. But if I sign something, I believe I should honor it, no matter how ridiculous. That's just the way I am. I'd rather refuse to sign and go home."

As the staff photographer for *Guitar Player* and *Keyboard* magazines, I dealt with contracts by crossing out the parts I found unacceptable and then signed. This usually worked because I knew the musician I was there to photograph wanted to be in the magazines. It may not work for you if you're shooting for a small, local publication, but it's worth a try. At any rate, you should *never* sign away your rights to anyone unless you are fairly compensated and understand the consequences. It's far better to refuse to sign and walk away. At least you'll still have your dignity, if not the photos.

Prior approval

One of the toughest demands to fight is the right to prior approval of published photographs. Some musicians, or at least their management, are so concerned about image that they require total control. They want to decide which photos are acceptable for publication and which are not. On the face of it, there's nothing wrong with someone wanting to protect his or her image. The problem is that the results are often arbitrary and puzzling. Every photographer interviewed for this book has some kind of horror story to relate regarding approval. A common theme: The photographer on deadline FedExes a tightly edited batch of slides to the manager. A week passes and there's no reply. After a few frantic phone calls, the verdict is finally rendered: Two or three slides out of 50 are deemed acceptable, none of which the photographer agrees are anywhere near the best. Then it's a fight to get the slides returned. When they finally are, some are missing or damaged. Ebet Roberts learned the hard way to never send originals. When she sent a batch of 30 slides to Joan Jett's management for approval, all but five were returned with pinholes punched in them. Naturally, she was furious that her well-established reputation for integrity was not good enough for Jett's management.

Mark Leialoha encountered a similar problem when he photographed a prominent hard-rock singer for the cover of *Kerrang!* magazine. "The publicist assured me that they did not require approval but asked if they could see them and make a suggestion. Twelve of the slides were not returned, and my agent kept asking where they were. It turned out that the artist had burned them, which launched us into a potential legal situation. I had written a cover letter that specifically required that all photos had to be returned. Fortunately, we were able to agree on a settlement before it came to that."

The moral to all this? If you agree to send photos for approval, always send duplicates, never originals. And always send a delivery memo (see Chapter 8) that explicitly states how many photos are enclosed and requires that all must be returned intact. It's always best to establish an agreeable working relationship with artists based on mutual respect. Failing that, don't let yourself be pushed around. Your photographs belong to you. Protect yourself.

Not all passes are created equal

Once you finally get your hands on your prized photo pass, the first thing you'll notice is that not all passes are created equal. The highest level is the all-access laminated pass worn by the people who work for the band. For working photographers, that's the Holy Grail, because it means you have onstage and dressing room access. Unless you have a very special relationship with the artist, however, the chance of getting one of these is virtually nonexistent. Lately, some bands have taken to issuing "VIP" laminates that are largely ceremonial. On the 1989 Rolling Stones *Steel Wheels* tour, it's said that there were at least ten levels of laminated passes.

Sometimes a photo pass is also a backstage pass, meaning you can actually get backstage with it, although it will probably be after the show. If that's the case, save your time and skip it unless access to the band has been explicitly pre-arranged. The "After Show" pass usually means that you're stuffed into a room with all the other wannabes and ignored until you get tired of waiting and go home. And even if it does permit pre-show and during-show access, you can pretty much bet that you won't get anywhere near the band, which will be comfortably secluded in a well-guarded dressing room.

Sometimes a photo pass is simply a backstage pass with "Photo" written on it and doesn't get you backstage at all. And sometimes a backstage pass is even a put-down, as Neil Zlozower recalls: "I remember going to a Stones show and

getting a pass that said 'ligger' on it. I wondered what that meant and found out as soon as I tried to go to the bathroom. It was like, 'Oh, you can't use the bathroom with that pass.' I found out later that ligger is an English slang word for someone who goes backstage and eats all the food and drinks all the drinks. Basically, it's a worthless nobody pass, like you're the scum of the earth. But photographers usually get treated like scum anyway, because there are so many unprofessional people that call themselves photographers who don't know what they're doing and don't have any ethics."

Three and out

Most likely, you'll be issued a rectangular cloth stick-on pass imprinted with the band's name and the date. You'll probably be required to put it on right away, and the natural inclination is to place it in the vicinity of your breast pocket. But after losing a couple, I found the safest place to stick them was about 6" above the knee on my pants leg, where it's less likely to get rubbed loose by a camera strap or while maneuvering for position. Eventually, I rigged up a clear plastic pocket with a strap that hangs around my neck. The photo pass slips into the pocket, which is cut from an album page for 4" x 6" prints. This not only secures the photo pass from loss, but puts it in plain sight of security people and keeps it intact for my collection.

Unless you have some prior arrangement, this little cloth rectangle you've fought so hard for will probably allow you to shoot the first three songs of the show only. That's been the industry standard since the early '80s. A couple of theories have been advanced on why this policy was implemented, but it basically comes down to too many photographers. Initially, we were told, it was designed to get the crowd of newspaper photographers out from in front of the stage, because they were distracting and generally only needed one shot to fulfill their assignments anyway. It wasn't long before it became a blanket policy for all photographers, unless they got special dispensation from band management.

The distraction issue is valid, especially in theaters where the area between the first row of seats and the stage is very small. Factor in a low stage, and blocked audience views and movement distractions become critical problems. But little or no distinction is made according to the venue, even in arenas and stadiums where the audience is standing and a high stage is blocked by a barricade. Photographers generally work in the 5'- or 6'-deep neutral zone between the

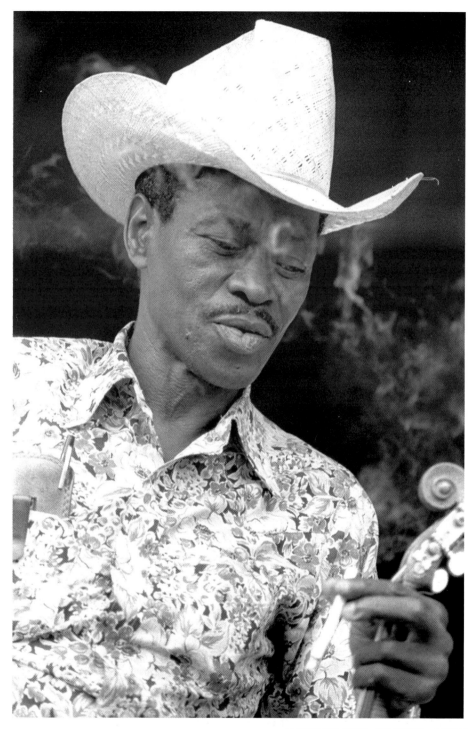

GATEMOUTH BROWN, 1977

stage and the barricade known as "the pit." It's possible to block audience views from there, but it's much less of a problem if the photographer is allowed to move around. Still, the photographers may be a distraction to the performer, and that's usually a good enough reason to ban photographers.

Artist egos are also part of the equation. Many simply don't want a photo of themselves sweating or looking rumpled. Maybe they figure they look best at the beginning of a show, before they get warmed up and into the performance. From a purely cosmetic standpoint, that's probably true. From a photographic and aesthetic standpoint, what's rock and roll without a little sweat? Beyond that, it's useful to have time to study the way an artist works the stage. Musicians reveal themselves as they slip into their onstage persona. With the best, energy climbs as the show progresses, bringing the audience to fever pitch. All of this adds to the stew that produces dynamic photographs. It's a rare performer who reaches peak rhythm in the first three songs. Sometimes the extra songs also give you more chances for the lighting to be especially good.

Still, that's the way it is. The time limit, lighting, and shooting position are givens, and it's up to you to get the shot. That may mean pulling the trigger a bit quicker on shots that you might normally pass up. Waiting for everything to be just right is seldom an option.

"It's amazing," notes Paul Natkin. "You can get the greatest shot ever in the first five minutes, or you can shoot for five shows and get nothing. There's no telling. But you've sure got a lot better chance the more you shoot."

Perseverance furthers!

Convincing people to give you credentials can be a very frustrating process. It's the old Catch-22: You can't get credentialed if you don't have a publishing track record, and you can't get a track record if you don't have credentials. As in any profession where the competition is stiff, the keys to success are perseverance and a burning desire to be the best at what you do. Everybody is going to tell you no until somebody finally says yes. Get used to hearing no, and don't take it personally. When somebody finally says yes, you've got the beginning of a track record, and that makes it easier to get the next person to say yes.

Shooting in Performance

verything is set. You've either arranged in advance for permission to shoot, or know that permission isn't necessary. You're ready to go to work. Now what? To a large extent, that will be dictated by the governing rules of the venue or the artist. A good place to start, however, is outside the venue. The marquee, or signboard, announcing the band or artist provides an interesting visual record of a day in the life. Some are quite ornate and have a way of becoming significant as auditoriums, theaters, and clubs are torn down to make way for new supermarket chains, boutiques, and banks. Clubs die and are reborn under new names and new management, leaving historic tracks in their wake. A look through pop music history books and booklets from CD retrospective packages proves that these kinds of photos are also quite marketable. And while you're outside, watch for interesting photos of the people waiting in line to enter. The audience tells you much about the band because they are bound to one another. Without a performance, there is no audience; without an audience, there is no performance.

Venues

Performances are liable to happen just about anywhere, including street corners, church basements, libraries, shopping malls, school auditoriums, parks,

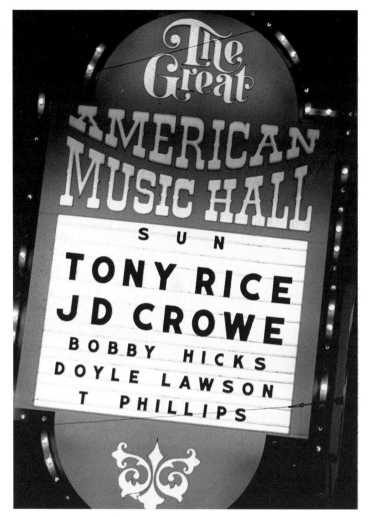

GREAT AMERICAN MUSIC HALL MARQUEE, 1981

clubs, bars, county fairs, theaters, amphitheaters, arenas, and football stadiums. Each site presents its own set of problems, although many share common obstacles. Once inside, you'll find out what restrictions are placed on you, if you haven't already been informed. They'll vary according to several factors, including the physical layout, venue management, band management, and the attitude of the security people. In general, however, you can usually figure that the bigger the act and venue, the tighter the leash will be drawn. The type of act or

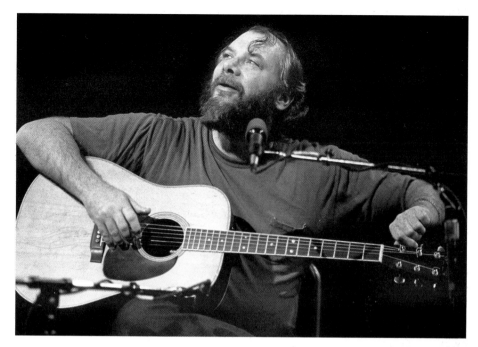

JOHN FAHEY, 1982

Don't neglect photo opportunities between songs. Seminal
folk/new age guitarist John Fahey creates a nice portrait,
telling a time-honored tuning joke while methodically retuning.

music being played also has a direct effect on working conditions. Classical concerts, for instance, are virtually off limits to photographers. If you want to photograph classical performers, you'll probably have to settle for rehearsals.

Public places

It's safe to assume that you'll have the fewest restrictions at public venues like malls, parks, and libraries, especially if the show is free. It's not easy to generalize about the type of working conditions you'll find because they vary widely. You can figure that you won't get much help with the light, however. Few such venues have stage lighting, because they weren't designed for performances. You're typically going to be stuck with marginal lighting unless outside equipment is brought in. The upside is that, except for common-courtesy concerns

such as not disturbing the show or blocking someone's view, you should be able to move about quite freely.

Clubs and bars

Things start to get dicey when you move indoors and admission is charged. More performances take place in clubs and bars than anywhere else. That's because there are so many of them, and because they present more opportunities for bands at all levels to show their stuff. Because of the uncountable combinations of lighting and seating conditions, clubs can be either the best place to work or the worst, and that can change from night to night at the same club. Common problems include crowding, drunks, smoke, and lighting.

If the audience is seated at tables, you'll be pretty much limited to working the sides of the stage or the aisles unless you can land a good seat close to the front. Look for something on the aisle two or three rows back. That way you can get up and move around to look for different angles during the course of the show. Sometimes there is a narrow buffer zone left clear between the tables and the stage that you can scoot into on your butt or knees. But that often leaves you with a severe shooting angle *too* close to the action. Working the aisles can be effective, but you have to be constantly aware of blocking the passage of customers and waitresses. You can't just kneel down and start merrily shooting away. There's nothing like getting a drink spilled down your back because you accidentally tripped the waitress. Hit-and-run tactics are necessary. Get into position, grab a few shots, and then move on.

Some clubs offer another option—a dance floor. If it's not too crowded or filled with exuberant dancers, you can stand close to the stage and move around to fill your frame without worrying about disturbing the audience. This can be a wonderful luxury. On the other hand, the dance floor is not fun when filled with people packed in body-to-body. If you don't get there early enough to stake out a spot in the front, you might not get anywhere near the stage. Unless you're tall enough to shoot over the heads of the crowd, you could end up going home empty handed.

Theaters

Theaters can be particularly difficult because of their more intimate nature and short distance between the front row and the stage. The ambiance is to-

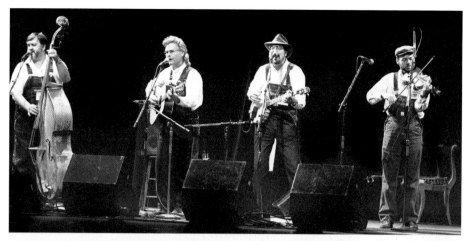

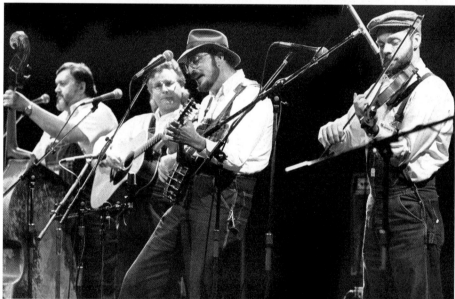

PINEY CREEK WEASELS, 1995

Shooting a band of four or more members stretched out on a stage
usually means very small images of each individual. The effect is at its
worst when you shoot from straight on with just about any lens, be-
cause of the space between performers. Try moving to the side for a
shot with a short to medium telephoto. The angle causes the musi-
cians to overlap, reducing the apparent space between them. The com-
pression effect increases as the lens gets longer, but depth of field
narrows, which means fewer members are in sharp focus. The 105mm
lens used here was focused on the banjo player at f/8, leaving enough
depth of field for all four members to remain reasonably sharp.

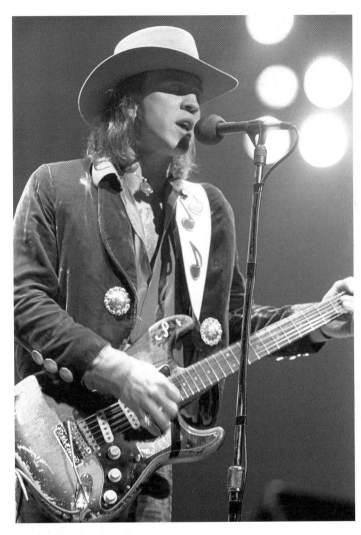

Hats can be an incredible pain to deal with, particularly those with flat, wide brims—like cowboy hats. Artists wear hats not only for style, but to keep spotlight glare out of their eyes. Stevie Ray's was a trademark. Unfortunately, they can create large cavernous dark areas that obscure the face. You can deal with this in a couple of ways: wait for the artist to raise his head far enough for the spotlight to get in under the brim, as I did at right, or use fill flash to open up the shadows.

STEVIE RAY VAUGHAN, 1984

tally different from that of a club, and the audience has different expectations. You're usually working on your knees, trying desperately to avoid disturbing the paying customers or blocking their view. That can be very tiring mentally as well as physically. Unlike in a club, it's also very difficult to walk up and down the aisles without causing a disturbance, because everyone is seated. Usually, the best place to be in a theater is comfortably ensconced in a seat slight-

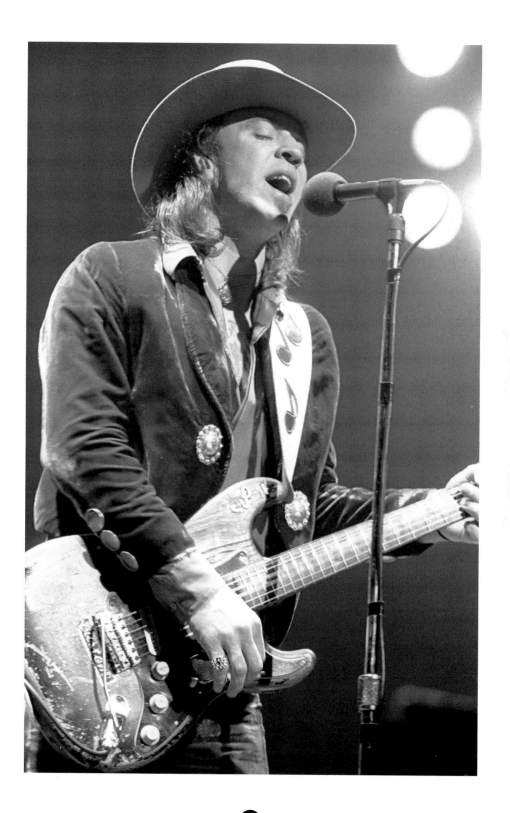

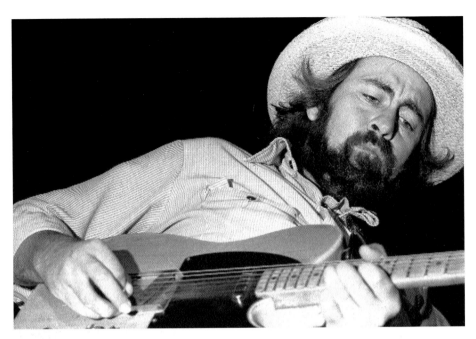

ROY BUCHANAN, 1976

Shooting from directly below creates an interesting look and graphic dimension. I was cramped right up against the front of the stage when Roy leaned over to play his guitar. I used fill flash to light his face, which otherwise would be lost in shadow. This technique of shooting from below also works well with horn players because of the natural position of their heads when playing.

ly off-center about one or two rows back. Of course, that's not easy to manage on a consistent basis unless you have some very good connections in the box office or with band management.

Amphitheaters, arenas, and stadiums

Arena, amphitheater, and stadium shows bring out many of the worst aspects of the music business. By the time bands or artists reach this level, the money involved is so big that everybody is out to assert his or her ego and establish turf. Be sure that you'll get the two- or three-song shuffle in "the pit," the barricaded area between the audience and the stage. Actually, the pit is

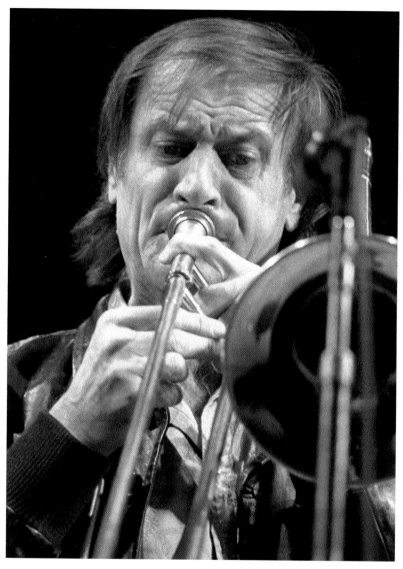

ALBERT MANGELSDORFF, 1975

an excellent place to shoot. You can stand and move around without being unduly concerned about disturbing the audience. Camera noise and even flash are rarely a problem. And unless you're forced to leave the building after three songs (it happens), you can sometimes wander around with your photo pass and grab shots from the aisles. That depends on the venue and security.

During the late '40s and throughout the '50s, Herman Leonard created an exceptional record of the era's jazz giants. One of his favorite techniques was to set up lights on stands (flashbulbs at first, strobes later) so he could control the lighting. He particularly liked to exploit the effects of backlighting. Because of the strong personal relationships he had built with the artists, no one objected. The happy result of this cooperation between photographer and musician was outstanding images such as this one.

Depending on the act, sometimes you don't even get the three songs in the pit. On a 1993 Michael Jackson tour, photographers were placed far back from the stage and forbidden to use anything longer than a 300mm lens, which produced a half-body shot. "A few days before the show," says Mark Leialoha, "the London *Daily Mirror* ran a full-face shot on the front page with arrows pointing to all of Michael's plastic surgeries, so they wanted to prevent tight head shots. Someone actually went around and checked the lenses. We all got a chuckle because the photographer next to me had a 2X teleconverter on his 300mm and the guy didn't notice it." For the 1994 Pink Floyd tour, photographers were banished to the back of the house, where 300mm lenses covered the whole stage.

Before the show

If you have good connections with the band, explore the possibility of shooting the sound check, if one is scheduled. The sound check is essentially a short rehearsal where the band runs through a couple of tunes to balance the sound for the venue and to make sure all equipment is working properly. If they have the time, almost every band does one somewhere around 5 to 6 P.M. on the day of the show. The sound check offers an excellent opportunity for unimpeded performance shooting, as well as for candid shots. The musicians are usually dressed in street clothes and wear no makeup, which is often reason enough for them to keep a photographer out. And unless the lighting crew uses the sound check to focus and test the lights, you'll probably have to use an electronic flash.

The sound check also offers the opportunity to scope out the venue. If there is no sound check, or you can't get into it, get to the venue early enough to look it over before the show starts. Each site presents its own set of problems, and

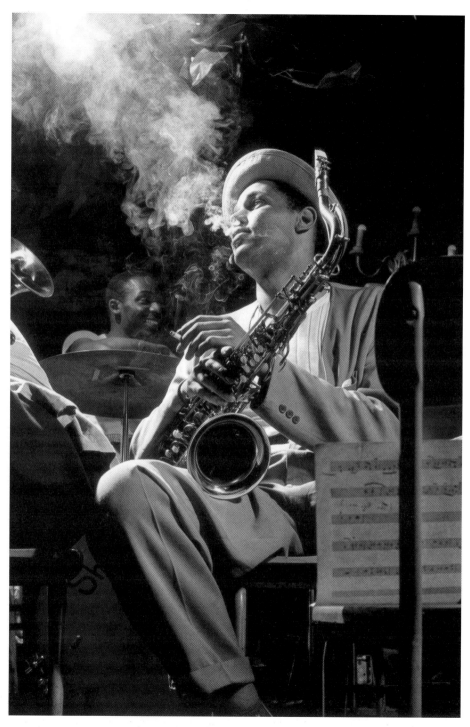

DEXTER GORDON, 1948. PHOTO BY HERMAN LEONARD

it's helpful to understand what they are before you start shooting, especially if you're under time constraints. Many venues share common obstacles, such as unpredictable lighting, limited access, and crowded working conditions. Shooting conditions are seldom optimum, but the mark of a professional is taking what is given, no matter how bad, and making good pictures out of it. Every hall has unique characteristics; learn to use them to your best advantage. Search balconies and hidden nooks and crannies that provide unobstructed vantage points. Find places where you can stand without blocking someone's view. Pillars and posts are quite useful for this purpose. Unusual camera angles, such as shooting from above or behind, create interesting photos with greater variety than routine straight-on shots. This kind of preparation before the show helps you make the most of your shooting time and expands the range of possibilities.

Getting the shot

"Don't be too intellectual about photography. Most great shots are the result of gut reactions." —Ansel Adams

It may seem obvious, but the single most important factor for getting a good shot is being in position to frame it in your viewfinder. If it's not in the viewfinder, it won't be on the film and no amount of wishing will change that. You have to be there, and sometimes positioning is a matter of inches between an OK photo and an outstanding one. Much of your energies and emotions will be devoted to getting yourself into position and making the best of the time you're allowed to stay there. Good photographers are seldom *pleasantly* surprised by what they find on their proof sheets. They know if they have a good shot the instant the shutter release is squeezed. The anxiety comes in waiting for the film to be processed to see if it was properly executed from a technical standpoint.

Musicians mirror their emotions in their faces and body language when they play and interact with each other and the audience. They can't help it. A common theme expressed by players is that they are most alive when onstage. Try to capture that range of emotions on film. I've found most musicians like to see photos of themselves smiling onstage, because it's usually a real smile based on feelings and not one induced for the camera. The big exceptions are hard rock and alternative thrash/punk musicians, who *hate* smiling pictures. They want to show attitude and anger in their performance, and often spend a great deal of time and energy honing their stage poses. Essentially, you're looking for

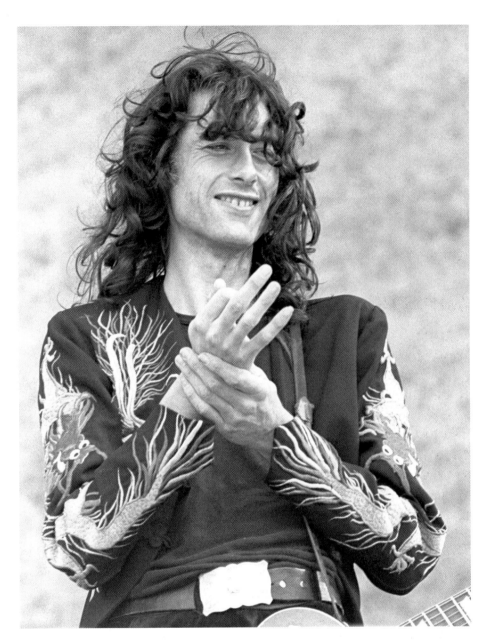

JIMMY PAGE, 1977

that split second when lighting, composition, and gesture come together in a synergistic moment to create a photo that equals more than the sum of its parts—in the immortal words of Henri Cartier-Bresson, the "decisive moment." Be pa-

tient. Wait for it to happen in your viewfinder. At the same time, cover yourself. Often, it *won't* happen and you have to settle for a competent shot. You must not only recognize that moment, but have your technical chops together to record it. To a certain extent, luck plays a part. But the more in command you are of your skills, the luckier you get.

Compose your shot carefully and fill the frame with the image. Examine the frame from corner to corner to see precisely what you are capturing on film. One of the most common mistakes of inexperienced photographers is leaving too much room around the subject, which reduces the size of the image on the negative. You can eliminate the waste space when you print, but you'll pay for it in the form of a degraded image because of the reduced amount of negative used. On the other hand, don't pass up a good shot if you can't fill the frame because you're not close enough or you're not in the best position. Grab what you can and be thankful that you at least have the option of cropping in the darkroom if you're shooting black & white or color-negative film. Keep working for the perfect shot, but don't be left holding an empty bag because it never quite materialized the way you envisioned.

Overcoming physical obstacles

Your primary enemies, once in position, are poor lighting, movement, microphones, monitors, music stands, and mic stands. At least one, or a combination of them, seems to bedevil you no matter how good your planning and positioning. Concert lighting is usually either low to marginal or high-contrast, gel-filtered spot lighting. Only the best lighting people understand how to light the stage like a movie set, with proper fill ratios and a consummate sense of balance and color. It doesn't take a million-dollar rig to do it right. In fact, some of the highest-paid rock bands with massive lighting sets don't have a clue. It all depends on the person behind the lighting board. Fortunately, it's possible to run into good lighting people anywhere, on any level.

The microphone and its stand are formidable obstacles. All you can do is work around them. One of the worst places you can set up is directly in front of the artist you are most interested in photographing; the mic blocks her face. Even if you are slightly off-center, it can still be a problem. If the singer persists in putting her mouth right up on the mic, then you'll need to change your position to get more of a side view, so you can at least see part of her mouth. Removed from the stand, however, the mic can change from an obstacle to an in-

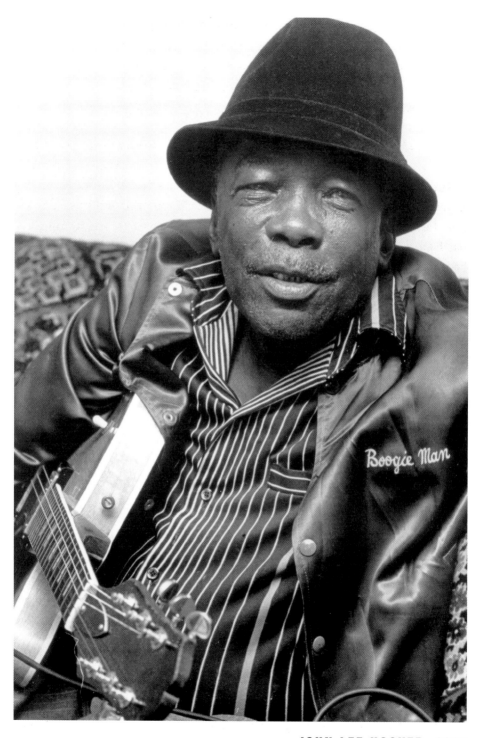

JOHN LEE HOOKER, 1984

teresting prop and graphic element. Some artists have become masters at manipulating it for visual effect. The Who's Roger Daltrey made a science out of manipulating the mic by a very long cord, throwing it into the air and swinging it out over the audience. From a photographic standpoint, the most annoying development is the cordless mic headset worn in a fixed position in front of the singer's mouth. This is a terrific hands-free convenience for an active musician, but a real drag for the photographer; the mic becomes a part of every shot, no matter what the artist does.

Unfortunately, there's not a whole lot you can do with monitors and music stands, except to move around and try to find a hole in the maze that offers a clear shot. Shooting from a higher angle, such as a balcony, is also an effective means for eliminating unwanted elements. Stage clutter varies from band to band and even musical idioms. Many rock and rollers not only work with cordless microphones but wireless instruments as well. Some bands have totally eliminated onstage monitors and speakers for a clean, uncluttered view of the stage. Instead, they use earphone monitors and speaker emulators that feed the signal directly to the sound system. Ironically, the worst mess of microphones and monitors is often found with bands that play acoustic music. Bluegrass bands, for instance, not only require vocal mics for several people, but instrument mics and monitors for everyone as well.

Hats also present problems. They may make for a snappy stage appearance or serve to convince you that a country singer actually has some cowboy in him, but they are a real pain for photographers. The brim cuts off the stage lighting, creating a dark, impenetrable band between the hat and the mouth that causes the eyes and nose of the performer to disappear. The only solutions are to use fill flash or to wait for the performer to tip his head back far enough for the spotlight to strike his face.

Working the front of the stage

"If your photos aren't good, you're probably not close enough." —*Robert Capa*

Working close to the front of the stage presents its own set of problems. If the stage is under 6' high, which is generally true of venues outside of stadium or arena shows, you're going to have to work from a kneeling or sitting position to avoid blocking audience views and becoming part of the show. Sitting can make your job much more comfortable, but doing so limits your mobility

and increases the severity of the shooting angle. More likely, you'll need to work on your knees, which allows you to crawl around and vary your attack. Good conditioning and a set of soft knee pads are effective for relieving the physical stress caused by this approach. Of course, there is one other solution if you're built right. The late Randy Bachman, rest his soul, was a "little person" who stood about 4' tall. As the club photographer for San Francisco's now-defunct Old Waldorf, Randy had a distinct advantage because he could stand in the spaces between tables, or walk to the front of the stage and shoot without blocking views; he was no taller standing than the paying customers were sitting. In clubs and venues with standing room only, he carried a milk crate around to stand on.

With high stages, extra height can be a real advantage, especially if you're working in the pit and can get your camera above stage level. It also allows you to stand a few rows back in a crowd and still get an unobstructed view over the heads of others. The bad part is that you block views. At 6' 6", I've been hit by any number of UFOs thrown by unhappy customers, particularly at hard rock and metal shows. I just try to keep moving and stay aware of where I'm standing.

If you're a little closer to normal height, Joel Bernstein (5' 7") offers a valuable tip to gain extra inches in the viewfinder: "I often use the camera upside down to get four or five more inches. There's a difference of about two inches between the center of a lens and the center of the eyepiece. If you turn the camera upside down, you've now gained the two inches plus. Your eye level remains the same, but instead of the lens view going *down* two inches, it's going up two inches. Sometimes, that's exactly the amount you need to turn a shot from a bad angle to a good angle or to even get the shot at all. It's especially effective for a short person, but it can help anyone."

Sometimes you'll find yourself pressed right up against the stage, looking up the performer's nose as he looks out at the audience—not a particularly appetizing thought. In that case, either you must move or hope the performer does. A few more options open up if the performer comes to the front of the stage. Then you can move to get a side angle, and switching to a wide-angle lens permits a shot that includes the performer(s) and the audience interacting. If, for example, a guitarist comes to the front of the stage for a solo, you can kneel and shoot straight up into his face as he watches his hands, capturing expression as well as hands on the instrument. This is also effective with horn players, who tend to look down when they play.

Unfortunately, this angle can play havoc with lighting. When the performer looks down, the face tends to go dark because of the angle of the spotlight. Shoot-

ing up can also cause a glare problem from the back spots. The first problem can be solved if fill flash is permitted. Because you are so close to the musician, however, you must take extra care to avoid blasting into the eyes with direct flash. Try bouncing the light off a white or light-colored surface, such as your shirt. This spreads and softens the light for a more pleasing effect. If you can't do that, at least get the flash off the camera with an accessory cord so you don't blind the performer. The glare of the back spot can be turned into an asset by positioning yourself so the performer's head is between the spot and the lens, creating a pleasing halo backlight that gives depth to the photo.

Because of the glare of stage lighting, a shade should be a mandatory part of your lenses at all times. Flare can seriously degrade or even completely ruin an otherwise good shot, and telephoto lenses are particularly susceptible. It can be especially troublesome when you're shooting outside at sunset as the sun drops in the sky behind a performer, making even a lens shade inadequate. The problem can sometimes be alleviated by holding a piece of cardboard or your left hand above the lens and manipulating it until the glare disappears from the viewing screen. Because this requires you to hold and fire the camera with one hand, it is obviously easier to pull this off if you have autofocus and a motor winder.

Your best lighting will probably come on uptempo songs or set closers. If you're not working under time restrictions, be sure to save film for the finale. And never shoot the last frame on your last roll until the dying note of the encore. If you use all your film, a perfectly lit, fantastic photo will materialize right in front of you, and you'll be helpless to capture it. Trust me, there's some cosmic force that makes this so.

Shoot the piano player!

In fact, shoot the whole band. In the star-driven world of popular music, the media tends to focus almost exclusively on the perceived leaders or front people of popular bands, usually the singer or lead guitarist. Everybody knows the face of U2's Bono, but how many people recognize drummer Larry Mullen, Jr. on sight? It's hard to avoid the visage of Hole's Courtney Love, but how often do you see pictures of guitarist Eric Erlandson? The message here is to photograph everybody in the band. Specialized magazines such as *Bass Player, Guitar World, Modern Drummer,* and *Windplayer* have created a demand for individual shots of all the instrumentalists. This policy is especially relevant if you're trying to establish a working relationship with a young band. If you try to sell

AL GAFA, 1976

Sometimes you are forced to use electronic flash, because lighting condi-
tions are simply not good enough to produce a quality photo. It should only
be used in an emergency, however, because of its intrusive nature and the
flat, harsh light it produces. Note the differences between these two photos.
The shot on the left employs flash, which indiscriminately lights everything
in its path, including the cymbal and background. The photo on the right is
lit only by house lights. Notice how the combination of several light sources
pulls Al Gafa's head off the unlit background and creates dimension in his
face and the folds of his clothing. Gafa, a prominent studio guitarist and
sideman, was a member of Dizzy Gillespie's band when these were taken.

the band on your talents and have only photos of the lead singer to show, you're
going to face skepticism and resentment. Every member likes to feel that his
or her part is equally important to the overall sound and look of the band. By
producing good individual shots of everybody, you demonstrate that you're aware
of those feelings. It's a good way to make important friends and allies.

Shooting from above and behind can create a most interesting perspective. I scaled a ladder and peeked over the edge of the Monterey Jazz Festival's stage backdrop to get this portrait of Marian McPartland, the grande dame of jazz piano. The combination of strong backlighting from the main spotlights and the fill light from the small back spots creates a superb sculpted look. I particularly like the way the keyboard is rendered vertical by the high angle.

It helps if you are familiar with the band and know how each individual moves onstage. Then you can anticipate the action and be ready to get an expressive shot. For instance, you may know that the lead singer is going to jump or run to the front of the stage at a certain point in a particular song, or that the guitar player is going to toss his instrument into the air or make a characteristic gesture. These are the moments that help make pictures that stand out from ordinary concert shots. Familiarity with the band's material also helps you anticipate the lighting changes.

Some of your best opportunities for individual shots come as a result of band interplay. You can tell a lot about a band's dynamics and state of mind by the way the members interact with each other onstage. Musicians continually send visual cues to each other—to signal time and chord changes, to start a chorus, to pass a solo, to share inside jokes, whatever. Try to catch some of those exchanges on film. You may find your best shot of the banjo player is not one of her with her head down and soloing, but plunking rhythm and watching the mandolinist take a solo. Be aware of what's happening onstage all the time. That includes the moments between songs when the band is tuning up and interacting with one another or even people offstage such as a manager or roadie.

Finally, while you're at it, be sure to photograph the entire band as a unit. Archivist Michael Ochs, who specializes in leasing historic music photos to magazines, book publishers, and record companies, reports that he is often unable to fill requests for full-band shots. Banjoist Pete Wernick, of the late, lamented bluegrass band Hot Rize, says he searched for a good, tight band shot for years. "I went so far as to have a card printed with our address that said we were looking for performance photos with all four musicians' faces and instruments clearly visible. When I saw someone photographing the band, I'd give them one. I

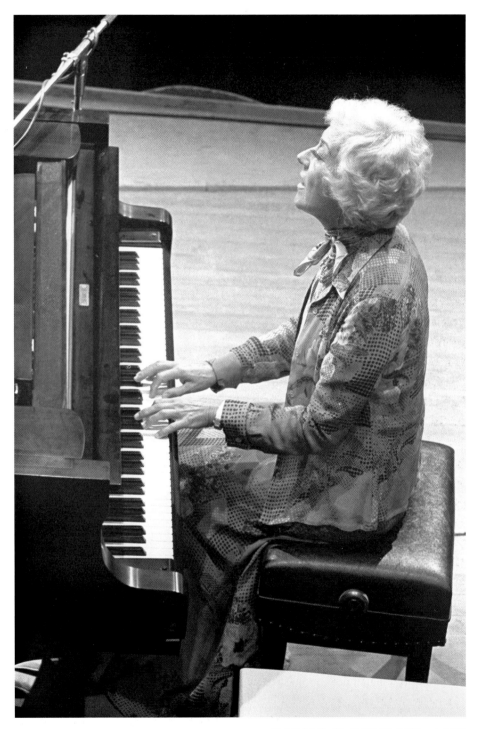

MARIAN McPARTLAND, 1975

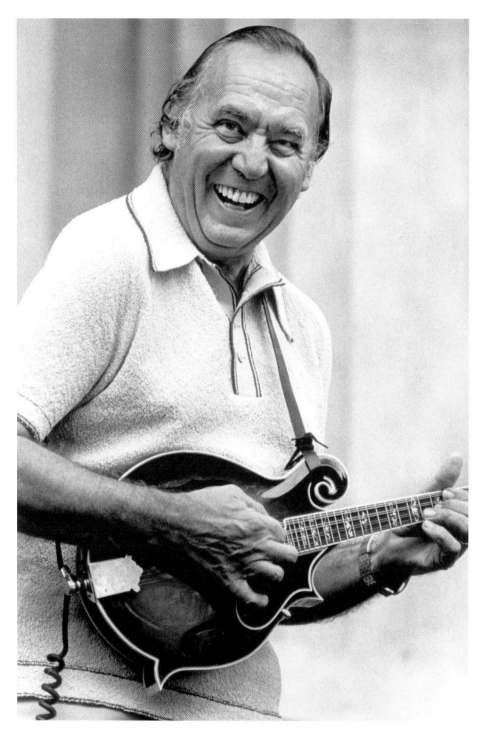

JETHRO BURNS, 1978

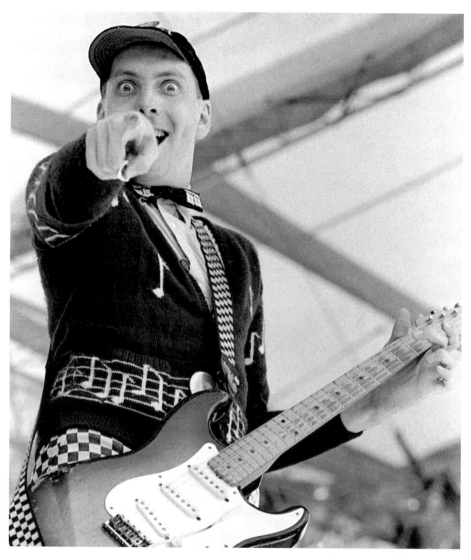

RICK NIELSEN, 1979

No matter how hard you try to keep a low profile, sometimes you're going
to be noticed by the performer. Direct eye contact can create any number
of responses, ranging from indifference to amusement. Whatever the
response, don't blink and miss the shot. Cheap Trick's Rick Nielsen busted
me in front of 20,000 fans, but I got him, too. And how could I resist the
wide-open smile of mandolin master/comedian Jethro Burns? Dizzy (next
page), on the other hand, wasn't particularly pleased when he looked up
and saw a strange photographer pointing a lens at him in his dressing room.

DIZZY GILLESPIE, 1976

must have handed out hundreds of cards over the years, but we never really found the shot we were looking for."

Typical problems include microphones or other band members blocking faces, uneven stage lighting that leaves one or more members in the dark, and spacing that leaves wide gaps between members. Once you're in position with the right lens with everyone in the frame, scan the frame repeatedly to keep an eye on everyone's face, to ensure they all look acceptable or that they don't disappear behind a microphone or someone's shoulder. Ideally, there will be some kind of action or interaction among the band members to make it more interesting.

If a band has five or six members, you'll almost certainly have to shoot them fairly straight on to keep everyone in focus. Sometimes you can get a more interesting framing by shooting them from a side angle. When you do that, how-

ever, depth-of-field limitations will almost certainly force you to focus on one member while the others drop out of focus, especially if you're using a particularly long telephoto lens. The closer you can get to the band and the shorter the lens, the less that depth of field becomes a focusing problem.

Don't neglect the instruments

For some viewers, clear, unobstructed shots of the instruments are almost as important as the performers. Guitar magazines, in particular, generally want the instrument to be readily identifiable. Guitar collecting has reached fever pitch, with several magazines and dozens of books devoted to the instrument's history, lore, and value. The mania now includes amplifiers and related equipment. This is a very live market. Outstanding photos that include logos and/or brand names are also likely candidates for sale to equipment manufacturers for promotional and advertising purposes. Photos with instruments provide rich historical clues to a musician's sound. For decades, not a single photograph of the pioneering bluesman Robert Johnson was known to exist. When a studio shot of him holding his guitar finally surfaced a few years ago, guitarists were delighted to discover that his trademark sound was apparently forged on a Gibson L-00. Because of that single photo, that instrument is now known as the Robert Johnson model among collectors.

Get the whole picture

Approach the show as a whole. Think of yourself as a photojournalist covering the show as an event. Instead of fixing only on the musicians, turn around and train your camera on the audience once in a while. In some cases, the fans are every bit as colorful and interesting as the band. Remember those shots of hysterical Beatles fans crying and screaming for Paul? Did you ever see a group of Deadheads at a Grateful Dead concert, or a gathering of Jimmy Buffett's Parrotheads? How about an aggregation of punk rockers or hip-hoppers? Festivals lend themselves to this approach particularly well, where the crowd spends a whole day or weekend interacting with each other and the bands. The audience *was* the story of Woodstock (even at the 1994 corporate version).

Shots that include the band and audience interacting can be particularly effective. Bluesmaster Albert Collins used to hook his guitar to a 100' cord and wander out into the audience or even leave the club and start playing on the

street. The interaction provided by such close artist/audience contact provides potential for great shots.

Shooting onstage

There may be times when you are given the opportunity to photograph from the stage itself during the show. Unfortunately, you'll seldom find this is the magnificent break you envisioned. Stages are work areas, filled with cables, monitors, instruments, sound equipment, and sound and lighting crews actively engaged in putting on the show. Cramped working conditions leave little room for photographers, who are generally none too welcome in any case. Without freedom of movement, your angles will probably be limited to what you can get shooting from the wings. At least you are at the same level as the performer, as opposed to looking up his or her nose from a pit. It is possible to get striking side views from the wings, particularly if you can isolate individuals with telephoto lenses, but it's not something you can count on, because the angles are so severe. Often, your best bet is to wait for the artist to turn, either to signal a musical change or otherwise interact with a band member.

Actually, the best location onstage may be from *behind* the performers, if you have a clear view. This sets up the possibility of more dramatically lit shots as the artist moves around, because of the angle of the spotlight. It also provides a performer's-eye view of the audience. Unfortunately, relatively few stages are set up to allow this. And the chances of someone permitting a photographer to actually walk onstage are slim, unless she is working for the band. (Remember the cardinal rule: Anything is possible if you're working for a band that grants you total freedom.) That's how Joel Bernstein got the memorable cover shot for Crosby, Stills, Nash, and Young's *4-Way Street.*

Some theaters use a huge curtain for a backdrop. If there's room behind it, you can stick your lens through the part in the curtain and shoot without getting in the show. Other venues, especially those that present live theatrical productions, employ a stretched canvas background with several holes, large enough for a lens, strategically placed at shooting height around its rear and side perimeters. The Monterey Jazz Festival has used such a backdrop for most of its 35-year history, which led to some of the better photos in this book. This is a wonderful way to shoot a show. You don't disturb the audience or the performer, and you get unusual camera and lighting angles. It's too bad more stages aren't set up this way.

Working with a lighting director

Becoming a house photographer, or at least a familiar figure at a venue, can lead to a productive working relationship with the house lighting director. Good directors often keep their lights well below the actual potential of their systems for both artistic and physical reasons, particularly in clubs. A battery of lights focused on the stage gets very hot and uncomfortable for the performer, especially in a small, packed club with marginal ventilation. However, there are generally peak moments of intensity in almost any kind of music when the lights can be raised at least enough to provide the critical difference between 1/30th and 1/60th of a second or f/1.4 and f/2.0. Sometimes, they can be brought up *much* more, like on a set-closer or encore, supplying latitude for smaller apertures for more depth of field or movement-stopping shutter speeds.

If you're in a good shooting position, you seldom need more than one or two songs to get some excellent shots. Approach the lighting director with sensitivity to his job. Offer to provide prints, which are, after all, as much examples of his work as they are images of the musicians. Let him know that you don't expect him to do anything that goes against his grain. If he realizes that you know what you're after, and you are properly respectful, chances are you can enlist his aid. A helpful lighting director can sometimes spell the difference between success and failure.

Using flash in performance

The use of electronic flash in concert is highly controversial and may not even be an option, since many venues forbid it under any circumstances without permission of the artist—and for good reason. Electronic flash not only has the potential to disturb the performer and distract the audience, but it produces a flat, ugly light and harsh shadows. Nevertheless, there are many instances when it can be the difference between getting the shot or walking away empty-handed. If you're on assignment, it may be the difference between getting another gig or not. The challenge is knowing when and, most important, when not to use it.

As a general rule of thumb, the louder the music, the less disturbing the flash. In arena rock shows, it's virtually invisible in the swirl of computerized lights, pyrotechnics, and Marshall stacks. In an intimate jazz club, it's a nuclear explosion. There is, of course, a wide gap between those two extremes, and

that's where good judgment becomes a factor. Surprisingly, however, it can work even in relatively subdued situations, if used judiciously. I use flash only if there are no house restrictions or I have permission directly from the artist or management. When I do ask, I'm seldom refused, because I have a good sense of when it is inappropriate, such as solo acoustic guitar shows, classical concerts, and quiet jazz.

Use good manners

No matter how unrestricted the use of flash, though, you still need to mind your manners. Don't blast performers directly in their eyes—it's very disorienting and breaks their concentration. The impact is magnified in a dark club because their pupils are already dilated. The effect can be lessened by getting the flash at least arm's length off-camera or by moving further back and using a telephoto lens. (A Vivitar 283, for example, is effective at distances of 40' or more with film speeds of ISO 200 and up.)

Pick your spots carefully. Just because your flash unit can recycle in 2 seconds doesn't mean you have to fire that often. That's like pumping a 36-exposure roll through the camera with a motor drive at top speed and hoping for the best. Keep your eye glued to the viewfinder and listen to the music. Wait for peak moments of intensity and volume to shoot. That's often when the performer is visually projecting the most emotion, and it's far less disturbing to the performance. I've seen shows, carefully built to a peak emotional high by the artist, shattered by an insensitive audience member exploding a flash at a quiet, inappropriate moment. Even the clatter of a camera's mirror and shutter is too much in some cases. Pay attention and don't be a jerk. A little flash goes a long way. My rule of thumb is: If there is even the slightest doubt, don't.

Light the stage

If you're working with a band that plays a lot of gigs in poorly lit clubs, take a page from the book of Herman Leonard and turn the stage into your own studio. It doesn't have to be an elaborate affair. A couple of strategically placed portable flash units will serve as powerful main and modeling lights. The units can be mounted on stands or in the lighting truss and triggered by photoelectric cell or wireless remote. This not only gets the lighting off camera but frees you

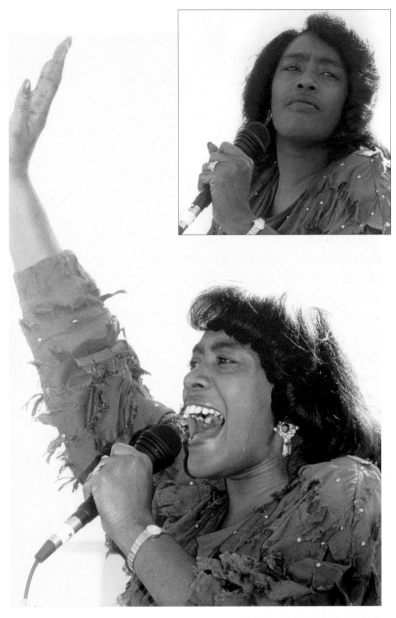

ANN PEEBLES, 1992

Though most people consider using flash only when it's dark, it is often most
effective and inconspicuous when used to supplement daylight. It's particularly
useful for illuminating dark skin. In the top shot, metered for the skin, it's difficult
to separate facial features because of low contrast in the shadows. Fill flash in the
bottom shot creates contrast and modeling, which helps bring the photo to life.

to move around to search for the best modeling effect. You can take this studio technique as far as the circumstances allow by adding more lights, and by experimenting with color gelatin filters and light-directing accessories such as snoots and barn doors. Just make sure you've set the lights up where they won't be kicked over by the band or the audience. Mark Leialoha has used this technique successfully with a couple of big-arena metal bands by mounting powerful strobes in the lighting truss. Sports photographers have done that for decades for college and professional basketball and hockey.

Warm the light

A common objection to using flash with transparency film is the color of the light. Electronic flash units are balanced for the color of daylight at high noon, which looks somewhat unnatural or cold on a subject photographed indoors. Adopt a trick employed by studio photographers and warm the color of your daylight-balanced flash with a gelatin filter taped over the face of the unit. Sheets of acetate or gelatin filters are available from most stores that cater to professional photographers, filmmakers, or theater lighting directors.

The most prominent manufacturer of these filters is Rosco, which makes hundreds of colors. Look for its Cinegel color-correction filters. Roscosun CTO filters are available in several densities to lower the color temperature by varying degrees. Try the 1/4 CTO first. If that's not warm enough, add another layer or try a 1/2 CTO. If you prefer less red, try Straw, which is also available in several densities. If you can't find the Cinegel filters, try the Roscolux Bastard Amber series. The filters are available in 18" x 24" sheets, which can be cut to fit your specifications. If you'd like to try several possibilities without buying full sheets, ask your dealer for the Rosco sample packs. These are small packets of filters that measure 1-1/2" x 3-3/4" and fit over the face of a small flash unit. That way you can run tests to see what you like best. If your dealer can't provide you with samples, write to Rosco (36 Bush Ave., Port Chester, NY 10573).

Some flash units, such as the Nikon SB-26 and the Canon 540 EZ, have a removable clear front panel that allows you to mount the filter between the flash tube and the lens. Slip a knife blade under the edge of the panel and pop it off. Be sure you keep track which side of the panel is which, however. The clear panel contains a fresnel pattern that controls light dispersion. If you flip it or mount it upside down, you can adversely affect the dispersion.

Balanced fill flash

Thinking photographers typically loathe using a flash at all, because its stark, overpowering daylight-balanced light yields hard shadows, flat modeling, and an artificial look. By using balanced fill flash to mix ambient light with the flash exposure, however, some of those problems can be partially solved. The idea is to let the flash illuminate only the main subject, with ambient stage lighting filling in the background. Fill flash can also be useful when the lighting truss is located almost directly over the performer, causing deep shadows in the eye sockets.

If you own the proper electronic camera and have a dedicated TTL flash unit, such as the Nikon SB-26, Canon 540 EZ, or Minolta Maxxum 5200i, achieving perfectly balanced fill light is a simple task. These camera/flash combinations instantaneously meter the existing light, decide how much flash is needed on the main subject to match it, and then automatically set the right amount of flash output and proper shutter speed. All you do is press the shutter release. There's even a provision for exposure compensation if you want to adjust the flash output to deliberately under- or overexpose. These units generally work quite well, although unusually dark or light backgrounds can fool the flash/camera computer, resulting in over- or underexposure of the subject. This can be critical if you're shooting color transparencies, less so with black & white and color-negative films that can be corrected in the printing. Before you try it on a paying shoot, make sure you've thoroughly tested the flash in the fill mode and know when and how to compensate your exposure, if necessary.

Fortunately, you don't need a $600 camera and a $350 flash unit to use balanced fill light. Just about any 35mm SLR camera/flash combination will work, as long as the camera has manual shutter speed and aperture settings. The flash can be a non-TTL unit with a built-in sensor, such as the Vivitar 283, or a completely manual unit with or without variable power settings. (See Chapter 14 for a more detailed explanation of the types of electronic flash units.)

First, determine your aperture, or f/stop, for the flash exposure, either by selecting a sensor range or by using an incident flash meter (see Chapter 5) to read the light falling on the subject, if you're using a manual unit. To avoid overpowering low ambient light, set the sensor or power setting so the flash produces the weakest light level possible within range of the subject. With a 283, the lowest light output is the "purple" setting, which provides an aperture of

f/11 up to 10' with ISO 100 film. If your subject is further away, switch to the appropriate sensor to cover the distance. The 283 offers a manual setting, as well as three additional sensor ranges—blue (f/8, up to 15' with ISO 100), red (f/4, up to 30'), and yellow (f/2.8, up to 40'). If you're unsure of the span between the camera and subject, simply focus on the subject and consult the appropriate distance scale on the lens, if it is so equipped.

With the f/stop determined by the flash, the existing-light exposure is then controlled by the shutter speed. Set the aperture and measure the available light with a hand-held meter or your camera's through-the-lens meter, turning the shutter-speed dial until you arrive at the proper exposure. That will provide a lighting ratio of 1:1, meaning the fill flash is the same intensity as the ambient light. Consider that a starting point. In reality, there is a lot of flexibility in exposing for the ambient-lit background. Many photographers routinely cut the ambient-light background reading by as many as two stops to avoid extremely long shutter speeds. Stage lighting varies from intensely bright, as in some big arena shows, to miserably dim, as in many clubs and smaller venues. Manipulating the shutter-speed dial provides a simple means of controlling the level between the flash and the existing light and creating an assortment of effects. As your shutter speed slows down, movement of the subject or the camera starts to register on the film as "ghost" images emanating from the subject. The longer the shutter speed, the more ghosting as the ambient light is registered. The effect can be quite startling and creative.

A code of conduct

It's sad but true that security people and other working personnel generally regard photographers with roughly the same respect as chewing gum on their shoe. To a certain extent, this status has been brought on by the conduct of some photographers with little consideration for the rights of others. A laminate or photo pass is not a license to impose yourself on the paying audience or the performer, no matter how important you think your assignment is. A few rules of common courtesy will go a long way to correct this impression and, in the end, make your job much easier. It's pretty simple, really: If you want to be treated as a professional, you must act like one.

• **Stay out of the show.**
Performers and the audience want photographers to be invisible, and right-

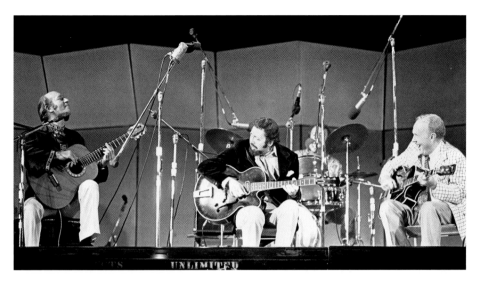

CHARLIE BYRD, BARNEY KESSEL & HERB ELLIS, 1974

Musicians constantly interact and communicate with each other onstage. Use those moments to create interesting photographs. Here, Charlie Byrd passes a solo to Herb Ellis with a visual cue. At left, John McLaughlin and Carlos Santana take a more direct hands-on approach.

JOHN McLAUGHLIN & CARLOS SANTANA, 1980

ly so. They didn't come to see you jumping around in front of the stage or otherwise becoming part of the show. Take a cue from video crews and wear black or dark clothing to blend into the background. Stay down. If you must shoot above the lip of the stage, pop up for your shot and then drop back down immediately, particularly if you are working a very low stage. When you're working a club or theater and must move around, do so with purpose. Know where you're heading and plan your route carefully before you get up to move. If you're directly in the visual path between the performer and the audience, wait until the song ends so you don't block views or create a distraction.

• Be considerate of people around you.

If you are going to block someone's view, let him know that it will only be temporary so he doesn't think his whole show is ruined. If you're on assignment for a publication or working for the band, it may help to mention that. In acoustic or otherwise quiet situations, camera noise can be very obtrusive. Turn off your motor winder. Learn to recognize when even the clatter of a shutter and mirror is too much and act accordingly. If you're shooting from the audience in close quarters, don't put your camera right in the ear of the person in front of you without fair warning. Most people will understand and cooperate if you are friendly and display a professional demeanor. If you're an insensitive clod, you make it hard on other photographers who are willing to play by the rules. And, if a customer complains to the management, it'll probably be the last time you'll be allowed to bring your camera into that club. Always be sensitive to your environment. Don't stay in one place for long—keep moving.

Still, as Ebet Roberts reminds, you've got a job to do. "I try to be considerate and stay out of people's way, but it's not always appreciated. You still have to get the shot if you're being paid to deliver. Sometimes you have to be aggressive, but that doesn't mean you have to knock somebody down."

• Respect the security people; they're paid to enforce house rules.

But remember that they may have some latitude in how rigidly they enforce those rules. Talk with them before the show and let them know what you are trying to do. Person-to-person relationships are vital. Treat everyone with respect and be friendly. Tell them you understand they have a job to do, and convince them that you do, too. If they give you an inch, don't take a mile; you'll regret it the next time you need to work the venue. Your relationships with security people can significantly effect your working conditions.

• Control your equipment.

Don't forget that you're armed with a serious weapon when you're carrying a camera around with a long telephoto lens. Hold the camera and lens straight up and down when you're moving through a crowd, to avoid poking or bashing someone. A 25-pound bulging camera bag has equal potential to do physical damage. I tend to grab the strap and force the bag in front of me, where it is less likely to whack someone.

• Stay out of the musician's face.

When you're working in small clubs or similarly intimate situations, you may discover that it's possible to get within a few feet of the performer. Unless you've been given permission beforehand, try to resist the impulse to lodge yourself into this position where you are bound to be an annoyance to both the artist and the audience. Back off a bit and let your lenses do the work.

• Clean up after yourself.

Don't leave empty film boxes and containers. Stuff them in your bag and take them with you, or dump them in a trash can when you get the chance.

• Be accommodating to fellow photographers.

If you're working in a photo pit, don't hog the best spot for the entire show. Share the space and your courtesy will be reciprocated. Granted, there will be instances when time is so severely limited that this approach will not be profitable. Sometimes it has to be every man for himself, or you might walk away empty-handed. Still, there's no need to treat the person next to you as your enemy. Let your initiative, skill, and resolve be your guide.

• Keep your promises.

If you've promised someone—an artist, a promoter, a security person, whomever—that you will send copies of a print or a proof sheet, then do it. Take it from someone who has made this mistake. People don't like to feel as if they've been taken, even if there's no money involved. They'll remember your slight and resent you for breaking your promise. Remember to always mark the pictures with your name, copyright notice, address, and phone number. If they're good enough, there's always a chance someone will want to use one or two for commercial purposes. A few free pictures distributed to the right people can reap a tremendous amount of good will and open a lot of doors.

Make the best of your opportunities

Concert photography is loaded with obstacles to success, including poor lighting, limited access, uncooperative artists, and police-state security. Whatever hurdles you face, however, don't fail to make the best of your opportunities. It's easy to take them for granted after you've done it many times. Each concert is a unique event in a performer's life, even if he or she has had 10,000 unique moments. Don't stop shooting just because you think you've got the shot you need. Take as many pictures as possible within the time you're given, but don't be indiscriminate. Film is still the cheapest element in any session, and today's pictures become tomorrow's archives much quicker than you can imagine. People come and go before our eyes, sometimes before their time. Think about how we treasure superb, revealing photos of lost artists like Jimi Hendrix, Janis Joplin, Jim Morrison, John Lennon, Stevie Ray Vaughan, and Elvis. You never know how and where your photos may end up being used ten or 15 years down the road. Think like an historian.

Controlling Exposure

hile content and composition are ultimately the most important parts of any photograph, even the most exciting shot can be rendered unusable by technical failure. The most destructive errors include incorrect exposure and lack of sharpness caused by poor focus, camera movement, or subject movement. These topics are addressed in this and the next chapter. With an understanding of the causes of such failures, and with practice, these problems can be solved and your publication "hit" rate will surely rise.

Exposure

Determining the correct exposure is critical for producing the best possible negative or transparency, a goal that should always be foremost in your mind. Color and black & white negatives offer wide latitude for under- and overexposure that can be corrected somewhat during processing and printing, but image quality will suffer in either case. Underexposure causes a loss of shadow detail and produces a print that lacks a full range of grays or colors. An overexposed negative is always less sharp and shows too much grain because of light scattering in excessively dense areas. Still, it is better to err on the side of over-

sure when shooting negative film because of the built-in latitude. Color transparencies are particularly unforgiving, however, allowing little more than a 1/2-stop error in either direction unless processing compensation is made. The price for that compensation is increased graininess and reduced color intensity. Your best ally in the quest for consistently accurate exposures is a good light (or exposure) meter.

The fundamentals

It doesn't require a degree in quantum physics to understand the principles of exposure, although the confusing array of exposure modes and metering options on today's electronic cameras might suggest otherwise. There are only two elements involved—lens aperture and shutter speed. The aperture, or lens opening, controls the volume of light entering, while the shutter speed regulates the length of time that light strikes the film. Aperture size is measured in f/stops and determines depth of field, the distance behind and in front of the focus point that appears sharp (see Chapter 6 for more on depth of field). The amount of light is doubled each time the aperture is opened up (made larger) one f/stop. Paradoxically, the size of the aperture opening is in inverse relationship to the size of the number; i.e., f/22 is smaller than f/2.0. The smaller the f/stop (the larger the number), the greater the depth of field.

Shutter speed regulates the action-stopping ability of the camera and is measured in fractions of a second. The faster the shutter speed, the greater the action-freezing power. The same relationship between f/stops and light gathering applies to the shutter speed; slow it down one click (say, from 1/125th sec to 1/60th sec) and twice the amount of light strikes the film. Conversely, a faster shutter speed or smaller f/stop halves the amount of light with each change.

Because of this precise mathematical relationship, the same exposure can be supplied by a variety of aperture/shutter-speed combinations. For instance, the following combinations all permit the same amount of light to reach the film: 1/30th sec at f/16; 1/60th sec at f/11; 1/125th sec at f/8; 1/250th sec at f/5.6; 1/500th sec at f/4; and 1/1000th sec at f/2.8. Your task, usually accomplished with the aid of a light meter, is to find the aperture/shutter-speed combination that produces the precise amount of action-stopping power and depth of field necessary to capture the photo as envisioned.

The first step in making that choice is to decide which is more important for the conditions—aperture or shutter speed. If the action is particularly fast, then

JOHN McLAUGHLIN, 1984

Sometimes you're stuck with harsh, contrasty lighting. A single hard, fixed, bright spotlight etches a side view of John McLaughlin out of the darkness, with no other light to fill out the rest of his face. Wait until your subject turns enough into the spot to let the light sculpt out the other eye.

shutter speed will probably be paramount. If, however, you require more depth of field, then aperture will prevail. In concert photography, though, poor lighting conditions often narrow your options considerably. I prefer to start with a shutter speed of 1/125th sec and let the aperture fall where it will. When you drop much below 1/125th sec, especially with telephoto lenses, you're courting unsharp photos from either camera shake or subject movement. If your aperture is wide open and you still don't have enough light, then you have no choice but to slow your shutter speed. In that case, steady hands, an inactive subject, or some kind of support are your best allies.

Metering

The concept of 18% gray

There are basically two types of meters: incident meters, which measure the intensity of light falling on the subject, and reflected meters, which measure the intensity of light reflected from the subject. Though each differs in how it measures light, both produce a reading by translating the scene it sees into 18% neutral gray (or zone 5 in Ansel Adams' zone system). This medium-gray tone represents an average of all blacks, whites, and grays found in a typical scene framed by a camera's viewfinder. If you think of the tonal range of any given scene as a scale ranging from 0 (black) to 100 (white), 18% gray would fall right in the middle at 50. Thus, an exposure based on 18% gray is designed to get the most from a film's potential by capturing the maximum number of tones from the deepest black to the brightest white found in any given scene.

With a scene that is truly average (i.e., one containing an even distribution of blacks, whites, and grays with no large expanses of white or black), you'd get the same reading with either type of meter. In real life, however, not all subjects fit so neatly into the "average" category—a spotlit guitarist outlined against a vast black background, for instance. A meter reading of this scene with an incident meter could easily vary by more than two stops from one taken with a reflected meter. To see why that's so, let's take a look at how each type works.

Incident meters

To take a reading with an incident meter, you position it between the subject and the light source and aim the sensor at the camera lens. Ideally, the me-

PETE TOWNSHEND, 1989. PHOTO BY JAY BLAKESBERG

To be consistently successful in this business, it's necessary to master a variety of techniques to provide different looks. The key to multiple exposures like this one is a release button that permits you to cock your shutter without advancing the film. For this triple exposure, Jay held his Nikon's release button in and waited for Townshend to move before making each exposure.

ter is held as close to the subject as possible to register the total intensity of all light sources striking it. Because the meter is measuring the amount of incident light, it provides an accurate exposure reading regardless of the actual distribution of tones in the scene. Even if it is *all* black & white with *no* gray tones, you'll get the best possible reading. Incident meters are favored by studio photographers and film lighting directors who work with "hot" lights, as well as many location photographers working with natural light. Studio photographers who work with electronic flash also prefer to read incident light. They use a flash meter, which is nothing more than an incident meter that measures a momentary

burst of light falling on a subject. If we could use an incident meter for all of our exposure readings, our metering tasks would be simpler.

For obvious reasons, however, an incident meter is not particularly useful for performance work. Few artists, not to mention security people, will let you climb onstage to take a reading each time the lighting changes. An exception occurs if you are shooting an outdoor concert that has no auxiliary stage lighting. Because the sun is your light source, you don't even have to be near the stage to get a correct reading. Just hold the meter above the crowd with the sensor facing your camera and push the button.

Reflected meters

The more common type of meter measures reflected light and is the kind built into your camera. Although many in-camera meters are quite sophisticated, you can't blindly rely on them to give you an accurate exposure under all conditions. Because different colors reflect varying amounts of light, reflected-light meters can be fooled by large expanses of white or black, or by highly reflective surfaces such as chrome and glass. Additionally, strongly backlit subjects can cause problems that all relate back to the 18% gray concept. The meter assumes that the scene is average and provides a reading that translates everything to 18% gray. Accordingly, if you point your meter at that spotlit guitarist outlined against a vast black background, it will give you a reading that renders the background as gray, not black, thereby grossly overexposing the musician. Conversely, if the background were white or a blank expanse of sky, the guitarist would be underexposed because, again, the meter reads the background as gray, not white. Once you understand this concept, you have part of the information necessary to interpret your camera's readings intelligently. To round out the picture, you also need to understand *how* your meter looks at a scene.

Metering modes

Early SLR-model cameras employed averaging meters based on the entire scene, much like a hand-held meter. In other words, everything in the frame was given the same weight regardless of relative importance. Because of the types of problems discussed above, though, manufacturers began looking for ways to fine-tune in-camera meters to produce more consistently accurate read-

MAXINE HOWARD, 1983

Though telephotos tend to dominate concert photography, the exaggerated perspective of wide-angle lenses can create powerful photos with great depth. This was shot with a 24mm lens no more than 2 feet from the performer. Note how sharp guitarist Troyce Key is in the background.

ings. Now, most of the new electronic cameras aimed at the pro and advanced amateur offer a choice of several metering modes—usually center-weighted, spot, and multi-segment (or Matrix, in Nikon terms). These modes divide the viewing screen into segments. They differ in where the meter sensitivity is concentrated in the frame and the amount of influence each segment has on the overall measurement.

Center-weighted meters replaced the overall averaging meters found in the earliest cameras. If you own a mechanical camera with a built-in meter manufactured in the last 20 years or so (a Nikon FM2, a Canon FTb, or a Pentax Spotmatic, for instance), it probably has a center-weighted meter. This type employs two segments and operates on the not unreasonable theory that the most important part of the photograph is going to be in the center of the frame. Most of the exposure (60% to 75% of the total, depending on the camera brand and model) is based on the subject matter occupying a centered circle covering 12% to 15% of the viewing screen.

Though center-weighted meters are a decided improvement over averaging meters that view the whole screen, they can still be fooled by backlighting or by a disproportionate amount of white or black in the circle. If, for instance, you've got a musician wearing a black T-shirt and playing a dark-colored guitar framed in the center of your viewfinder, you'll overexpose if you don't close your lens down a stop or two from the indicated reading. Conversely, if the artist is wearing all white and you're shooting outside against the sky, you'll underexpose if you don't open up a stop or two.

A **spot meter** takes 100% of its reading from a small, round spot (usually from 1% to 3% of the frame) in the center of the picture. The degree of coverage depends on the focal length of the lens. This tiny spot allows you to isolate a specific detail, such as a known 18% gray tone or a face. This method is quite effective because skin tone is arguably the most important detail in any photo with people. However, taking a spot reading can be tedious. You must center the spot on the face, lock in the reading by pressing and holding a button, recompose the photo, and release the shutter. If you're also using autofocus, some both functions can be executed at the same time with some cameras, since the face is also usually the most important focus point. The process must be repeated for each shot unless your camera provides a means of locking in a reading. And because the area covered by the spot is so precise, you must be extremely careful with your aim. If you get sloppy and are off just a bit so it's aimed at dark hair or a black shirt, your exposure will be way off.

NEW GRASS REVIVAL, 1984

You don't always have to show someone's face to create an interesting shot. Silhouettes sometimes include enough information to tell the story.

Although built-in spot meters are convenient, they still can't quite match the precision of a dedicated hand-held spot meter that offers 1° coverage. Several manufacturers build these, including Minolta, Pentax, Gossen, Sekonic, and Soligor. I generally use a dedicated spot meter and take a reading off a face. If you choose this method, be aware that 18% gray is a bit dark for Caucasian skin tones. Either manually open up at least one stop beyond the suggested reading, or set your exposure compensation dial to +1 to +1.5 to get full exposure. If your subject is particularly pale-skinned, you may have to open up as much as two stops. The indicated reading should be correct for most African or Asian skin tones.

Segmented meters, a refinement of center-weighting, are a relatively recent wrinkle. Also known as multi-pattern or Matrix meters, they break the viewfinder into zones, or segments. Depending on the manufacturer and model, the num-

ber, shape, size, and configuration of these zones vary dramatically, but all work essentially the same. The onboard computer chip takes an independent reading from each of the segments, makes an overall evaluation based on position, contrast, and brightness range, and then proposes the optimum exposure. Segmented meters are very effective under most circumstances, but they have the same kinds of problems with wide contrast and brightness ranges as other modes.

The fact remains that you cannot simply leave all the thinking to the meter, no matter how sophisticated it may be. The relative effectiveness of each mode varies significantly from brand to brand and even from model to model. All of these metering modes are capable of producing excellent exposures as long as you understand how they work and are prepared to override them when appropriate. The only way you can be sure you're getting the right exposure in all circumstances is through experience. Take the time to get to know all the nuances of your camera and lenses. Study your owner's manual and put what you've learned into practice. Selective metering of a scene's important parts is still the surest way to assure accurate exposure.

Exposure modes

In addition to manual exposure, where you choose the aperture and shutter speed, most electronic cameras offer a choice of several modes that provide full or partial exposure automation based on the information supplied by your meter. These modes differ from brand to brand and model to model, with more than a dozen possibilities available on some models. Generally, the more advanced models usually offer aperture priority, shutter priority, and several program-mode variations.

As their names imply, the aperture-priority and shutter-priority modes allow you to fix one or the other to control either depth of field or movement-freezing ability. Once set, the other element is automatically selected, based on metering information. Various program modes set both aperture and shutter speed, with each employing different priorities. Normal program mode emphasizes neither aperture nor shutter speed, choosing instead a middle course that stops moderate action and provides reasonable depth of field. High-speed programs are designed to freeze movement, and thus favor a fast shutter speed. With some cameras, merely attaching a 135mm or longer lens puts them into a high-speed mode. Some brands also offer a mode that favors small apertures to provide greater depth of field.

No matter what mode is chosen, however, you can't just blindly accept the camera's decision. For instance, you must be sure the shutter speed doesn't drop so low that the photograph blurs because of camera or subject movement. In concert, I prefer to use manual mode, where I can choose the shutter speed and manipulate the aperture to make corrections, if necessary, to the indicated meter reading. When I do shift to autoexposure, I favor shutter priority with an initial setting of 1/125th second. Only experience will determine what works best for you.

Sharpness

oes a photo have to be sharp to be great? That question has been around almost as long as photography. The simple answer is no, but unless your subject matter is very unusual, compelling, or rare, few things turn off an art director faster than a soft, squishy image. If you're going to cross that boundary, the "mistake" must contribute materially to the photo's success, such as soft focus to create a mood or a blur to suggest motion. A few photographers have successfully harnessed soft focus as a style, and you may feel that works best for you. But first, it's best if you understand the rules before you break them.

Unsharp photos are caused by one or more factors—camera movement, subject movement, or missed focus. With practice, concentration, and knowledge of your equipment, you can learn to avoid the common mistakes that lead to soft photos.

Camera movement

Moving the camera while making an exposure is probably the most common cause of unsharp photos, particularly at shutter speeds below 1/125th sec. Such photos are characterized by an overall soft, blurry appearance. Nothing in the photograph is sharp. The movement is usually caused by shaking or jerking the camera when pressing the shutter release, moving the lens while manually focusing, or by the downward pull of the weight of a heavy telephoto lens.

The first step for ensuring sharp photos is holding the camera steady. Assume a well-balanced stance with feet slightly spread and grip the side firmly with your trigger-finger hand while cradling the lens with the other. At the same time, tuck your elbows snugly against your body for further support.

Kneeling on one knee while supporting your elbow with the other provides a firm platform for steadying the camera.

weight. As a rule of thumb, when hand-holding telephotos your shutter speed should roughly equal the focal length of the lens (e.g., 1/250th sec for a 200mm, 1/500th sec for a 500mm, etc.). Of course, the more experienced you become with telephotos, the easier it gets to break that rule. A practiced pro should be able to hand-hold any SLR with a lens up to 105mm at 1/30th sec without camera shake. Some can do much better. Steve Jennings says that, under the right circumstances, he can successfully hand-hold a 300mm lens at that speed. From the look of his photos it's hard to question his claim; he obviously has a very

strong left arm and nerves of steel. Photographers who routinely work with rangefinder cameras (see Chapter 11), such as the Leica, say they can hand-hold at shutter speeds as long as 1/2 sec. They attribute this to the absence of a mirror banging up and down, and the uninterrupted view provided by the rangefinder-type viewfinder.

Holding the camera steady

The secret to eliminating shake starts with holding the camera properly and maintaining a solid stance, no matter what focal length of lens you're using. Grip the body with the palm of your right hand and place your index finger on the shutter release. The left hand cradles the lens for manual focusing and support. Assume a solid stance, with the feet spread slightly apart at a comfortable distance and the elbows tucked into the body for bracing. Some photographers find that the heavier a camera is, the easier it is to balance and the less susceptible it is to movement. That's no doubt one reason for the continuing popularity among pros of the Nikon F3 and F4S, which weigh in at more than two pounds *without* a lens.

The slower you set your shutter speed, the more support you require. Leaning your shoulder and hip against a wall or column while shooting also provides tripod-like support. If that's not possible, try kneeling on your right knee and supporting the elbow of the arm holding the camera on the left knee. If you're seated in a club, rest your elbows on the table. Just be certain that the table itself is solidly supported. If it rocks or moves even slightly, your efforts will be in vain.

Once you have the camera firmly locked into position, don't negate your precautions by jerking or lunging when you press the shutter release. Take a tip from experts who shoot handguns and rifles. Suck your breath in deeply, slowly release it halfway, and then squeeze the shutter slowly and evenly. Practice without film until you know precisely at what point your shutter release engages. By making this technique second nature, you'll virtually eliminate camera shake at reasonable shutter speeds.

Mechanical support

Of course, there will be times when hand-holding is simply not enough. Then you will require a mechanical support, such as a tripod, monopod, or shoul-

A table-top tripod makes an effective "chestpod" when you are shooting at 1/30th sec and below.

Monopods are generally more useful than tripods for concert work. They not only take up less room, but are less cumbersome to carry. Your legs serve as the other two support points, and monopods can be used while standing, sitting, or kneeling.

der brace. The most stable support is a tripod, but that presents problems of its own. You have to lug it to the job and find a suitable place to set it up. A tripod takes up a lot of space; few seating arrangements allow enough room for its three extended legs between you and the seat ahead of you. Furthermore, it presents something of a hazard if you're in a crowd; people can trip over it and injure themselves or knock over your camera. A tripod also limits your mobility, leaving you rooted to the spot you've staked out. Still, there's no substitute for its solidity when you're shooting with a long, heavy lens at relatively slow shutter speeds. If space is not a problem, by all means take one along. Every serious photographer should own a high-quality tripod.

More practical solutions, perhaps, are the monopod, tabletop tripod, pistol grip, and shoulder brace. As the name suggests, the monopod is a one-legged version of a tripod. A favorite tool of sports photographers (who rely heavily on long lenses), it is lightweight, mobile, and collapsible for easy transport. The monopod is particularly effective in crowds and confined spaces, standard working conditions for the concert photographer. You brace it against your body while standing or kneeling, in effect making your legs and the monopod function together as a tripod. When working from a kneeling position, the knee supports the device.

The tabletop tripod is a miniature, collapsible unit with a detachable ball-and-socket head that swivels in all directions and tilts down at a 90° angle. Despite its small size (less than a foot long when collapsed), it is remarkably solid and can be used on almost any flat or semi-flat surface, including tables, walls, or support columns. Many photographers find it useful as a chestpod. The best of these units are built by Leitz (the same folks who bring you Leica cameras), although there are now several sturdy, less-expensive alternatives on the market. Because of its versatility and size, a tabletop tripod is usually standard gear in my camera bag.

Other useful steadying devices include a pistol grip that attaches to your camera's tripod receptacle, a shoulder brace, and a beanbag. This last is a small cloth or canvas bag filled with steel shot (or the like, but seldom beans) that drapes over a hard or irregular surface, such as a railing, to support the lens. A trip through a catalog from large mail-order houses like Porter's and B&H will reveal several variations on each of these aids. As good as these devices are, however, they still must sit on a solid, immovable surface to do their job. It won't do you much good if your $300 tripod is resting on a wooden floor and 10,000 people are stomping their feet.

Subject movement

Unsharp photos caused by subject movement too fast for the shutter speed are recognizable by blurred subject matter and a sharp background. Used creatively, this effect suggests the illusion of movement, adding excitement to an otherwise static photograph. If that's not the look you have in mind, the most obvious cure is to increase the shutter speed, although that's not always practical or possible due to the ambient light level. Another solution is to use an electronic flash, which freezes action into razor-sharp stills. Again, this is not always a practical or even desirable answer. However, if you're working with a hyperactive subject at relatively low light levels, a couple of techniques routinely used by sports photographers can save your bacon and produce interesting photos.

Most useful, perhaps, is learning to anticipate peak action points where movement comes to a halt, if only briefly. These points occur when a moving body or body part has gone as far as possible in one direction and is about to begin a return motion—for instance, a softball player at the end of her swing, a quarterback with his arm cocked to the limit just before he fires a pass, or a pole vaulter at the top of his trajectory. Watch for the gyrating lead singer to reach the apex of a kick, the flailing drummer to hit the top of his stroke, or a leaping guitarist at the peak of his jump. This technique requires extreme concentration and lightning-fast reflexes, but it is capable of producing powerful and stimulating photographs, even at shutter speeds below 1/30th sec. A keen sense of anticipation is one of the most powerful assets that a photographer can possess.

Panning is a time-honored technique for freezing moving objects while creating an illusion of motion. Everyone has seen a photo of a race car in action with everything in sharp focus except for the blurred spoke wheels and streaked background. This effect is achieved by locking a moving subject into the center of your viewing screen, following it across your entire field of vision, and trip-

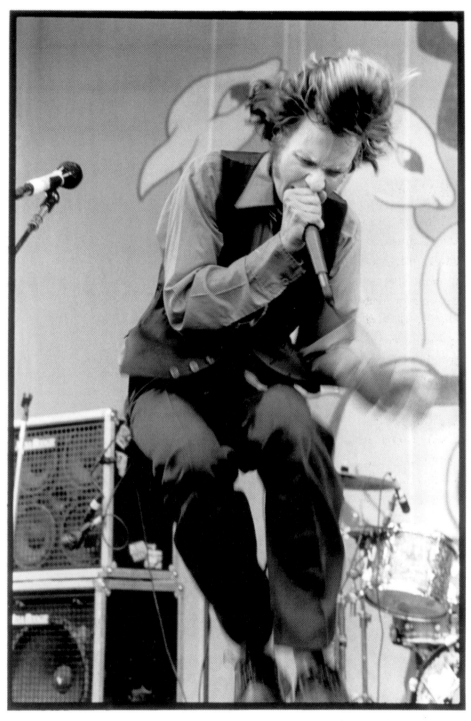

BECK, 1995. PHOTO BY JAY BLAKESBERG

ping the shutter at the decisive moment. It's important to pan at the same speed that the subject is moving and follow through after you've tripped the shutter— just like you are advised when swinging a baseball bat or golf club. If you don't follow through, the background will blur unevenly and the subject will appear unsharp. This panning effect works best with a shutter speed of 1/30th sec or below, a telephoto lens, and a subject moving continuously in one direction. One possible application in concert photography is following a musician running from one side of the stage to the other, which produces a streaked background and a blur of moving legs and arms with the head and torso relatively sharp.

In the end, you might actually get a better photo by doing nothing but employing your imagination. "Rock and roll energy is not a crisp, clean, in-focus kind of shot," reminds Jay Blakesberg. "It's movement and action. There's a real difference between an out-of-focus shot and blur caused by movement when you're shooting at 1/30th of a second. The blur suggests movement and sweat, because he's rocking out. It gives the shot a feel for the circumstances."

Remember, the techniques described here are all somewhat unpredictable and risky. But with practice, persistence, a lot of film, and a little luck, you'll find it's possible to produce exciting, salable photographs in less than ideal working conditions.

The art of focus

Focusing can be particularly difficult under performance conditions for several reasons. First, you are frequently working with telephoto lenses at wide-open apertures, providing a depth of field measurable in inches or fractions of inches. Second, your target is prone to movement, frequently in an erratic manner. And third, the light levels are often quite low in clubs and small venues, making it hard even to see the subject clearly in your viewfinder. Despite these obstacles, it *is* possible to get sharp, accurately focused photographs by training yourself both mentally and physically. Whether you choose to use manual focus or autofocus, you'll find many common problems facing you in either case.

Manual focusing

Autofocus is a '90s buzzword, but for the first 150 years of photographic history there was only manual focusing. Photographers somehow still managed to get sharp photographs under the most trying conditions. The fact is

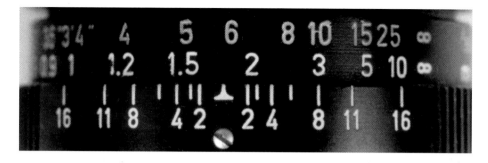

Depth-of-field scales are quite useful, although some lens manufacturers have now eliminated them. This example is from a 35mm f/2.0 Leitz Summicron. The top line of numbers shows feet, while the row below denotes meters. The bottom row indicates f/stops. The pointer in the middle shows the focus point, which is 6' in this case. To determine depth of field at f/8, line up the two 8s with the distance scale. This example shows that everything between 4' and 10' is in focus. At f/16, the range extends from about 3' to infinity.

that the *only* method of achieving full control over a variety of pictorial effects is the use of manual focus coupled with manual exposure. By using selective focusing techniques in combination with varying focal lengths and apertures, skilled photographers can render foreground objects invisible, smooth distracting backgrounds, or make everything in the photo sharp from front to back. This type of control is made possible by a thorough understanding of the concept of *depth of field*.

Depth of field

The zone in front of and behind the precise focus point that also appears to be sharp is called the *depth of field* and is infinitely variable. Of this total in-focus zone, 1/3 is in front of the focus point, while 2/3 lies behind it. Three variables determine the depth of field—the distance between the camera and the subject, the focal length of the lens, and the f/stop, or lens aperture. Depth of field decreases as the subject and camera distance decreases, as the lens focal length increases, and as the f/stop diameter gets larger. For instance, the depth of field shortens if the camera/subject distance changes from 10' to 5', if a 50mm lens is replaced with a 100mm lens, and/or if the f/stop changes

from f/16 to f/8. By manipulating these variables, depth of field can range from fractions of an inch to infinity.

Unfortunately, the tools to help pre-visualize depth-of-field effects with any given combination have nearly disappeared from all but a handful of modern cameras and lenses. Before the advent of the autofocus era, almost every camera had a *depth-of-field preview button*. The button temporarily stops the lens down to the selected taking aperture, allowing you to see the scene in true depth perspective as the lens does at the instant of exposure. (Virtually all modern lenses focus wide open, stopping down to the selected aperture only when the shutter is released.) The only problem is that stopping down the lens decreases viewfinder brightness, making it difficult to see when reduced a couple of stops or more. Still, this capability can be enormously useful in certain situations, such as close focusing. It is also beneficial for visualizing the relative differences between dark and light values in the scene in much the same way squinting does.

Another disappearing feature is a depth-of-field scale engraved on the lens barrel. It is designed to line up with the aperture setting and distance scale to provide a rough indication of depth of field for a particular aperture at any given focus point. Some manufacturers, such as Leica, engrave the f/stop guides in pairs on the scale. Others, like Nikon, employ a series of color-coded lines that match the f/stop numbers on the lens. Either way, the principle works the same: With the f/stop lined up, the appropriate lines bracket the in-focus range on the distance scale. For users of rangefinder cameras such as the Leica, this feature offers the only means of determining depth of field, since it is not visible in the viewfinder. It can be useful in other situations as well. For instance, if you're trying to capture someone racing nonstop around the stage, you can pre-focus on a spot, note the depth-of-field range, and trip the shutter when he or she enters the in-focus zone. This technique is known as zone focusing.

As mentioned, not all lenses incorporate a depth-of-field scale. If you feel such a feature can be useful, keep it in mind when you're selecting your system.

Techniques and tips

Manual focusing is an intense discipline that requires fine-tuned coordination between your eye, brain, and nervous system. For me, the process is a multi-step exercise that starts with prefocusing on the subject by rotating the

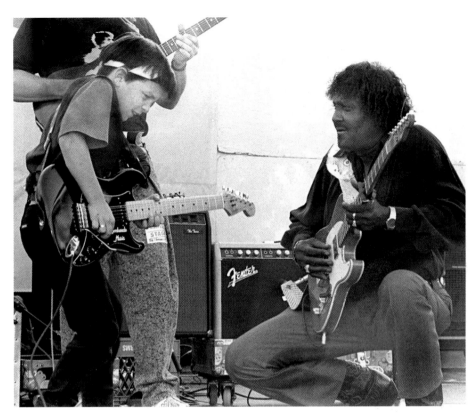

NATHAN CAVALERI AND ALBERT COLLINS, 1992

Sometimes you're in the right place at the right time to see a genuine passing of the torch. Australian Nathan Cavaleri was 11 when this shot was taken. At age 3, he faced a near-death illness and came out of it playing blues guitar like a man who had been to the Crossroads.

When *Guitar Player* magazine brought Nathan to the U.S. for a San Francisco Blues Festival appearance, he visited the offices. At an in-house jam session with editors and employees, the charming, humble, and seemingly otherwise normal youngster stunned the cynical veteran writers with his inexplicably mature playing.

Before the Saturday night headline appearance of Albert Collins, Festival director Tom Mazzolini asked Albert to let the unknown kid sit in. Collins good-naturedly agreed, no doubt expecting to hear yet another kid with a clever talent for stringing blues licks together. Within the first minute, Albert was grinning, floored and tickled to hear Nathan returning subtle variations of Albert's own signature licks. In a display of respect and showmanship, the 63-year-old blues vet crouched to Nathan's level and bridged generations with their guitars, wowing an unbelieving 8,000 fans. Within six months, cancer had claimed Albert's life.

focusing ring with my fingers in ever-tightening semi-circular arcs until the image is sharp; this is a maneuver known as "racking." With the image sharp, composition begins as I move in, back, or to the side to frame the subject the way I want it, fine-focusing as I go. Then I re-aim my in-camera spot meter at the subject's face to check the exposure and final focus, and swing back to my final composition to wait for the instant to squeeze the trigger, making focusing and composition adjustments as needed. Ideally, this whole exercise takes only a few seconds.

Choosing your focus point is critical, especially when you're working with long lenses at large apertures, because of depth-of-field limitations. The focus point tells the viewer what you consider to be the most important element of the shot. If you're photographing a performer onstage, focus on the face, unless you have some kind of effect in mind. It's usually the first thing people look at. This is particularly important if you've isolated a head shot for a portrait effect, either onstage or in a studio. Specifically, you should focus on the eyes. If they are out of focus, the photo's impact is all but destroyed. The nose or eyes offer vertical or horizontal lines to lock on to if you have a split-image rangefinder screen in your camera. Of course, the wider the lens view or the greater the distance between subject and camera, the more room you have for error. Still, it's good discipline to always pick a precise point— one you feel *must* be sharp.

The short depth of field inherent in 180mm or longer telephoto lenses can make minute focusing adjustments frustrating because of the tiny increments that you must turn the focusing ring. Sometimes it's easier to achieve precise focus by moving the camera itself by shifting your weight back and forth from the balls of your feet to your heels or by bending slightly forward or backward at the waist to "focus through" the subject. But be sure you've stopped moving before you trip the shutter, or you'll create another kind of unsharpness that's just as destructive to the image.

If the target itself is constantly moving, such as a singer bobbing in and out from the microphone, that produces a different dilemma. We discussed using zone focusing as one solution, but what can you do if you don't have a scale or your depth of field is very shallow? You can use a variation called *trap focusing*. Keep your lens tightly focused on the microphone, and when the vocalist sticks her head in to sing, nail her. Time your shots so you actually engage the shutter a split second before the musician hits your focus point, to cover your reaction time.

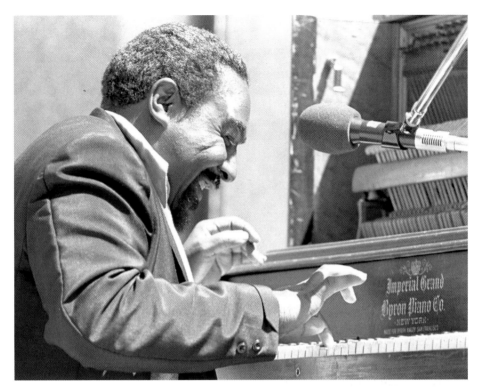

FLOYD DIXON, 1975

Zoom lenses call for special technique. For maximum sharpness, focus at the longest focal length and then back off to frame the photo.

Focusing aids

Manufacturers offer several options to help solve focus problems. A fast lens (f/2.0 or better) is your best bet because it admits more light, making the image brighter in the viewfinder. *Viewfinder screens* also make a difference. The best provide three different ways of focusing—a split-image rangefinder spot, a spot-surrounding microprism ring, and an overall fresnel (ground-glass) screen.

The *split-image rangefinder spot* is made up of two semicircular prisms that divide the image into wedge-shaped halves. By rotating the lens, the two halves, which are split horizontally or diagonally, are brought together until they line

up on a precise focus spot, often a vertical line. When the prism images join, focus is assured. The split-image spot emulates the fast-focusing, accurate system employed on Leica rangefinder cameras for nearly 75 years. On the whole, this method works quite well, but it has limitations that sometimes surface in performance conditions. One or both of the halves have an annoying tendency to black out in low lighting levels or when you use telephoto lenses. It also happens when close-focusing and when small lens apertures are used. Despite its obvious utility, the rangefinder spot has all but disappeared from the viewfinder screens of electronic autofocus cameras, primarily because it interferes with built-in spot meters.

The *microprism ring* that surrounds the rangefinder spot is a better choice when it comes to telephoto lenses and dim lighting. The prism ring, which noticeably brightens the image, contains a visible crisscross pattern that "vibrates" when the image is out of focus. The pattern and effect disappear when focus is achieved. Alas, microprisms, too, are being phased out in autofocus cameras, although some models still accept interchangeable screens.

The *fresnel screen* employs a fresnel lens embossed on a ground-glass screen. Made up of a succession of stepped, concentric rings, the lens acts optically to create a brighter, more evenly illuminated image than is possible on a plain ground-glass screen. Focusing with the fresnel screen is especially effective with long lenses, though it sometimes takes a bit of getting used to. The subject doesn't "pop" in and out of focus as definitively as it does with a split-image rangefinder or a microprism. You have to learn to trust your eyesight. Many people feel this is the easiest way to focus. Ground-glass focusing offers the added advantage of not having to reframe your shot after you've focused, as you must with any technique that uses the center spot.

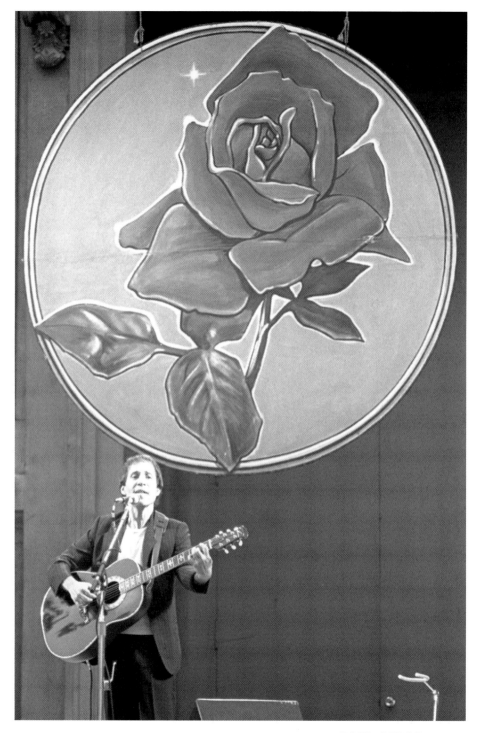

PAUL SIMON, 1981

Much of your success using this method is dependent on screen brightness, which is affected by a couple of factors. All viewfinder screens transmit less light than the lens delivers. The best cut less than a full stop; the worst, up to two stops. Be sure to note the differences when you're comparing brands side by side. Screen brightness is also affected significantly by the lens speed. The faster the lens, the greater the amount of light reaching the screen and therefore the viewer's eye. The fresnel screen is routinely found on all modern auto-focus cameras.

If you have particular difficulties focusing under low light levels, either because of slow lenses or failing eyesight, you can improve your hit rate by retrofitting your camera with a replacement focusing screen designed to increase viewing brightness. According to the manufacturers, the screens are capable of providing up to a four-stop-brighter image than a conventional fresnel screen. Even if that seems a little inflated, two or three stops can make a huge difference in marginal lighting. It means that an f/2.8 lens appears to be an f/1.4 in terms of the brightness of the viewing screen. Two manufacturers, Beattie Systems [P.O. Box 3142, Cleveland, TN 37311] and Brightscreen [1905 Beach Cove Dr., Cleveland, TN 37312] produce replacement screens for a wide variety of current and older camera systems. Contact your professional camera dealer or the manufacturers for more information.

Eyepiece correction diopter

Ultimately, your most important focusing aids are your eyes. If you can't see the viewfinder image sharply, then you're going to be doing a lot of guessing, which leads to focusing errors. If you've tried all the methods discussed here and still have problems focusing, get your eyes checked. Glasses present problems of their own, however, by poking, smudging, and fogging when you're trying to squint through the viewfinder. Bifocals and trifocals are even worse. Soft-rubber eyepieces cut the impact between metal and glass, but they also cut the viewing area.

One answer to this problem is an accessory diopter lens, which optically corrects the viewfinder for your prescription. Of course, this may not be a great idea if you tend to stumble around and bump into things when you're not wearing your glasses. You can keep them close at hand by hanging them around your neck on a long elastic eyeglass band. Just be sure they don't hang at the same level as your 3-lb camera; it's going to win that war every time. You don't need

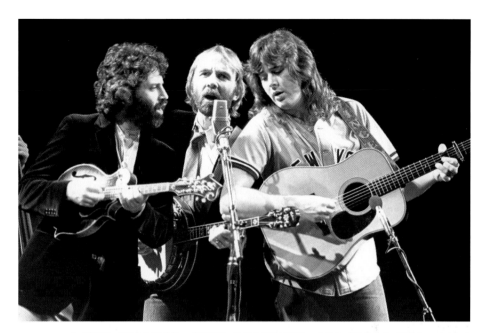

DAVID GRISMAN, HERB PEDERSEN, AND VINCE GILL, 1982

Technology may have altered the sound of most popular music in the past 25 years, but little has changed in the world of bluegrass. Close-harmony vocals are a defining part of that music, and many bands still prefer singing into a single microphone because they feel they can hear each other better. This not only creates a better vocal blend but good photos as well. This trio was the heart of a short-lived band called Here Today, long before Gill cut his hair and became a country music superstar.

an optometrist to get the proper diopter lens, although it might help to have your prescription. If you don't, any decent-sized camera dealer should have an assortment for most major brands you can try. There aren't that many possibilities. The lens screws into the viewfinder eyepiece.

Practice makes perfect

Focusing is a skill that improves with practice. The routine is the same whether you're using manual or autofocus. Wherever you are, rehearse raising the cam-

era to your eye and quickly snapping an image into focus. Start with a normal lens and then progress to medium and long telephoto lenses. Keep a camera with a short telephoto lens mounted close by when you sit down to watch television. During commercials, practice focusing on people or objects in the room under all kinds of conditions, particularly in low, contrasty lighting. Focus on an object such as a magazine on the table and then rapidly move to another object like the edge of a chair or the fireplace poker, fine-tuning each focus shift as quickly as possible. Go outside and practice "follow-focusing" on moving subjects such as a passing jogger or cyclist. Lock on and keep refocusing as your subject moves across the frame.

Work with all focal lengths, but concentrate on 100mm and longer telephotos. Focus on an object 10' away, then quickly shift your aim to one 5' away, snapping it into focus as quickly as possible while holding the camera steady. Change from an object in bright sunlight to one in open shade. Open your lens to its widest aperture and fill the frame with a head shot. With a wide-open 180mm f/2.8, depth of field may not be more than an inch or two, calling for extremely precise focusing. At first you can do these exercises without film in the camera. But after you feel like you're getting the hang of it, load some film and go through the same routine. This forces you to consider the consequences of camera movement, because your mistakes will be clearly evident once you process the film. These kinds of exercises are excellent for honing the fast-focus reflexes necessary for performance photography. They also give you a better sense of the range of your lenses and what it takes to fill the frame with a well-composed image. It's better to make the mistakes when it doesn't count, so you won't make them when it does.

Autofocusing

"No camera can predict what Iggy Pop is going to do." —Clayton Call

When Minolta introduced SLR autofocusing in 1985, it was initially seen as a boon to amateurs, with most professionals scoffing at its inability to track in fast-moving situations and/or poor light. Besides, they said, if you can't learn to focus your camera, you shouldn't be selling yourself as a pro. That part is still true, but after a decade of breakthrough development, autofocus (AF) technology has caught up with and surpassed human capacities in most respects. The fact is, autofocus works—usually—if you play by its rules, and some systems work

better than others. When it *doesn't* work, you must either figure out how you've disobeyed the system's rules or focus manually.

Active vs. passive systems

There are two approaches to autofocus—*active* and *passive*. Active systems, which are employed in point-and-shoot cameras, send out an ultrasonic signal or infrared light beam that reflects off the subject and back to the camera's sensor, which examines the information and assigns a focusing zone. Though these systems work quite well, they're only functional up to 30' or so, and they don't provide the kind of accuracy necessary for professional-quality results.

We are more concerned with the passive systems found on nearly every autofocus SLR camera. Passive systems employ sophisticated electronic circuitry to analyze contrast differences in neighboring areas within the sector covered by the sensor. By looking at the lines, mainly vertical, that separate the contrasting zones, the camera's circuitry can determine the exact focus point and rotate the lens accordingly. This method is extremely accurate and quite fast. Still, it does have some limitations, although continuing technological improvements are gradually minimizing them. One of those limitations concerns the ability to focus in very low light. To combat that problem, some cameras have a built-in focusing-assist beam that's different from the infrared beam found on point-and-shoots. Instead, the camera projects a target of vertical lines that the sensor then can lock onto.

Modes

A choice between two modes—*single-shot* and *continuous*—is offered on just about every AF SLR currently produced. When you depress the shutter release halfway in the *single-shot* mode (also called *single servo*), the lens locks focus on whatever is targeted in the viewfinder's AF brackets. (Most systems provide either an audible or visible indication that focus is locked.) As long as you keep the button partially engaged, you can recompose all you want and focus stays locked on the initial target. The camera will not fire unless the subject is in focus. Furthermore, the focus stays locked even after you've engaged the shutter release, provided you don't remove your finger.

In *continuous mode*, the camera continues to focus as long as you keep the shutter release slightly engaged. This is particularly useful when you are shoot-

ing a moving target, but there's also a significant downside. Focus does not have to be locked in order to release the shutter, which means you won't necessarily be in focus when you take the shot. In general, it's best to stick with single-shot mode unless you are tracking a moving subject.

Most AF SLRs also provide a variation of continuous mode called either *predictive autofocus* or *focus tracking*, depending on the manufacturer. It is used when you have established focus on a moving subject. This mode compensates for subject movement *after* the shutter has been released. The lens aperture must be wide open and the mirror down for AF systems to work, but there's a split second after you've released the shutter when neither of these conditions apply. In this mode, the camera calculates the speed and direction of the subject you're locked onto and determines where the subject will be at the moment of exposure. The resulting compensation theoretically assures that your subject will be in focus.

This system works well if the speed and direction of the moving subject are constant—less well if movement is erratic. It also works better on subjects moving toward or away from the camera (as opposed to those moving on a horizontal plane). Minolta claims that its "Omni-Dimensional" predictive AF can capture any subject, even if it changes speed or direction. Nikon and Canon have also addressed this problem successfully in its newest models.

One further focusing mode found in many cameras is *trap* or *focus priority*, which does not allow the shutter to release until it has confirmed a focus lock on something. This permits you to pre-focus on a predetermined spot, which can be useful if you're trying to capture a continually moving target at a precise point on the stage, such as at the microphone or next to a specific prop. Although this mode works pretty well, it does require some skill and practice because you must avoid accidentally locking focus on something very close to your target area and prematurely firing the camera.

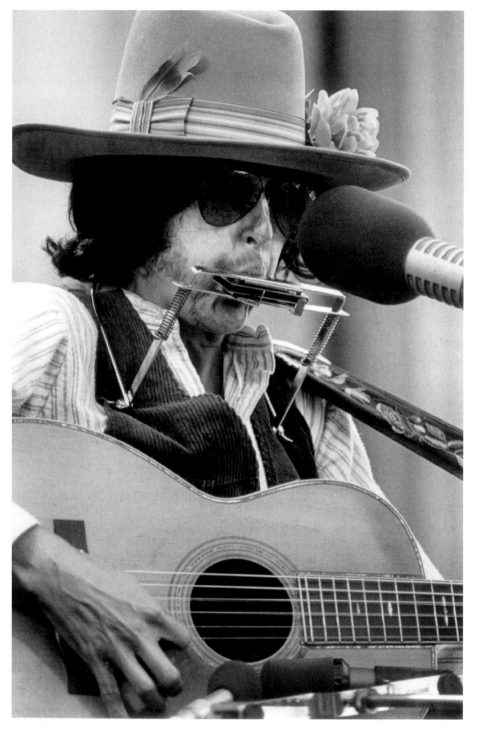

JOAN BAEZ, 1977

The rules

Today's autofocus systems are effective in most cases, although they operate under their own set of rules. You must abide by them even if it changes your normal working pattern, because the camera is not going to adjust to you. You must adjust to it. Here, in no particular order, are some realities that must be observed.

• The subject must have contrast.

The sensor can't focus on a gray wall, a dark suit, or a white shirt, for instance. Without some kind of contrasting element, the system gets confused and refuses to lock focus or starts running the lens barrel in and out, searching for a focus point. When that happens, you either have to find a contrasting line nearby or switch to manual focus. By shifting the focusing brackets slightly off the target, you can often find the contrast necessary to achieve focus. Possibilities include differences between light and dark, color changes, a light source, a highlight, the line between the hair and the face, the line between a jacket and a shirt, and the line between a guitar and the background. Try to find something in the same focusing plane (lens-to-subject distance).

• The autosensor prefers vertical contrast lines.

The first generation of autofocus cameras recognized only vertical lines, but by the late '80s both Canon and Minolta had introduced systems with limited abilities to read horizontal lines as well. Though both companies have improved their systems over the succeeding years, both still require a lens rated at f/2.8 or faster to ensure a horizontal focus lock. Nikon was slow in picking up on vertical and horizontal focusing, preferring instead to rely on a vertical sensor tilted slightly to provide a limited ability to sense horizontal lines. Two recent models, the N90S and the N70, have a wide-area vertical sensor that can be switched to what Nikon calls a "high-density cross spot." Only the recently introduced F5 has true vertical and horizontal wide-area autofocus tracking.

• Long lenses usually focus faster manually.

The weak point of most autofocus systems has typically been an inability to lock focus quickly with long lenses. That's because of the distance the lens barrel must be rotated when focus is shifted, for example, from something 10' away to a target 50' away. The hand can gross-focus and then fine-focus much faster

than the camera's focusing motor. Canon has led the way in addressing this problem by mounting motors on the lenses themselves, not just on the camera body as most manufacturers do. Recently, Nikon has also adopted this strategy for some of its longer, premium-glass lenses.

You can speed the process and save expensive lithium batteries by manually pre-focusing on your subject and then switching to autofocus to fine-focus. If you have a Canon EOS system, it's possible to simply grab the lens and gross-focus manually without switching out of autofocus mode. Other systems specifically warn against turning the lens by hand while in autofocus mode.

• You must tell the autosensor where to focus.

The camera doesn't know what you have in mind. On its own, it will focus on the object closest to the focus starting point within the sensor zone. The best cameras offer both a wide-area focus and a spot-focus choice. The wide-focus option works well as long as everything in its area of coverage is roughly in the same focus plane. If a monitor speaker or stage prop in the foreground intrudes, the camera will lock on that. When that happens, switch to spot focus and lock directly on your subject.

• Don't activate autofocus until you are targeted on your subject.

If you do, you're telling the sensor to focus on something besides your intended subject. This is particularly important if you're using continuous servo mode. If you lose the subject you're tracking in the AF brackets, release the AF lock by removing your finger from the shutter release and focus again.

• Don't hesitate to turn AF off when it gets in the way.

Autofocus is a tremendously useful tool, but it can also be terribly frustrating if the conditions aren't right. If the lens starts running in and out or refuses to lock focus, disengage AF and try again. If that doesn't work, turn it off and focus manually. Save yourself the frustration.

Mechanical problems

If you've tried all the remedies discussed above and your photos still have an overall fuzziness, then it's probably time to investigate mechanical failure. The most likely suspect (assuming you've previously tested the lens and found it satisfactory) is a misaligned or damaged lens mount. A camera is especially

susceptible to this problem if you use long, heavy telephoto lenses frequently. A 4-lb lens hanging from the camera exerts enough force to eventually pull the mount slightly out of alignment, particularly if you smack it against something or someone bangs into it.

The relationship between the lens mount and the mirror box prism assembly is critical, since it controls the distance your image travels from the front of the lens to the film plane. It doesn't take much to make a difference when you're shooting at wide-open apertures with little depth of field. You can test for this problem by focusing on a sheet of newspaper or lens test chart mounted on the wall from a distance of 8' to 10'. Shoot the test target from straight on and then mark an "X" on the target and focus on that from a 45° angle. If either of the photos is soft, chances are you have problems with your lens mount and it's time for a trip to the repair shop.

Shooting Offstage

L earning to photograph artists in concert is only one part of the success equation. Equally important is knowing how to capture them in "real life" and in photo sessions, especially if you hope to market your work to the general media. This was driven home with the death of Jerry Garcia. Because I had interviewed and photographed him on several occasions over two decades, I was besieged by calls from mainstream news media looking for "anything *except* a shot of him playing guitar." Ordinary people like to see famous people doing ordinary things they can relate to in their own lives, and the concert stage is not real life for most folks. Unless you're willing to settle for the *paparazzo* approach (lying in wait to ambush celebrities in public places), getting these kinds of informal photos generally requires cooperation of the artist or management. With the most successful artists, this always means prearranged permissions, a topic addressed in Chapter 3. Let's examine some of the places and conditions that provide the opportunity for informal photos. Later in the chapter, we'll discuss the psychology and mechanics of working with musicians in sessions.

Backstage

Some of the most powerful and revealing photographs of musicians ever taken were shot in backstage dressing rooms and hallways. Jazz photographers gave

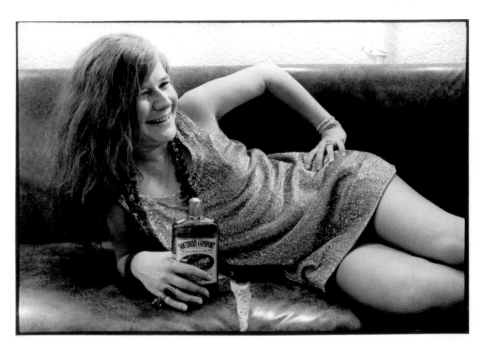

JANIS JOPLIN, 1968. PHOTOS BY JIM MARSHALL

Shooting in a dressing room is a privilege that demands sensitivity and discretion. No photographer has ever exercised those traits better than Jim Marshall. These two shots, taken within 15 minutes of each other at San Francisco's Winterland Arena, say much about the precarious burden of fame. Interestingly, each was on different roll, and Marshall does not recall which was shot first.

us our earliest look at musicians both onstage and offstage, starting in the 1930s with the work of Alfred Lion and William Gottlieb. The tradition was continued in the '40s, '50s, and '60s by many, including Popsie Randolph, Herman Leonard, William Claxton, Lee Friedlander, and Chuck Stewart. Ernest K. Withers provided revealing looks of the popular R&B stars of the '50s and '60s from his Memphis hometown. David Gahr captured the performing and the human side of the late-'50s/early-'60s folk and blues revival. Jim Marshall bridged eras and genres by documenting early-'60s jazz, the folk revival, and the '60s San Francisco rock revolution. As *Rolling Stone*'s first staff photographer, Baron Wolman gave us a glimpse of the private lives of a new breed of rock stars. And before she became a cultural icon for her brilliant studio work, Annie Leibovitz showed us that life on the road with the Rolling Stones was crazier than we ever imagined.

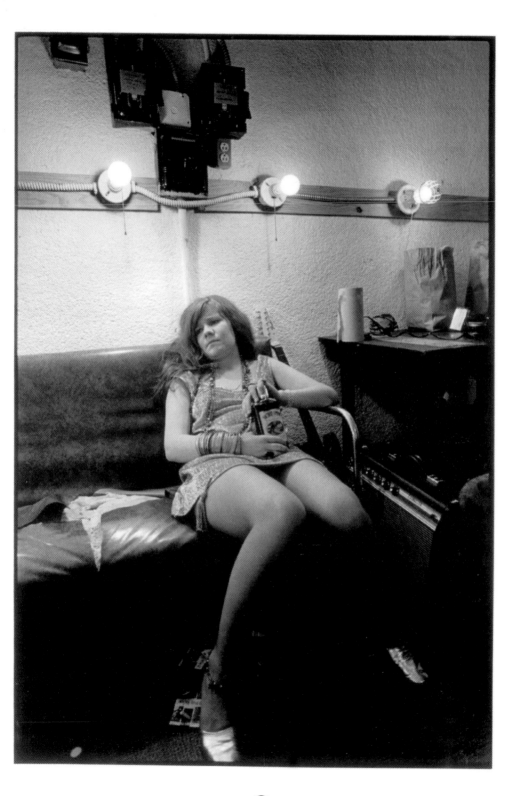

A key element of success for all of these photographers was access. The musicians knew and trusted them because of their track records. As a result, the photographers wandered freely among dressing rooms, stage, and audience, leaving us with a record of how everything is interconnected.

Unfortunately, that kind of access has all but disappeared from the big-time rock and roll and pop scene. The music has grown too big commercially and the star system imposes impossible media demands on the musicians. With rare exceptions, even tour photographers hired by the band don't have the freedom of the early days, much to their chagrin. Neil Zlozower (Van Halen, Motley Crüe, others) and Paul Natkin (Rolling Stones and others), both of whom idolize Marshall's work, have witnessed this firsthand. "Rock and roll photography was a lot different when Jim was shooting," observes Zlozower. "He was more of a photojournalist. He'd eat dinner with the band, travel in limos with them, hang out in the dressing room, and go onstage whenever he wanted. Now you don't go anywhere without a laminate [an "all-access" pass, usually encased in plastic] and even that is limited. The band comes offstage and the manager will say, 'Don't go in the dressing room for 15 minutes. They want to cool down and discuss the show.' Back then, Marshall would probably just walk right in and hear them shouting at each other and get some great shots."

The primary reason for this change, in Natkin's opinion, is image control. Musicians don't want to be caught on film doing something stupid or illegal. "Back in the '60s, they thought it was cool to be photographed smoking a joint, but the politics are so much heavier now. I can't blame anyone for wanting to control their image. Why jeopardize record sales or invite a bust? The only photography I do backstage now is posed." Whatever the reason, this restrictive policy effectively ensures that, with occasional exceptions, revealing and sensitive backstage photographs are pretty much a thing of the past, at least among established rock and pop stars. Marshall is still an active photographer, but he refuses to shoot a show unless given complete access. Since few bands are willing to grant it, his unique talent is only rarely applied to current artists. That's their loss, and ours. Fortunately, Jim's work is still widely reproduced and accessible to students and lovers of photography as art. Many of his most famous photos can be viewed (and purchased) online via his web site (http://www.marshallphoto.com).

If all this sounds discouraging, remember that we're talking about a relatively small percentage of performing musicians who exercise this kind of control. Unknown bands, and those on the rise, are much less worried about their images

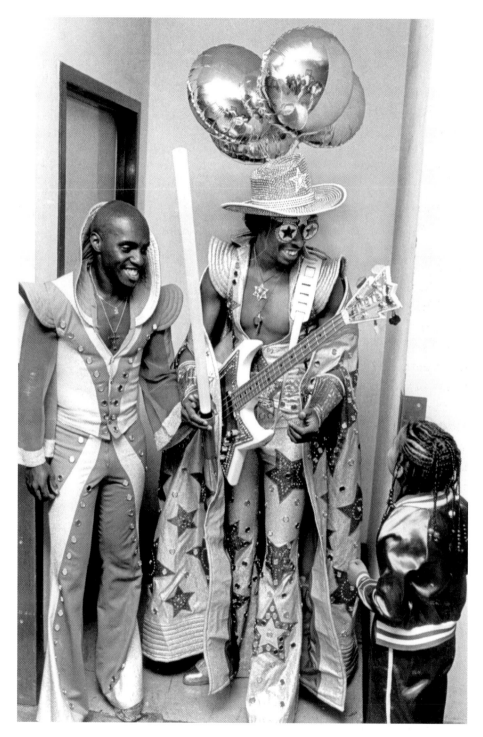

BOOTSY COLLINS AND FAN, 1978

being exploited. For most of them, *any* media coverage is welcome as long as they're not shown doing repulsive or illegal acts. (Even then, there are some performers who actually go out of their way to publicly display repulsive or illegal acts, just to cultivate a "bad boy" or "bad girl" image.)

And depending on the individual artist and venue, backstage shooting opportunities still exist in smaller niche markets, such as blues, bluegrass, jazz, folk, and various kinds of ethnic music. The artists in those disciplines are generally much more grounded and connected to their fans than pop and rock stars. Still, it usually takes some kind of connection to get you in position. Cultivate your relationships and earn the trust that gives you the kind of access that leads to dramatic photographs.

Obstacles and etiquette

Sitting in the audience, it's easy to conjure up an image of what it must be like backstage. If only you could somehow get through the door, you just know you'd find the musicians sitting right there partying and hanging out. In fact, that's seldom if ever the case. The musicians are usually ensconced in a dressing room (or rooms), which can mean anything from a closet off the kitchen in a club to large, sumptuous rooms with carpeting, sofas, and makeup mirrors in a theater or arena.

Depending on the venue, however, there may also be hallways and other areas where the artists can walk around backstage or relax and just hang out with friends after the show. I've always operated under the belief that, unless otherwise instructed, an artist is generally fair photo game if he or she is openly wandering around backstage or mingling with guests in a hospitality area. However, I also believe in discretion. If, for instance, I see a famous musician cuddling with someone other than his or her spouse or surreptitiously consuming illegal substances, I don't try to sneak a shot. I'm not interested in *National Enquirer*-style photos, but you'll have to make your own decisions. It only takes one photo to destroy a carefully cultivated relationship with an artist, record company, public relations firm, or promoter. Think twice before you pull the trigger and submit such photos for publication.

Backstage areas can also be excellent for posed shots. On many occasions, I've set up a small studio with background and lighting for magazine shoots. Lynn Goldsmith says she often uses a backstage bathroom as a studio because it's the best place to find privacy.

SHAWN COLVIN AND POPS STAPLES, 1991

I look for interaction and moments of contact when I'm in comfortable backstage shooting conditions. Singer/songwriter Shawn Colvin was shy, thrilled, and humbled when introduced to the gentle legendary patriarch of the Staple Singers. When she reached out with respectful hesitance, Pops laid his hand softly on her shoulder, radiated a 10,000-watt smile, and transmitted the healing warmth of his presence.

Dressing rooms are another matter. They are the band's home away from home, and it takes an invitation to get inside. If you wander in uninvited, there's no way to blend in without being noticed, especially if you're carrying a camera and packing gear. Some artists will be gracious, while others will have you tossed into the street. For the big-name artists, of course, you'll seldom get anywhere near the dressing room unless you're working for the band or on assignment from a magazine of interest to the artist. The better you know the band, the more the members will trust you and relax, knowing that you won't publish an unflattering or compromising shot of them. That kind of trust comes only with time.

It's easy to take top-quality portraits with a minimum of flash equipment if you have the right conditions and a great subject. Bonnie Hayes is a gifted songwriter and keyboard player who has written several hits for Bonnie Raitt. I photographed her in the music room of her apartment, bouncing the light of my Vivitar 283 off the white ceiling to create a softer, more even light, much like that created with umbrellas or soft boxes. It sure helped that she had two keyboards in the room and a warm camera presence. Bounce lighting can be a powerful tool in backstage locations, but can create problems with deep, dark eye sockets when the bounced light source comes from directly above the subject. That problem was circumvented here by standing on a chair and having Bonnie look up, exposing her whole face to light.

The best advice I can offer is to stay cool, particularly if you aren't acquainted with members of the band. Your greatest asset is a confident demeanor. If you look and act like you belong, people will assume you do and either leave you alone or schmooze up to you. If you appear meek, uncertain, or fumbling, you'll attract unwanted attention from people anxious to impose some kind of power. Handle your equipment confidently, and don't compensate for nervousness by being obnoxious or overbearing. If you do happen to bump into your hero, *don't stare.* Even if he doesn't appear to notice, he can usually feel it, and it makes him just as uncomfortable as you might feel if someone were staring at you.

Lighting

The type and quality of backstage lighting varies dramatically. At some venues you'll find a few bare bulbs, while others will be lit up like supermarkets with fluorescent fixtures. Some present a combination of both, and may also include daylight from a window. You have to be prepared for anything. In general, high-speed black & white film will serve you well most of the time, although contrast may be a problem, particularly in low-light conditions where shadows and highlights are starkly defined and there are few midtones. If you shoot either slides or color negatives, color balance becomes an issue. Incandescent lights (light bulbs) require tungsten-balanced film, and fluorescent lights must be filtered to avoid a ghastly green color cast. And, of course, light from a window calls for daylight film. Mixed light sources in the same shot produce odd

BONNIE HAYES, 1984

color casts that are seldom pleasing. Chapter 10 addresses the issue of film color or balance in detail.

A common way to standardize the light source is to use an electronic flash, which introduces its own problems. For one thing, it can be intrusive, especially in a small room. And direct flash creates harsh shadows and a flat, unnatural look. You can get the flash off-camera with an extension cord to introduce some modeling, but the contrast problems remain. And you still have to deal with the hard shadows that are cast on faces and the background.

Bounce flash

If the room you're working has a light-colored (preferably white) ceiling and walls, you can create smooth, overall lighting by employing a technique called *bounce flash*. As the name suggests, the flash head is aimed at a ceiling or wall and the light is reflected, or "bounced," back on the subject. The result is a soft, broad, overall light that eliminates hard shadows. So, how do you know where to point the flash head? Easy. Just remember a basic law of physics that states that the angle of incidence equals the angle of reflectance. If you aim the head at the ceiling at a 60° angle, the light will reflect at the same angle.

Several factors must be considered when using bounce flash. For one, the loss of light caused by absorption and the increased camera-to-subject distance requires at least a two-stop exposure increase. Fortunately, today's automatic electronic flash units with tilting heads make exposure calculation a piece of cake. Just be certain you've chosen the correct range. And even if you're off, most flash units will warn you if you've underexposed. Another problem is created if you are too close to the subject and must aim the flash almost straight overhead. The severity of the angle of the bounce creates deep shadows in the eye sockets and under the nose. This can be alleviated somewhat by increasing the distance between you and the subject, or by positioning your subject close to a white or light-colored wall and bouncing the light from the side. Finally, if you're shooting color film, the color of the bounce surface becomes a factor, because it's imparted to the photograph. A light cream or pink surface can sometimes actually add to a photo by "warming" the light. Green, blue, or yellow surfaces, however, produce a ghastly effect and should be avoided. You can ensure a properly colored bounce surface by bringing your own in the form of a large piece of white poster or foamcore board. With the aid of an assistant or bystander, you can place your bounce surface at any angle you de-

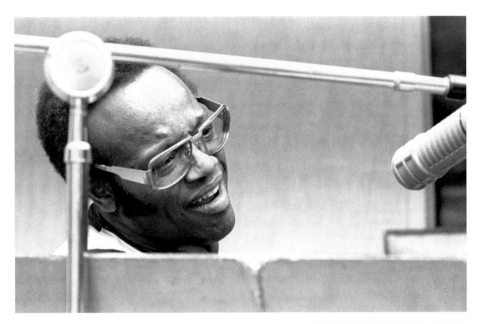

BOBBY WOMACK, 1975

Recording studios present many obstacles to clear shooting angles, including microphones, headphones, and sound baffles. Instead of avoiding them, use them as compositional elements.

sire. If you have neither a light-colored surface nor a piece of posterboard to work with, your white or cream-colored shirt will serve in a pinch.

On location

Once you leave the confines of the concert venue, the opportunity for interesting and unusual photos expands. For our purposes, we'll define "on location" as any place *except* onstage and backstage. Potential sites include the recording studio, the rehearsal hall, at home, in public buildings, on the street, and on the road in limos, cars, airplanes, vans, or trucks.

The possibilities are limited only by your imagination and the cooperation of your subject. Mark Leialoha, for instance, once transported an entire band from Northern California to Utah's Bonneville Salt Flats for a record company shoot. That's certainly a dramatic and exotic place for a shoot, but you don't

have to go that far to create outstanding images with urban or rural backdrops. Chances are there are many possible sites within easy driving distance of your home. Scout local areas at different times of the day and take notes. Study the direction and color of the light and note the time. Great lighting conditions can often be more of an edge than the actual background itself. The startling reds and oranges of sunrise and sunset make those particularly good times for color film, although you'll find few musicians ready to be photographed at sunrise. Also note such things as possible access problems and the amount of activity at various times of the day. You don't want to be bothered by a lot of gawkers or fans when you're trying to keep the attention of the band. Once you've charted a few good sites and are familiar with their limitations, you'll be able to act quickly when a session is booked.

When you have only one or two subjects, you have more room for spontaneity, particularly if you're using available light or minimal fill flash. Then you can just take off on foot or in a car, and stop wherever it seems appropriate. Look for those images that show the musician's humanity, like hanging out at home, playing with the kids, or just clowning around. Remember Andy Warhol's definition of a great photo—"a famous person doing ordinary things."

In the recording studio

Recording sessions offer the potential for dramatic, intimate shots of creative artists at work, if you can get access. Sessions are usually very private affairs, because of the pressures involved. If you do get invited, understand that your presence is a privilege shared by few. Common sense will guide you on most shoots, but photographing in the recording studio requires an understanding of the process. There's simply too much at stake to have a take ruined by a bumbling photographer doing the wrong thing at the wrong time.

Just 10 years ago, recording-studio ownership was the exclusive domain of record companies and entrepreneurs with the resources to invest hundreds of thousands of dollars. Since then, however, the rapid development of digital technology has put album-quality recording into the hands of anyone for a fraction of that amount. A solo guitarist, for instance, can now record his own compact disc with a single DAT (digital audio tape) machine and a couple of good microphones. As a result of this technological bonanza, the number of commercial studios has multiplied and thousands of home studios have popped up around the world.

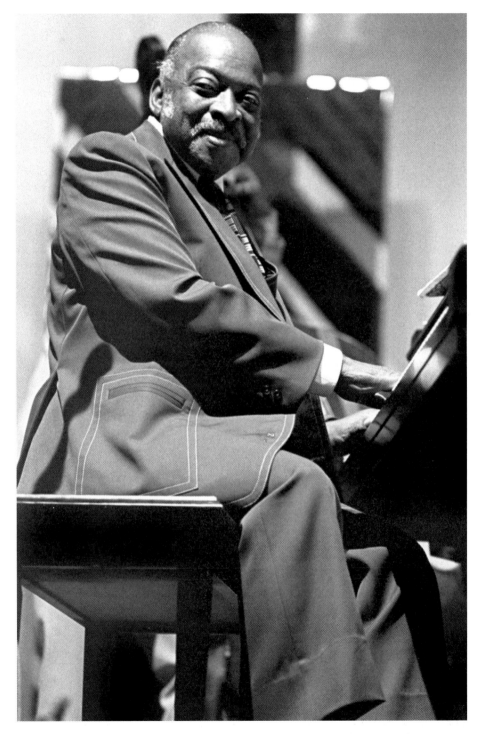

COUNT BASIE, 1977

No matter what size the studio, however, the basic layout and ground rules are pretty much the same wherever you go. There is usually a control room, where the producer, engineer, mixing board, and recording equipment are located, and the studio proper, where the musicians perform. In most studios, a thick piece of soundproof glass separates the two rooms, allowing the principals to maintain visual contact at all times. Lighting conditions vary drastically, although many of the older large commercial studios employ banks of fluorescent fixtures and white walls made of sound-absorbing material. The combination produces smooth overall illumination throughout the room that's bright enough to easily make hand-held shots with ISO 400 film. Fluorescent lights play hell with color film, though, forcing you to use a balancing filter that cuts your effective ISO by as much as two stops. Newer studio designs tend to feature softer, more subdued area lighting to relax the musicians and make them feel more at home. That means you'll probably have to use a higher-speed film, longer exposures, or auxiliary lighting such as a flash or hot lights. Control rooms nearly always have subdued lighting and present the same kind of exposure problems.

Don't assume that you have the freedom to do anything you want just because you have a good relationship with the artist or band. The real bosses in the studio are the producer and recording engineer, and you need *their* cooperation. Talk to them before the session starts to let them know you recognize their authority. Tell them you understand their concern, and ask for some guidance on where to stand and when you're permitted to shoot. Until you've proven yourself, you'll probably be restricted to shooting while parts are being rehearsed or during playback, without tape rolling. That really isn't a handicap, though, since most of the interaction between the musicians, the producer, and the engineer takes place when the machines are off. You'll find many fine opportunities for character-revealing shots while the musicians are tuning up or just discussing things between takes.

Once you've convinced the producer that you know what you're doing, you may be allowed to shoot while tape is rolling. Noise is the primary concern, even if you're not shooting during an actual take. With the pressure to get a part right, just the sound of the shutter releasing can break a musician's concentration and put her on edge. Timing is everything. Your choice of camera and lens can help; if your camera has a particularly noisy shutter, use a lens that's long enough to allow you to back off. If the studio is big enough, a 180mm or 135mm lens provides tight closeups from a suitable distance. If you can't

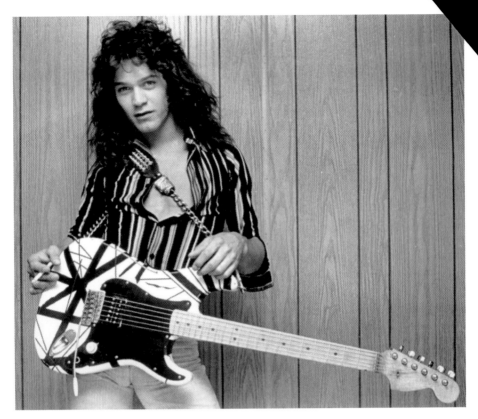

EDDIE VAN HALEN, 1978

back off far enough, try muffling the camera with a towel or sweatshirt. It may look ridiculous, but it works. Fortunately, most of the newer electronic cameras have extremely quiet shutter releases.

An understanding of how microphones work is also an asset. Microphone types are distinguished by their directional sensitivity, or pickup pattern. The most common type found in studios is the *cardioid*, which is most sensitive directly in front, with decreasing sensitivity on the sides and a dead spot directly in back.

The most basic pattern is the *omnidirectional*, which picks up sound equally from all directions. You might find this in a studio for a group of a cappella singers or for a guitarist making a solo monaural recording. Or, sometimes the engineer uses one in combination with other mike types to pick up the sound of the room. In general, however, they are of limited use, because they're too

k up unwanted sounds.

ere's the *bi-directional* mike, which is most sensitive directly in front of the capsule.

If you're going to shoot during an actual take, it's critical that you understand what kind of mikes are being used and where they are located, so your movement or shutter sound doesn't end up on tape. This is something to discuss with the producer and engineer before you go in. Just the fact that you understand these considerations might cause them to grant you more latitude.

Use your ears and musical sense, and shoot during the louder parts of the tune, where any camera noise will be covered. If you sense a quiet part coming up, back off. When the take ends, remain absolutely motionless and silent until you hear someone speak, because the notes must be allowed to fade naturally. Any kind of noise during that period will ruin the take, and probably get you banished.

Photo sessions

A commercial cornerstone for the music-business photographer is the photo session, where almost all publicity photos and CD and magazine covers are created. There is a demand for photo sessions at all levels of the music business, and you don't need a studio to get a piece of the action. It is important, however, that you are able to deliver studio-quality material. That usually means sharp, well-lit, fine-grain photos with strong visual impact.

Sessions require a different set of skills than performance and candid photography. With the latter, you are watching and reacting to what is happening in front of the camera, with no input into the subject's actions, and generally using available light. Sessions, on the other hand, require you to interact with and guide your subject, usually under controlled lighting conditions determined by the photographer. Good interpersonal skills are critical.

To consistently produce the kind of technical excellence required, most pros hired by the top bands and record labels use medium-format cameras for sessions, notably the Hasselblad, which produces a 2-1/4" x 2-1/4" image, and Mamiya's RB- or RZ-67 (2-1/4" x 2-3/4"). These formats yield a negative or slide with more than four times the surface area of 35mm film, which measures 1" x 1-1/2". The increased image size makes a dramatic difference in quality, particularly when enlarged above 8" x 10". If session work is your ultimate aim, you're eventually going to need a medium- or large-format (4" x 5" and up)

Photographing a subject being interviewed provides a range of revealing expressions. Les Paul happens to be a particularly animated subject.

LES PAUL, 1975

camera to play in the big leagues.

That doesn't mean that you can't or shouldn't use a 35mm camera for sessions, though. In fact, a 35 has a couple of advantages over its larger brothers, namely increased mobility and a wider variety of lens choices. It's possible to get excellent quality if you exercise proper care. That means you must focus

meticulously; frame the photo so there is no wasted space (to maximize image size); employ strong, even lighting that permits you to use your lens's sharpest apertures; use slow, fine-grain film (ISO 100 or slower); and expose and process the film precisely. Then, if you are shooting black & white, you must make the best possible print. A breakdown at any one of these points means a less than optimum image. The margin for error is much slimmer with 35mm, and only careful attention to detail assures that your photos will stand up to the best the format allows.

Lighting

Perhaps the most critical element defining the look and feel of your photos is lighting. Certainly, it is workable under the right circumstances to use natural light for photo sessions, particularly outside in open shade or when fog or clouds create a soft, diffused feel. But bright, sunny days with cloudless skies present an especially brutal challenge, because of the extreme contrast between highlights and shadow areas. Expose for the highlights, and shadows go deep black. Expose for the shadows, and highlights are burned out. The only successful way to handle this is to expose for the highlights and use fill light to bring the shadow areas into an acceptable contrast range for the film. This can be accomplished with either electronic flash, tungsten lighting, or strategically placed reflectors to bounce natural light back into shadow areas. Fill-flash calculations are effortless if you own a top-end Nikon, Canon, or Minolta and their corresponding high-tech flash units. In combination, they automatically set the controls for perfectly balanced fill flash, maintaining a natural balance between the subject and background. If you *don't* have all the auto gadgets, Chapter 4 contains tips on using balanced fill flash.

If you have any designs on making your mark as a session shooter, you must study the art and craft of studio lighting. It's not difficult to learn the fundamentals, but mastery can take a lifetime. Many of the highest-paid studio pros have built their look and style around lighting techniques, sometimes very simple ones. The intricacies of studio lighting are beyond the scope of this book, but there are several volumes listed in the bibliography that address the issue in detail. Books will only take you so far, however—hands-on practice is essential. That can be done in the context of a school with a good photography curriculum and a well-equipped studio, or on your own. Buy, borrow, or rent some lights, round up some willing subjects, and expose a lot of film. Your slides

JERRY GARCIA AND DAVID GRISMAN, 1991

It's not always necessary to have your subjects looking at the camera to create an effective studio shot. This photo of two old friends was taken at the conclusion of a fairly long Garcia cover session for *Guitar Player*. Jerry was never comfortable or happy with photo sessions, and he was particularly bored and tired by the time David stepped in. After a series of posed shots that clearly weren't working, I asked them to just play. The communication and thought processes at work between them is evident.

and negatives are the best evidence of your progress. Chapter 14 provides advice on selecting studio lighting equipment.

After you've gained a grasp of the fundamentals, an excellent way to refine your technique is to assist a successful pro with experience in both studio and location lighting. It doesn't have to be a music-business photographer, although that can certainly be helpful for learning how to deal with musicians, managers, and publicity people. What's more important is working with a talented photographer who understands the nuances of controlled lighting, whether

discipline is fashion, advertising, portraiture, or weddings.

Booking the session

Groundwork begins when you book the session. Here are a few questions you need to ask up front:

• How are the photos going to be used? Are they for publicity? A CD cover? Magazine editorial? The answer will affect not only how you approach the session, but how much you should charge. In general, publicity photos provide less flexibility, because they must be executed simply and cleanly enough to be readable when reproduced in black & white on newsprint. That usually requires a clean, uncluttered background, excellent contrast, and a long grayscale. Album covers and editorial shots are not necessarily subject to the same restrictions. They allow for more creativity in composition and lighting.

• Is the primary need for color or black & white? If it's a publicity session, then black & white will generally fill the need. This is especially true for a new or unsigned band, since the primary use will be for black & white publication. Photos intended for magazine layouts, CD covers, or commercial uses, such as posters or T-shirts, usually require color. If you have the time and cooperation, you can shoot both, of course, although you always run the risk that the best shot is in black & white when you need color.

• Will it be shot in the studio or on location? Photographing groups takes a lot of space and a big background. It's possible, but very limiting, to shoot a six-piece band against a typical 12'-wide paper background. The musicians have to be tightly grouped almost right up against the background, which eliminates the use of a background light to remove shadows. Alternatives include finding a large, neutral indoor background (such as a wall), using a large cloth or canvas background, or moving the shoot outside. Pros like Jay Blakesberg and Neil Zlozower resolve this problem in their studios by painting a large section of a wall and floor flat white and then constructing a gentle curve from the wall to the floor to eliminate the line where they come together. When the surface gets dirty enough that it can no longer be cleaned, it's freshly painted. Shooting on location may also mean hauling your studio to a hotel room, club, or theater, which presents its own logistical problems.

• How much time will you have? With young bands still seeking recognition, this should not be a problem. It is in their best interest to take all the time the photographer needs to make an idea work. The time can be used to make clothes changes, shift groupings and positions, or change the background or location. Things get much tougher, though, once a band achieves national recognition. Shooting conditions are almost impossible when dealing with the biggest names. That's when the publication you're working for and your personal relationships and stature as a photographer become critical. Of course, some artists and bands are more cooperative than others, so it's difficult to generalize here.

There are only a handful of photographers with the power to consistently command lengthy sessions with artists at the top of the chain, and that's because they themselves are celebrities. Annie Leibovitz, Albert Watson, Richard Avedon, Herb Ritts, Matthew Rolston, and *Rolling Stone*'s Mark Seliger are a few who come to mind. What they have in common are reputations that transcend the music business and day rates that, in some cases, exceed $25,000. More prevalent is the 10-minute photo session, where the artist or band steps into a prearranged studio setup. Fortunately, there are a few bands who respect the photographers they choose to work with, and understand that it often takes time to get everything working right.

• Are makeup and styling required? If so, who will handle it? This is usually not an issue with younger bands, who either disdain the process altogether or take the responsibility themselves. Still, it behooves you to either learn something about makeup or to bring someone along with an understanding of how to cover glaring blemishes and shiny noses, even if you're only getting paid $100 for the session. Your job is much easier if you don't have to keep coming out from behind the camera to adjust a piece of clothing or comb down a stray lock of hair. It doesn't have to cost much if you find someone who recognizes your potential and is eager to gain a toehold in the business. It can even be a friend or significant other who is willing to do it just to help or to be part of the session. Your photos will be better for it, and the artist or band will appreciate your efforts and recommend you to their friends. It stamps you as a professional with an eye for detail.

• Who is responsible for making sure everybody is there on time, properly dressed, and sober? This is no small consideration, particularly when five or six people are involved. For young, unsigned bands without management, it will

probably be the band member who booked the session. If there is a manager, then it is his responsibility. If a record company orders the shoot, you'll probably be dealing with someone in the publicity department. Ultimately, the person's title doesn't matter as much as her ability to command the artist's respect. No matter who is in charge, however, this will always be a potential problem, because it only takes one bored, stoned, or angry band member to blow the whole session. Bands are extremely dynamic and complicated social/business units. Understand that there are sometimes going to be attitudes and circumstances beyond your control.

In session

The secret to successful photo sessions ultimately has little to do with your equipment, though it must be adequate to execute your ideas. More important are your personality, confidence, and ideas. This applies whether you are shooting an unknown local band or a superstar. If you can't command the respect and undivided attention of your subjects, you're in deep trouble before you even remove the lens cap. They have to believe that they're not wasting their time and money. Inner confidence comes only with experience. You must know that your equipment and knowledge are up to the technical demands of your idea, so you can concentrate on getting what you want in the viewfinder. The time to experiment is *before* you have a paying customer in front of your lens. Another good opportunity is at the end of a session, *after* you have a safe shot in the can. Then, by all means, give your wildest ideas a try as long as your subject is cooperative.

Ideas can come from anywhere, but a good place to start is by looking at a lot of photographs in music magazines, newspapers, and books. Note how various photographers arrange groups of two or more people, and decide which shots have the strongest impact. Try to figure out what focal length of lens was used. Was it an extreme wide-angle? A short telephoto? Was the photo shot from a noticeably high or low angle? How about the lighting? How many flash heads do you think were employed, and where were they placed? Was a background light used? Helpful clues include the number of "catch lights" in the eyes and the direction and intensity of the shadows. The answers are right there in front of you if you know how to look.

One outstanding idea resource is *Rock Archives*, by Michael Ochs (Doubleday/Dolphin). It is loaded with great portraits and group photographs that will convince you there's not a whole lot new in portraiture despite the technolog-

When considering locations, don't neglect your subject's home turf, espe-
cially if it reveals something about him. This was taken in blues singer J.C.
Burris' San Francisco rooming-house bedroom and used as an album cover.

ical advances of the past five decades. Few photographers have been able to
match the imagination and execution of James Kriegsmann, who began pho-
tographing black musicians in his New York studio just off Times Square in the
mid-'30s. His publicity shots of the great black doo-wop and R&B groups of the
1950s have yet to be surpassed, and they provide a cornucopia of possibilities
for all photographers.

Providing guidance

It's up to you to provide guidance to your subjects, particularly young artists
and bands who have little experience in the photo studio. You must take charge
and help them find positions and emotions that are comfortable and natural.

At the same time, don't be afraid to solicit their ideas. Just because they haven't had a lot of experience being photographed doesn't mean they haven't spent time thinking about it. Some people are terrified or just hate to have their picture taken, and you can be sure that will show up in the photos if you don't find a way to get them to relax and work with you. The tendency for most subjects is to focus their eyes on the front of the lens, which dilutes the power of eye contact with the viewer. I ask my subjects to look straight through the lens, imagine the viewer on the other side, and consider what image they want to project. If it's warmth and intimacy, get them to imagine they are looking at their lover or children. If it's attitude, like many hard rock and alternative bands seem to prefer, ask them to imagine a music critic.

By the time most artists reach superstar status, they have endured many photo sessions and are real pros in the studio. They often know exactly what works best for them and what they want to avoid. Indecision or fumbling on your part can cause them to quickly lose patience or become bored. Thus, preparation becomes the most important aspect of the session. Do your homework and find a way to engage your subject in a meaningful conversation. Find a topic that she is especially knowledgeable about outside of her own music. Actually, there's nothing wrong with discussing the artist's music, but be sure you can speak very specifically about something in it that shows you are a careful and thoughtful listener. Don't just babble on about how great the show was or what a fan you are. Jokes can be good, but risky. An offensive or badly delivered joke can be a disaster and set an uncomfortable mood.

You must have specific ideas to succeed. If you know what you want, and can express it confidently, most people will help you get there. Try to exude an aura that says you know what you're doing and are not star-struck. If you're fumbling and sweating, the artist will pick up on it and reflect a negative attitude. It's easy to forget that, when you look at a portrait in a magazine or on a CD cover, the expression is a direct result of the subject's relationship to the photographer at the moment of exposure. Portraits are all about revealing something vital and meaningful about the person in front of your lens. The more consistent and successful you are at doing that, the more your services and photographs will be in demand.

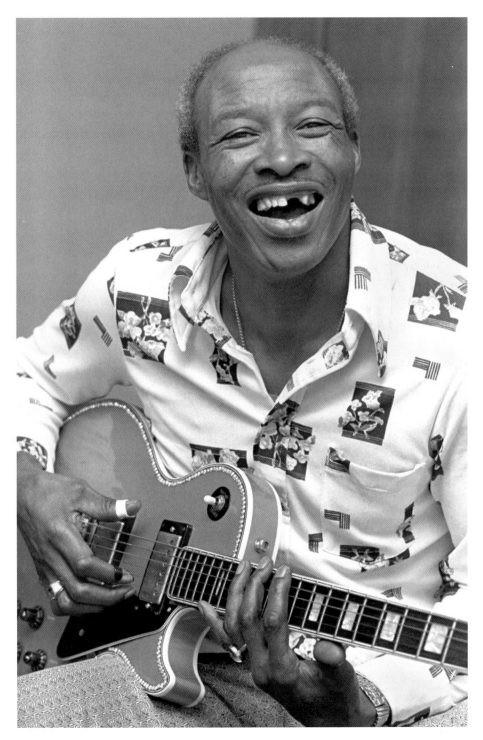

JIMMY REED, 1976

Protecting Your Rights

When you start photographing public figures and negotiating rights and fees, you need to be aware of legal considerations that can affect you. In Chapter 3, we discussed being forced to sign one-sided "contracts" before getting your photo pass. In this chapter, we'll explore the necessity of formalizing agreements, the basics of copyright and work for hire, and the ways you can legally use your photos. This information is not a substitute for legal advice; only a knowledgeable intellectual rights attorney can provide answers for your case. But it *can* help you determine what questions to ask, should legal action be considered.

Get it in writing

Photography is a discipline that attracts creative personalities who, for the most part, just want to make art and trust the business end to take care of itself. Unfortunately, that approach only ensures that they won't be doing much business. If you want to sell or lease your photos, you must also be a businessperson, unless you can afford to hire someone to handle your scheduling,

invoicing, taxes, correspondence, and all the other aspects involved in running a business. And even if you do hire someone, you must still think like a businessperson so you can monitor your employee's work.

A critical part of doing business is making certain that all parties agree on the terms. Oral agreements seem friendlier but are difficult and sometimes impossible to enforce; terms are often remembered differently by the contracting parties when legal action ensues. It's always in your best interest to document agreements in writing when money and photos are changing hands. Among the points that should be confirmed are:

- a description of the work being sold or service being performed
- use rights granted
- licensing considerations
- copyright ownership
- fees and payment terms
- physical protection of the images
- schedule for return of the images
- a mechanism for resolving disputes

Everything should be spelled out in clear, unambiguous language; leave the legalese to the lawyers, and don't take anything for granted. In general, you want to limit use rights to one time only, unless you've been asked to provide more and are compensated accordingly.

Depending on the nature of the transaction, there are several points in the process where you can and should state your terms in writing—when an assignment estimate is made and/or confirmed, when a transfer of materials occurs, and at the time of invoicing.

Assignment estimate or confirmation

Assignments are the lifeblood of professional photographers who rely on publication for a living. Typically, assignments are initiated by a phone call, when compensation and details of the shoot are discussed. The caller will either award the assignment outright, or in the case of a complicated record company shoot, request an estimate that includes a shooting fee and projected expenses. Either way, you should immediately confirm the details of your discussion in writing, before the shoot and while the terms are still fresh in both parties' minds. If everyone agrees on the terms and conditions before the work begins, there shouldn't be any misunderstandings when the bill comes due.

Waiting until the invoice stage to state your terms can be a recipe for trouble, especially if the invoice includes anything that wasn't mentioned prior to the shoot. A court might decide that you are trying to dictate a contract after the fact. The invoice, however, does provide another format for restating the agreed-upon terms.

The delivery memo

With the possible exception of your invoice, the most important form you will use regularly is the delivery memo. Every time you are asked to send photos, they should be accompanied by one. The delivery memo itemizes your submission, establishes its value, specifies compensation in case of loss or damage, stipulates a deadline for the photos' return, and details all other terms of submission. It's also a good place to specify any restrictions you may wish to impose. For instance, some photographers don't want their photos cropped or digitally manipulated. With the conversion to desktop publishing throughout the industry, more photos are being scanned to digital media. Once a photo has been reduced to bits and bytes, everything is subject to alteration. Heads can be placed atop different bodies, backgrounds can change, and objects can be moved. If you don't want your photographs altered, tell the art director and include a clause in your delivery memo that states your restriction. The clause can be something as simple as: "This photograph may not be digitally altered without written permission of the photographer."

The delivery memo is also an appropriate place to establish that you are offering one-time use rights only, particularly if you don't have a prior understanding with the publisher on this point. Without this express agreement, the publisher with the copyright on a collective work (any publication that combines the work of a number of contributors, such as a magazine, anthology, or newspaper) with your photo can use it in a subsequent issue *of the same publication* without paying you again. All that's required to prevent this from happening is a simple written statement that you are transferring one-time use rights only.

When signed by the recipient, the delivery memo confirms receipt of the materials. There is no guarantee that all of the terms of your delivery memo are enforceable, however. For instance, simply declaring that your transparencies are worth $1,500 apiece if lost or damaged does not necessarily make them worth that much in the eyes of the court, even though that figure has been

upheld in several cases. If forced to litigate, you will have to establish that the value of your photos bears some relationship to the stated figure. Among the elements that will be considered are your reputation and earning level, the uniqueness of the image(s), the potential resale value, and your established sales or use rates. Despite these possible limitations on enforceability, you should still always send a delivery memo and keep a copy for yourself. It provides a record of your submissions, while alerting the recipient that you place value on your work and expect him or her to do the same. If necessary, a court will consider the facts and determine the enforceability of your delivery memo.

Drafting contracts and agreements

Drafting your own contracts and agreements can be intimidating, especially if you believe such exercises should be left to an attorney. In fact, according to intellectual property rights attorney W. Andrew Harrell, you may be better off doing it yourself unless the agreement is so complicated that its not covered by boilerplate language.

Your agreements may be formalized via pre-printed stock forms or by customized letters that list only the terms applicable to a case. Either way, they must be signed by both parties to be binding. There are several publishers who offer books of ready-to-use sample forms. One of the best is *Business and Legal Forms for Photographers* (Allworth Press) by Tad Crawford. It provides 24 forms with explanations and negotiation points covering such topics as delivery memos, assignment estimates, assignment confirmations, invoices, book publishing contracts, model releases, permission forms, and copyright transfer forms.

The American Society of Media Photographers (ASMP), a leading advocate for photographers' rights for more than 50 years, also has an excellent publication devoted to this end. *Formalizing Agreements* offers not only a selection of sample forms, but a system for creating custom letters of agreement to fit various situations. It asks questions about what you want included and then provides stock clauses to fit your needs. A supplementary computer disk containing the stock clauses is also available, so you can "cut and paste" directly into your customized letters or forms. Both can be purchased directly from ASMP (14 Washington Rd., Suite 502, Princeton Junction, NJ 08550-1033).

"Don't be too trusting of lawyers when it comes to drafting agreements," advises Harrell. "Virtually every intellectual property dispute I handle is in large

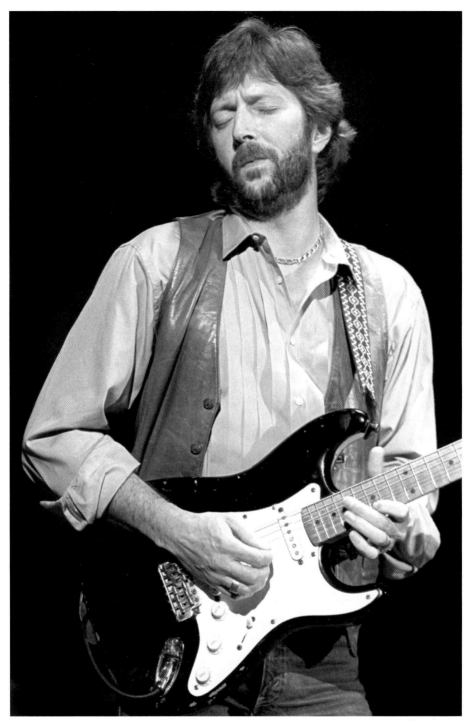

ERIC CLAPTON, 1983

part a product of bad lawyering at the agreement drafting stage. Most lawyers do not have first-hand experience as publishers, so they lack the knowledge and imagination to anticipate what can go wrong. I'd advise you to exercise a good dose of self-help and to trust your own experiences, those of other seasoned photographers, and incorporate any 'uses' or possible contingencies that your instincts tell you could surface to complicate life in the future. The best way to protect your rights is through well-drafted agreements and reliance on legislation that protects those rights. If you choose to use an attorney for your agreements, make certain that he or she has proven experience in the areas you're seeking help.

"With sales or licensing agreements, the key to avoiding disputes is to specify exactly what you are selling, whether it's reproduction rights, the original negative, preliminary or discarded shots, rights to use the work on commercial products, or whatever. In addition, you should always establish how much, when, and how you are to be paid, especially in any licensing agreement. It's also important to have a dispute mechanism built into any agreement. This can be as simple as a liquidated damages clause stating that the buyer can pay a certain amount of money to rescind the agreement if an unresolvable conflict develops. I personally favor binding arbitration or mediation to resolve such disputes, because the photographer and buyer consciously seek out points of agreement to minimize friction and bad feelings on the contentious issues. Mediation is especially valuable in cases where both parties want to preserve a professional relationship. I always attempt to mediate disputes for clients who come to me, and I've seen miracles worked. It's also much cheaper, quicker, and happier than going to court."

Copyright

A knowledge of the fundamentals of copyright is essential if you are serious about protecting your rights. Copyright law assures that creators of written, pictorial, graphic, and sculptural works have the exclusive international right to profit from the distribution and publication of those works. Copyright protection has been recognized in U.S. law since ratification of the Constitution in 1789, and the publishing industry as we know it could not exist without it. Under current law, established on January 1, 1978, with implementation of the 1976 Copyright Act, all "original works of authorship" are granted copyright protection at the instant they are "fixed in a tangible medium of expression." In the

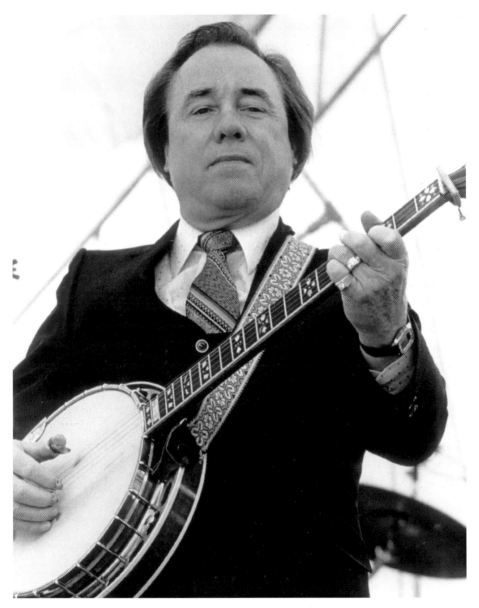

EARL SCRUGGS, 1980

case of photography, that occurs when the shutter release is engaged and a latent image is deposited on film. The film need not be developed and the copyright need not be registered to gain protection, although there are reasons for registering that are explained later.

The criteria for originality and creativity are low. All that's necessary is that the work originate with the author and contain a minimal level of aesthetic values. Only the actual expression of creation embodied by the work can be copyrighted, and not the underlying themes, concepts, and ideas. The only exception to this rule of automatic protection is if the photograph is created as a "work for hire" by an employee or an independent contractor who has specifically signed away his or her rights.

By placing control in the hands of the creator from the outset, the 1976 Copyright Act represents a 180° turnaround from previous law. Under the 1909 Copyright Act, unless there was an expressed or clearly implied agreement to the contrary, copyright was assumed to belong to the person or entity that paid to have the photos taken. Even if you submitted a photograph taken on your own time, it was presumed that copyright passed to the client unless the prints or slides were marked and the photographer's terms of submission stated otherwise. Savvy media photographers learned the hard way to make agreements *before* the shoot, and to mark every print or slide with proper copyright notice before releasing them. Newcomers to the business didn't always fare so well. Some music-business photographers who got started in the mid '60s boom lost control of some good photos before they realized they had to assert their rights.

A series of rights

Copyright protection is actually a series of rights, each of which can be separately granted or withheld. Only the copyright holder has the exclusive right to copy the work, to reproduce the work, to produce derivative works (e.g., a painting, sculpture, or any other kind of likeness that mirrors the image), to distribute copies of the work to the public, and to display the work publicly. Furthermore, copyright is an asset that can be sold, transferred, or licensed in whole or in part to others. Violation, or infringement, of copyright is punishable by federal law, usually in civil court.

Copyright notice

Until March 1, 1989, when the United States fell in line with the rest of the world by becoming signatories to the Berne Convention, marking your photos and assuring they were published with copyright notice were key to protection. Under the terms of the Berne Convention, notice is no longer required,

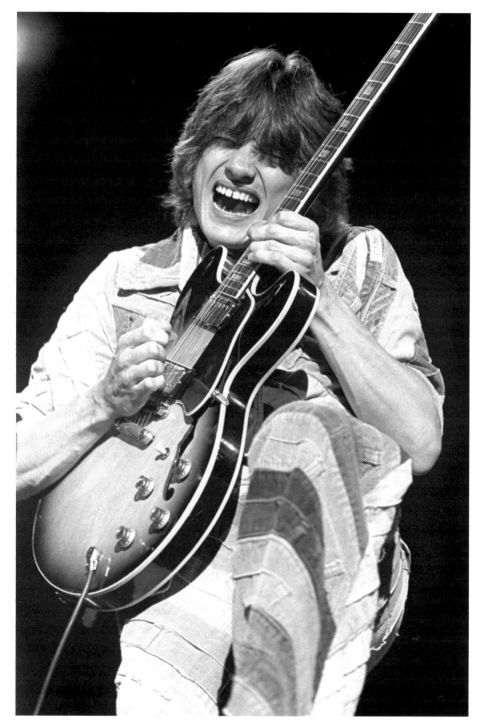

ROBBEN FORD, 1983

although it is still in your best interest to include it. Copyright law provides room for a person to claim "innocent infringement" by declaring he or she "was not aware and had no reason to believe that his or her acts constituted an infringement of copyright." A lack of copyright notice can provide the basis for an innocent infringement defense, which can mean a reduction in recoverable damages.

The notice consists of three components—the word, abbreviation, or symbol for copyright; the year of first publication; and the copyright holder's name. Three forms are recognized by law:

©1997 Frieda Fotographer
Copyright 1997 Frieda Fotographer
Copr. 1997 Frieda Fotographer

Alternatively, the date may be written in Roman numerals (a common practice by filmmakers to obscure a film's age) or spelled out in words.

In a bow to a now-obsolete international convention, many photographers also add the phrase "All Rights Reserved." Though this is no longer necessary, it doesn't hurt to remind people that they must deal with the photographer if they want to publish the photo. Taking it a step further, I also stamp the following notice on the back of prints: *Permission to copy, televise, digitally scan, or otherwise publish this photograph, or any part thereof, must be obtained from the photographer in writing.* That way there is no confusion. And don't forget to include your address and/or phone number.

For prints, the notice can be affixed directly to the front or back of the work, or on a firmly attached backing or matte. For 35mm transparencies, it should be marked on the slide mount. Many photographers use a rubber stamp for this purpose, but that works only on fiber-based prints or cardboard mounts. Standard stamp pad ink doesn't adhere to RC (resin-coated) prints or plastic slide mounts. Ask the person who makes your stamp for a permanent fast-drying ink for this purpose. You probably won't be able to find it in a standard stationery store. Alternatives include writing the notice with a permanent marker, such as a Sanford Sharpie, or applying a sticker that bears the relevant information.

If you use a computer, the process can be simplified by printing custom stick-on labels. Many popular software programs, including Microsoft Word, Word Perfect, and Filemaker Pro, provide templates for a variety of Avery labels that can be run through your laser or inkjet printer. Avery itself offers LabelPro, a software program with ready-to-use templates for more than 150 formats. Per-

fect Niche Software also markets a program called The Cradoc Captionwriter, designed primarily for slide captioning. It allows you to print labels and create a searchable database history file of the labels at the same time.

Copyright duration

Copyright protection lasts from the moment of creation until 50 years after the photographer's death. Under the 1909 act, protection began on either the day the work was first published or the day it was registered, and lasted for an initial term of 28 years. In the final year of the first term, the copyright could be renewed for another 28 years, for a total of 56 years. When the 1976 Copyright Act went into effect, the renewal term on existing copyrights was extended from 28 to 47 years, for a total of 75 years.

Photographs created before January 1, 1978, but not published or registered, are treated as new works and automatically receive the current life-plus-50-years term of protection.

It's important to note that the definition of "publication" extends beyond appearance on the printed page. Publication occurs when you distribute one or more copies of a photo to *anyone* without a restriction on showing it to others. By definition then, that includes submission to a magazine, newspaper, or book publisher for *possible* publication. A photograph is considered published if a copy or copies have been distributed to the public by rental, lease, loan, sale, gift, or any other type of ownership transfer. The medium in which it appears— newspaper, magazine, television, CD-ROM, whatever—is irrelevant.

Registration

Though registering your copyright is not necessary for protection, there are good reasons to do so. For one, you can't take legal action for infringement unless the photograph in question is registered. If you register prior to infringement and within three months of publication, you are eligible to sue for legal fees and statutory damages for up to $100,000 per infringement. If you wait until after infringement occurs, however, restitution is limited to the actual amount lost and profits realized by the infringer. Those figures can be very difficult to establish, and the legal fees incurred in the process can turn your action into an expensive and empty exercise.

Photographs may be registered singly or as an unpublished collection with

one application and fee. To qualify for group registration, a collection must meet the following criteria: (1) the photos are assembled in an orderly manner; (2) the combined photographs bear a single title that identifies the collection as a whole; (3) the photographs were all shot in the same year; (4) the copyright claimant in all the elements and in the collection as a whole is the same; and (5) all the photographs are by the same person. There is no limit on the number of photographs that can be included under a single title.

The copyright office has few requirements regarding size or format for assembling photos in an orderly manner. Transparencies must be at least 35mm in size, and if 3" x 3" or less, they must be fixed in cardboard, plastic, or similar mounts. All other types of identifying material must not be less than 3" x 3" and not more than 9" x 12", and 8" x 10" is preferred. It is clearly in your interest to make sure that the images are sufficiently large and clear enough to positively identify each one. Transparencies, prints, and proof sheets are all acceptable and may be mixed, providing all requirements listed above are met. Consider binding or attaching like materials together in some kind of "book" form that separates black & white proof sheets, color proofs, transparencies, and prints. The key to acceptance of a group registration is presentation in "an orderly form" with a single, unifying title. The title can be something as simple as "1996 Photographs of Frieda Fotographer." Once a photograph has been registered as part of an unpublished collection, it does not have to be registered again when published.

Photographs that have been published in newspapers and periodicals can also be group registered, if all examples have been published within a 12-month period and the copyright claimant is the same for all. In that case, Form GR/CP must filed along with Form VA (Visual Arts), both of which are available free from the United States Copyright Office via a 24-hour hotline—(202) 707-9100. Form VA is a simple two-page form that includes line-by-line instructions and solid basic copyright information. Mail the completed form to the Copyright Office, along with the $20 filing fee and one copy of the photo (or collection of photos) if it's an unpublished work, or two copies if it's been published. If the photo has been published as part of a collective work (a magazine or book, for example), deposit one complete copy of "the best available edition" of the collective work instead.

Registration is effective on the day that all required materials arrive at the Copyright Office, although it will be at least 120 days before you receive your certificate of registration. If the certificate is issued prior to or within five years

of first publication, it will be considered proof of the copyright's validity should an infringement action prove necessary.

To register or not to register?

At $20 a pop, costs mount quickly if you register every potentially publishable shot, even as a collection—especially if you are very active. From a statistical standpoint, based on how often it really happens, chances are slim that your photo is going to be stolen by a copyright thief. Still, it does happen, though it generally takes a strong image of a musician with a big following for someone to take the chance. Most legitimate music magazines, record companies, and merchandisers studiously avoid deliberate copyright infringement. Few images are worth the potential trouble, and it's safer to get permission. For the "big boys" to get involved in such tactics, there would have to be substantial money involved and they would have to feel they had at least *some* legal claim to the image. As for bootleggers, most artists with big-buck merchandising stature have a bank of lawyers sniffing them out.

More likely, the infringement will be by a small-time bootleg CD or T-shirt maker, a fanzine, or a World Wide Web page, and you'll never know it happened. And even if you see it and have registered the image, the cost of bringing suit might easily exceed potential compensation, considering the infringer's ability to pay. This is sad, but true. If you *do* find a photo of yours that's been bootlegged, contact the offending parties and let them know that they have violated your copyright and that you must be paid for the use. Depending on the violator's sleaze factor and continued visibility, you might get satisfaction. Filing suit is a last resort, and you should always consult a knowledgeable copyright attorney before doing so.

When you contemplate registration, you must decide how likely it is that your image is going to be used illegally. If the subject of the photo is particularly newsworthy, say a compromising shot of the King of Pop or Princess Di with her new rock-star boyfriend, then registration is prudent and should be taken care of immediately. A photograph of your average bluegrass banjo player is considerably less urgent. There are, of course, many degrees in between that call for a judgment that only you can make. If you feel you are at risk, then copyright your image.

Short of registration, your best protection is to mark your prints and transparencies with proper copyright notice and carefully control their distribution

to trustworthy recipients. It's hard to make a high-quality bootleg from a photo that's already been screened for printing, which is what the thief will have to use if he doesn't have anything better. If you like uploading photos to online computer services or you have a web page, make sure the images are small and scanned at a low resolution. That way, quality will be poor if someone actually tries to reproduce one. Jim Marshall adds another safeguard by drawing a diagonal line through the images displayed on his web page.

Work for hire

Although the 1976 Copyright Act reversed decades of favoritism to the parties who hire freelance photographers, it did create one notable exception—work for hire. Its primary aim was to cover works created by employees (of publishers, for example) in the normal course of their duties, and to spell out the exceptions to the rule that independent contractors automatically own the copyright to their creations.

The basic rules are simple enough. Unless there is a prior written agreement to the contrary, all rights to any photographs created by an employee *as part of his or her job* belong to the employer. Conversely, photographs by an independent contractor can only be considered a work for hire if both parties sign an agreement to that effect *and* if the ultimate use for the photo(s) falls into one of the following categories—a contribution to a collective work (magazine, newspaper, book, encyclopedia, etc.), part of a motion picture or other audiovisual work, a compilation created by collecting and assembling existing materials or data (an anthology, for example), an instructional text, answer material for a test, or an atlas.

When the new copyright act went into effect, disagreements about the meaning of the new law surfaced immediately between freelancers and hiring parties. Many clients tried to apply standards to the definition of an employee that defeated the spirit of the new law. In 1989, a court case clarified the distinction between an employee and an independent contractor by applying such tests as "the hiring party's right to control the manner and means by which the product is accomplished; the skill required; the source of the tools; the location of the work; the duration of the relationship between the parties; the extent of the hired party's discretion over when and how long to work; the method of payment; whether the work is part of the regular business of the hiring party; whether the hiring party is in business; the provision of employee benefits; and the tax

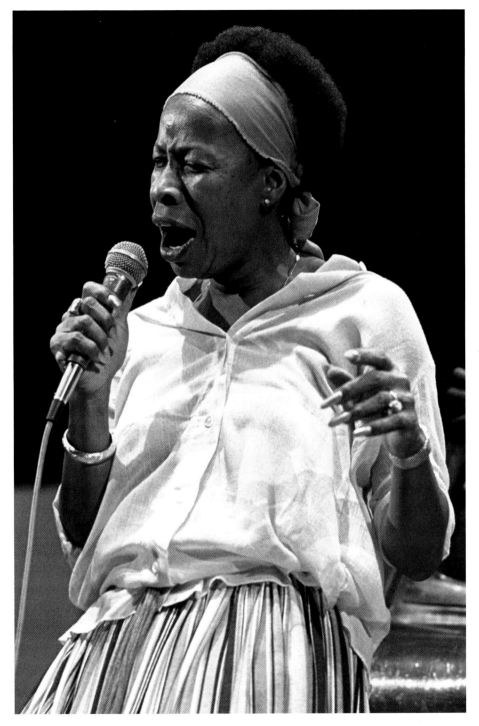

BETTY CARTER, 1977

treatment of the hired party." These tests pretty much eliminated the possibility of a freelancer being unfairly identified as an employee.

Unfortunately, this has not stopped some parties from trying to seize copyright by other means. One ploy is to include a paragraph on a check that says you surrender all rights to your photo if you endorse the check. If you are presented with such a check, either cross out the offending paragraph and initial the alteration, or return the check and ask for a new one without the clause. In another case, the editor of a popular fanzine sent a letter to all its contributors that stated: "In the best interest of you—the contributor—and ourselves, we have been advised that it is necessary for each of you to sign a release for the works that you have done, are doing, or may do for us." The release read: "This is to acknowledge my agreement that all previous submissions to [name of magazine] have been done as a 'Work For Hire' and that my current submissions, and any future submissions, will be considered 'Work For Hire.'" Not a few unsuspecting writers, illustrators, and photographers were burned by this sneak attack before howls from more savvy contributors ended the practice.

The publisher of a national blues magazine tried a different approach. A sentence in the masthead read: "Unless otherwise stipulated, articles and photos become property of [the magazine] after publication." This would not hold up in court, but the clear intent is to exploit contributors' ignorance of the copyright law. Don't fall for any of these tricks. Remember, it cannot be a work for hire unless you have signed an agreement to that effect or are an employee of the publisher. Read carefully everything you are asked to sign.

This doesn't mean that you should necessarily reject every work-for-hire agreement out of hand; just consider the circumstances carefully. If you're asked to shoot something that has little or no commercial possibilities beyond the initial use, then you may well consider it. One of the few times I have done this was for an equipment manufacturer at a trade show. My assignment was to shoot "grip-and-grin" photos of company officials with various recording-industry luminaries in the company's booth. The public relations director insisted on exclusive control of the photos. Seeing no commercial value to the shots, I agreed to accept twice my normal rate for the job in exchange for the negatives. That was in 1984, and I still have not regretted that decision. In the early '90s, however, I agreed to shoot a huge band for an equipment manufacturer and surrender all rights for $750 plus expenses. That was a mistake that I do regret, considering the hassle of the shoot and the loss of good, long-range salable images. My mistake was charging too little for what I gave up, not the work-for-hire agree-

ment per se. Moral: If you're going to give up all your rights, make sure you are adequately paid. Otherwise, you're going to feel really bad if your photos make a media splash and your name is not on them.

How can I use what I've shot?

Just because you've been given permission to shoot a concert doesn't mean that you have the right to use the photos any way you want. Public figures (in this case, musicians) are protected by the *right to privacy* and the *right to publicity*.

Right to privacy

All U.S. citizens are guaranteed a right to privacy, although laws vary from state to state. Attorney Tad Crawford defines it as "the right to be free from unwanted and unnecessary publicity or interference which could injure the personal feelings of the artist or present the artist in a false light before the public." Though the law is open to finely shaded interpretation, ways in which a citizen's right to privacy can be violated include using a photograph to imply something that is false; using a photograph to publicly divulge embarrassing private personal information; physically encroaching on a person's privacy to take a photograph (trespassing on private property, for example); and using a person's photograph for purposes of advertising or trade without his or her permission.

The law is applied differently, however, when it comes to public figures such as well-known musicians. Because public figures are newsworthy, they are forced to relinquish much of their right to privacy. The public demands the right to know about their lives, and media that report such information are protected by the First Amendment. The more famous public figures are, the less right to privacy they are afforded. The President of the United States, for instance, has virtually no right to privacy because everything he does is of interest to the public.

We can now address the question, "Under what circumstances can I publish a photograph without a signed release or permission of the subject?" The answer is: any time it is used with an article that contains current news of immediate public interest and/or any article that is educational or informative. In general, this means anything that is used editorially in magazines, newspapers, books, television, documentary film, and the emerging field of electron-

ic publishing. The only recourse for public figures who conclude that they have been wronged is to prove that the photograph was used editorially with "intentional malice" or a "reckless disregard for the truth." This is the language of libel, defined by the *American Heritage Dictionary* as "any written, printed, or pictorial statement that damages a person by defaming his character or exposing him to ridicule." As such, it is subject to the same legal tests.

Like private citizens, however, public figures are protected from advertising and trade uses of their images without permission. "Advertising" means anything that implies a direct or indirect endorsement of a service or product. That means that Fender Musical Instruments can't use one of your photos of an artist playing a Fender guitar in an ad without the artist's permission. "Purposes of trade" essentially translates to "merchandising." Simply put, you can't use artists' names or images on a commercial product without their permission. That includes T-shirts, posters, postcards, photo buttons, or any similar item.

Right to publicity

The right to publicity is a fairly recent legal concept that applies *only* to public figures. It states simply that a celebrity's name and image are property rights and that only he or she has the right, or can grant the right, to exploit them for profit. As mentioned, right-to-privacy laws offer protection from commercial exploitation to all citizens, but right-to-publicity statutes expand those rights for public figures.

By defining a celebrity's name and image as property rights, the publicity law permits him or her to assign or license those rights to someone else. It also allows the celebrity to pass on those rights to heirs. California's celebrity rights law, enacted in 1984 and emulated by a number of other states, preserves a public figure's right to publicity for up to 50 years after his or her death. The law applies to people whose name, image, voice, or signature had commercial value at the moment of death. The right to privacy, conversely, is not assignable and ends at death. Anytime you want to use a celebrity's image for commercial purposes, you *must* have a signed release.

Shades of gray: original or fine art multiples

Until laws are interpreted by the courts, they exist in shades of gray. One gray area is fine art prints featuring celebrity images. Examples that immediately spring

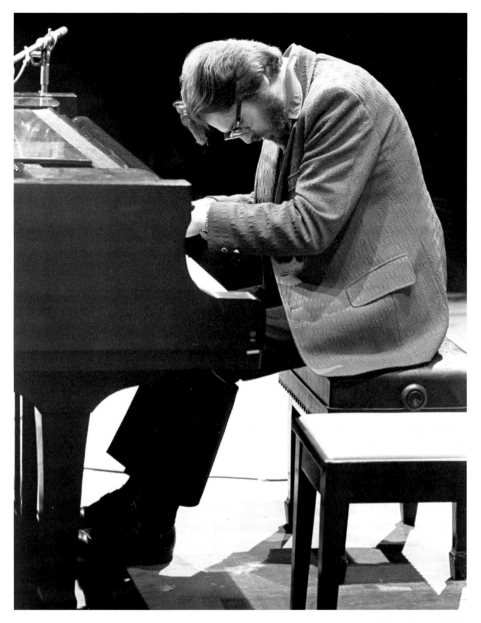

BILL EVANS, 1975

to mind are Andy Warhol's famous Marilyn Monroe series and the signed and mounted photographs of artists like Annie Leibovitz or Jim Marshall. Some courts have traditionally protected single and original works of fine art, but the issue of multiples is less clear. When does selling fine art become merchandising? And

who decides what is fine art?

One person who has been compelled to address these concerns is Laura Eveleigh, owner/director of Walnut St. Gallery in Ft. Collins, Colorado. Eveleigh founded her business in 1989 to represent the limited-edition graphics of Rolling Stones guitarist Ronnie Wood and the rock and roll photographs of Baron Wolman, *Rolling Stone* magazine's first staff photographer. Her first show was such a success that she quickly expanded her client roster, which now includes Herb Greene, Paul Natkin, Ebet Roberts, Carl Studna, Jeffrey Mayer, and John Bellissimo. "We felt that we had really hit on something for the people who grew up in the '60s and '70s," she says. "The most important thing in their life to many of them during that era was the music. We offer them a way to collect the visual images of the music they love so much."

The most common size of print she sells is 11" x 14", which is mounted, matted, and framed. All prints are signed and numbered, usually in editions of 50 (although some photographers issue editions of 100). Hand coloring of black & white images is not uncommon. The photographer pays for the printing, and the gallery covers advertising, marketing, mounting, and framing costs. A typical sales price is $450, which is split 50/50 between the photographer and the gallery.

Eveleigh believes that limited editions and the reputations of her photographers as artists provide a certain amount of shelter from litigious personalities. She says she has made a concerted effort to work directly with musicians and their agents, to abide by their wishes. She's also careful to make certain that the photographers did not sign anything at the time of the shoot that restricts use of the photos.

"We're getting real strict with that," she explains. "Photographers have to sign a disclaimer. Their role has to be clearly defined. Does the band or manager retain the rights, or does the photographer? Has the photographer agreed that he or she won't sell the photos beyond an initial one-time use? Let's face it: If the musician or entertainer feels that the association with the photographer will benefit them, either monetarily or career-wise, they probably won't do anything. It's unlikely that anyone is going to sue a photographer with the stature of Annie Leibovitz, Jim Marshall, or Paul Natkin, because there's a certain amount of cachet of being associated with them. They have earned respect as artists. But if you're a little guy with no name recognition, who knows what might happen?

"So far, I've never had a musician contact me and say, 'Hey, I hear you're selling my image.' There are a few who have told us we can't use their images in

advertising to sell the prints, but they haven't stopped the art. We're just very, very careful. I'm not going to push anyone. I've tried to straddle the fence and be both the photographer's and the musician's friend."

Using photos for self-promotion

Postcards or flyers, either printed or created on photo-sensitive paper, have long been a favorite way for working photographers of all disciplines to call attention to their work. But if your promotional materials use a musician's image, you're asking for trouble. Courts have ruled that this is a form of advertising. We can thank an over-the-edge *paparazzo* for that. Ron Galella is a freelance gossip-magazine photographer who made his reputation (and a lot of money) targeting Jacqueline Onassis and her family. His *modus operandi* included literally chasing them down anytime they stepped out in public. Churches, theaters, parks, schools, and funeral services were merely photo ops to Galella. Often, he would surprise the subjects directly, using offensive language to evoke a strong reaction for his camera.

The family's attempts to evade and impede the photographer were met with a lawsuit in 1972. Galella charged Mrs. Onassis with having him falsely arrested, malicious prosecution, and interfering with his business. He argued that because she was a public figure, he had a right to photograph her in public. Mrs. Onassis filed a counterclaim for harassment and invasion of privacy. In a side complaint, she also charged that Galella had used her photo for advertising purposes when he put it on a Christmas card that he sent to editors he wanted to impress.

The court ruled strongly in favor of Mrs. Onassis, and set harsh restrictions on Galella's photo activities. Most of the restrictions were overturned on appeal, however, because of her stature as a public figure. The court agreed it could not stop him from taking and selling pictures of her to the news media, although it did place a physical distance restriction on him. It *did* say he couldn't use her image for advertising, however, such as on his self-promotional Christmas card. The ruling permitted Onassis to sue in a separate action, thereby establishing the Galella Christmas card as a precedent.

So, does that mean that promotional mailings with celebrity photos are out? Not necessarily, but you've got to be very careful about whose photo you use and how you use it. My experience has been that, except for the very biggest superstars, most musicians are either flattered and happy for the exposure, or

indifferent to the whole idea. They know that the photographer is not making a pile of money by presenting their image as a work of art. They also know that the award for successful legal action seldom covers the cost of bringing suit. (Of course, if the shot really offends the subject, all bets are off.)

But because they are so open to exploitation, the biggest superstars (Barbra Streisand, the Rolling Stones, Michael Jackson, Bruce Springsteen, Elvis Presley's estate, the Beatles, etc.) employ teams of $300-an-hour lawyers to watch for the unauthorized use of their clients' names and images. To justify their retainers and strike legal terror, these lawyers attack *any* infraction regardless of the cost or potential for recovery. Offenders are crushed, no matter how trivial the offense.

Dawn Laureen, an award-winning Los Angeles freelancer, discovered this truth in 1992 when she used a photo of Rolling Stones guitarist Keith Richards on an invitation to an art show of her work. Within a week of distributing the invitations, she was contacted by an attorney representing the Stones, who charged that she was using Keith's image for advertising and merchandising. He demanded that she surrender all prints and the negative, as well as unspecified damages. Cowed, Dawn called more than a dozen music-business attorneys for help, all of whom turned her down because of a professional conflict or because they didn't want to offend or tangle with the Rolling Stones. Eventually, she found a lawyer outside the music business who explained that to collect damages above $750, the Stones would have to prove that she had gained financially from the use of the photo, such as receiving photo assignments from record company personnel attracted to the show by the invitation. Failing that, they would have to prove that the photo, a head shot taken on a public street, had substantially damaged Richards' marketability.

Laureen considered contesting the charge, but didn't have the money required for such an undertaking. Before it came to a lawsuit, however, she left an explanatory message on the answering machine of Richards' management. The next week, the charges were dropped on the condition that she never use the photo again. Of course, they can't keep her from using the photo editorially, but the threat of the financial and legal power of the Rolling Stones was enough to convince her to comply.

So be aware that if you use the image of someone in this league, you will probably hear from his or her attorney. And it will probably cost you money. Bottom line: Ask for permission, particularly if you think it will be an issue with the artist. And understand that if you use a musician's photo for promotional

purposes without permission, you may be sued for doing so. Know your subject, and act accordingly.

For further reading

This chapter is intended to be an overview, not an all-inclusive discussion of your legal considerations. Only a qualified attorney can provide advice should litigation be contemplated. There is, however, an abundance of excellent reading material that addresses most of your concerns, including when you need an attorney.

Two books that should be in the library of all photographers who want to sell or license their work are *The Law [in Plain English] for Photographers* by Leonard DuBoff and *Legal Guide for the Visual Artist* by Tad Crawford, both from Allworth Press. DuBoff and Crawford are attorneys with extensive experience in the visual arts. Another valuable all-purpose guide is the *ASMP Stock Photography Handbook*, available directly from ASMP and in many camera stores that cater to professionals. All of these books provide detailed coverage on virtually any legal consideration you're likely to encounter.

For more copyright information straight from the horse's mouth, contact the U.S. Copyright Office (Library of Congress, Washington, DC 20559) for a free copy of The Copyright Information Kit. It includes regulations, application forms, and informative circulars about various aspects of the law. A complete copy of the Copyright Act of 1976 (Circular 92) is also available for $3.75. For those connected online, much of the same information can be accessed through the Copyright Office's World Wide Web site at *http://lcweb.loc.gov/copyright/*

Selling
and
Leasing

Most music-business photographers I know began photographing musicians solely for sheer love and enjoyment. Shooting for profit was almost an afterthought that came when expenses began to mount and the quality of their work started drawing attention. That's a pretty good way for you to approach it while learning your craft, although that doesn't mean you shouldn't try to recoup some of your expenses as soon as you can. There are more places to sell and lease music-business photos today than ever. If there is any "secret" to selling your photos it is this: Make technically and emotionally strong photographs that stand out, and get them into the hands of the people who can use them, when they need them.

Who will buy my photos?

There are two ways to make money photographing musicians, music-industry figures, and products. You can freelance your work, or you can be hired by a band, a magazine, a record company, a manufacturer, or another commercial

party. Obviously, it's better to get a fee, all expenses paid, and a guarantee of publication, but that will come only after you've proven yourself by freelancing. For the most part, you'll be shooting photos on your own and hustling prints and slides for publication to get your foot in the door. Once you get a few good shots and begin to acquire an inventory of artists on file, you'll find there are many potential markets. You can't sell them efficiently with a shotgun approach, however. Target marketing is crucial. Keep a running list of the names in your files, preferably sorted by idiom. That way you can tailor the list to the market you are soliciting. *Bluegrass Now*, for instance, doesn't care if you have photos of Smashing Pumpkins. They want to know what you have of Bill Monroe and Alison Krauss.

Buy a copy of *Photographer's Market* (Writer's Digest Books, 1507 Dana Ave., Cincinnati, OH 45207). Updated annually, it lists 2,500 photo buyers, including advertising, public relations, and audio-visual firms; art/design studios; book publishers; record companies; stock photo agencies; and all types of magazines and newsletters. Each listing provides addresses, phone and fax numbers, the editor's name, circulation, frequency of publication, subject-matter focus, photo needs and requirements, preferred means of making contact, and pay. Except for an informative section on small record companies, you won't find many specific music-business photo buyers here. Still, the information is invaluable self-education on how the market works. In addition to the listings, each edition contains a series of articles and interviews by and about successful photographers and publishing figures. You should be able to find *Photographer's Market* at just about any bookstore.

Here are some potential markets and how you can reach them.

Magazines

Magazines present the most bountiful territory for getting your work published, if only because of sheer numbers. Appendix 1 lists several hundred publications that focus exclusively on music, musicians, or some aspect of the music industry, and there are hundreds more worldwide. Still, they represent only part of the picture. Think of all the other magazines where you find photographs of musicians or music-business figures on a regular basis, such as *Time, Newsweek, Life, Vanity Fair, Fortune, Esquire,* and *Playboy*. And that's just on the most visible level. The computer has put desktop publishing within the financial and creative reach of anybody who really wants to try it. Some efforts

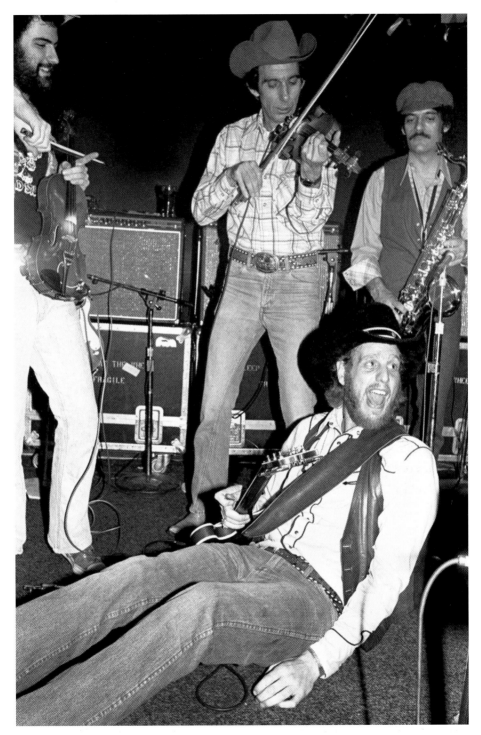

ASLEEP AT THE WHEEL, 1977

last only a few issues; others strike a resonant note with readers and advertisers and thrive. Either way, each new issue of every magazine requires a certain number of photographs, and some of them can be yours.

Publications dealing strictly with the music or entertainment business represent the complete spectrum, with circulations ranging from the hundreds to the hundreds of thousands. Most are written to appeal to music consumers and are circulated by newsstand and subscription sales. There are also many trade publications geared to specific segments of the music industry, such as music-store owners, equipment manufacturers, and the recording trade. These publications have narrowly targeted, controlled circulations that are restricted to certain members of the music industry. With few exceptions—*Billboard* and *Mix* come to mind—they are not available on newsstands.

In recent years the most growth has come in the area of 'zines—publications with small circulations dedicated to a single subject. These are usually labors of love by one or two devoted fans with access to a computer. Music has proved a particularly fertile ground for these types of publications, with dozens of 'zines devoted to a single artist, band, or style of music. These can take just about any form, from well-written, slick publications featuring four-color photos—for example, *Backstreets* (Bruce Springsteen) and *Dupree's Diamond News* (Grateful Dead)—down to unreadable four-page newsprint rags. The next big-growth area is online publications. There are already quite a few on the World Wide Web, and new entries are coming online every day.

Unless you've sneaked some great shots from the first three rows of a Barbra Streisand or Michael Jackson concert, your best bet when starting out is to target local publications. If you're into a musical idiom with a relatively small but devoted audience, such as blues, bluegrass, or folk, search out and join local or regional appreciation societies or clubs. They're great places to meet local musicians and knowledgeable fans, and many of them publish a magazine or newsletter to keep members advised of local concerts and events. These publications can provide an important forum for your photos, even though you probably won't be paid for them. They can, however, provide photo access to events featuring famous musicians in the idiom, as well as local bands and artists.

Search out the publications that focus on the type of music you most love to shoot. Appendix 1 is a good place to start, but it's hardly all-inclusive. Each year, magazines disappear and new ones are born to take their places. Haunt newsstands constantly to look for new titles. Ask knowledgeable friends and

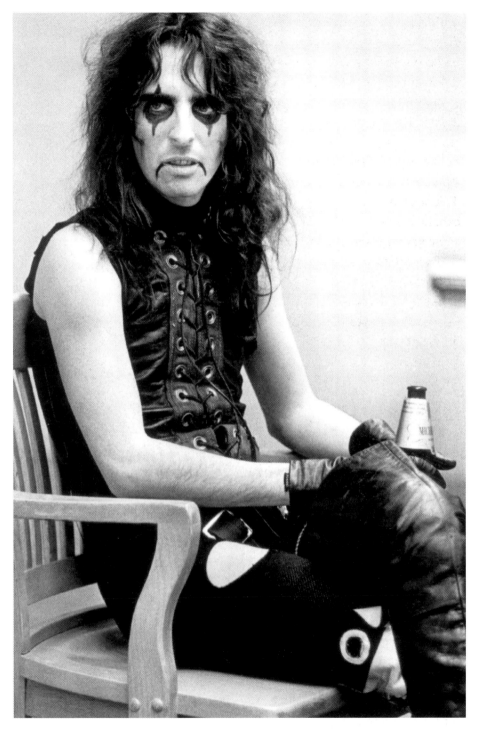

ALICE COOPER, 1972

musicians about ones they've seen. If you are bilingual, your potential market expands at least twofold, particularly if you speak Japanese, German, French, or Spanish. Visit your local library and consult *Ulrich's International Periodicals Directory*. In *Vol. 3*, you'll find the names and addresses of more than 1,700 publications around the world listed under the heading of "Music." (Of course, you don't have to actually speak the language to do business with international publications, especially if they have someone who speaks English, but it makes it easier.) The best, and most complete, listings for magazines published in the United States are *Bacon's Directory of Magazines* and *Burrelle's Media Directory*. Both are updated annually and can be found at many libraries.

If you hear about a magazine that caters to your interests but can't find it on a newsstand, write and request a sample copy. Many publishers will be happy to accommodate you if you indicate your interest in providing articles and/or photos, although you still may have to pay. It probably depends on how convincing you are.

Keeping track of all the 'zines is a bit more daunting because they come and go so quickly. The definitive in-print guide is *Factsheet Five* (P.O. Box 170099, San Francisco, CA 94117-0099), which lists and reviews from 1,000 to 1,500 publications of every conceivable ilk in each quarterly issue. The music section is often the largest.

Newspapers and newsletters

Newspapers and newsletters make up a significant part of the print media explosion created by desktop publishing technology. While the number of large daily newspapers has continued to shrink, the number of weekly and monthly papers devoted to neighborhoods, regional areas, or targeted constituencies has grown considerably. Virtually every daily newspaper provides some kind of local entertainment coverage, but those that belong to the American Newspaper Guild strictly limit the use of photographs by freelancers (although there is nothing in the Guild's contract that mandates this policy). Still, there are times when their staff photographers cannot provide photos of specific musicians or bands, and that's where your opportunity begins. Better bets are the many local and regional publications that feature bands and musicians indigenous to their circulation area.

Newsletters tend to concentrate on a single artist, band, or type of music.

While they use fewer photos than newspapers, their tightly targeted focus allows you to pinpoint those that cover the type of music you like to photograph.

Books

According to R. R. Bowker's *Books in Print,* more than 2,000 new books are published each *week* in the United States. Walk into any music store or bookstore and you'll quickly see that the music business produces more than its fair share of those numbers. Publishers need photographs of musicians, music-business figures, and instruments for a wide variety of publications, including biographies, music history, and instruction books. Appendix 2 lists some publishers who specialize in books dealing with various aspects of the music business. Remember, however, that they represent only part of the picture. For instance, most biographies of the biggest-name stars are issued by major publishing houses such as Doubleday, Alfred A. Knopf, and HarperCollins.

Fortunately, the long lead time required to bring a book to market gives you a chance to find the publishers who need the photos you have in your files. Start by contacting those specializing in music books. Send them a list of the artists in your files and ask to be kept informed about titles currently in production or planned for the future. Once you establish a good relationship with a publisher's art director, he or she will be happy to keep you notified of current and future needs.

For relevant titles generated by the larger houses, keep an eye on newspapers and magazines, particularly the entertainment columns. They often report on upcoming releases after being solicited by book publicists. You can find addresses in *Literary Market Place* (R. R. Bowker), the bible of the book industry. Your local library should have a copy. Another excellent source is *Forthcoming Books,* a bimonthly publication also generated by R. R. Bowker for the book trade to help bookstores identify and order new releases. You can usually find the most recent edition behind the counter of your local library or friendly neighborhood bookstore. It probably won't be on the shelves. Ask the librarian or store owner if you can look at her copy.

Digital media

The explosive growth of digital media in the mid '90s has redefined the world of publishing in exciting ways that only time will fully reveal. "Multi-

media" has become the buzzword of the decade. One thing certain, however, is that photographs will play an important role in this developing art form. The evolution of CD-ROM and online services such as America Online and the World Wide Web has already provided significant new marketing possibilities for photographers. It seems like everybody has an idea for a CD-ROM project or their own web page. Because this form is so new, however, uniting buyers and sellers is something of a random act. As of this writing, there are no directories that list multimedia developers, although it's only a matter of time before one appears.

The best strategy is to put yourself in a position where developers can find you. One good way is to get online and make yourself a presence in the conferences where developers are likely to congregate. If there's a school near you that's devoted to the electronic arts, make it a point to find potential authors. If you see a CD-ROM that touches on your areas of interest, note the name and address of the developer and let him know you're around. Better yet, come up with an idea that incorporates your photos and find someone to develop it. It's going to take imagination to find your way in this territory, but the search is likely to be worth the effort.

Television, video, and film

Though these media are all devoted to moving images, many producers have found that the integration of still photographs is both effective and necessary in many instances, particularly if they are dealing with historical material where no movies or videos exist. If you have photographs that fall into this category, you've got a chance to participate in this market. Unless you're dealing directly with producers on a regular basis or are wired into the film industry, though, your best bet is to have your images on file with a stock photo agency where they can find your work. Stock agencies are discussed in more detail later in this chapter.

Record companies

Record companies are prime targets, and there are more of them now than ever. Access to recording technology has become so plentiful and cheap that even local bands can afford to make their own albums. Young artists and bands no longer have to wait for a record company to come to them. They are start-

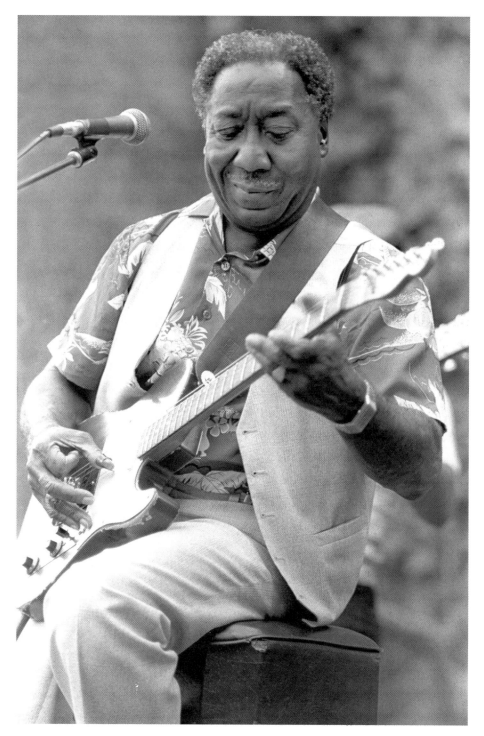

MUDDY WATERS, 1981

ing independent labels to produce CDs and cassettes to sell to their fans, use as calling cards with club owners, and serve as demos for pitching major labels. This is where your connections with hot local bands can pay off.

Labels have many photo needs, including CD covers, booklets, posters, and promotional materials. If you've established a working relationship with an artist or band, your chances for a session to produce these materials are greatly enhanced. Even if you've never met the musicians, if you've shot them live and have good photos, you still have an opportunity to make a sale. Fortunately, there are many excellent resources for identifying and making contact with the people who make buying decisions for record companies.

Two publications are especially comprehensive in this regard, the *National Directory of Record Labels & Music Publishers* (Rising Star Publishing, 710 Lake View Ave. N.E., Atlanta, GA 30308) and *Pollstar Record Company Rosters* (4333 North West Ave., Fresno, CA 93705). The *National Directory* lists more than 2,500 major and independent labels with addresses, phone numbers, and styles of music they feature. The companies are cross-indexed in separate listings by state and musical styles. The *Pollstar* directory focuses on the major labels, but provides much more information about each one, including the artist roster and the name, title, and phone number of executives and A&R (artist and repertoire), marketing, promotion, sales, and publicity personnel. An index cross-references artists and label personnel with their companies. Other publications provide this kind of data in varying degrees of thoroughness. Details about them can be found in Chapter 3.

Musical equipment manufacturers

Pick up any music magazine and check the ads, and you'll find musicians of all stripes featured as endorsees. Equipment manufacturers are always looking for an edge to point out the superiority of their products, and artist endorsements theoretically have that effect. (Of course, that doesn't necessarily mean that the musician actually uses the product, but that's another story.) If you have a particularly dynamic shot of a noted musician playing or using a readily identifiable instrument or piece of audio equipment (preferably with the brand name prominently displayed in sharp focus), you can be sure that the manufacturer is interested in seeing it. If it meets his needs, and he can negotiate a deal with the artist (or already has one), you've got a good chance to sell it. And even if he can't get the artist's cooperation, you can probably at

least sell him a nice print for his personal files. If he does choose to use it in an ad, you may find the photo has tremendous staying power. Some advertisers run the same ad in several publications for months. Remember this when you're trying to figure out what to charge for the use of your photo.

Most ads in publications carry the manufacturer's address, but you may have to look elsewhere for it. The most comprehensive listing of musical equipment manufacturers I've found is the Annual Directory of Suppliers published as the May issue of *MMR—Musical Merchandise Review*, a trade publication distributed to music retailers. Your friendly neighborhood music store probably has a copy that they'll let you look at if you ask nicely. If they aren't so friendly, or you want your own copy, contact *MMR*, P.O. Box 9103, Newton, MA 02159. Another excellent resource is the directory of exhibitors published by the National Association of Music Merchants (NAMM) for its huge January trade show held annually in Anaheim, California. If your favorite music store is a member, you might be able to talk the owner or salesperson into giving you the previous year's directory; the information should be at least 95% accurate. Better yet, ask him to grab a copy off the stack for you at the show. If that doesn't work, try contacting NAMM directly (5140 Avenida Encinas, Carlsbad, CA 92008) to request a copy.

Bands or artists

Sometimes the best way to sell your photos is to go directly to the bands or artists. After all, they are especially aware of immediate needs and will ultimately decide on the photographs that will be used on their behalf. This is particularly effective if the band is new or unsigned. Your excellent performing shots could very well lead to a working relationship that results in a session for publicity purposes or an album cover. If the artist is famous and can't be reached directly, contact his or her management. Several publications listed in Chapter 3 can help you find names, addresses, and phone numbers.

Merchandisers

In the world of big-time concert touring, merchandising has become an income source that often equals or betters gate receipts. Just about every band of any note has at least a t-shirt for sale at their shows and the biggest names are likely to have a dozen different items bearing their likeness, ranging from

hats to tour books to lunch boxes to still photos. More often than not, the image is derived from a photograph.

The concert industry is dominated by about a half-dozen companies that bid for the exclusive merchandising rights of hot new bands and artists. Advances to seal the contract often run into the hundreds of thousands of dollars, depending on the artist's perceived marketability. Images usually come from band management or are selected from photos submitted to the merchandiser directly. In either case, the band or artist usually retains veto power. Sometimes, the images are selected from photo sessions specifically commissioned for merchandising purposes. More often, they come from album cover or publicity sessions or live-performance photos.

If you've got an image you'd like to see used on a T-shirt or in a tour book, your best bet is to contact band management. Dealing directly with the merchandiser is not uncommon, but you have to figure out who is representing the band. And even if you do, the image will still have to be approved. Appendix 3 provides a list of tour merchandisers. Their rosters change frequently, however, so you'll have to contact them individually to find out whom they currently represent.

If you've got a good imagination to go along with some good photos, you might get an idea for a clever merchandising item you figure will make a bundle. How do you handle that? Herb DeCordova, a former Director of Merchandise Development for Winterland Productions, explains: "The place to start is with the merchandiser that holds the rights to a particular artist or band. First of all, you should understand that we're not interested in ideas. They're a dime a dozen. We want a product. When the New Kids on the Block were hot, we'd get calls with conversations that would go something like, 'I have an incredible idea. Let's make toy building blocks with pictures of the band members and call them New Kids on the Blocks. Every two-year-old will have to have them.' And I'd say, 'Fine, does your husband own the XYZ Toy Company, and can he make them?' 'No, I just want to license my idea to a toy company.' Forget it, you're out. If you want to *produce* your idea and patent it, then come ask us if you can license it. While you're at it, tell us how you're going to market it into 1,000 stores. And if you get that far, you're going to have to come up with a hefty advance against royalties. As you can see, you really have to believe in your idea and have the money to back it up."

The time to hook up with a band is before they sign a major-label contract and start drawing big merchandiser interest. Just as many young bands

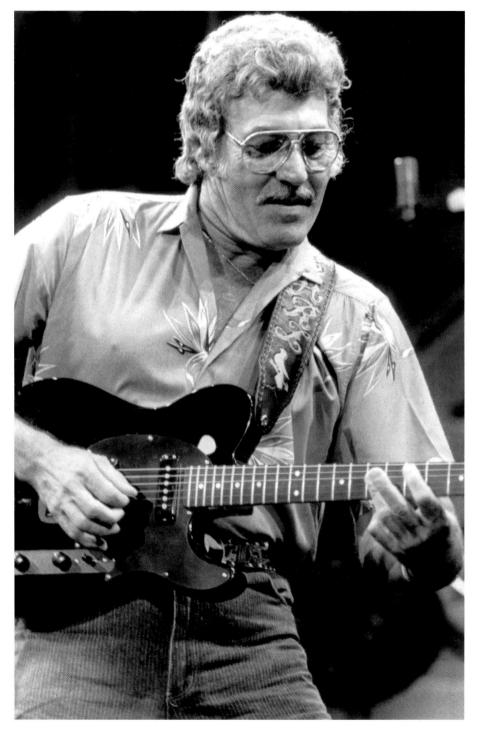

CARL PERKINS, 1986

and artists are producing their own publicity kits and CDs, they are also creating their own merchandise. There's also still plenty of room for reasonable negotiation with established artists in smaller commercial realms, such as blues, bluegrass, and folk music.

Photo contests

One way to gain limited recognition and get your photos published is to enter (and win) photo contests. However, beware of publications that sponsor photo contests primarily to obtain free photos. One now-defunct bluegrass/folkie publication (not *Frets*) sponsored an annual contest offering subscriptions as prizes. The winning photographs were published as a special feature. On the surface this might seem reasonable, especially if you like the magazine and enjoy the recognition of winning. However, the small type in the rules stated that the entries would not be returned and that the magazine retained the right to publish the photos for any reason, at any time, without compensation to the photographer. This was a rip-off, pure and simple. The prizes cost the magazine little more than postage, and the art director ended up with a stash of free photos.

In another contest by a different magazine, the winners were required to surrender their copyright to the sponsor. Don't fall for this scam. The sponsor should get one-time rights to reproduce the photo to announce and honor the winners. Any additional publication rights not directly associated with the contest should be negotiated. Read contest rules carefully and think hard before entering. The prize should at least equal the value of payment for publication.

How much will I get paid?

Bylines are nice, but the thrill of seeing your name in print wears off quickly if that's your entire compensation. Music-business pay is an inexact science, because the market is diverse and exists on many economic levels. How much you'll get paid for any particular image ultimately depends on who wants to buy it and how much they're willing or able to pay. Most print media or record companies have set rates for specific uses, based on the size of reproduction and how the photo is used; that's how much you'll get paid, unless you have a negotiating edge. Say, for instance, you have the only available photograph that fits a precise need. Or you have a rare early shot of Brooooce. Or you are

Annie Leibovitz or Richard Avedon. Or the buyer *needs* your shots and you refuse to sell yourself or your photos too cheap.

There are several good books with suggestions for pricing stock photos and negotiating tactics to help achieve them. Among them are *Stock Photography: The Complete Guide* by Carl and Ann Purcell (Writer's Digest Books) and the *ASMP Stock Photography Handbook* (available in many professional camera stores or directly from ASMP, 14 Washington Rd., Ste. 502, Princeton Junction, NJ 08550). Their suggested negotiating starting points are a bit optimistic, certainly among music-business markets, but they are right in urging photographers to place value on their work. Both books also provide excellent information on all other aspects of the stock photography market, such as copyright, choosing a stock agency, and agency listings.

Pinning down just what different entities are prepared to pay for photographs is a daunting and elusive task; there are just too many, and each seems to have its own method of deciding what your photos are worth. The following attempt is made only to give a general idea of what you might expect and to provide negotiating standards.

Magazines, newspapers, and books

At the top of the heap in pay and prestige are the large-circulation general-interest consumer magazines (*People, Vanity Fair, Cosmopolitan, Newsweek,* and *The New York Times Magazine,* for example) and the tightly targeted specialty publications (*Musician, Guitar Player, Spin,* etc.) that draw high-priced national advertising dollars. These publications base pay rates primarily on the size of the reproduced image, starting with $150 to $225 for 1/4 page and scaling up to $350 to $500 for a full page. For photos smaller than 1/4 page, most pay a minimum of $75. Cover shots may range anywhere from $300 to $1,000, depending on the publication. If you are fortunate enough to get an assignment, you'll usually be offered a day rate vs. a space rate, plus expenses. That is, you'll get paid a minimum fee for the shoot even if the publication decides not to run any of your photos. However, if the art director chooses to run several of your shots, you'll be paid a space rate for each if the total is higher than the day rate.

Among the bigger magazines, a day rate might range from $250 to $500 plus expenses. Below this group are thousands of consumer and specialty publications that offer anything from a credit line to $100 for one-time use. Rates sometimes bear little or no relationship to circulation or the amount of advertising

contained in the magazine. Of course, there are dozens, probably hundreds, of small publications that make little or no money. But before you agree to accept $5 or $10 based on the editor crying poverty, make your own evaluation. If, for instance, it's a monthly with a four-color cover, interior color photos, 120 pages, and lots of ads, you're being cheated. Any magazine with those specs should be paying *at least* $50 to $75 per photo. I believe that *any* photo published in any commercial publication is worth at least $25.

Conversely, if the publication has 16 pages and a half-dozen small ads, then nobody is making any money (unless it's a popular business newsletter with $150-a-year subscriptions). That's when you have to decide if you want to support someone's hobby to fulfill your desire to get published. If you like what the magazine is doing, then it might be worth it, especially if it provides you further opportunities to shoot and a place to publish. I don't put much stock in giving photos away for publication, however (at least not more than once to any given magazine). If it's good enough to publish, it should be worth something, even if it's only a free subscription. It's a matter of respect. Ask yourself how badly you want to be published and what you need to get in return to feel good about the transaction. If you feel exploited by an offer, don't accept it. It can be very empowering to make this choice when you know your work is worth more. On the other hand, don't be so stubborn that you're not willing to examine the circumstances carefully to see if there is any advantage to underselling your work. Sometimes, the foot in the door or the exposure provided will tip the scales, especially if you believe in the publication or project.

Newspapers show the same kind of pay variance as magazines, although rates generally run to the lower end of the scale. The largest daily newspapers are unionized, which means photo contributions from outside the staff are severely limited. Free publicity photos are OK, but buying photos is virtually prohibited (although there is nothing in the American Newspaper Guild contract that mandates this policy). Sometimes they have no choice, however, and they need a photo that's not in their library. If you're lucky, you might get as much as $100 for a shot, but $25 to $50 is more the norm. In my experience, local entertainment newspapers have rates that vary from $10 to $75, depending on their size and prosperity.

Book print runs are generally smaller than those of magazines, with average editions of about 10,000. As such, the maximum payment for photos is correspondingly less, although I've always had a little trouble with this logic. Books may not be as widely circulated as magazines, but they don't end up in the re-

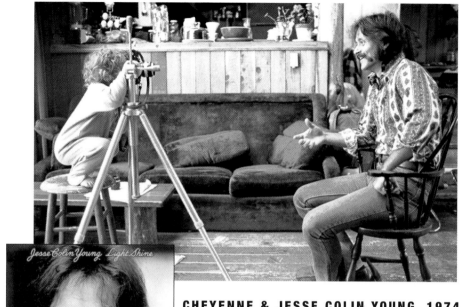

CHEYENNE & JESSE COLIN YOUNG, 1974

Found images sometimes turn out to be the best things to come out of a photo session. I had just finished a roll of black & white (which included the album cover photo at left) and reloaded the camera on the tripod with color. When I went to my bag to get another body loaded with black & white, Jesse's young son Cheyenne took over. I grabbed the shot that ended up as the back cover photo.

cycling bin after a week, either. They have a permanence that magazines don't. Depending on the publisher's size and the book's anticipated marketability, payment can vary widely—$25 to $150 is typical for music book publishers, although $40 to $100 is closer to the norm.

Record companies

The record business is a curious beast, dominated by a half-dozen conglomerates who account for nearly 90% of all record sales. That makes it tough for anyone to crack the business with so few art directors to target. The good

news is that hundreds of small, independent record companies account for the other 10%, which provides an opening for many photographers at the local and regional levels.

Stock photography plays an important role in this market, particularly for live concert albums and historical packages. Nevertheless, most photos used by record companies for CD packaging, publicity, posters, and advertising are produced through assignments. Back in "the good old days," the art, promotion, publicity, and advertising departments of the major labels often arranged separate sessions to fill their own needs to produce and promote an album. That often resulted in several shoots with the same artists. Now the trend is for record companies to try filling all their needs in one shoot, which puts more pressure on the photographer to create a wide variety of "looks" in both color and black & white. It's tough to generalize about payment here, because of the variables, which include the rights involved and the complexity of the shoot. In many cases, the company wants a buyout of all rights to all the material. Sometimes it offers to split the shoot with the photographer, retaining all rights to the material it keeps. All of these factors must be considered in the pricing, but my unscientific survey suggests that a creative fee of $2,500 to $3,500 is typical for a major-label CD packaging shoot, while a publicity session might yield between $1,000 and $2,500. Of course, all expenses are paid by the client. Stock photos can draw anywhere from $100 to $1,000, depending on how they are used.

Independent labels are even tougher to pigeonhole because there are so many, and because their relative sizes vary greatly. In general, you can expect less, often *significantly* less, than what the majors pay. A look through the 50 or so companies listed in the *Photographer's Market '95* reveals a spectrum of rates ranging from $10 to $2,500 an image. The "Making Contact & Terms" section for each entry is particularly informative; read it carefully and consider the stated or implied factors. Because of the rapid developments in digital recording technology, anybody can start a record company with a minimal investment. The glamour of the music business attracts all types, from the hopelessly naive to the willfully corrupt. Before you send your precious original transparencies off to some name you've found in a book, do a little investigation. Try to find some of their CD packages and note how good (or bad) they look. *Photographer's Market* suggests that you request copies of the forms and contracts that photographers are asked to sign. It's also helpful if you can speak with someone who has done business with the company. Other photographers and the

MONDO MANDO, 1981

label's artists provide the best information.

So, given the wide range of prosperity among independent labels, how do you know what to ask for your photos? One good approach is to look at the record's sales potential rather than the size of the company. For instance, the label may have six artists who sell between 5,000 and 10,000 units, and one artist who sells 100,000 units. You might charge $500 for an artist who sells 5,000 units and $1,500 for the one who sells 100,000.

A good example is Relativity Records, a Hollis, New York company that's been around since 1979. For the first decade or so of its existence, the company struggled before hitting the jackpot with guitarist Joe Satriani. His gold-record success has allowed Relativity to sign even more artists. None have approached Joe's sales success yet, but at least they've been given the chance. Relativity offers $250 to $1,500 for a publicity session, $500 to $2,500 for an album cover, and $250 to $1,500 for a back cover, depending on the level of the recording artist and his or her sales potential. That is on the high end of the spectrum for independent labels. *Photographer's Market* gives you good insight into the range of possibilities. Study it carefully, and use common sense. Someone who offers

$100 for a CD cover and demands all rights is not playing fair. Don't fall for it. And I contend that anyone who requires you to pay for a portfolio review, and urges you to resubmit it often, is probably more interested in a source of income than in finding talent.

Black & white vs. color

Many publications and record companies have a two-tiered rate structure, one for black & white and a higher one (sometimes as much as double) for color. Since most of my work is in black & white, I naturally believe that this is an arbitrary distinction. Why should any photo be worth twice as much simply because it is in color, with no regard for the actual image itself? This penalty is doubly insulting considering the cost, time, and difficulty of producing a good black & white print compared to producing a transparency. The only factors that should affect how much you are paid are the quality and unique nature of the photo, the final reproduction size, and where it is used (on the cover or inside). Significantly, the most professional publications don't make such distinctions. When I lease a black & white photo for reproduction, I usually specify that I must be paid at the color rate. This stand has cost me sales, but if everyone who submitted photos for publication adopted this posture, the two-tiered pricing structure would disappear.

Stock agencies

When you're starting out, it's up to you to find sources that will publish your photographs. Once you've accumulated a reasonable backlog of salable images, however, the option of placing your work with a stock agency becomes a possibility. These agencies serve as repositories of images created by a number of photographers. Buyers from all over the world solicit them for specific needs. No matter how aggressive you are at selling your work on your own, there's no way you can reach as many potential buyers as a well-established agency. LGI, for instance, serves more than 5,000 publications in the United States alone, according to owner/photographer Lynn Goldsmith. "We lease photos for magazines, newspapers, television, film, and electronic rights in 28 countries. There's no way an individual photographer could keep track of that many outlets and deal with the paperwork. There are a lot of magazines that individual photographers wouldn't even consider, because they don't run

into them in their daily lives."

There are hundreds of stock agencies throughout the world, but you should try to land with one that specializes in music personalities and celebrities. The most prominent U.S. agencies include Retna, the Michael Ochs Archives, LGI, Onyx, and London Features, but there are smaller ones as well. In addition, many agencies specialize in serving the foreign press, particularly in Europe and Japan. There are also individual agents who represent one or a few photographers.

How do they work?

Most stock agencies have similar goals and operating procedures. Your job is to supply them with transparencies and quality black & white prints. Everything else associated with marketing is the agency's responsibility, including fielding requests, pulling prints and slides, duplicating, mailing, and billing. It is also the agency's responsibility to make sure that all images sent out are returned undamaged, and that no unauthorized use has been made of them. For this service, they typically receive 50% of domestic sales and 60% to 65% of foreign sales. Another advantage of working through agents is that they are experienced negotiators and know how to get the most money possible for a photo. The best agencies have a minimum use rate somewhere around $150, so you're guaranteed to make at least $75 on every sale. Statements and checks are issued monthly or quarterly. Most agencies require you to sign an exclusive contract, which means only they can represent you. But if they want your work badly enough, they'll drop that condition. Photographers generally retain the right to make sales on their own, although the agency expects a cut if it introduces you to the client.

Choosing an agent

Choosing an agency (or agent) to represent you is a two-way street, because they must also choose you. The quality of your work and the range of subject matter in your files have to meet their needs. Your work *must* be of professional quality in terms of exposure, sharpness, and lighting if you want to be successful selling stock. According to Retna's Julie Graham, that's rarely the case: "People need to understand that if they're going to do this, they have to do it really well. If the images aren't right, they're no good. I never cease to be amazed by the number of photographers who manage to make a living and really aren't very

good. I see tons of performance shots every day from different people all over the country, and most of them are not very good. Edit your submissions. Nobody wants to see really soft images. Nobody wants to see images that are completely red or orange. We understand that it's not easy to shoot these people. The circumstances are often very difficult. But you have to be strict with yourself in what you submit. On the other hand, if you only send me two images from a shoot, I have to wonder if that's all that came out. You have to find a happy medium. The photographer should learn to have an eye for what she is shooting. There are a ton of people out there doing it, and if they want to make it, they're going have to be pretty special."

If you feel your photos measure up, start by surveying the agencies that represent photographers you admire. Check bylines to see which names and agencies pop up on photos from the musical idioms you prefer to shoot. Most big agencies tend to specialize in artists who sell a lot of records, since that's where most of the media interest lies. Transparencies are the coin of the realm, accounting for more than 90% of all stock sales. Even with renewed interest in black & white, most agencies prefer to handle only slides, because they're so much easier and cheaper to duplicate. "We will copy black & white prints," says Graham, "but it really has to be a great shot, because of copying costs. We syndicate to 20 countries, so it starts to get really expensive. If one of our photographers wants us to sell his black & white shots, we ask him to supply several copies of the same print." One notable exception is the Michael Ochs Archives, which specializes in historical music photos going back to the 1920s. Black & white represents a significant part of its business, and it handles the problem of multiples by making an 8" x 10" copy negative of any print ordered. Then it's just a matter of making contact prints each time that photo is subsequently leased.

Making contact

Once you've narrowed your options, contact the agencies you feel are most appropriate, and tell them what you have. Some will ask you to send a representative sample of your work, while others will first screen you on the phone. Lynn Goldsmith says she doesn't want people sending photos unless they're asked: "I don't want to be responsible for their photos or spend the time and money to answer them and then return their images. If someone calls, we ask them what they have and how they got it. We can tell by talking with them if they know what they're doing."

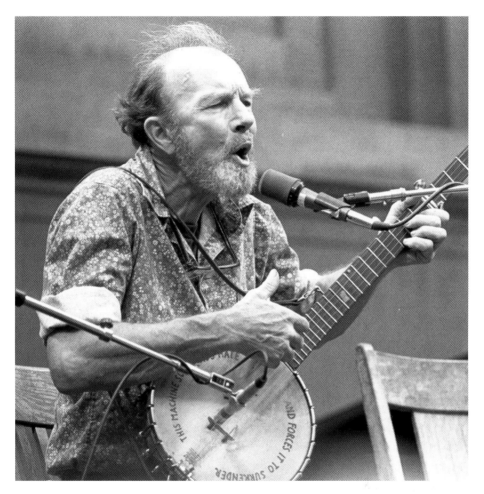

PETE SEEGER, 1979

One of the most satisfying parts of being in this business is getting
the opportunity to photograph, and sometimes meet, your heroes. Pete
Seeger has always been one of mine because of his lifelong devotion
to fighting for the rights of people who are denied political power
because they are poor or the wrong color. The inscription on his banjo
reads "This machine surrounds hate and forces it to surrender."

If you pass that hurdle and the agency indicates interest in representing you,
then it's your turn to ask the questions. Find out what their contract terms are,
and if you have any control over altering the conditions. If an agency feels it
can sell your work, terms such as how long you are exclusively bound to them

or how your byline is used are usually negotiable. Most important, ask for the names and addresses of the photographers it represents. Because the agency handles all the requests and collects the money, trust is essential. You have to know if they're honest, and the only way to find out is to talk to other photographers who work with them. Unfortunately, it's not unusual to be ripped off. That's a major reason why so many agencies go out of business and why some photographers constantly change agents. It's a sickening feeling to find your photo on a two-year-old album cover and realize you never got paid for it. If you get a good agent, however, you'll discover the satisfaction and joy of "found money" in your mailbox.

The Alternative Pick

How would you like to have your phone number and a selection of your best photos within immediate reach of several thousand of the most influential photography buyers in the music business? That's the idea behind *The Alternative Pick*, a sourcebook targeted at the creative end of the music and entertainment industries.

Sourcebooks that display the work of commercial visual artists have been around since the early '70s. Despite hundreds of pages of exquisite four-color printing and hardcover bindings, however, only a relative handful of these books are actually sold. The vast majority are distributed free to decision makers who buy stock images and/or hire photographers, illustrators, and designers. Production costs and profits are generated by those who pay to be included.

Until 1992, when Maria Ragusa and Juliette Wolf launched *The Alternative Pick*, sourcebooks were almost invariably created for the advertising industry. Both were working for *The Creative Black Book* when they recognized the need for a book featuring edgier, more creative styles than those aimed at corporate America. "A designer friend working on an album cover needed an illustrator or photographer with a looser, less commercial style than he could find in *The Black Book*," recalls Ragusa. "We started talking to our friends in the record and movie business, and discovered there was no one sourcebook to serve them."

Published annually in March, *The Alternative Pick* has more than 350 four-color pages featuring the work of many of today's most creative designers, illustrators, and photographers. According to Ragusa, nearly 10,000 copies are distributed to creative departments at record labels, movie studios, magazines,

design firms, public relations companies, publishing companies, and selected ad agencies. The book is a visual feast that provides hundreds of sparks for the creative mind.

Participation is not cheap, with a single ad page selling for $2,400 plus production costs. If you can't afford to advertise, however, you can at least be listed in a special section in the back of the book for only $20. If you're not on the selected list to receive a copy, you can purchase one directly from the publisher for $50. For more information, contact Storm Music Entertainment, 1133 Broadway, Suite 1408, New York, NY 10010, or call (212) 675-4176.

If you're thinking about taking out an ad, Jay Blakesberg offers some advice: "Sourcebooks take a special approach, because there's such a long lead time from when you choose your images and when the book is published. It can look dated because the music industry has a time limit on who's hot. When you choose your images in July for a book that comes out nine months later, the artists you select may already be off the charts and out of people's minds. For my pages, I used 11 images that showed a few timeless artists like Jerry Garcia, Isaac Hayes, and Allen Ginsberg, and newer artists like Alanis Morissette, Mother Hips, and Elastica."

Submitting for publication

Your solicitations have borne fruit and you're starting to get calls from magazines, newspapers, and publishers asking if you have photos of certain artists. Where do you go from there?

Who's asking?

First, you need to make a positive identification of the prospective lessee. It's one thing to get a call from the art director of *Rolling Stone* or *Musician* asking you to send your materials to the address listed in the magazine. It's quite another to receive a call from Ima Crook requesting you to send your material to a Chicago post office box. I've had people call and say they were writing a book, or putting together a calendar, and ask me to send them slides for consideration. Always check them out before you send anything. Ask for the publisher's name or a credible reference in the business, and then follow through with a phone call or letter. Don't let your eagerness to make a sale get the best of you. Sending slides overseas is particularly risky if you

don't know who you're dealing with. In any case, you should always send good dupes, not originals, unless the client insists and/or you have had previous dealings with them. In other cases, the originals can follow when the client decides precisely what he wants to use.

Send only the good stuff

The process of selecting submissions is governed by a simple rule—send only the good ones. Underexposed, overexposed, or unsharp transparencies are a turn-off to most art directors, even if the image is otherwise excellent. Edit the bad ones; they only bring down the level of the good ones. The same goes for black & white prints. Muddy low-contrast prints with white dust spots will be rejected by all but the most desperate, low-paying publications. The standard print size is 8" x 10", although 5" x 7" is acceptable to many art directors, unless they want to reproduce it larger than that.

Most important, don't send a photo that makes the artist look bad. You never know when you're going to find an editor or art director with his or her own agenda. "I know a lot of photographers whose only measure for a good photo is that it's in focus and well exposed," says Neil Zlozower. "It doesn't matter to them if the guy has three or four chins, or there's something hanging from his nose. One of the reasons I've lasted 25 years in this business is that I look for all the details. It's up to the photographer to edit his selections before he sends them out, because the photo editors aren't always the wisest in picking what they run. They see a guy jumping around and wailing on his guitar and think, 'Wow, look at the action in this photo.' Meanwhile, the guy's gut is hanging out over his belt. The artist is going to see that and think, 'Man, I look bad. How could Zlozower, or whoever, send that out? He'll never photograph me again.'" Egos are very big and fragile in this business, so pay attention.

Send duplicates

Because original slides are unique, you're going to have to come up with a good method of duplication. Most art directors prefer to work with originals, but that doesn't mean you can't first send dupes for consideration. If they decide to use a shot, then you can send the original, if necessary. That way you're not continually exposing your originals to damage or loss by a disorganized art director or the U.S. Postal Service. Of course, you can always pay to have your

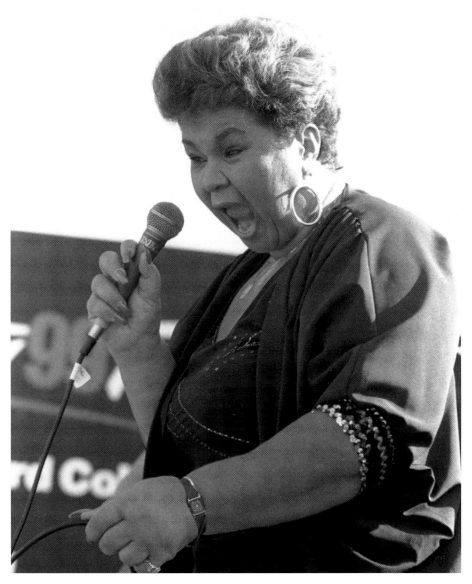

ETTA JAMES, 1986

slides duped, but that costs between $2.00 and $10.00 apiece, and you have to wait a few days. Better to have your own system if you must do a lot of duping.

If you've got a grand or so to spare, you can buy a duping unit that contains its own camera body, light source, and filtering options, such as the Beseler Dual Mode or the Bowens Illumitran. These are beautifully designed machines that

allow you to crop your images and easily manipulate color balance. You can make dupes for a lot less, however, if you're only sending out a few each month. Several manufacturers offer simple devices that attach to your camera's lens mount via an adapter. Porter's Camera, the huge Iowa mail-order house, has two such devices priced under $120. No matter what you choose, however, for best results you should use a duplicating film like Ektachrome SO-366 to keep contrast under control. Unfortunately, this film is available only in 100' rolls, so you'll have to bulkload your own cartridges.

There are a couple of alternatives to sending slides if all you want to do is show someone what you have. Slides that have been scanned to Photo CD, or some other digital media, can be printed out on a laser printer and submitted for consideration via fax or mail. Another option is the Vivitar Instant Slide Printer, which costs about $150. It employs Polaroid Type 669 Polacolor ER film to make an instant 3-1/4" x 4-1/4" color print from your transparency. At discount film prices it costs about $1 a shot, which is a bargain when you absolutely must have a quick copy of an image for a potential customer. It's also portable, weighing less than a pound, and it operates on four C cell batteries.

Consider sending digitized images

With the overwhelming majority of publications now being produced on computers, some photographers have begun submitting photos digitally scanned to disk. The value of this procedure is that you have first crack at manipulating the image on the computer with a program such as Adobe Photoshop. Unwanted details can be erased, scratches and dust marks can be filled in, color balance can be corrected (or distorted), and creative effects can be applied freely. And with the introduction of low-cost storage devices such as the Iomega Zip Drive, with its $20 100mb removable cartridge, sending large digital images is inexpensive and easy. And soon enough, it will be cost-effective to transmit large digital files over telephone lines for instant delivery. Not all art directors are sold on this idea yet, however. Most still want to control the scanning and manipulation process to assure it meets their standards. Ask first before you submit digital images. If the art director is amenable, she'll give you the specs she needs.

Selling in other countries

Although the United States is the world's largest music-business market, mu-

sic is an international language with commercial roots just about everywhere. If you can target relevant media and deal with the language barriers, tapping into the international market can significantly enhance your income.

There are other issues to deal with besides language, however. Shipping, for one, can be a confusing and frustrating experience. Every country has its own way of doing things, and you need to know how to fill out the forms to minimize duties and delays. Counter personnel at Federal Express, UPS, or wherever can sometimes help, but they're not always sure how to value and treat photographs. The person you negotiate with is usually your best source of information, so be sure to ask. Some international publications have representatives in the United States whose sole job is to negotiate with writers and photographers, and to facilitate their dealings.

Another problem can arise when you get paid. You don't want someone sending you a check payable in yen or lira, because your bank is going to charge you a hefty premium to cash and convert it to dollars. There are two good ways to handle this problem. You can insist that the check be in dollars and drawn on a U.S. bank, or you can ask the publication or company to wire the funds directly to your bank account. The latter is called an Electronic Funds Transfer (EFT) and may cost a small fee, but you get the money instantly. No more "the check's in the mail." Now, it's "the computer ate it."

The easiest way to lease photos in other countries is through an agent. All of the best U.S. agencies handle requests from international customers, and some photographers are also represented by agents in Europe and Asia.

Pack it right

Your photos may be visually strong, but physically they are fragile pieces of paper or plastic that must be packaged carefully for shipping. Transparencies belong in clear, soft-plastic slide pages (the kind with pockets for 20) while black & white prints should go in archivally safe polyvinyl sheet protectors. Sandwich the materials between two pieces of cardboard, or enclose them in a cardboard envelope, to protect against bending or other forms of mutilation by the carrier. Each package should also include a cover letter, captions, and a delivery memo that itemizes the enclosures and restates the terms and conditions of submission, including rights being offered and a date by which the photos must be returned. Delivery memos are discussed in detail in Chapter 8.

If you have confidence in the U.S. Postal Service, send your package first class

and hope for the best; the odds are in your favor. A better option is to use certified mail, which requires the recipient to sign for the package when delivered. The safest and quickest solution is to use an air or ground delivery service such as Federal Express, Airborne, or UPS. It's also the most expensive, but all of these services can track your package should it somehow go astray. Federal Express (*http://www.fedex.com/cgi-bin/track_it*) and UPS (*http://www.ups.com/tracking/tracking.htm*) even allow you to personally track your package via the World Wide Web. Type in the airbill or package number and you get an accounting of when the package arrived at all checkpoints along the way, as well as the name of the person who signed for it at its destination. This is particularly useful when shipping overseas, and is the *only* way I send photos out of the country. If you're sending the photos at the request of an art director, you can usually get her to pay for the delivery service. Ask for the company's account number and enter it in the proper place on the airbill. On the other hand, if you are sending your photos unsolicited, be sure to enclose a stamped, self-addressed envelope if you ever hope to see them returned.

Follow up!

Your work is not finished when the package goes out the door, because you still have to make certain the photos are returned in a timely manner. Your delivery memo is an excellent means for tracking submissions. It contains all the relevant information, including the date the photos are to be returned. Unless the client has asked for an extension, hold to that date. It may take a couple of faxes or phone calls to get your photos back, but stay on top of it or they can be lost in the shuffle. There are few things more frustrating than getting a panic call from an art director who wants you to rush into the darkroom *right now* and then send prints overnight, because he *might* be able to use them. Then he decides he can't use them and you have to call constantly to get your photos returned. Unfortunately, this is not uncommon. Still, there are few things more satisfying as opening a magazine, seeing your photo and byline, and cashing the check.

Film

F ilm is the indispensable link between the eye and the lens that makes the magic of photography real. The number of choices available is staggering, with well over a hundred 35mm films on the market. Fortunately, you need know about a mere handful.

There are three types used by working photographers, each chosen for the result required—color slides, color prints, and black & white prints. As it stands now, if you want to produce materials acceptable to the music-industry print media, your primary output should be color slides and black & white prints. Most magazine and record company art directors use color prints only when no other option is available. As a second-generation medium, prints can't match the sharpness, color saturation, and brightness range of transparencies. With the increasing move to digital media, however, color negative film is gaining greater acceptance in professional circles, particularly daily newspapers.

A word about film speed

Film speed, expressed as an ISO (International Standards Organization) number, refers to an emulsion's sensitivity to light. The higher the number, the greater the sensitivity and the film's ability to perform in low light. Why not use the fastest film available to assure fast shutter speeds and small lens apertures for maximum sharpness and depth of field? Well, for one thing, that's

not always the result you want. Controlling depth of field via the aperture setting permits the photographer to manipulate what is in focus and what is allowed to go soft. More important, image quality suffers as film speed increases—grain gets larger and more visible, making fine details in the subject difficult to pick out. Colors also get weaker, and contrast decreases. By their nature, then, slow films (ISO 64 and below) offer the best sharpness, smoothest grain, and richest colors. A generally agreed-upon rule of thumb is to always use the slowest film possible that allows you to get the job done under the lighting conditions.

Choosing a high film speed (ISO 400 and up) doesn't mean you have to accept an inferior image, however. Today's high-speed films produce remarkable quality under the most trying conditions. Most concert photography is accomplished with film speeds rated from ISO 200 up to ISO 3200.

A film's ISO rating is a only a manufacturer's guideline for optimum performance. One manufacturer's ISO 400 is not necessarily the same speed as another's ISO 400. Within reasonable limits, it's possible to expose film at a lower or higher ISO than its marked rating. Many photographers routinely expose color and black & white negative film one f/stop slower than its rated speed (ISO 400 at 200, for instance), to increase detail in the shadow areas. The film is developed as though it were exposed at the rated speed, which produces a slightly denser negative.

Push processing

Rating film at a higher speed is a bit more problematic. Changing the ISO setting on your meter does not magically increase the film's speed. You must compensate for underexposure by developing the film for a longer period of time. This is called "push processing," or "pushing." Of course, overdeveloping won't put something on the film that isn't there, but it can assure that you're getting the maximum detail in underexposed areas.

Photographers think of pushing in terms of f/stops. Pushing one stop (i.e., closing down one f/stop more than your meter indicates for correct exposure) doubles your ISO film speed—from 400 to 800, for example. Push two stops, the practical limit, and it doubles again to 1600. Naturally, there is a price to be paid for this illusion. Highlights and midtones increase in density, but shadow areas don't. That means harsher contrast and increased grain. And pushing really only works well with low-contrast subjects. Still, there are times when you simply must

have more film speed, and push processing can spell the difference between success and failure. And some films are actually designed to be pushed.

Color transparency

Also called reversal film, slides, or chromes, transparency film is the mother's milk of publishing although it accounts for less than 5% of annual U.S. film sales. Almost every color photo reproduced in magazines and books and on posters, album covers, and calendars starts with a transparency. Art directors like slides, because they can get an accurate representation of color, exposure, and sharpness by projecting or studying them with a loupe. That's much more difficult with a color print when someone else (the color printer) has made an interpretation in between the original medium (the negative) and the viewer.

Color transparency is the most demanding of all films, because it is developed directly to the finished product. There is no negative, only the original positive, which means your exposure must be dead-on accurate. A variation of more than 1/2 stop in either direction can produce an inferior image that is either too dark or too light. To a certain degree, corrections can be made with altered processing or computer scanning techniques, but maximum quality demands proper exposure.

Then there's the matter of *color balance*. The color of artificial light, like that emitted from incandescent bulbs and fluorescent lamps, is quite different from that of daylight or electronic flash. Our eyes and brain can make the adjustment, but film can't. Because of color temperature differences, slide films must be balanced for the lighting conditions they will be exposed under—tungsten (Type B, 3200° Kelvin), photoflood (Type A, 3400° Kelvin), or daylight (5500° Kelvin). You must select the proper film for the lighting conditions. Expose daylight film under artificial light, and everything takes on an orange cast. Expose tungsten film in daylight and you get a blue cast. To a certain degree, the cast can be filtered out when making color prints from a negative, but that flexibility is not readily available with transparencies unless you put a corrective filter over the lens. Filters, however, cut light transmission and effectively reduce your film speed by a full stop or more. Under the tough lighting conditions of concert photography, that's seldom an option. Fluorescent lights *must* be filtered (either at the light source or at the lens) to avoid an overall green cast to the scene, however, because there's no film that's balanced for that color temperature.

Slide films can be further divided by the way they produce color. E-6 films, which include all Fujichromes, Agfachromes, ScotchChromes, and Kodak Ektachromes, have dye-producing color couplers included in their emulsion that are activated during processing. Uniquely, however, Kodak's Kodachrome has color dyes added during the development process, which helps produce its distinct look.

Tungsten vs. daylight films

You'll encounter both tungsten and daylight-balanced light when you shoot a concert, and must choose your film accordingly. Unfortunately, as Jay Blakesberg points out, it's not always an either/or situation: "It's really hit or miss because the lights are so different at every show. It's not like shooting sports, where the lighting in the Oakland Coliseum is the same every time you go there to shoot the Warriors. Bands bring their own lights with them. Every time I go to the Coliseum to shoot a concert, there's a different lighting rig."

Nevertheless, there are some guidelines to help you. In general, you'll find most bright, white spotlights, particularly at bigger shows, are balanced near 5500° Kelvin, which means you can shoot daylight-balanced film and get good skin tones. Sometimes, though, they're in the 6000° to 8000° range, so even if you use daylight film, skin tones tend to go blue. And sometimes the lighting crew puts yellow gels on the spots, bringing the color temperture down to who knows what. If you shoot daylight film, you go a little yellow. If you shoot tungsten film, you go a little blue. You're damned if you do and damned if you don't. The only way around it is to take a reading with a color-temperature meter and add color-correction filters to compensate. By the time you do all that, however, your time has run out and the lights have changed again. And even if it stays the same, you still have the problem of reduced light transmission caused by the addition of a filter, which reduces film speed.

As a general rule, the smaller, onstage color-gelled lights used for backlighting and ambiance are tungsten-balanced. The exceptions are the moving, synchronized computerized lights found in big arena productions like those of Prince, Metallica, and Pink Floyd; those lamps are daylight-balanced. Sometimes you'll also find a small assortment of tungsten lights mixed in, but you should stick with film that's compatible with the dominant light source.

Clubs, theaters, and smaller venues, however, present a more conventional mix of spotlights and smaller lamps. Joel Bernstein suggests the only solution is to have both daylight and tungsten film loaded. "My own personal thing is

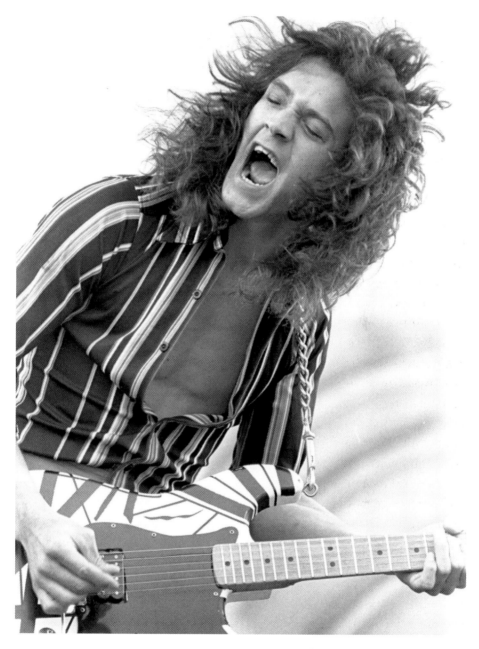

EDDIE VAN HALEN, 1978

to use tungsten film if I'm doing a wide-angle shot of the entire stage—and I don't mean necessarily with a wide-angle lens—because most of the light is coming from the tungsten-balanced lamps on the lighting truss. If I want a

head or upper-torso shot of the star, though, I'd go to daylight film, because the star is almost always going to be in a spotlight. I'd much rather have the face warmed up and the shoulders red-orange than have the face a cadaverous blue-white and the shoulders beautiful true color." In many smaller clubs or venues, however, the spotlight may be less than 5500° Kelvin because of the strength of the other tungsten lights. Or there may be no spotlight at all. In those cases, you can use tungsten film almost exclusively. Again, the only way you'll know for sure is to take a color-temperature reading. One of the advantages of shooting a lot at one venue is familiarity with the lighting, As a rule of thumb, you'll probably need tungsten film in clubs, particularly those with modest lighting rigs.

Daylight-balanced films

All but a few transparency films on the market are balanced for daylight and, in the United States, there are really only two players in the professional film market—Kodak and Fuji. Agfa and 3M (ScotchChrome) also produce a full line of transparency and color print films, but I've yet to encounter anyone who favors them for day-to-day use over Kodak and Fuji, except for special effects. The one possible exception is ScotchChrome 400. Although the grain is somewhat pronounced, this film produces pleasing warm, saturated colors and pushes quite well up to two f/stops.

Medium- and slower-speed films favored by the photographers interviewed for this book are Kodachrome 25, Kodachrome 64, Fujichrome Velvia (ISO 50), Ektachrome 64X, Fujichrome Provia 100, and Kodak E100. Faster films include Kodachrome 200, Ektachrome 400X, Fujichrome Provia 400, Fujichrome Provia 1600, and Ektachrome P1600. With all these choices, how do you decide which ones to use? Because each has a different look, the *only* way to know what you like best is to try them out. There are noticeable trade-offs in contrast, grain, sharpness, and color saturation. Until you test these films with your own eyes, you won't know what they are.

Kodachrome

For nearly six decades Kodachrome has been renowned for "those nice bright colors," as immortalized by Paul Simon. Compared side by side with Fujichrome's "ultra-real" bold, vibrant colors, however, Kodachrome actually appears a bit

flat. Nevertheless, for sharpness, saturation, resolution, skin color, and archival stability, Kodachrome is still in a class by itself. For all these reasons, Kodachrome 64 has long been a studio staple for uncounted 35mm pros in all fields. And Kodachrome 200 is a particular favorite of many professional sports and concert photographers, because it can be pushed up to two stops (to ISO 800) without apparent loss of sharpness or saturation. In fact, saturation actually appears to improve when pushed. Tom Kunhardt, customer relations specialist for San Francisco's renowned New Lab, attributes that to the K-14 developing process: "With E-6 processing, a film is pushed by increasing the time in the first developer. But because of the nature of the Kodachrome machines, which are designed like cine [movie film] processors, you can't alter the speed that the film goes through the baths. You have to alter the temperature, instead. Different things happen to the contrast and color saturation when you do that. It picks up a noticeable magenta shift the more you push it, but that should be pretty negligible in a concert situation where the light is all over the place."

Despite Kodachrome's unique charms, however, many photographers have stopped using it because of the inconsistency and dearth of K-14 processing facilities. There are now only 14 labs in the entire world capable of processing Kodachrome, and of those, only four offer push processing. At best, it now requires a 3- to 5-day turnaround for Kodachrome processing when dropped at a local Kodak outlet. That's intolerable for most professionals, who need their film immediately. Several labs, including A&I in Los Angeles and BWC in Miami, offer professionals expedited service and push processing. Appendix 4 contains a list of all K-14 facilities as of mid-1996. In contrast, there are thousands of E-6 labs, some of which offer a *two-hour* turnaround.

E-6 films

The Ektachrome and Fuji 400 films can be pushed up to a stop-and-a-half to ISO 1000, although the Fuji films appear to retain colors better. With both there is yellow-green shift, but the fickleness of concert lighting usually makes that moot. Fujichrome 1600 and Ektachrome P1600, on the other hand, are designed to be pushed up to two stops. They're manufactured with a built-in color bias that reduces or eliminates the sickly green tinge in the blacks, typical of films pushed beyond their stated limits. Both are actually ISO 400 films that shouldn't be exposed at that speed, because of the color balance for the push.

If you expose them at 400, the colors look strange. Both work well at ISO 800, but their optimal speed is 1600. I tend to favor the Fujichrome, because its pumped-up colors hold up better when pushed.

One other entry worth mentioning is Agfachrome 1000 RS. Although its rated speed appears to make it a good candidate for low-light work, it has an extremely coarse (though sharp) grain structure and yields somewhat unreal colors. Agfachrome 1000 RS is probably best suited for "art" photos, but don't take my word for it. Try it yourself. It may provide just the effect you're seeking to stand out from the crowd. Unfortunately, Agfa doesn't make it easy for you to try this film. It's available only in 50-roll "pro-packs."

Tungsten-balanced films

There are far fewer choices when it comes to tungsten-balanced film: just two, in fact—Ektachrome 320 (EPJ) and ScotchChrome 640. The Ektachrome is clearly superior. It's one of Kodak's T-grain films, and is actually Ektachrome 400X with the emulsion tweaked for tungsten lighting. The grain is very sharp and tight, and the color is quite rich. It also pushes well up to a stop-and-a-half to ISO 800 with a slight yellow-green color shift. According to Kodak, EPJ is specifically designed for events such as concerts, the ballet, and the opera, where you have a combination of spotlights and stage lighting.

ScotchChrome 640 may be the fastest tungsten film available, but it has an unconventional look that's not particularly good for "straight" reportage. The grain structure is quite coarse (though sharp) and the colors tend toward soft pastels. It's not as sharp as Ektachrome 320 EPJ, either. Still, *you* must decide what you want your photos to look like, and you can only make that decision after you've exposed some film.

Black & white

In the beginning there was only black & white, and it dominated the print medium for decades. Kodachrome was introduced as early as 1914, but it was decades before color began to show up regularly in print, and then primarily in advertisements. Color was not common in editorial layouts until the '60s. By the '80s, however, that's all publishers wanted. Black & white was seen as a poor stepchild to be used only when color was not available. In the last few years, the tide has turned again as photographers and art directors rediscover black

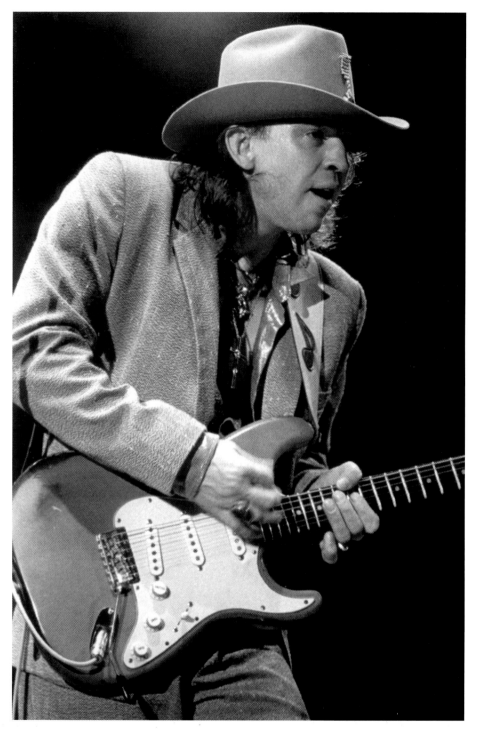

STEVIE RAY VAUGHN, 1985

& white's unique vision of reality. Advertisers now use it to stand out from the pack, and photographers such as Herb Ritts, Albert Watson, and Steven Meisel have built lucrative careers with their compelling black & white musician and celebrity portraits. Black & white film accounts for about 5% of total sales.

Advantages and disadvantages

Black & white offers several advantages. For one, a carefully made print from a well-exposed black & white negative yields a tonal range with far greater detail than any color film can deliver. Slide film can record a brightness range (the difference between the darkest shadow and the brightest highlight) of 1:16 at best, while a moderate-speed black & white film is capable of 1:125.

Black & white also provides much wider exposure latitude. Three stops over or two under are well within printing reach with corrections in the developing and printing process. Furthermore, the color of the light is no longer a problem. Daylight, fluorescent, and incandescent light all look pretty much the same to black & white film, even mixed in the same scene, though contrast may differ. Additionally, black & white films are generally faster and can be pushed more effectively than color films.

Finally, the proliferation of small local music publications and fanzines due to the desktop publishing revolution has substantially increased the demand for black & white photos, because they are significantly cheaper to reproduce than color. Publications can (and do) convert color images to black & white, but extra steps are required, and quality suffers because of the compressed brightness range.

Of course, there is a disadvantage to shooting everything in black & white. Color is still preferred by many record companies and magazines, particularly for covers and lead photos, so your publishing opportunities will be limited in some cases. It's also a lot tougher to find black & white processing and printing facilities. Color printers catering to professionals and amateurs are everywhere, while quality black & white labs are relatively rare and not cheap. An 8" x 10" print that's been properly burned and dodged costs anywhere from $10 to $15, depending on the printer, the type of paper used, and where you live. If you like to submit several photos for consideration and/or hand out gift prints, it gets expensive quickly. The best solution is to learn to print your own. It's not difficult to learn the fundamentals, and a black & white darkroom is cheaper to build and operate than a color darkroom. You have more con-

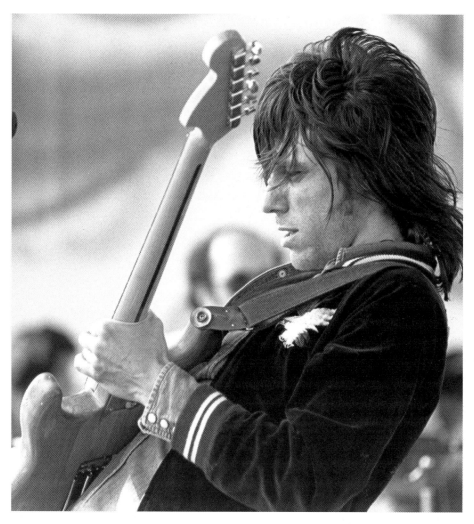

JEFF BECK, 1976

trol over the final look of a black & white print through the use of such techniques as burning and dodging, contrast control, cropping, and paper choice.

Choosing a film

Most music-business photographers use two speed ranges of black & white film in their work: ISO 125 and below for studio or controlled natural lighting conditions, and ISO 400 and above for concert photography. Kodak and Ilford

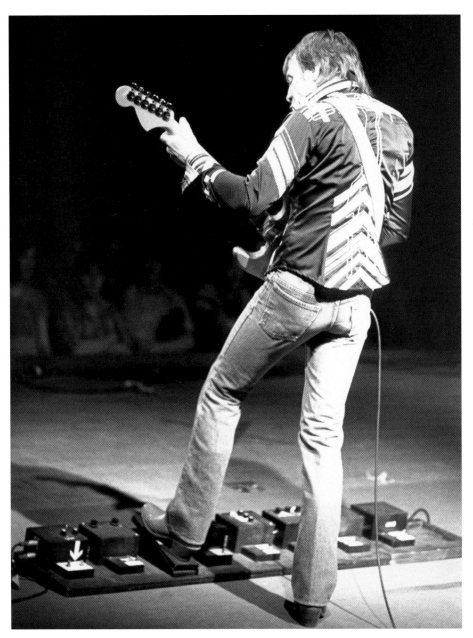

ROBIN TROWER, 1980

dominate the U.S. market for black & white films, papers, and processing chemicals, although Fuji and Agfa maintain a small presence.

ISO 125 and below

For decades, the standard films in this category were Kodak Plus-X and Ilford FP4 (now FP4 Plus). Both are outstanding products rated at ISO 125, with very fine grain characteristics and forgiving natures, particularly if overexposed. In some respects, however, Plus-X and FP4 have been surpassed by newer products—Kodak's T-Max 100 and Ilford's Delta 100. Both offer extremely fine grain, cutting-edge sharpness, and a smooth, broad tonal range.

T-Max 100 employs Kodak's proprietary "T-grain" technology, named for the tabular-shaped silver grains that make up the emulsion. Because of the flat, geometric shape of individual grains, the emulsion is thinner than that of films made with traditional irregularly shaped grain. The result is a smoother, sharper grain pattern less apparent than that found in conventional films. Most photographers have willingly made the switch from Plus-X to T-Max 100 for just that reason, even though T-Max is slightly slower. Like all T-Max films, however, it is somewhat contrasty and must be exposed and processed by the numbers. Overexposure or overdevelopment can make the brightest parts (highlights) of your negative almost unprintable.

Delta 100 outperforms a slower film in the Ilford line, Pan F Plus (ISO 50). Using what Ilford calls its "core shell" technology, it may well outperform *any* black & white film. Processed in Ilford's ID-11, Delta 100 produces virtually grain-free, razor-sharp 8" x 10" prints with extraordinary tone gradation. Though a bit more contrasty than FP4 Plus, which fits into a comparable speed range, it is noticeably less so than Pan F Plus or T-Max 100. It's also more tolerant of overexposure than T-Max 100.

ISO 400 and above

This is the category you will most frequently draw on for concert and low-light photography. Fortunately, there are a number of excellent choices offered.

Kodak

Let's start with the reigning longevity champion—Kodak's Tri-X Pan. Introduced in 1955, Tri-X revolutionized photography. There was nothing anywhere near it. With a nominal speed of 400, Tri-X offers a pleasing fine-grain film structure, medium contrast characteristics, and wide exposure latitude. It is very for-

giving of exposure errors and can be pushed quite nicely to the ISO 1200-1600 range. And because it's compatible with many developers, it can be processed to adapt to almost any lighting conditions. Although its formula has changed several times over the years, it remains the ISO 400 film of choice of many veteran photographers and is likely the best-selling black & white film in the world.

Of Kodak's three black & white "T-grain" films, T-Max 400 is the most controversial. There's no question that it has a finer grain structure than Tri-X, but many photographers simply don't like the way it looks. The words "mushy" and "ugly" seem to come up a lot. Perhaps the most troubling aspect for many photographers, however, is the film's demanding nature. T-Max films are inherently contrasty and require careful exposure and processing. Density builds quickly in the highlights, which causes problems if you like to overexpose a stop or so to ensure good shadow detail, or are photographing a contrasty subject (a stage-lit musician against a black background, for instance). That contrasty nature also makes T-Max films poor candidates for push processing. A combination of overexposure and even slight overdevelopment can render highlights virtually unprintable. Kodak says this film can be rated at ISO 800 without changing the processing time because of its latitude. This may be true if you're shooting under controlled lighting conditions with a compressed contrast range, but that's seldom the case in concert photography.

The superstar of the T-Max galaxy is T-Max P3200. Rated at ISO 3200, it is at least two stops faster than any other black & white film (including Fuji Neopan 1600). Unlike the other T-Max films, however, the grain is quite pronounced and readily apparent. Nevertheless, P3200 is capable of capturing an impressive range of tonal values. And many find the grain unobjectionable, even pleasing, because of its sharpness. Despite its contrasty nature, I prefer to expose this film at ISO 1600 for better shadow detail and skin tones. It can also be pushed a stop to 6400 if the subject is of low or medium contrast. There is no better film if you're forced to work under extremely poor lighting conditions. Occasionally, I find myself using it in situations where ISO 400 would be acceptable, simply because of its look and the latitude it provides for faster shutter speeds and smaller apertures.

Ilford

Ilford manufactures three different ISO 400 films, each with its own characteristics. HP5 Plus is to Ilford what Tri-X is to Kodak—an excellent conventional film comparable in terms of grain vs. speed, tolerant of overexposure, and nice-

ly pushable. The differences between them are subtle, but each has its own devoted legions. I've stuck with Tri-X because HP5 Plus seems a bit slower. If you expose both at 400 and process normally, the HP5 negative is slightly less dense and slightly less contrasty, but tonal gradation is very smooth. Still, it can be easily pushed to ISO 1600 with low-contrast subjects.

Delta 400 is Ilford's answer to T-Max 400. It's an excellent film with a slightly finer, softer grain structure than HP5 Plus, though the difference is not dramatic. It's less inherently contrasty than T-Max, but when processed according to directions it appears about a stop slower in the shadows. It doesn't push as well as HP5 Plus, either, though it can be rated as high as ISO 800 if you can handle the contrast. If you want to push-process, it's probably best to stick with HP5 Plus.

The most intriguing Ilford black & white product is XP2 400, which is really a color film in disguise. It's a *chromogenic* film that uses color dyes instead of silver to form an image, and it produces surprisingly good negatives with an outstanding range of tonal values. The film's latitude is also remarkable, capable of producing acceptable prints when overexposed as much as three stops and underexposed by one. In fact, the grain actually gets finer when the film is overexposed, although the negatives get very dense and tough to print. The kicker, however, is that the film is processed in conventional C-41 chemistry, the same process used for color-negative films. That means you can take it to your local one-hour processor, who will give you black & white prints with a blue cast. The negatives can then also be printed on conventional black & white papers with excellent results. Although it's possible to get decent prints from XP2 400 when rated at ISO 800, you're still better off with Tri-X or HP-5 Plus if you're going to push.

Fuji and Agfa

Though Fuji is a relatively minor player in the black & white industry, it does have two films worth mentioning. Neopan 400 fits in the same category of Tri-X and HP5 Plus as a medium-contrast film with fine grain and excellent sharpness. Significantly, however, Neopan 400 appears almost one f/stop faster. Where those two films really like to be exposed at ISO 200 for full shadow detail, Neopan 400 delivers the goods at ISO 400 and is tolerant of overexposure.

Neopan 1600 is Fuji's entry in the fast-film sweepstakes, although it's nowhere near the ISO 1600 mark that Fuji claims. In fact, it is probably no more

than 1/2 stop faster than Neopan 400. Nevertheless, it is a very forgiving film because it builds density in the highlights very slowly during processing, making it an excellent candidate for push processing.

Finally, Agfa, too, makes an ISO 400 film, called Agfapan APX 400 Professional. It is sharp but quite grainy by current standards (as grainy as T-Max P3200, actually), and it doesn't push particularly well. Still, fans of this film say they like the distinctive look it provides when enlarged.

Color negative

According to statistics compiled by the photo industry, color negative (or print) film accounts for about 90% of all film sold in the United States. Nevertheless, color negative currently plays a limited (though increasing) role in the publishing business. The big sales numbers are derived primarily from the amateur market (i.e., Mom and Pop taking pictures of the kids with point-and-shoot cameras). Professional users consist almost solely of portrait and wedding photographers, who are required to deliver a color print as the finished product.

The primary impediment to the acceptance of color prints by art directors is the nature of the print itself. Even if made with great care and skill, a print inevitably suffers in comparison to a transparency in terms of color saturation, brightness, sharpness, and detail. Nevertheless, color negative film offers some attractive advantages. There's no question that a *properly exposed* transparency rated below ISO 400 has finer grain and contains more detail than a color negative of equal speed. At ISO 400 and up, however, today's color negative films clearly outperform their transparency counterparts in terms of grain characteristics, color saturation, and tonal range.

At the same time, color negative provides much greater exposure latitude. Where as little as a half-stop of over- or underexposure can ruin a transparency, all print films have *at least* a one-stop-under and three-stops-over latitude. Additionally, color negative is the most versatile of all films, capable of producing good black & white prints as well as color prints. It's even possible to make transparencies from a color negative, although it's expensive and won't be as good as those shot on transparency film because of the added generation. Then there's the convenience of being able to buy color print film almost anywhere at any time. Run out of film at 1 A.M.? No problem. Just zip down to your local 7-Eleven and pick up a couple rolls. When you're done shooting, drop it off for one-hour processing, available just about anywhere. And

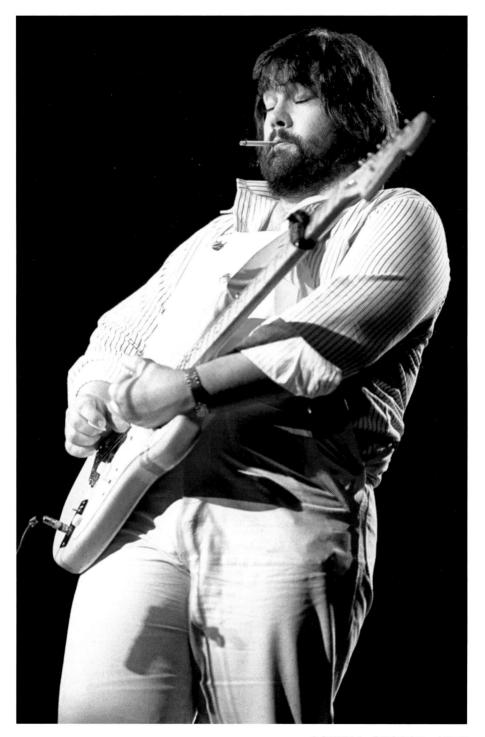

LOWELL GEORGE, 1978

finally, there's the satisfaction of the print itself, which can be framed and hung on the wall, given as a gift, or passed around among friends for easy viewing. For many people, that alone is reason enough to use color print film. Of course it's possible to have prints made from transparencies, but quality inevitably suffers because of the added generation.

There is one significant drawback to using color negative films in concert, however, particularly in clubs. All of them are balanced for daylight, which means tungsten lighting will impart a dense orange cast to your photos. This can be corrected somewhat in the printing or scanning process, but you'll never get the natural color provided by film that's balanced for tungsten lighting.

To shoot or not to shoot?

Do you limit the possibility of getting your work published by shooting color negative film? As of now the answer is probably yes, particularly if you are shooting for magazines publishing high-quality color. Art directors like slides because they can be projected or laid out on a light table and examined for sharpness and color balance. The subjectivity of a third party (the printer) is eliminated. But that's changing quickly as photography moves deeper into the digital age. The electronic publishing revolution led by the desktop computer has rendered the original medium less important. Differences are minimized by scanning the negative directly into a digital file that can viewed on a computer screen and manipulated with an image-editing program such as Adobe Photoshop. This process eliminates most of the problems of working with a second-generation image.

Magazines may be lagging, but color negative film has become the standard for staff photographers at dozens of daily and weekly newspapers that are produced on the desktop. At the *San Francisco Examiner*, for example, everything is shot on color negative and processed on-site on the same kind of machine found in your local one-hour photo shop. Negatives are scanned into a high-powered Apple Macintosh computer, manipulated with Photoshop software, and exported to a page layout program. Color separations are made in the computer and output to film. All this is accomplished in less than an hour when necessary.

If you really want to work with color negative film, go ahead, although expect to meet some resistance from some magazines when you try to submit color prints. The bottom line is, however, that good art directors will not automatically

reject an outstanding image just because it wasn't shot on transparency film. If the print is technically unacceptable, the art director always has the option of scanning the negative for better results.

Which one?

There's no shortage of possibilities when it comes to selecting a color print film. At least six different manufacturers compete for your business in the U.S.— Kodak, Fuji, Agfa, 3M, Polaroid, and Konica. Any film from any of these manufacturers will provide good results if all you're looking for are 3-1/2" x 5" machine prints. I prefer Kodak and Fuji films; not only are they the most widely available, but they're generally superior in terms of color saturation, accuracy, and sharpness. But taste is subjective. The look I want isn't necessarily right for you. Make your own comparisons.

Selecting the right film speed for the lighting conditions is still the most critical factor in your decision. If you're shooting outside in bright sunlight or using flash, then you may want to opt for lower speeds (ISO 25 to ISO 100) to achieve maximum quality. You can do no better than Kodak's Royal Gold 25 and Royal Gold 100 or Fujicolor Reala (ISO 100). They are outstanding films that offer high resolution, smooth grain, and maximum color saturation. As a practical matter, just about any film in this speed category will provide fine results, although Royal Gold and Reala stand out from the pack.

More likely you'll be facing conditions that demand films rated at ISO 400 and up. The good news is that today's 400 films outperform those rated at 100 just a few years ago, and they're getting better all the time. My favorites in this speed range are Fujicolor Super G Plus 400, Fuji 400 Professional NPH, and Kodak Royal Gold 400. All render excellent skin tones, smooth grain, and high color saturation. For results similar to Royal Gold 400, with the added option of push processing, try Ektapress Professional 400, favored by many newspaper photographers.

For a step up in speed with little or no loss in quality, there's Fuji 800 Super G Plus. It costs a bit more, but it's well worth it if you need the extra stop. It can even be pushed to 1600 with little image degradation. In the upper speed ranges, you can choose between several films, including Kodak's Royal Gold 1000, Ektapress Professional 1600, and Fujicolor Super HG 1600. Ektapress offers the option of push processing to ISO 3200. The fastest print film is Konica SR-G 3200, but if you're going to use it, make sure that you're a fan of coarse, clumpy grain.

Unless you're looking for a special effect, you're much better off sticking with one of the ISO 1600 films.

Final advice

Pick two, at most three, films and stay with them until you've learned their capabilities. Think about what kind of final output best fits your ambitions—black & white prints, color slides, or color prints—and choose accordingly. Be very methodical. Put each film through its paces under variable lighting conditions. Find out how well each can be pushed. After you've learned a film's strengths and shortcomings, you'll have a realistic basis for judging it against others. Don't be shy about exposing film, either. If you're in a position to get good photographs, remember that film is still the cheapest and best investment you can make. Take plenty with you—it's not heavy, and your expensive camera is useless without it. Running out when you've still got access to good shots is *very* frustrating.

After you've exposed the film, take good care of it. Don't subject it to extreme heat, cold, or moisture. Take it to a lab you trust, or develop it yourself to assure that it's processed correctly and kept free from dirt and dust. When you get it back, store it in archival-quality negative and transparency sleeves. Think of your negatives and slides as your own little piece of history, and treat them accordingly. If you take care of them, they may take care of you someday.

Camera Systems

efore you get too far in this business, you're obviously going to need a camera and at least one lens. Given the right conditions, it's possible to get a decent shot of a performer or a band with just about any camera/lens combination. Even an inexpensive point-and-shoot or cheap disposable camera will work. Unfortunately, you're seldom given the right conditions. You're either too far away, or the lighting is bad, or you've got a bad angle, or you're being jostled by a crowd, or some combination of all four. To a certain extent, the right equipment can help overcome those obstacles. The rest—getting into position and knowing how to use your equipment—is up to you.

Your needs will vary, depending on the type of musicians you want to photograph and what kind of access you have. At the very least, you'll need a body that accepts fast, interchangeable lenses. For nearly every active music-business photographer that means a 35mm single-lens reflex (SLR) camera. The SLR's primary appeal is a viewing system that employs a series of mirrors and prisms to show precisely the angle of view that the lens sees. This is particularly useful with telephoto lenses. An overwhelming percentage of all published performance photos is shot with lenses longer than "normal" (50mm to 55mm).

The SLR is not necessarily the best choice in every instance, however. If you plan to consistently work in conditions where *any* camera noise is a problem or light levels are very low, then you may want to consider a 35mm rangefinder camera such as the Leica or the Contax G1. The rangefinder's advantage is *its* viewing system, a small optical peephole similar to that found on snapshot cameras. Without mirrors or prisms, the viewfinder is considerably brighter and operation is almost inaudible. However, the system is not practical for telephoto lenses longer than 90mm.

35mm SLR systems

Choosing an SLR that can keep up with your growth as a photographer requires considerable research and forethought. Once you choose, you've made a long-term commitment to a proprietary system that includes interchangeable lenses, focusing screens, viewfinders, motor drives, data backs, electronic flash units, and many other accessories. With very rare exceptions, lenses and accessories from one system are not compatible with another. Before we examine the options, however, let's consider some of the more desirable characteristics in a system suitable for concert photography.

MANDATORY

High-speed interchangeable lenses

Because performance photography is often practiced under trying lighting conditions, a system of fast, interchangeable lenses is essential. The camera you choose should have access to a wide variety of lenses rated at f/2.8 or faster from its original manufacturer, as well as independent third-party builders. Nikon, Canon, and Minolta offer the most choices, followed by Pentax, Leica, Contax, Olympus, and Sigma.

Full manual control

Automatic meters that determine the f/stop and/or shutter speed can be helpful for getting fast, accurate exposures, but they can't think for you. If you are serious about producing professional-quality work, you must understand the use of selective focus combined with the depth of field provided by the f/stop

These familiar-looking markings are called DX coding and have nothing to do with the price. They tell your automatic camera's meter what type and speed of film you have loaded.

choice. Only then will you have full control of the image. That's why the camera you choose must also provide optional manual metering and focusing. Manual control is also necessary for working with studio strobes and mastering the principles of flash photography.

PC terminal

A PC terminal is a small, circular opening on the front or rear of a camera body, designed to allow connection of a flash-synchronization cord. If you aspire to studio work, a PC terminal is imperative. Once standard on most cameras, this feature is now included only on top-of-the-line models. It's one of the manufacturers' little tricks to separate "amateur" and "professional" models for pricing purposes. Fortunately, all models equipped with a flash hot shoe accept an accessory PC terminal. Make sure the camera you're considering provides this option if there is no dedicated PC terminal.

Manual ISO indexing

You've probably noticed that every roll of film has a bar code on the canister similar to that found on products at your local supermarket. It's called DX coding, and the encoded information is not the price, but the film speed and

type. The code is read by a sensor in your camera and passed to the auto-metering system. It works very well if you plan to expose the film at its nominal rating, but what if you want to use a higher or lower speed? That's accomplished by manually resetting the film's index. Some lower-priced cameras don't provide this option. Be certain the one you choose does.

Reliability and durability

Reliability and durability rank high on the list of desirable features; you can't afford to have your camera fail at a critical moment. If you stick with name brands, you can't go too wrong with any system as long as you pick a professional or advanced-amateur model. Manufacturers build a full line of cameras to attract customers at several price points, and there's a direct correlation between price and durability. Corners are cut, features dropped, and plastic parts substituted for metal in entry-level models. Camera wear is governed by how much film is pumped through it, how often lenses are changed, and in the way it is handled. If you intend to shoot more than, say, 10 rolls a week, week in and week out, make sure you've invested in a camera that can handle the load.

To put this in perspective, let's look at some numbers. Nikon says that its professional "F" model cameras (F, F2, F3, F4, and F5) will last for 150,000 exposures, or cycles, before getting worn beyond repair. Mid- to top-of-the-line amateur models of all major brands are built to sustain somewhere around 100,000 cycles. Divide that by 36 and you'll see that you should be able to expose more than 2,700 rolls of film before your advanced-amateur camera gives up. That means that if you shoot an average of ten rolls of film per week each year (which is a lot), it should last more than five years. And if you are shooting that much film, you should have at least two bodies, which effectively doubles the life of each. You can feel pretty safe with any model that's targeted to the advanced amateur or professional photographer.

Feel and handling

The camera must feel good in your hands, with controls laid out in a way that makes sense. The heft should be precisely to your taste, and your fingers should naturally come to rest at just the right points that make you feel in total contact with the camera. Trust your sensual demands. Some people find heavy cameras easier to hold, while others prize light weight above all. All other con-

siderations being substantially equal, "feel" should ultimately be the deciding criterion after you've explored all the options.

DESIRABLE CHARACTERISTICS

Built-in spot meter

Although just about every camera produced in the last three decades has some kind of meter built in, it's only recently that autoexposure spot meters have begun to appear. A spot meter does just what its name suggests—it meters a very small portion, or a spot, of the scene. In the best hand-held meters, the area can be as small as 1°. Those built into cameras are usually designed to cover a wider area, more like 3°, though that changes with the lens length. A spot meter allows you to target a very small part of the scene, such as the light falling on a face, from the back of a theater. This is particularly useful when you're dealing with a large black background and rapidly shifting lighting intensity.

Because you can buy stand-alone spot meters from manufacturers such as Minolta and Sekonic, it's not absolutely essential to have the meter built in. However, the readings from a stand-alone meter must be manually transferred to the f/stop and shutter speed settings, which forces you to lower the camera from your eye.

Exposure compensation dial

If you don't have a spot meter in your camera and rely instead on a center-weighted or segmented meter for autoexposure, your onstage readings may be wrong. This is especially likely if there are large black areas surrounding your subject. When you realize that your meter is being fooled, an exposure-compensation dial allows you to quickly open up or stop down as much as two f/stops to bracket your indicated exposure, without touching the aperture or shutter speed controls.

Fast electronic flash synchronization speed

The time will come when you'll want to use electronic flash to fill the shadows in your subject's face. This is especially a problem on bright, sunny days when the contrast range between highlight and shadow is particularly wide.

If you expose for the highlights, shadows go black. If you expose for shadows, the highlights are blown out. Properly applied fill flash reduces contrast by placing just enough light into the shadow areas to show natural-looking detail. You can't just use your flash at any shutter speed, however. It must be timed precisely to fire only when the shutter is fully open. If the timing is off by even a few thousandths of a second, only part of the film will be exposed.

In older cameras with mechanical focal-plane shutters, flash synchronization was typically set at 1/60th, 1/90th, or 125th sec, depending on the brand and model. These speeds are usually adequate but can be a problem if you're shooting in bright sunlight with moderately fast film, where you might ordinarily choose a shutter speed of 1/250th or faster. If you're forced to shoot at 1/60th or 1/90th, your subject will be in sharp focus at the point the flash fired, but surrounded by "ghost" images from movement. This is not necessarily bad if you want to create an effect that suggests motion, but you must be able to control it. Some of the new electronic cameras synchronize at speeds as high as 1/300th sec.

Shutter priority autoexposure

Almost all autoexposure cameras offer an aperture priority mode where you choose the lens aperture to control depth of field and sharpness, and let the camera decide the shutter speed for proper exposure. That works fine when your subject is well lit or unlikely to move much. Unfortunately, that's more the exception than the rule. In my experience, it's more important to control the shutter speed. Once you drop below 1/125th sec, you invite unsharp photos from subject or camera movement. It makes more sense to select the slowest speed acceptable in shutter priority mode (usually 1/125th, and rarely lower than 1/60th, unless you're seeking a special effect) and let the aperture selection fall where it will. Fewer models offer shutter priority autoexposure, but it's an option worth considering. Most professional and advanced-amateur models offer both aperture and shutter priority.

Illuminated display

Because you're literally in the dark in typical shooting conditions, it's important to be able to quickly check your settings. Many models offer an illuminated viewfinder display and/or illuminated LCD panel on the top of the

camera. Of course, you can always use a small flashlight to achieve the same result, but it's not nearly as convenient.

Quiet operation

If your primary interest is loud electric bands in clubs, theaters, and stadiums, camera noise will seldom be a problem. However, if you want to photograph acoustic string bands, solo acoustic guitar concerts, jazz or classical music, poetry readings, or drama in small, intimate settings, it's a real issue. No matter what kind of clearances or passes you have, you don't have the right to disturb the audience or divert attention from the artist. The clatter of a mirror/shutter release and the whir of an autowinder can be intolerably loud. Some manufacturers have addressed this problem better than others—notably Canon and Pentax—so a listening test should be on your checklist.

Easily overridable autofocus

Though autofocus has been around for more than a decade, it is still controversial among some photographers. There are those who feel that if you can't focus a lens, you've got no business calling yourself a professional. Nevertheless, autofocus works (most of the time, anyway), and the technology is getting better all the time. It can be particularly useful if you wear glasses or shoot a lot of action. Unfortunately, autofocus tends to break down when light levels are too low or your subject is strongly backlit. Since these are not uncommon conditions for concert photography, you must be able to shift quickly to manual focus. Most systems force you to engage a switch or button. Canon's EOS system is a notable exception. EOS lenses feature a "clutch" mechanism that allows you manual focus by simply grasping the focus ring and turning.

Automated vs. manual operation

Dramatic advances in computer technology have radically changed the way cameras are built. Moving mechanical parts have been largely replaced by electronic chips. Autoexposure, autofocus, and multi-pattern metering systems are now the norm. At the same time, familiar and useful features such as film-advance levers, rewind knobs, mirror lockups, depth-of-field preview buttons, and PC flash terminals have nearly disappeared. This new technology has reduced

size and weight, increased reliability, and produced many genuinely useful features, including electronic shutters, multi-segment metering, auto film loading, quiet motor drives, DX film coding, auto rewind, and through-the-lens (TTL) dedicated flash. However, it's also creating a generation of photographers who have little idea of how their cameras work.

Manufacturers have pushed these automated wizards as easier to use and easier for learning photography. In fact, many photography pros and teachers feel just the opposite. The controls for a modern high-end automated camera present a confusing array of LCD readouts, buttons, dials, and things that buzz, whir, and light up like a video arcade. Time was, if you understood how one camera worked, you could pretty quickly determine how any other did. Now each brand and model has its own unique button array and set of features that have to be learned and mastered. Significantly, many pros have been slow to buy into this new technology, although they are gradually coming around. Many photographers interviewed for this book still use mechanical workhorses, including Nikon FM2s, FE2s, F2s, and F3s as well as Canon F-1 and A models. Part of the reason is an unwillingness to learn a new interface that seems less intuitive and more confusing. The other part is an unwillingness to dump outstanding, expensive (but paid-for) manual-focus lenses for expensive new autofocus lenses to take full advantage of the electronic camera's capabilities.

Photography is not quantum physics. The act of taking a photo can be broken down into just three components—composition, focus, and exposure. Certainly, a lifetime can be devoted to mastering the intricacies of each, but the basic concepts can be learned fairly quickly. If you simply put your camera into program mode and let it decide the f/stop and shutter-speed combination, you've surrendered control of your final image to the camera's designers. At the very least, it's essential to take the time to learn the pictorial effects of aperture and shutter speed, so you can understand the implications of letting the camera decide.

I'm not saying that automated cameras are bad and should be avoided. But remember that the vast majority of history's greatest photographs were shot with manually controlled cameras. It's the photographer's vision and command of technique that make great photos—not the camera. By all means, take advantage of the features these sophisticated new designs have to offer; you don't have to buy the most expensive models to do that. At the same time, don't dismiss the possibility of buying a classic used manual body. If

you have limited funds, it's better to put your money into great lenses. That's where the real action is.

A Look at the choices

Shopping for a camera can be confusing and overwhelming, because there are so many choices. The task can be made easier, though, by identifying your needs and using common sense. While examining the offerings of each manufacturer, consider the entire line. You might buy the top-of-the-line model for your primary body and a less-advanced model with similar control placement for your backup. (You're eventually going to need at least one backup body to cover your butt on assignment. Editors and art directors relying on you don't want to hear that your only camera jammed after the first shot.) With two bodies, you also have the option of shooting two different film types at once or keeping two different focal-length lenses mounted.

The names and features of most models mentioned here will change over the years, but the basic information won't. The best way to keep up with current advances is to read consumer publications such as *Popular Photography, Shutterbug,* and *Petersen's Photographic.* All three provide comprehensive annual compilations that compare features of more than 100 current models side by side.

Nikon and Canon dominate the ranks of 35mm professional photographers, with control of more than 90% of the market by most estimates. Their dominance can be attributed to quality, reliability, and technological leadership, coupled with long-established momentum and aggressive courting of the market. Years before the SLR acquired professional status, both companies were well entrenched with pro shooters because of their top-quality rangefinder cameras and lenses. Although 35mm SLRs began to appear as early as 1935, they weren't fully accepted as legitimate professional tools until 1959, when the legendary Nikon "F" and its integrated system of interchangeable lenses and add-on accessories was introduced.

Canon followed shortly with its own SLR system, and the two companies have battled for the professional's business ever since. It's not really the pro's bucks they're after, though; most pros I know spend grudgingly and demand deep discounts. The manufacturers are really targeting the much larger market of amateurs who buy middle- and lower-end models because they want the brand that's used by the pros. If it's Nikon or Canon, it's got to be good—right? Actually, yes. Except for a misstep here and there, they are very good. But not nec-

essarily better than equivalent models of other brands competing in the same market. Canon's and Nikon's pro models are very good indeed, however, and advocates of each tend to be passionate and unyielding in their certainty of superiority. Of course, neither is the perfect system for everyone. Personal tastes dictate how different photographers want a camera to operate.

Nikon

Despite significant gains by Canon in the past few years, Nikon still commands the lion's share of the pro market. Just how big the margin is remains unclear, although a few years ago Nikon claimed that nearly 70% of all professionals used its products. Though challenged from several fronts, Nikon has maintained its hold largely because of critical design decisions made long ago, particularly regarding the lens mount. The bayonet mount found on today's most sophisticated Nikons is virtually identical to that on the first Nikon "F". With rare exceptions, every Nikon SLR lens ever built fits on any Nikon body (although some require a slight modification). This is no small matter. Nikon understood that serious photographers, pro or amateur, invest much more in lenses than they do in bodies. By maintaining a policy of continued compatibility, Nikon has made it possible for photographers to buy expensive lenses with the confidence that they will be usable on succeeding generations of Nikons. Of course manual-focus lenses won't autofocus on autofocus bodies, and autofocus lenses will only focus manually on manual bodies, but at least they are usable if you're willing to accept a loss of some features.

This compatibility works especially well for the financially challenged beginner who wants professional equipment but can't afford the latest electronic models. Newspaper classifieds and photo magazines are stuffed with ads for used Nikon bodies and lenses at reasonable prices. The decision to maintain compatibility has imposed some limitations, however—primarily in the realm of autofocus technology. For years, Nikon's autofocus was arguably the slowest of the major manufacturers. That doesn't mean its system wasn't perfectly usable and accurate in most circumstances, but the one place where autofocus speed *does* make a difference is in the use of long telephoto lenses. Because Canon's EOS system was noticeably faster, it captured the allegiance of many prominent photographers who use long lenses for fast-moving action like sports and fashion. Occasionally, rumors surface that Nikon is about to change its lens mount, but the company maintains that there is no research aimed in that direction. In-

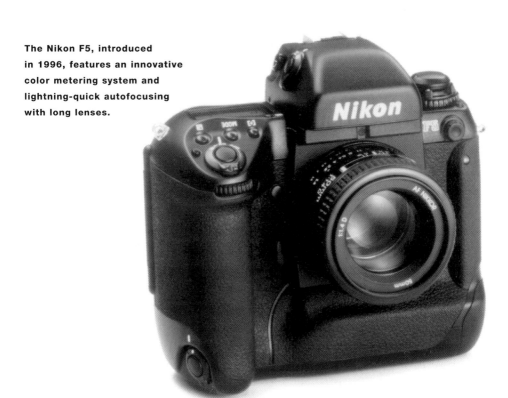

The Nikon F5, introduced in 1996, features an innovative color metering system and lightning-quick autofocusing with long lenses.

stead, it has chosen to improve and work around existing technology with software, better motors, and a new line of lenses with built-in autofocus motors. And with the long-awaited introduction of the F5, Nikon has eliminated the autofocus speed gap while maintaining its treasured lens compatibility.

Other factors contributing to Nikon's ongoing pro appeal include a huge selection of fine lenses (about 26 at last count); an unmatched accessory line; rugged, dependable construction; outstanding handling characteristics; and the finest TTL (through-the-lens) flash system available. Particularly alluring to some pros, especially the globetrotters, is the fact that its top-end electronic models are powered by standard AA batteries available just about anywhere in the world. In contrast, exotic and expensive lithium batteries are the norm in most other electronic cameras.

When you consider all the possibilities, new and used, Nikon offers the greatest selection of bodies suitable for our purposes, with prices ranging from more than $2,500 to as low as a couple hundred dollars. As of mid-1996, there were several Nikon models equal to the job in varying degrees.

At the top of the line is the F5, designed to meet Canon's challenge to Nikon's market share head on. It replaces the F4s, a tough all-metal autofocus work-horse loaded with traditional features not available on any other AF SLR. The F5 retains some of the F4s's unique characteristics (interchangeable viewfind-ers, all-metal construction, and a folding mechanical rewind crank, for instance) while integrating dramatic technological advances originally developed for its electronic line of cameras. The result is a state-of-the art professional camera that ups the ante for Canon. Unique features include the ability to fire off eight frames per second with autofocus tracking, five internal spot meters, and an advanced metering system that adds color into the exposure equation. It also lists for more than $2,500.

Next in line is the N90s, a superb instrument that offers high-performance autoexposure and autofocusing. Available at a street price around $1,100, it has been widely adopted by many professionals who don't need all the features and the cost of the F5. Other current models worthy of consideration are the elec-tronic N70 and the all-mechanical, non-autofocus F3 and FM2. The F3 is par-ticularly revered by pros who disdain autofocus and autoexposure. And, of course, there are more than three decades' worth of used Nikons no longer made that accept all those lenses, including the F, F2, FM, FE, and the Nikkormat.

Canon

For nearly 30 years, Canon contested Nikon's commanding hold on the pro market by going head to head with similar products—rugged and well-designed mechanical bodies, exceptional lenses, and a large catalog of accessories. Canon entered the SLR market with the FA lens mount, quicker than the Pen-tax screw mount but more awkward than Nikon's single-motion, snap-in bay-onet mount. The user was required to mount the lens and twist a collar to lock it in place. In 1971, Canon switched to a more conventional bayonet mount called the FD, with the introduction of the F-1, a beautifully designed and crafted cam-era that anchored the company's professional line for 18 years.

In 1989, Canon attacked Nikon on the technological front, introducing the EOS-1 professional autofocus system with an innovative EF electronic mount introduced two years earlier on some amateur models. The system spawned a new line of autofocus lenses incompatible with all previous Canon manual-fo-cus bodies. Instead of supplanting the FD lenses, however, EF lenses were in-troduced as a parallel line. In doing so, Canon was spared the wrath of users who

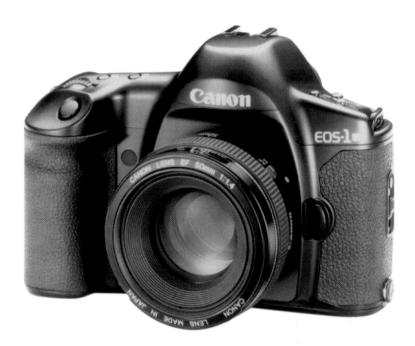

Canon's EOS-1 set new standards for
camera technology when introduced in 1989.
This is the current model, the EOS-1N.

weren't ready to dump their manual-focus systems because their lenses had sud-
denly become obsolete. The F-1 and FD lenses remained in production until 1996,
and there were still plenty of anguished howls from longtime users when the cam-
era and lenses were finally discontinued. Still, the FD lens line is impressive, and
there are many excellent used or discontinued Canon models widely available
that will accept them, including the F-1, T-90, T-60, and the FTb.

Canon has staked its future on the elegant EOS system, which has made a
serious dent in Nikon sales with its space-age approach. Prior to the introduc-
tion of the Nikon F5, the EOS's autofocusing system smoked Nikon's in terms
of speed and accuracy, particularly with telephoto models. Lynn Goldsmith and
Mark Leialoha are two top music-business shooters who dumped extensive Nikon
systems in favor of the Canon EOS-1N and never looked back. The bodies are
constructed of a polycarbonate plastic and metal combination that provides
outstanding protection against moisture, cold, wear, and hard knocks. The springs,
pins, and levers of the traditional mechanical lens mount have been replaced
by an 8-bit onboard microprocessor linked to a 4-bit counterpart on each lens.

When a lens is mounted, all relevant information such as focal length, maximum aperture, and shooting modes are sent to the camera's microprocessor, which speeds up automatic function calculations.

But it's the EF lens line that lies at the heart of the EOS system. Canon has consistently been at the forefront of lens technology, and there are currently several dozen examples ranging from a 14mm f/2.8 wide-angle to a 600mm f/4.0 telephoto. Each has a dedicated focusing motor, as opposed to the body-integral motor found in most other autofocus designs. About a third of them feature the USM motor, an ultrasonic solid-state design with high-torque direct drive. It not only operates silently, but permits instant switching between autofocus and manual focus by simply grabbing the lens and turning. No mechanical switch is required.

Currently, the EOS-1N tops the Canon line and will for the foreseeable future. A 1995 update eliminated complaints about the embarrassing auto rewind/autofocus noise of its predecessor while adding notable new features such as five-point autofocus, mirror lockup, tighter spot metering, and 16-zone metering. Prior to the EOS-1 update, Canon lavished its technological breakthroughs on the A2/A2E, an excellent design with a list price half that of the EOS-1. The A2E differs from the A2 in the inclusion of Eye Control Focus, innovative technology that autofocuses the lens on one of five points merely by looking at it. In summary, Canon offers an excellent selection of autofocus and manual-focus cameras, but you must commit to one or the other—EF lenses and FD lenses are not interchangeable.

Minolta, Pentax, Leica, Olympus, Contax, Sigma

So, just because most pros are locked into Nikon or Canon, does that mean you must have one or the other to succeed? Not at all. Far more lenses are available for Canon and Nikon from independent manufacturers such as Tamron, Tokina, Sigma, and Vivitar, and most rental outlets offer only Nikon and Canon 35mm bodies and lenses. Nevertheless, the market provides many other fine choices, often priced substantially less than corresponding Nikon and Canon models. If you're shopping for the long haul, however, you *do* want to choose from one of the half-dozen or so full-line systems available.

Minolta has produced exceptional 35mm SLRs and lenses for more than three decades. It has been the autofocus technology leader since introducing it on the Maxxum 7000 in the early '80s. In fact, Minolta has led the way on many

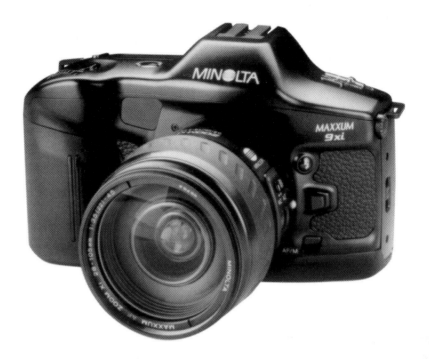

The Minolta 9xi, arguably the technological
equal of Nikon's and Canon's top models,
costs significantly less than either.

technological fronts, producing unique gee-whiz features such as expansion cards
that pre-program the camera for specific shooting conditions, and eye-start,
which automatically turns the camera on, autofocuses, and sets the exposure
when you raise the camera to your eye.

But Minolta offers much more than gadgets. Its cameras are well designed
and rugged, and offer a lot of bang for the buck. The top-of-the-line pro and
advanced amateur models (notably the 9xi and 700si) are arguably the equal
of comparably placed models in the Canon or Nikon lines and markedly less
expensive. The superb Maxxum autofocus lens system features nearly three dozen
entries ranging from a 16mm f/2.0 fisheye to a 600mm f/4.0 APO telephoto. Many
after-market lens manufacturers also produce a full line to fit Minoltas. In ad-
dition, Minolta still produces the X-700, a manual-focus entry with the same
basic bayonet lens mount found on Minoltas since 1958.

Pentax is another fine Japanese manufacturer, with SLR roots stretching back
to the '50s. In 1954, the Asahiflex (later renamed Pentax) introduced the rapid-
return mirror, perhaps *the* critical element for professional acceptance of the

SLR. In an SLR viewing system, a silvered mirror is placed in the film plane for focusing and composition, and then flipped out of the way when the shutter is engaged. Prior to the Asahiflex, the mirror moved out of the way and the viewfinder picture blacked out until the mirror was manually reset. Naturally, this was quite disconcerting to photographers shooting a series of pictures. Pentax solved the problem with a mirror that returned to viewing position at the end of the exposure. In the process, it became the first 35mm used extensively by professional photographers. Pentax has remained an important player by continually producing technologically advanced, user-friendly cameras and outstanding lenses at reasonable prices.

Current jewels in the Pentax line include the autofocus PZ-1P, the autoexposure/manual focus LX, and the manual-exposure K-1000. The PZ-1P, with a street price around $500, is an amazingly sophisticated piece of machinery with more features than a Nikon F4S or a Canon EOS-1. Although it may not stand up to the same kind of wear and tear as either of those competitors, it is more than adequate for someone shooting no more than, say, 15 to 20 rolls a week. The LX is a manual-focus, autoexposure entry that's been in the Pentax line since 1981. Designed to compete directly with the Nikon and Canon pro systems, it succeeds admirably from technical and feature standpoints. The K1000 is an all-metal, manual-focus, manual-exposure camera with a street price under $200, making it an outstanding entry-level unit for someone ready to learn the fundamentals.

All Pentax cameras produced in the past two decades feature some variation of the "K" lens mount. Most Pentax autofocus and manual-focus lenses fit any Pentax body, albeit with some loss of features. The current Pentax catalog offers more than 40 lenses, and many after-market manufacturers build for Pentax, as well.

Leica built an unsurpassed reputation for quality, precision, and high prices with a succession of brilliant rangefinder cameras introduced more than 70 years ago and still in production today. Leitz, Leica's manufacturer, waited until the early '70s to enter the SLR market with the Leicaflex, however, and has fought an uphill battle for a significant piece of the market. Part of the problem has been the company's ultraconservative approach. Leicaflexes are bulky, heavy, tank-like in endurance, and *very* expensive. Their primary appeal is a line of world-renowned lenses that offer unparalleled sharpness and contrast. That's a lot, of course, but the differences in price and bulk haven't persuaded many pros to give up their Nikons and Canons.

Current models are the autoexposure R7 and the manual-exposure R6.2. Both

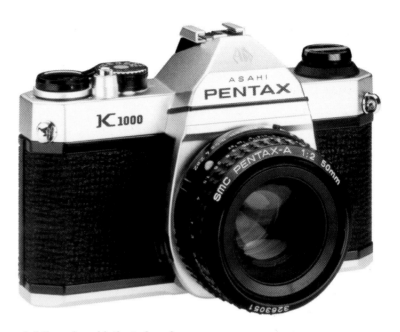

Pentax produces a full line of sophisticated mod-
els at bargain prices. This all-metal, manual-focus
K-1000 sells for about $200 at street prices.

are metal-bodied manual-focus cameras with price tags approaching $3,000. There are several dozen Leitz R-series lenses, ranging from a 15mm f/3.5 to an 800mm f/6.3 telephoto, all of which are very sharp and equally pricey. If you're a Leicaphile, you have to have one. If you just want to make high-quality photos, however, remember that you can buy a Nikon N90s or Canon A2 body and two or three very fine lenses for the price of *one* R7 body.

Olympus has long enjoyed a cult following for its compact, jewel-like creations. The OM-4T, a true classic with cutting-edge spot metering technology, features autoexposure, manual focusing, and access to nearly two dozen Zuiko lenses ranging from a 16mm f/2.5 wide angle to a 1000mm f/11 telephoto. The small, all-metal body weighs in at just over a pound, but delivers big performance and a full system of accessories.

Contax, a German firm, was an early pioneer of the SLR that dropped out of sight when Japanese manufacturers seized the technological edge and captured the market. Contax re-entered the SLR game in the mid '70s with the RTS, a solid, well-designed package with a hefty price tag. Current models include the top-of-the-line RTS III (a manual-focus, autoexposure tank that weighs 2-1/2 lbs),

the electronic RX and AX, and the S2b. A full line of outstanding Carl Zeiss "T-Star" lenses ranges from a 15mm f/3.5 wide-angle to a 1000mm f/5.6 mirror lens.

Contax offers excellent quality and a couple of flashy features not found elsewhere, including a vacuum-operated ceramic pressure plate to hold the film flat. Despite such innovation, the cost of these German/Japanese hybrids places them in a very small market segment competing for the Leica SLR dollar. In 1996, however, Contax introduced a radical new autofocus concept on its AX model called the Automatic Back Focusing System. It autofocuses by moving the film plane back and forth instead of rotating the lens, which means standard manual-focus T-Star lenses can still be used. It's too early to tell how much impact this revolutionary new system will have on the market. But if it can live up to the hype, Contax could conceivably challenge Nikon and Canon for a piece of the professional market.

The most intriguing new SLR entry comes from **Sigma**, known primarily for its prowess as an independent lens maker. The Sigma SA-300N is the first new interchangeable-lens autofocus SLR with a unique lens mount to emerge in many years. This precocious newcomer is priced close to the bottom of the low-cost autofocus SLR market but delivers the features and performance of cameras up to twice its cost. The SA-300N offers such unexpected amenities as three metering options (including spot metering), a built-in quartz data back, mirror lock-up, depth-of-field preview, a stainless-steel lens mount, cordless remote control, autobracketing, an illuminated LCD panel, and cordless flash control. About 30 lenses with the unique Sigma lens mount, ranging from a 14mm f/3.5 to a 1000mm f/8, are currently available, but only one faster than f/2.8 (a 28mm f/1.8). Only time will tell how durable these fiberglass-reinforced polycarbonate bodies and electronics prove to be, but there's no reason to believe they will be any less reliable than many higher-priced counterparts. If you have a limited budget, are interested in pursuing maximum bang for the buck, and willing to trust that faster lenses will eventually become available, give this system a good look.

35mm rangefinder systems

The SLR may dominate camera sales but there are still plenty of photographers who aren't convinced it is superior to the original 35mm rangefinder design introduced in 1924 by E. Leitz, a German microscope manufacturer.

During the peak of the rangefinder's reign in the '40s and '50s, the Leica system spawned several imitators, including excellent entries from Nikon and Canon

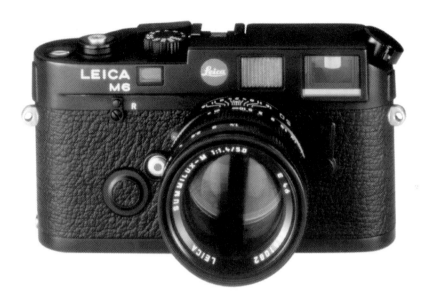

With its compact size and unsurpassed quality, the Leica laid the foundation for modern photojournalism. The M6 represents the current state of the art of elegance in camera design.

that are now highly prized collectibles. With the ascendancy of the SLR, however, all of them dropped by the wayside, leaving (until very recently) the Leica M6 as the only 35mm rangefinder system in production. Jim Marshall is the most prominent active music-business Leica photographer. His poignant backstage and candid photos of artists such as Janis Joplin, Jimi Hendrix, the Rolling Stones, Miles Davis, John Coltrane, and many others over the past 30 years set a standard rarely equaled for sensitivity, and have been widely reproduced.

Leica

The Leica's strengths (and weakness) revolve around its viewfinder, a small window on the back of the camera above and to the left of the lens. A look through the finder reveals a fixed view that's independent of the mounted lens length, with a small, bright rangefinder focusing square in the center. A changeable white frame line defines the area covered by the mounted lens, ranging from 28mm through 135mm (depending on the camera model). Focusing is accomplished by aiming the center square at your subject and bringing a split image of the

subject together by turning the focusing ring. Most photographers who have tried Leica's split-image system find it faster and easier to focus than an SLR, particularly with wide-angle lenses and in low light conditions. Because there are no mirrors or prisms involved, the image in the finder is brighter than an SLR, the body is smaller, and the shutter release is little more than a quiet "whoosh." Handling a Leica is a sensuous experience; it snuggles in your hand like a bird in its nest. Leica photographers find they can successfully hand-hold shots at much slower shutter speeds than with an SLR, because the viewfinder never blacks out and there's no mirror movement and vibration.

Of course, the rangefinder has limitations, or there wouldn't have been any reason to invent the SLR. Most significant for our purposes concerns the use of telephoto lenses. Although the Leica viewfinder provides a frame for a 135mm lens, the frame is so small that details are almost impossible to discern. Even the 90mm frame is scarcely adequate. And because the viewfinder is located above and to the left of the lens, it doesn't show precisely what the lens sees, making the Leica impractical for close-up work. To some extent this difference ("parallax error") is compensated for by the framing lines in the viewfinder, but not enough to make macro photography possible. To deal with these limitations, Leica offers a special reflex housing that essentially converts the camera to an SLR. However, this housing is so large and cumbersome that it negates the Leica's special advantages.

The Leica is not for everyone. For photographers raised on an SLR, it operates in strange ways. A Leica lens focuses in the opposite direction of most SLRs, and film is loaded by removing a plate from the bottom of the camera (in contrast to the SLR's familiar hinged back door). Nonetheless, for certain situations the Leica is unbeatable, and few dispute that Leitz M-series lenses are probably the sharpest the world has seen. If you must have one, be prepared to spend some serious bucks. A new M6 body lists for well over $2,000, with lenses starting at over $1,000 each. A huge market in used Leicas also exists, but their collectible nature keeps prices unusually high. Magazines such as *Shutterbug* are excellent places to start looking if you've been bitten by the Leica bug.

Contax G1

The Contax G1 is unquestionably the most intriguing new camera design in decades. Introduced in 1994, it is a high-quality rangefinder with autoexposure and passive autofocus (the same kind found in top-end SLRs). This gor-

geous little gem features a titanium body shell and a viewfinder that zooms to match the installed lens, automatically correcting for parallax and focal distance. It also offers a sophisticated exposure-compensation system and TTL (through-the-lens) flash metering with Contax TLA flashes. There are currently four Carl Zeiss lenses designed for this camera, including the AF Biogon 28mm f/2.8, the AF Planar 45mm f/2.0, the AF Sonnar 90mm f/2.8, and the Hologon 16mm f/8.0. However, any current Zeiss "T-Star" SLR lens can also be used on the G1 with the GA-1 Mount Adapter. This brilliant new design appears to hold the potential to revive professional interest in the rangefinder camera. And priced at little more than half the cost of a Leica M6 body, it no doubt has sent serious shock waves throughout E. Leitz.

Medium-format systems

Why use 35mm at all when there's the better-quality Hasselblad 6cm x 6cm (2-1/4" x 2-1/4") image or some other medium-format camera? Generally speaking, medium format is limited for performance photography by its bulk and a scarcity of fast telephoto lenses. Furthermore, few high-speed films are produced in 120 format; ISO 400 is currently the fastest-rated emulsion available. Since many of the problems of photographing concerts and performances are caused by low light levels and long shooting distances, these are important limitations. Herman Leonard and Chuck Stewart, who both produced superb jazz images in the '40s, '50s, and '60s with Hasselblads and Rolleiflexes, made it work by using flash bulbs or electronic flash in concert.

Medium-format technology is progressing, however. Most promising are the 645 format cameras by Bronica, Mamiya, and Pentax. These small, ergonomically designed systems use 120 roll film to produce an image measuring 6cm x 4.5cm (2-1/4" x 1-7/8"). It's the Hasselblad/Rolleiflex 6cm x 6cm format chopped to the rectangular proportions of an 8" x 10" print. That's nearly three times the size of a 35mm negative, which makes an enormous quality difference—particularly when enlarged. Until quite recently, the fastest lenses beyond normal length in this format have been about f/3.5. Mamiya now offers a 300mm f/2.8 (equivalent to a 186mm lens in 35mm) for its M645 Super. The price: a cool $11,000. In addition, electronic design has shrunk these cameras into comfortable hand-holdable packages. The Pentax, in particular, has a strikingly similar feel (in weight and bulk) to a professional system camera such as the Nikon F4S or the Canon EOS-1. New fast lenses, combined with push processing, add

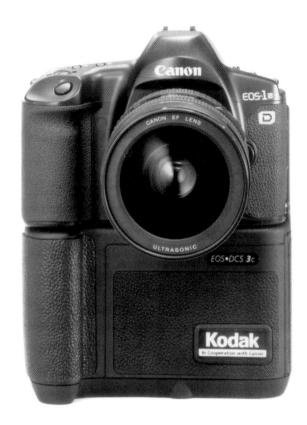

Eventually, all of our photos will be captured by filmless cameras, but the technology is still developing. This Canon EOS DCS-3 is a collaboration with Eastman Kodak and is designed for pros working on deadlines in news, commercial, and scientific photography. It uses all Canon EF lenses and can capture and store up to 12 digital images with a resolution of 1,268 x 1,012 pixels in four seconds. It also costs $16,000—without a lens.

to the 645's potential to produce in the difficult conditions often associated with concert photography. And, of course, the larger format is decidedly superior in the studio.

The move to digital

After more than 150 years of silver-based film and liquid chemical processing, the photo industry is poised for radical change as the promise of digital technology reaches fruition. The introduction of digitized images has already made the desktop publishing industry possible. These images can be easily imported into programs such as Adobe Photoshop and manipulated in ways limited only by the imagination. They can also be sent across phone lines, posted on a World Wide Web page, stored on removable media, and duplicated with no loss of image quality. With rare exceptions, however, most digital images begin in analog form (print, negative, or transparency) and are converted via a

scanning device. The revolution won't be complete until the analog step is eliminated by digital cameras that match the quality, ease of use, and price of conventional film cameras.

Digital cameras have been around for years, but only recently has image quality begun to approach that of film. Digital images are composed of *pixels*, which are essentially analogous to the silver halide grains that make up film images. The more grains/pixels and the smaller they are, the better the image quality. According to a 1996 report in *Popular Photography*, the smallest pixel measures 6 microns, while a silver halide grain can be as small as 1/2 micron. By most estimates, we will be well into the 21st century before digital images can match the resolution of film.

Nevertheless, digital cameras are here now and making money for some professional photographers. But are they suitable for concert photography? Sometimes, certainly. But you'd better have a corporate employer or a trust fund and be committed to the future. The cameras that are closest to meeting our demands cost between $11,000 and $30,000. And that doesn't include the computer equipment and extra data storage required to manipulate the images. Digital point-and-shoots (priced between $500 and $1,000) are fine for computer display and rough placement prints, but inadequate for most print publication standards if the image is larger than 2" x 3" or so.

Most promising for our purposes are hybrids produced by Nikon and Canon with Eastman Kodak. These models marry Nikon N90s and Canon EOS-1 bodies with digital technology, allowing the photographer a conventional feel and the use of interchangeable lenses. They have been especially popular with news photographers on short deadlines, because it allows them to download their images over the phone lines or directly to a computer and skip the processing and printing steps altogether. But there are still problems with resolution and dealing with low light levels. If you've got the money, by all means give one of these beauties a try. But don't discard your film just yet. You can buy a couple of top-end Nikon or Canon bodies and several lenses for what it costs to buy a suitable digital system.

Summary

The industry provides a staggering range of possibilities. But if you follow the guidelines discussed here, your decision should be easier. For detailed up-to-date information on models, consult one of the year-end guides published

by the leading magazines and talk to your dealer. The ultimate decision should be based on what feels and handles best to you, not to mention what fits your pocketbook. Many top-flight pros started with Pentax, Olympus, or Minolta until the grind of hard day-to-day use eventually took its toll or the lure of Nikkor or Canon lenses became too strong. If you don't expect to work your cameras and lenses day in and day out as hard as a pro, you'll get years of excellent service out of any brand-name system.

Lenses

hoosing a camera system is only the beginning. Now you'll need a proper complement of lenses. Because the cost of a single specialized lens can easily exceed that of a camera body, you'll want to make judicious choices. Leaving aside the question of manual focus vs. auto-focus (discussed at length in Chapter 6), there are two elements besides brand name to consider: *speed* and *focal length*.

Speed

Although the efficiency and quality of high-speed films have improved dramatically in recent years, it is still desirable to carry the fastest lenses you can afford. "Fast" in lens lingo refers to light-gathering power, which is defined by the maximum aperture (f/stop) opening. The smaller the number, the faster the lens.

The two fastest lenses in production as of 1996 are Canon's 50mm f/1.0 and 85mm f/1.2. These are very fast (and very expensive) lenses indeed. Although it is certainly possible to get excellent photographs with slower maximum apertures, I recommend that you purchase only lenses rated at f/2.8 or faster. And if you can afford it, set your bottom line at f/2.0. That extra stop can make the difference between hand-holding at 1/30th sec instead of 1/15th sec in a crucial situation. It's also critical for viewfinder brightness. The only

exceptions I would consider to the f/2.0 minimum are lenses that are 300mm or longer, because of their prohibitive cost.

Focal length

The number of focal-length choices available today can be almost overwhelming to a photographer looking to build a versatile arsenal. It's possible to buy single-length lenses ranging from an 8mm ultra wide-angle covering 180° to a 1000mm telephoto that covers a 2.5° angle, with more than a dozen choices in between. Depending on the circumstances, a case can be made for each, although only the most successful photographer (or rock star) could afford them all. Fortunately, you need only a few to get started and established in the business. Lenses can be purchased in single focal lengths (sometimes called primes) or as zooms that incorporate a range of focal lengths. You'll probably end up with a combination of both. We'll deal with primes first, which are still generally considered optically superior to zooms.

Prime lenses

Zooms rule the market now, but not long ago most new camera buyers picked a fixed-length 50mm to 55mm lens to start. (Actually, it was often picked for them by retailers who packaged the lens with the body at a special price.) Covering an angle of 46°, the 50mm is known as the "normal" or "standard" lens because it provides an angle of view that closely corresponds to a pair of human eyes without peripheral vision. When it comes to bang for the buck, 50mm lenses are hard to beat. Not only are they the fastest lenses made, but they are among the least expensive. A new 50mm f/1.8 Nikkor, for instance, is less than $100.

Nevertheless, if you asked a selection of pro photographers from almost any discipline (fashion, sports, photojournalism, weddings, etc.), few would say they use a 50mm lens a lot. There's something about the view it provides that's just *too* normal and maybe a bit boring. Most prefer to use a fast 35mm, or even a 28mm, as their standard lens. The extra coverage leaves more room for a framing error when working in rapidly changing conditions and provides more depth of field. Still, a fast 50mm lens remains a valuable asset in the concert photographer's bag. It's a great value and is very useful close to the stage when you want a full body shot or two musicians in the same frame. Buy the fastest one you can afford. Sometimes an aperture of f/1.4 or even f/1.8 can be the difference

A 180mm f/2.8 lens like this Nikkor is an integral part of nearly every pro music-business photographer's bag. Its focal length makes it easy to fill your frame with a head and upper body from a reasonable distance. It's also quite fast.

between success and failure when the light is really bad. If you prefer to start with a 35mm as your primary lens, make sure that it is rated at f/2.0 or faster.

Aside from speed, some photographers select a normal lens for its ability to close-focus. For this they choose a "macro" lens, which permits you to focus close enough to render a small object on film in its actual size. You could, for instance, capture a guitar pick, a dime, or an eye at full size on a 35mm frame. More likely you'll use it to capture something like a hand shot of a guitarist or the details of an instrument. The standard macro lens runs between 50mm and 58mm with a maximum aperture of f/2.5. A 100mm to 105mm f/2.8 macro is also a popular choice of many photographers who want close-focusing without being too close to the subject. Whether or not you decide to substitute a macro for a normal lens, it is a piece of gear that belongs in every photographer's bag sooner or later.

The second lens

The selection of a second lens is more difficult. Should it be a wide-angle or a telephoto? Obviously, a well-rounded photographer needs both, and you've

already answered the question if you started with a moderate wide-angle such as a 35mm. For our purposes, the decision is easier because of the shooting conditions we're most likely to encounter. Concert photography relies heavily on moderate to long telephoto lenses, because of the typical distances between the camera and subject. Since we can't climb onstage to get close enough to fill the frame, we must bring the subject to us through the use of optics.

Many retailers will try to sell you something like an inexpensive 135mm f/4 with your initial camera/lens package. Resist the urge. It's a tempting length if you're planning to do a lot of short telephoto work, but it's too slow and the gap between the 50 and 135 is just too wide. Better to get something shorter and faster first, like a 100mm/105mm f/2.5 or f/1.8. The 100/105, noted for its compact, lightweight design and sharp optics, has long been a favorite of working photographers. It's not only an outstanding portrait lens, but it also provides an ideal length for capturing head and torso shots that include guitars when you're working in front of the stage or seated in the first couple of rows. For several years it was the longest lens I owned, although I definitely felt its limitations. As long as I could get close to the stage I was okay, but that's not always possible. Still, you'll find this will be one of your most-used lenses.

The third lens and beyond

Your third lens is dictated by the types of situations you are most likely to encounter. If you have a 50mm and a 105mm, then it's time to get a wide-angle if you seek versatility. It's not only useful for capturing shots of a whole band onstage, but it's invaluable in tight, crowded conditions backstage or when you're shooting a posed group shot. Wide-angles are capable of producing exciting photos because they impart a sense of intimacy and dimensionality between the viewer and your subject. Consider a 28mm first. It's noticeably wider than a 35mm but still produces minimal distortion. For more dramatic results, you may want to add either a 24mm or 20mm later.

If you have a 35mm and 105mm, there are a couple of possibilities. If you think that most of your work will be in clubs or other places where you can get reasonably close to the artist, then you may want to fill the gap with an 85mm. It's an excellent lens that's available in speeds as fast as f/1.2, depending on the camera system you own. If, however, you plan to shoot festivals, fairs, large arenas, or stadium shows where close access may be restricted, then you'll want to think about longer lenses. A 180mm or 200mm f/2.8 is a popular choice for

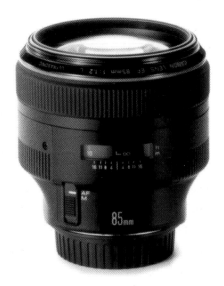

An 85mm lens is ideal for portraits and for working close to the stage. This Canon 85mm f/1.2L is compact and lightweight, and its speed makes it especially suitable in bad light.

many veterans, and Nikon, Canon, Minolta, and Pentax all make excellent AF examples. Among independent lens builders, however, only Sigma makes an autofocus model. A more versatile answer for some, perhaps, is a 135mm f/2.0. Add a 1.4x teleconverter and you've also got a 189mm f/2.8. Surprisingly, Nikon appears to be the only manufacturer who makes an autofocus 135mm f/2.0, although Canon makes a manual model for its FD system.

Once you've gathered a core group of lenses capable of handling typical shooting conditions, you have the luxury of taking your time to plan further additions based on your most common needs. Just remember that the further you deviate in either direction from the standard 50mm, the higher the costs go. Prices escalate especially rapidly as you get longer and faster. For instance, you can buy a premium-quality 180mm or 200mm f/2.8 from Nikon or Canon for less than $700 at mail-order prices as this is written. A 300mm f/2.8 costs six times that amount, but it's a fantastic lens. At the same time, however, a 300mm f/4.0 can be had for less than $1,000. By the time you hit the high-speed 600mm bracket, the tab runs as high as five figures. Not too many shooters can justify that kind of expenditure. Most photographers start thinking about rentals, tele-converters, or mirror lenses when they need that kind of firepower.

Zooms

According to retailer surveys, nearly 80% of all lenses sold in 1995 were zooms. This overwhelming popularity of multi-focal-length lenses is powerful testi-

mony to the advance of technology since zooms were first introduced in the late '50s. For more than two decades, they were largely shunned by professionals because of distinct quality disparities compared to prime lenses. Common complaints included reduced overall sharpness, unwieldy bulk, a tendency to flare, vignetting (fall-off in brightness and sharpness in the corners), distortion, and small maximum apertures. By the 1980s, though, manufacturers had made great strides on several fronts, and zooms began to appear in the bags of many pros. Today, due to advances in multi-coatings, computer-assisted optical design, and new synthetic elements, the best zooms are arguably the equal of their prime counterparts.

Zooms offer some obvious advantages over prime lenses, most notably the convenience of having a single lens mounted that can do the work of several. In fast-moving conditions where a performer is prowling the stage, the ability to rapidly zoom in or out to keep the subject in the frame is enormously beneficial. The best shot can easily be lost while you're changing lenses. Even if the performer is relatively stationary, zooms allow you to pull in for a tight head shot or back off for a head and torso or full-body shot from your fixed position in front of the stage. Precise framing is a snap whether you need a focal length of 71mm, 96.5mm, or 103mm. This is particularly valuable when you're shooting transparencies and don't have the opportunity to crop in the darkroom. The downside to zooms is that they are bigger, heavier, and slower than prime lenses. And only the very best of them measure up to prime lenses in sharpness.

Variable or fixed aperture?

Modern zooms are either variable-aperture or fixed-aperture models. As the name implies, the maximum opening of a variable-aperture lens changes as it is zoomed in or out. For instance, a 28mm–70mm/3.5–4.5 starts with a maximum aperture of f/3.5 at the 28mm setting but changes to f/4.5 by the time it reaches its maximum length of 70mm. Variable-aperture zooms were developed to cut size and cost, and have succeeded admirably. They are, however, not particularly practical for our purposes. Though they may be sufficient for daylight concerts and backstage shots with flash, they are usually too slow for club and theater work unless you're using very fast film or the lighting is particularly good. They're also a hassle if you're metering with a hand-held light meter or using a flash unit that doesn't calculate exposure via a TTL (through-the-lens) reading; you must manually make exposure adjustments

Third-party lenses are no longer necessarily inferior to those from original equipment manufacturers. This Tokina AT-X 270 AF Pro 28–70mm f/2.6–2.8 is easily the equal of comparable entries from Nikon and Canon. It also produces images as sharp as any fixed-focal-length model at apertures of f/5.6 and smaller.

every time you zoom in or out.

More useful are the fixed-aperture zooms, which typically have a maximum aperture of f/2.8. Unfortunately, there are fewer choices among these types. Currently there are three ranges available—80mm–200mm telephoto, 28mm–70mm "super normal," and 20mm–35mm wide-angle. (The exact numbers may vary according to the manufacturer. For example, Sigma and Tamron both offer a 70mm–210mm f/2.8.) Most popular is the 80–200, a very effective range for concert photography. However, these marvels exact a heavy price in weight and size; an 80–200 f/2.8 typically weighs about 3 lbs and is more than 7" in length. Put that on an EOS-1 and you've got quite a load to carry around for an entire evening. Furthermore, you're forced to practice the same kind of hand-holding steadiness at the 80mm end as you do at the 200mm end. And while f/2.8 is fast for a 200mm lens, it is slow when you move to the other end of the zoom spectrum. Despite these shortcomings, a high-quality 80–200mm f/2.8 zoom is extraor-

dinarily useful. I just wouldn't want to be caught with it as the only option for that range, especially if I had to shoot in a club where the lighting was rather dim. I'd want to have something like a 105mm f/1.8 along as a backup to accommodate the club's poor lighting or my own tired arm. The same can be said of the other zoom ranges regarding speed. Fixed-aperture zooms are miracles of modern optical science, but they're not the answer in every case.

OEM vs. independent manufacturers' lenses

Independent makers have been building lenses for Nikon, Canon, and Minolta SLRs as lower-cost alternatives almost since those cameras appeared. In the past, they have generally been considered inferior to those produced by the original equipment manufacturers (OEM). Times have changed, however. Just as in the case of zoom lenses, advances in computer-assisted optical design and new materials have conspired to put the best of these independent designs on equal footing with their OEM rivals. I know I'll never convince some hardcore Canon or Nikon users of that, but that's my conclusion after personal experience, talking to working pros, and reading articles and lens tests in camera magazines.

My awakening came with Tokina's AT-X 270 AF Pro 28–70mm f/2.6–2.8. It's not only the sharpest zoom I've ever encountered, but at apertures f/5.6 through f/11 it appears to be the equal of any prime SLR lens I've ever used. Priced 30% less than Nikon's closest equivalent (the Nikkor 35–70mm f/2.8), it also offers a "clutch" mechanism that allows you to switch instantly from autofocus to manual simply by grabbing the lens and turning it. You can't do that with the Nikkors (although you can with Canon's EF lenses). All this and a 10-year warranty, too. Of course, one lens doesn't prove anything about the worthiness of independent lenses as a whole, but it finally removed my own fear of them. The very best lenses will show their superiority only when used with slow or medium-speed transparency films or with greatly enlarged prints (16" x 20" and up) made from slow color-negative or black & white films. Thus, if you're shooting T-Max 3200, Ektapress 1600, Fujichrome 400, or any other high-speed film, it's unlikely you'll see any differences between a Nikkor or Canon lens and a premium Tokina or Tamron. If you plan to make a 20" x 24" poster from a Kodachrome 64 slide, then it can make a difference. Of course, that presumes your focus, aperture setting, and shutter speed were optimum when you exposed the slide.

When you're stuck in a venue where you can't get anywhere near the stage, a lens like this Canon EF 300mm 1:2.8L will bring the stage to you. At 6.3 lbs and nearly 10" long, however, you'll need strong arms, a tripod, or a monopod to eliminate lens shake.

What's a "premium" lens?

So how do you know which lenses are premium models? Obviously price gives you a pretty good clue, but certain features are a more reliable indicator. A premium lens should offer low-dispersion glass, internal focusing, and a tripod collar for longer models. Low-dispersion glass was developed as a lower-cost alternative to crystal fluorite for controlling chromatic aberration, a phenomenon caused by different colors (wavelengths) focusing on different planes. This aberration, depending on its severity, can cause reduced sharpness and color "fringing" around the subject, much like a slightly out-of-register color separation. Lens manufacturers such as Leica, Schneider, and Zeiss have used low-dispersion glass in certain lenses, particularly telephotos, for some time without any special fanfare. Recently, however, it has become a common feature in top-of-the-line lenses of many manufacturers. In most cases, it's easy to spot them by letter designations in the description. Nikon labels its models ED, while Tamron uses LD. Tokina dubs its SD or HLD, and Sigma utilizes SLD for identification. Canon's premium lenses are simply marked with an L. Sometimes

you'll see the letters "APO" used, shorthand for *apochromatic*, which indicates the same type of correction. Well-designed lenses that use low-dispersion glass generally show a marked improvement over less-exotic counterparts.

Typically, a lens' length changes and its front element rotates as you focus it. Lenses shorten when focused at infinity and lengthen as you focus closer. Functionally, this is not necessarily a problem unless you're using a polarizing filter that must be set at a specific angle. In an effort to speed autofocusing and reduce bulk, however, manufacturers developed *internal focusing*, where the lighter, internal elements move instead of the heavier front elements. As a result, lens length is constant throughout the focusing range and the front element remains stable. IF lenses tend to be lighter and more compact than their predecessors.

A *tripod collar* is a simple device that allows you to attach the lens, rather than the camera body, to a tripod for better balance and stability. Despite its simplicity, it is conspicuously absent from some lenses that need it, most notably Nikon's 80–200mm f/2.8 zoom. It should be standard issue on any prime lens 180mm or longer and most zooms that reach beyond 100mm. Fortunately, after-market tripod collars are available for most lenses.

A glance through magazine ads or a trip to a well-stocked store may present a confusing choice of seven or eight manufacturers. How do you know which are the best? The consensus of my research indicates that the most consistent results come from lenses made by Tamron, Tokina, Sigma, and Vivitar. That doesn't mean all of their models are good or that a lens made by another manufacturer is bad. It's just that those four have proven over the years that they can produce consistently good results. You'll still have to do your homework. One common complaint about independent lenses is that they won't stand up to the wear and tear of professional abuse. To some extent, this is a valid concern. Sigma, for instance, employs a lot of polycarbonates (plastic) in its designs. The upside is that its products are not only optically excellent but very light. They cannot, however, take the kind of abuse that a Nikon or Canon lens can. Of course, that's balanced by the fact that some models cost less than half of their Nikon or Canon counterparts. The independent manufacturers are fighting this perception of lack of durability by offering 5- or 10-year warranties on their premium lenses. You can protect yourself from being stuck with a bad lens by buying from a dealer who permits you to return it for credit within a reasonable period if you're dissatisfied with its performance.

One of the most useful accessories you can carry is a teleconverter like this Nikon TC-14E AF-1. It increases the focal length of a lens by a factor of 1.4x, while giving up only one f/stop. Thus, a 135mm f/2.0 becomes a 189mm f/2.8 when the teleconverter is attached between the lens and camera body.

Teleconverters

Teleconverters are optical devices that increase focal length when attached to a rear lens mount and camera body. Though they've been around for decades, they have long been vilified as inferior. Like all other lens technology, however, things have changed in the last few years. Quality has risen in the best examples to the point where a teleconverter is now one of the more useful accessories you can carry in your bag.

The advantages are obvious. For a fraction of the cost of a new lens, a 2x teleconverter turns a 200mm lens into a 400mm lens without changing the minimum focusing distance. The focusing scale remains accurate, and all aperture and depth-of-field controls remain fully operational. Of course, there's a price for this convenience, namely loss of lens speed, finder brightness, and image quality. A teleconverter works by magnifying the center portion of an image, which makes it dimmer. As a result, a 2x converter reduces the effective maximum aperture by two full stops, turning an f/2.8 lens into an f/5.6. The loss is only one stop with a 1.4x converter. A corresponding loss of viewfinder brightness accompanies the maximum aperture reduction.

Image degradation varies according to the quality of the master lens and the teleconverter. If you start with a mediocre lens and add an inexpensive converter, then you can expect poor results. If the lens has flaws to begin with, a cheap converter will only magnify the flaws and impart a few of its own. The

secret to getting high-quality images is starting with a top-quality lens and adding a properly matched teleconverter. Nikon, Canon, Minolta, Olympus, and Pentax all make matched converters for their lenses. Be advised, however, that the best of these devices are not cheap. Nikon's and Canon's cost more than $300. Still, that's less than another lens, and the teleconverter takes up less space in your bag. Teleconverters can also be used with zooms, although the results will generally be less satisfactory than with prime lenses. Autofocus teleconverters are also available, but they won't work properly with maximum apertures smaller than f/5.6. If you put a 2x converter on an f/4.0 lens, it becomes an f/8.0 lens and your autofocus won't work.

There are several independently built teleconverters by manufacturers such as Sigma, Tamron, Tokina, Vivitar, and Kenko. Some are excellent and some are less than that. Your safest bet for optimum results is to use a teleconverter made by the same manufacturer who built the lens. If you want to use one from a third-party builder, buy it from someone who will allow you to return it if you're unhappy with the results. Finally, remember that the more you magnify an image, the more it degrades. Limit your teleconverter use to a 1.4x and a properly matched prime lens from a premium manufacturer, and you'll see little or no image degradation and only a one-stop aperture loss.

Mirror lenses

Mirror (catadioptric or "cat") lenses are a special breed of telephotos that look and work quite differently from conventional models. They are, in fact, built like small telescopes. Where conventional teles employ a series of front and rear elements to focus the light and magnify the image, cats use front-surfaced mirrors to "fold" the light path back and forth inside the lens barrel. As a result of this design, mirror lenses are shorter, fatter, lighter, and less expensive than their conventional counterparts of equal focal length. They also have a much shorter minimum focusing distance, and chromatic aberration is virtually eliminated. Sounds great. So, how come all lenses aren't mirror lenses?

For one thing, cats are generally not as sharp as conventional lenses. More important, they do not have a diaphragm; the lens aperture is fixed at a single f/stop, most often a slow f/8. And even then, because of limited mirror efficiency, they won't transmit as much light as f/8 on a conventional lens. Exposure is controlled either by changing shutter speeds or by using a series of neutral-density filters. This is not necessarily a problem if you're working with

daylight and using the aperture-priority mode of your automated camera, unless the light is so bright or your film so fast that you have to employ a neutral-density filter. This is less of a problem today than in recent years, however, because of the ultra-fast shutter speeds in modern cameras. The biggest problem arises when you want to use a mirror lens indoors where the light is not nearly as bright. The slow shutter speeds necessary to get the right exposure become a real hassle when you're hand-holding the lens or your subject is moving. The fixed aperture also eliminates the freedom to control depth of field by stopping down or opening up.

Despite these shortcomings, a mirror lens offers the financially challenged photographer the opportunity to keep a 500mm (or longer) lens available for those times when a slow, fixed aperture is not a critical problem. Furthermore, some manufacturers have found ways to produce lenses with apertures as big as f/4.0, but they are *very* expensive. If you decide to buy a mirror lens, new or used, be certain that the neutral-density filters designed for that specific lens are included. They are usually an important part of the optical formula.

Accessories

Cameras and lenses are your most important equipment, but they aren't everything. Let's take a look at some accessories that should always be with you on a shoot.

Camera bags

Once you've gathered the requisite cameras, lenses, flashes, and other gadgets, you'll need something to carry them in. A trip to a well-stocked store presents an overwhelming variety of bag options, most of which should be ignored. Your strategy should be to find a bag that will accommodate all the equipment you're likely to need on a typical shoot—two bodies, three or four lenses, a flash unit and power pack, a spot meter (if you don't have one in your camera), film, and an assortment of accessories. With that kind of load, you want something lightweight and durable with a minimum of bulk, which rules out the stiff, heavily padded designer bags that dominate dealer shelves. You also want a bag that facilitates quick and easy access to its contents, with compartments where you can safely store loose lenses when making fast lens changes in the heat of shooting. It's also useful if the compartments can be moved to fit your requirements. And look for plenty of pockets where you can store accessories and film. A zippered pocket for exposed film is particularly valuable, because it's easy to lose a roll while frantically digging around in your bag. If it drops on the floor of a dark club, you probably won't even know it's gone until it's too late— a very painful lesson.

A favorite of photojournalists everywhere is the Domke shoulder bag. Designed

by globe-trotting photographer Jim Domke, it's made of a natural cotton-fiber canvas that is soft, pliant, water resistant, and extremely tough. The only padding is on the compartment inserts and the bag's bottom, which leaves plenty of room to carry a lot of equipment safely with easy access to each piece. It features a handle and 2"-wide webbed shoulder strap with the same rubber shoulder pad used by U.S. mail carriers. I like the way the bag molds to your body, even when full.

Domke makes a complete line of different-sized bags and add-on accessory pouches. Most popular is the F-2, which has a compartment insert for four lenses and plenty of room left over for camera bodies, flash, and accessories. The compartment insert can be easily moved around via a series of Velcro strips.

There is a drawback to the versatile shoulder bag, however. A fully loaded bag can easily weigh 25 to 30 lbs. By the end of an evening, your back can get mighty tired with that kind of load. Some manufacturers provide an accessory strap that fastens around your hips to distribute the weight more evenly. Another approach is to do away with the bag altogether and use a photo vest, which has various-sized sealable pockets all over to carry lenses, film, batteries, meters, and even an extra camera body. Unfortunately, you can't get as much equipment in a vest as you can a bag, and a vest gets uncomfortably hot in a packed club. Most working photographers actually own two or three bags in different sizes, packing the smallest one possible for any given job. Fanny packs are useful adjuncts for extra film, batteries, and other accessories.

Filters

Filters have limited utility in concert photography, primarily because most cut the amount of light reaching the film. As we've mentioned before, this is hardly useful when you're already severely restricted by poor lighting conditions. Use the properly color-balanced film for the conditions and there will be no need for color-balancing filters.

One potentially useful special-effect filter is a star filter, which turns point light sources and specular highlights into starbursts. They can make back spots and reflected light into dramatic effects, and require no exposure compensation.

A clear UV or skylight filter should be mounted on every lens. Think of it as a transparent lens cap that protects the front element from fingerprints, dirt, bumps, and scratches. This is not a universally accepted procedure, though. Some photographers feel that a filter affects lens sharpness. But as long as you use high-quality brand-name filters and keep them clean, the impact is minimal,

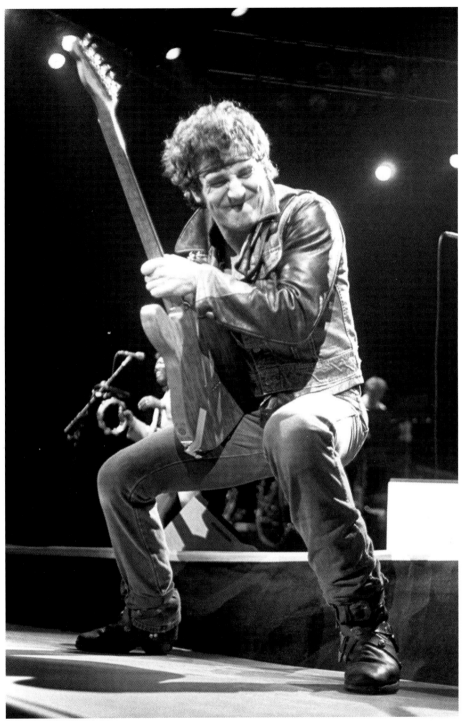

BRUCE SPRINGSTEEN, 1984

especially when shooting at large apertures with high-speed film. If I ever had any doubts about using a filter, they were resolved when one of my cameras took a nose dive off a file cabinet onto a concrete floor. It struck on the front edge of the lens, shattering and bending the filter so badly that it had to be removed by a camera repairman. The lens element itself was undamaged.

Earplugs

According to audiologists, sustained sound levels above 85dB (decibels) can cause permanent hearing damage. With rock concert volumes routinely reaching 100dB and peaking at 130dB, hearing protection is an absolute necessity. Who guitarist Pete Townshend has all but abandoned concert performances because of the damage caused by long-term exposure to high volumes. Damage is cumulative—once you've sustained hearing loss, it's permanent. Anytime you hear a ringing after a loud noise, you've done irreparable damage.

Concert photographers are particularly susceptible because they work so close to the stage, sometimes positioned directly in front of a loudspeaker. Fortunately, there's a cheap, effective solution—foam ear plugs. Marketed under several brand names, including E.A.R. and D'Addario, they cost less than a buck a pair and can be found in music stores, drugstores, gun shops, and some hardware stores. The kind I prefer are rolled between your fingers and placed in your ears, where they expand to fit your ear canal to cut approximately 29dB of sound. You can still hear the music plainly, but the pain is gone. When they get dirty, stuff them in a shirt pocket when you do your laundry, and they're as good as new.

If you prefer a more elegant solution, an audiologist can fit you for a custom pair shaped to fit your ears. Two options are available. In the first, a soft silicon compound is inserted in your ear canals and allowed to harden, leaving plugs that are custom shaped just for you. They will probably cost somewhere between $60 and $80. A second possibility involves inserting a tuned resonator and an acoustic resistor into the silicon to provide better frequency response than simple plugging. Many musicians are now using this type for performances. These will probably run you about $120 a pair.

Flashlight

Trying to find something in your bag, read a label on a film canister, or check an f/stop can be difficult in a dark theater or club. That's why some sort of flash-

A small squeeze light like that pictured here is very useful, especially when your hands are full. Just put it in your mouth and bite down on the sides.

light should be standard equipment. I carry two. One is a tiny disposable squeeze light on a key chain. It's perfect when you need a momentary light source. Squeeze it, and the light comes on. Release, and it goes off. You can even stick it in your mouth and squeeze it with your teeth when you need both hands free to load film or whatever. When I need a brighter, more sustained light I use a mini Maglite that slips into a pen pocket on my bag.

Pens and notepad

Never go to a shoot without a pen or pencil and a notepad. Inevitably, you'll need to make notes for caption material or will meet someone without a business card who can be helpful. Maybe you'll just want to write down the name of your band contact or someone who wants information about buying a print. A particularly useful type of pen is a Sanford Sharpie, a permanent marker that writes on nearly any surface. It's perfect for labeling film canisters or getting a print or album cover autographed by an artist. The fine-point model is best.

Knee pads

Kneeling for any period of time on concrete, hard wood, dirt, or gravel is no fun. You could end up hobbling around for hours after the show. If you know you might face such conditions, pack a pair of padded athletic knee pads. They're thin enough to wear under reasonably loose-fitting pants, and will spare you much agony. Jim Marshall says he has worn them since the 1960s, following the

example of Pete Townshend, who relied on them to shield his knees when landing from his trademark leaps.

Lens-cleaning accessories

Inevitably, your lenses will become smudged and dirty from constant handling. Always carry lens tissue, a blower brush, and lens cleaner. Use the brush first to remove any grit and apply the lens cleaner *sparingly* to the tissue and wipe. Never squirt lens cleaner directly on the lens. It can seep down into the elements and dissolve the cement.

Spare batteries

Modern electronic cameras and accessories are voracious battery eaters. Always carry ample spares for every battery-operated device in your bag. The day you don't is the day your batteries will fail at a critical moment. Trust me.

Film-Stor boxes

Instead of carrying a jumble of bulky film canisters, or stashing exposed film loose in a pocket of your bag, invest in a few plastic Film-Stor storage boxes. Each will keep six rolls of your precious 35mm film protected from water, dust, dirt, and sand, and this compact, tough case slips neatly into your jacket, coat, or pants pocket. Dedicate one to black & white film, another to color, and a third to exposed film, and eliminate digging around in your bag searching for the right film. Though completely plastic, it has a sturdy hinge and a safety latch that locks a tongue-and-groove seal tightly in place. Film-Stor boxes cost less than $3.00 apiece, and are available from Porter's Photo Catalog (Box 628, Cedar Falls, IA 50613-0628), a massive newsprint publication filled with hundreds of photo gadgets.

Buying your equipment

After reading the last few chapters, your head is probably reeling from contemplating the cost of fully equipping yourself. Nobody said this was going to be cheap. Photographic gear *is* expensive, but you don't need to buy everything all at once to get started; a camera body and a lens or two will suffice. Build your equipment inventory slowly, adding items as you need them. You can also

A Film-Stor box holds six rolls of film ready for instant access. The curved shape slides easily into a pants pocket, and the box is water- and dust-resistant when closed.

help yourself by being a smart shopper. Unless you're dead set on acquiring the absolutely newest, just-released camera or zoom lens, there's never any reason to pay list price for anything. The market is simply too competitive.

Shopping with a local dealer

There are several advantages to establishing a working relationship with a good local camera dealer who caters to professionals. You get to see and hold the equipment you are considering, and a knowledgeable dealer can answer your questions and point out the differences between competing brands. A good salesperson will also keep you abreast of new models that might tempt you to upgrade. If you buy a piece of equipment and something goes wrong with it right away, you can return it for immediate replacement (providing the dealer has another in stock, of course). And once you establish a solid rela- tionship, your dealer might even let you try out a lens for a day or two before you buy. A good dealer can be an excellent source of information and gossip about the local pro scene. He or she should also be ready to offer competi- tive prices, although they probably won't be able to match the big New York mail-order houses. But if you can get within 10 to 15% of mail-order prices,

the relationship is often well worth the difference. For many people, shopping locally is the only way to go.

Mail-order buying

Mail-order shopping is convenient and can save you money. Not only can you buy equipment at a significant discount, but you don't have to pay sales tax if you live out of state (although some states, such as California, impose a use tax that amounts to the same thing). If you read photo magazines, you've no doubt seen the ads for mail-order retailers in the back. There are dozens of these retailers, but not all are created equal. Seldom will you be cheated outright, but deception is not uncommon in matters of availability and "gray market" merchandise. Certain popular merchandise is tough to keep in stock, and subtle bait-and-switch pressure tactics are applied. Ads offering great prices on popular items lure you to the phone, where you're told the piece of equipment you want is out of stock and are urged to buy a substitute instead.

Gray-market merchandise consists of equipment not originally intended for resale in the United States. Retailers buy it in big lots from overseas distributors, using fluctuations in currency values to get a better price. Although gray-market merchandise is legal and generally identical to equipment intended for the U.S. market, you won't get U.S. warranty protection. The only companies I do mail-order business with anymore are B&H Photo, Adorama, and Porter's, although I'm sure there are plenty of other reliable sources. Your chances for complete mail-order satisfaction are excellent if you follow a few simple rules:

• Know precisely what you want before you pick up the phone, including the brand, model number, and price. Phone sales reps are generally order-takers only, and they won't have the time, patience, inclination, or knowledge to discuss the features or merits of equipment. You have to do the homework first. Read magazines and ask people you trust. Casually check out the gear at a local camera store, but don't play your local camera retailer for a chump by taking up a lot of his or her time and then buying mail-order. If he or she is a knowledgeable and helpful salesperson, it may pay to strike up a relationship and buy from that person.

• Always ask about availability and total price, including shipping. I've learned the hard way to never place an order for an item not currently in stock. Large re-

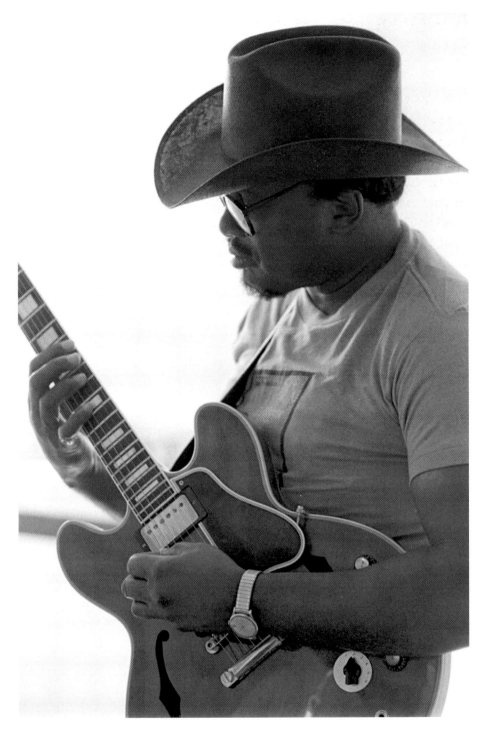

OTIS RUSH, 1985

tailers place back orders when they have enough demand for an item to meet a manufacturer's minimum order requirements. That's not necessarily when *you* need it. I know people who have waited weeks or months to receive back orders.

• Ask if the article has a U.S. warranty. If it doesn't, it's probably a gray-market item. If something goes wrong while under warranty, you may have to ship the item overseas for repair. Worse yet, you may discover you have no warranty protection at all.

• Always pay with a credit card. Plastic provides more protection against deceptive business practices. If you have a legitimate beef, you can usually get your credit card issuer to freeze payment.

• Specify the method of shipment and ask for an order-confirmation number, the name of your salesperson, a shipping date, and the approximate date it will arrive. That way you'll likely have recourse if it doesn't show up when expected.

• Ask about the store's exchange and refund policies. If you decide you've made a bad choice, you'll know how long you have to return it and what penalties, if any, apply.

• When the item arrives, ensure that it's brand-new and not a repackaged return. Tip-offs include shrink-wrapped boxes (few manufacturers seal boxes in this manner) and missing items such as a body or lens cap, warranty card, or instruction book. Any expensive SLR ships with a plastic shield to protect the shutter, and you have to open the camera back to remove it. If it's not there, you probably have a repackaged item.

• Hang onto all paperwork, warranty cards, and packaging materials for several months, at least. No retailer will accept a return if the warranty card has been filled out, even if it's only been a couple of days since you bought the item. You'll then be forced to deal directly with the manufacturer, which means time and hassle. The purpose of most warranty cards is to gather marketing information. That's why they ask so many questions that have nothing to do with the item you've purchased. Your warranty is in effect whether you send in the card or not, as long as you retain proof of purchase.

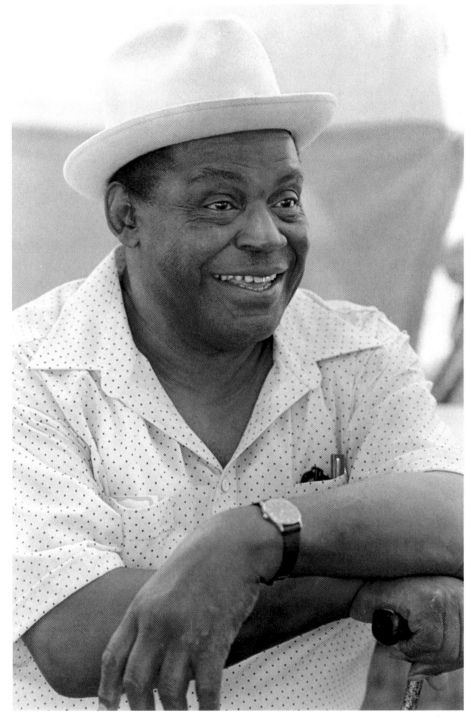

WILLIE DIXON, 1983

Lighting

No matter how skilled you are at working with available light, the time will come when you need more light and more control over its direction, intensity, and color. This is particularly certain when you move beyond performance photography into backstage and location studio work. The solution is supplementary lighting, with either hot lights or electronic flash. Supplementary lighting comes in many sizes, from 250-watt photofloods and tiny pop-up electronic flash units built into your camera to 1000-watt quartz lamps and 5000 watt-second power packs. We won't attempt to address all of the possibilities. Instead, let's concentrate on hand-held units that fit in your camera bag, and on how to put together a small studio lighting kit.

Portable flash units

Even if you *hate* to use flash, never go on a paying shoot without one. If someone is counting on you to deliver good photos, you can't afford to miss just because the lighting is bad. Of course, there are going to be many places where flash is strictly prohibited, particularly in concert. With a flash unit available, however, you may be able to satisfy your needs with backstage shots taken before or after the show. Fortunately, ever-shrinking electronics mean you don't have to lug a lot of extra weight and bulk to pack a powerful lighting punch.

And you don't have to spend a fortune, either. You can be adequately equipped for under $100.

Electronic units are available in a variety of sizes, shapes, and output. We'll limit our discussion to those designed to slip into a hot shoe on the top of a camera. Powered by AA batteries or auxiliary battery packs, these units combine compact size with surprising power. There are dozens of models, but you can narrow the possibilities by limiting your search to those that meet the following criteria:

• Guide number (GN) of at least 100. This number indicates the relative power (light output), usually using ISO 100 film as the baseline. The higher the guide number, the greater the power. Before auto flash, photographers calculated aperture by dividing the guide number by the distance from camera to subject (e.g., GN = 110, distance = 10 feet, 110/10 = f/11). Any salesperson should be able to tell you a flash unit's guide number by referring to the owner's manual.

• Automatic flash control. Just about all compact units now have computerized components that determine the amount of light necessary for correct exposure. A photoelectric sensor mounted on the flash or the camera reads the light reflected off the subject and cuts flash duration when it sees enough. This not only guarantees the right exposure, but also saves power and provides shorter recycling times. The best units have four power settings, each corresponding to a specific f/stop. Select an f/stop, and everything within a designated distance range is correctly exposed.

• Accepts external power pack. Nearly all compact shoe-mounted units are powered by either two or four AA batteries, which work fine if you're shooting a limited number of frames and are willing to accept increasingly longer recycle times as the batteries drain. Third-party accessory power packs, such as those built by Dyna-Lite, Quantum, and Lumedyne, can deliver hundreds of shots with virtually instant recycling. They are mandatory for any professional. Make sure that such packs are available for the flash unit you choose.

• Accepts accessory cord to get the flash off-camera. Mounting your flash in the hot shoe and shooting direct flash is seldom desirable. Be certain there is an accessory cord available that allows you to get the flash off-camera, where you can control the direction of the light and use bounce flash.

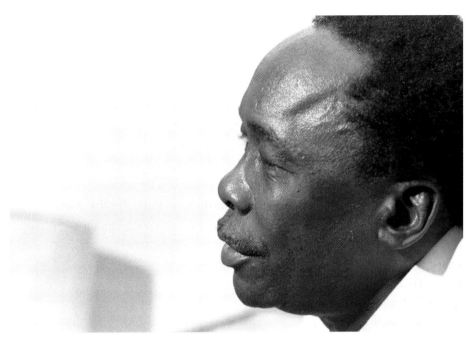

It doesn't take a fortune to assemble a small studio lighting kit good enough to produce strong, well-lit photos. This shot of John Lee Hooker was created with two 500-watt reflector photo floods mounted on light stands. A similar kit, with case, can be acquired today for about $150.

TYPES OF UNITS

Flash units are divided into three types—non-dedicated, dedicated, and dedicated autofocus.

Non-dedicated

Non-dedicated flashes are relatively inexpensive, easy to operate, and work on nearly any camera with a hot shoe. They determine exposure via a sensor on the face of the flash unit. Though this method is not as consistently accurate as readings through the lens (TTL) off the film plane, it is more than adequate in most situations.

The Vivitar 283 is the Volkswagen Beetle of this category. Millions have been

sold since its introduction in 1971, and its popularity shows no sign of waning despite formidable competition. Rugged and inexpensive, the 283 (GN 120) features a tilting head, auto thyristor circuitry, an external exposure okay test button, an illuminated control dial, and four automatic flash ranges effective up to 40'.

The 283 also accepts many third-party accessories that significantly extend its utility, including low- and high-voltage power packs, reflectors, light-softening devices, sync cables, lighting stands, umbrellas, and slave triggers. A couple of manufacturers even convert 283s to accept "bare-bulb" heads or 200 watt-second power heads. You can't go wrong by starting with a Vivitar 283 or a Vivitar 285HV, a slightly bigger brother that also offers variable manual power, a 35mm-105mm zoom head to optimize the lighting pattern, and a 28mm wide-angle adapter. The 283 lists for about $140 but sells for as little as half that at discount stores or mail-order houses. The 285HV runs about 20% more.

The Vivitar's most worthy competitor in its price range is the Sunpak 383 Super, with a head that swivels 330°, three autoflash power levels, and variable manual output. There aren't nearly as many accessories available for it, though.

Dedicated

Dedicated flash units are meant to work with specific camera brands, although some models accept add-on modules for use with other brands. In general, they are more expensive than non-dedicated models but offer more features, such as TTL exposure control and ready lights in the viewfinder. This category is primarily designed for manual-focus cameras. A few also work with autofocus models, but some features are typically sacrificed. Contax, Minolta, Nikon, Olympus, Pentax, and Yashica all make dedicated units. Achiever, Metz, Kalimar, Sunpak, and Vivitar are third-party manufacturers that also make dedicated models. Some of these third-party models are not fully dedicated, however, and the difference in price between partial and full dedication is often quite small. How can you tell if you're getting full dedication? Count the contacts on the flash's foot and the contact points on the camera's hot shoe. They must be the same.

Dedicated autofocus

At the top end of shoe-mounted flash units are the *dedicated autofocus* models. TTL metering is only a starting point in the best of these. The Nikon SB-26,

for instance, provides perfect autobalanced fill flash, an assist beam for focusing in total darkness, a built-in white bounce card, second-curtain sync that permits you to combine flash and natural light to leave a light trail *behind* a subject, variable-output manual power, and flash synchronization at any shutter speed up to 1/4000 sec. Furthermore, it has a terminal that allows you to chain additional units for multiple-flash setups. With a street price over $300, these amenities don't come cheap. Nikon, Canon, Minolta, and Pentax all have dedicated autofocus models.

These super-smart portables offer tremendous versatility and convenience, but they also have steep learning curves. The manual for the SB-26 runs nearly 100 pages. It's not like choosing a flash range on the Vivitar 283 and firing away. Blinking displays and warning beeps can be confusing in the heat of the moment. Once you've learned how to use all of the features, however, you'll have a tremendously versatile tool at your command. If you don't need all of those features or can't afford the ticket, lesser-equipped dedicated autofocus units are available from both original equipment manufacturers and third-party builders. Sunpak's 433AF, for instance, provides full TTL dedication for all Canon EOS, Minolta Maxxum, and Nikon AF cameras, an AF assist light good up to 23', thyristor circuitry, and a tilting bounce head—all for less than $100 at street prices.

HOT-ROD 283s AND BEYOND

Despite the versatility and convenience of shoe-mounted flash units, they are somewhat underpowered for pros seeking high-quality location lighting. With a nominal guide number of 120, it's really stretching to mount a Vivitar 283 in an umbrella, for instance. The two-stop loss means you have to be *very* close to the subject to assure enough light for a good exposure. This has prompted some clever manufacturers to build a better mousetrap using the 283 as a starting point.

S.A.I. NVS-1

The most ingenious of these hybrids is the NVS-1 by Norman Stuessy. He doubles the flash output of the 283 by installing a second power capacitor in the battery chamber, adding a full f/stop at peak power. Then he adds a 7-stop variator (flash power reducing control) so you can dial in as little as 1/256th of the flash's available power for precision lighting control. In addition, the Vivitar's easily breakable plastic flash foot is replaced by a metal Paramount flash foot

with a household-style socket that accepts standard "H" plug-style PC sync cords, slave and infrared triggers, and radio-control sync wires. The NVS-1 can also be adapted to accept interchangeable flash heads, allowing you to choose between the standard 283 head or a bare-bulb head. There's even a provision for what lighting guru Jon Falk calls "strobe on a rope." Hook a flash head (standard or bare bulb) to a 20' cord and place it anywhere for a hidden light source. A wide variety of reflectors and other accessories is also available. The NVS-1 is a remarkable system that turns a Vivitar 283 into a legitimate professional tool. A top-of-the-line model with a round-reflector, interchangeable flash head and all accessories costs $359. The only way to obtain this unit is directly from the manufacturer. For more information, contact S.A.I. Photo Products, 126 Somers Court South, Moorestown, NJ 08057, (609) 778-0261.

Sunpak AutoPro 120J TTL

Sunpak's AutoPro 120J TTL is a powerful commercial-production answer to the souped-up Vivitar 283. It accepts 16 different models of camera-specific dedicated modules for TTL metering, and has a bare-bulb flash head, five-step variable manual power output, three autoflash power levels, and a removable two-position round reflector for 360° bare-bulb operation. The unit has a guide number of 150, and can be powered by four AA batteries, AC power, or either of two external Sunpak battery packs that provide 1.5-second recycling in full-manual mode. The round reflector also accepts Lumedyne and Norman accessories, such as snoots, barn doors, and diffusers, which help control the dispersion and direction of the light. The AutoPro 120J is widely available from full-line camera stores.

Quantum Qflash

Quantum's Qflash is in a class by itself. Bigger than a typical shoe-mount flash but smaller than a handle-mount unit, the Qflash QFT delivers a guide number of 160 (ISO 100) with the Quantum Turbo battery. Sophisticated electronics provide unparalleled control, allowing you to select among 19 manual settings or 25 automatic settings in 1/3-stop increments. An LCD panel provides an instant readout of guide number, flash duration, depth of field, and exposure indication. The head uses a parabolic reflector that can be removed for bare-bulb lighting. Additionally, Qflashes can be chained together to produce mul-

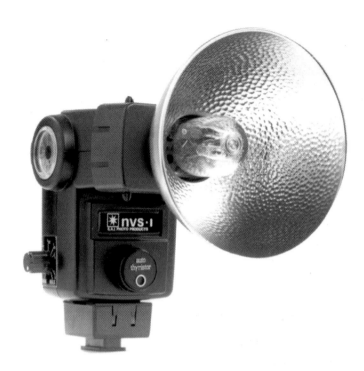

The S.A.I. NVS-1 is a souped-up Vivitar 283 that features interchangeable flash heads, four auto-thyristor f/stop options, and a variator that provides seven f/stops of precision manual control.

tiple lighting setups that approach studio quality and power. If you own a Lumedyne or Norman power pack, you can buy a special model (QFX) of the Qflash that provides up to 400 watt-seconds, which pushes the guide number to 220. With the use of an accessory adapter specific to your camera, the Qflash also supports TTL exposure control.

Auxiliary battery packs

Your flash unit's most useful accessory is an auxiliary battery pack that replaces the puny AA batteries that normally power it. The best of these packs produce up to six times more full-power pops than batteries and feature instant recycling. And you don't have to dispose of environmentally hostile batteries when you're done.

Battery packs are available in low-voltage (6VDC) or high-voltage (330VDC) units. Low-voltage units have been around since 1983, when they were introduced by Quantum. However, because of the dramatic improvement in performance, high-voltage packs have largely superseded low-voltage units. Quantum still offers two low-voltage models—the Bantam and the Battery 1+. The Bantam mounts on your belt or underneath your camera via the tripod sock

et. With a Vivitar 283, Quantum claims you'll get about 100 full-power flashes with 2- to 3.5-second recycling. The belt-mounted Battery 1+ provides up to 250 full-power flashes with 3.5- to 5-second recycling. Both use lead cells that can be recharged hundreds of times.

High-voltage units provide greater flash capacity and shorter recycling. Any flash that accepts high-voltage packs will probably also accept low-voltage models. The high-voltage market offers the Dyna-Lite Jackrabbitpack, the Lumedyne 052C Minicycler, the Quantum Turbo, and the Armatar Procycler. All deliver 350 to 450 full-power flashes per charge and 1.5- to 2.5-second recycling. If you're using a thyristor-controlled unit at distances under 10', you can get thousands of flashes on a single charge. My favorite is the Jackrabbitpack, because it can accept two flash units at the same time without an accessory "Y" cable, and because it delivers up to 75 full-power 400-watt-second flashes with Dyna-Lite's UNI400 JR monolight. That means you can actually get something resembling true studio power with an umbrella or soft box in a very compact unit.

Small flash accessories

Because on-camera direct flash is boring and ugly, get a cable that allows you to move the flash off-camera to vary lighting effects. These cables typically lock into the hot shoe and the flash unit, permitting you to move the flash at arm's length in a 360° radius around the camera. Vivitar's 283 cable mounts in the hot shoe and accepts the unit's thyristor sensor that's normally plugged into the face of the flash. This is so the amount of light reaching the camera is read correctly no matter where the flash is located or aimed.

Another useful accessory is a wrist strap that clips to the flash. Let the flash dangle from your wrist to free your hands when you need to change film, write a caption, or whatever.

Finally, several manufacturers offer devices to reduce the harshness of direct flash. These gadgets clamp to the flash head and redirect or diffuse the light to lighten and soften shadow edges, and to eliminate hot spots or glare from shiny subjects. Unfortunately, most are not particularly effective. Nearly all suck up a lot of light and require a flash unit with a tilting head. One moderately effective choice is the Lumiquest Pocket Bounce, although it causes a light loss of 2-1/2 stops, a severe penalty with these relatively underpowered units. The gadget I've found most useful is the Sto-Fen Omni-Bounce, a translucent dome that works by combining bare-bulb and bounce-flash techniques. All of these

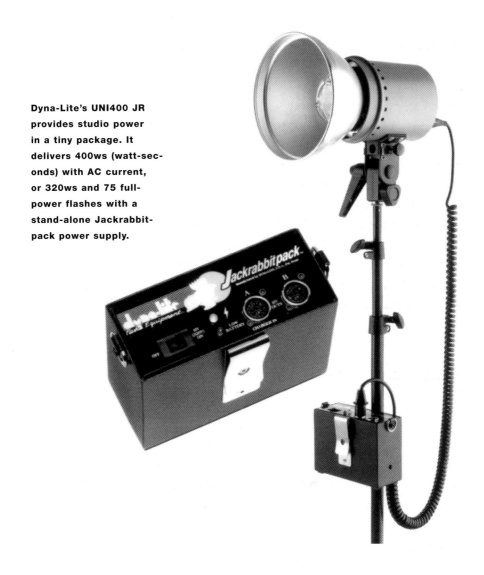

Dyna-Lite's UNI400 JR provides studio power in a tiny package. It delivers 400ws (watt-seconds) with AC current, or 320ws and 75 full-power flashes with a stand-alone Jackrabbit-pack power supply.

devices are most effective with subjects no more than 10' from your camera. They can help, but don't expect too much.

Studio lighting

For most people, the term "studio" conjures the vision of a room dedicated exclusively to photographing people or products. Backgrounds, light stands, lamp heads, soft boxes, umbrellas, power packs, and various other lighting accessories stand at constant ready. This is not inaccurate, of course, but it is a limited view. In the world of music-business photography, dedicated studios are a luxury and

often irrelevant. Unless you are already a well-established name, or shooting for a record company or a national magazine, it is difficult—if not impossible—to get big-name artists to come to your studio. Private time is precious to touring musicians, and few want to spend it doing photo shoots. More likely, you're going to have to take your studio to them and set it up in a hotel room, a backstage bathroom, or an empty dressing room.

Studio lighting is available in continuous (or hot) tungsten lights and electronic flash, sometimes called "strobe." Each has its virtues, but electronic flash is the rule in most professional studios. Remember, however, that many of the greatest musician and band portraits of all time were shot with hot lights or flash bulbs. Electronic flash was not common in studios until the late '50s.

Hot lights

The advantages of hot lights include economy and a continuous light source that permits you to instantly see the effect of light placement. Minute adjustments are visible, enabling you to fine-tune the results. Focused spots accurately highlight small details, and metering is precise and easy. What you see is what you get. Hot lights are also usually cheaper, lighter, and quicker to set up than their electronic counterparts. The problem is that they are, well, *hot.* The quartz-halogen lamps typically used in professional setups range from 250 watts to 2,000 watts. Lighting a color set big enough for an entire band requires several thousand watts of light, particularly if you require action-stopping shutter speeds and small f/stops. If you've ever been in a television studio, you have some idea of how bright and uncomfortably sweaty that can be. And should you accidentally touch a reflector, the burn can be severe. Finally, you are limited to black & white or tungsten-balanced color film, which narrows your choice considerably. You *can* use daylight-balanced film with a lens correction filter, but that reduces film speed by as much as two stops.

Despite these drawbacks, a small tungsten-light setup is useful for shooting portraits and still lifes. The most economical way to get started is with several photofloods mounted in simple reflector bowls. Add a couple light stands, and you're in business for less than $200. A setup like this can be useful for helping understand light placement, but you'll be pretty much restricted to black & white work. Photofloods, which are shaped like a light bulb, emit a color temperature of 3400° Kelvin when new, and there's only one film balanced to match—Kodachrome Type A (ISO 40!). Even then the color temperature is unstable, and

This Norman pack
can power up to six
flash heads while
delivering 2400ws
of light output.

One of the simplest and most
effective ways to soften the
light quality of direct flash is
this snap-on diffuser from Sto-fen
Products. It is shown here mount-
ed on a Nikon SB-26 flash.

photofloods have a very short working life.

Quartz-halogen lamps are a better option. Originally designed for the film industry, they are smaller and more stable than photofloods with comparable output. They emit light at 3200° Kelvin, allowing a choice of a half-dozen Type B tungsten-balanced films ranging from ISO 50 to ISO 640. Several manufacturers offer professional quartz-halogen systems. For size and economy, my favorite is the Lowel Tota-light system. At the heart is a 2" x 3" x 11" fixture with adjustable barn doors for precise angle control. Capable of up to 1000 watts' output, the Tota-light weighs only 22 oz and, with optional hardware, can be

Monolights, such as the three shown here from White Lightning, are completely self-contained. No outboard power pack is required.

mounted two to a stand or to walls, doors, and windows. A slightly larger companion Omni-light features a 6:1 spot/flood focusing range, making it ideal for either key, backlight, or accent lighting tasks. There's also a full line of accessories, including clamps, flags, reflectors, umbrellas, and gels. Other hot-light manufacturers to investigate include Arri, NRG, and Smith-Victor.

Experience is the only way to tell if tungsten lighting suits your style. If you're not ready to buy, try renting from a local store that caters to professionals. A decent system with three lights and essential accessories costs about $30 a day. After a couple of sessions, you'll have a pretty good idea what tungsten lighting can do.

Electronic Flash

Studio flash units operate on the same principle as their hot-shoe-mounted counterparts but deliver much more power. All things considered, electronic

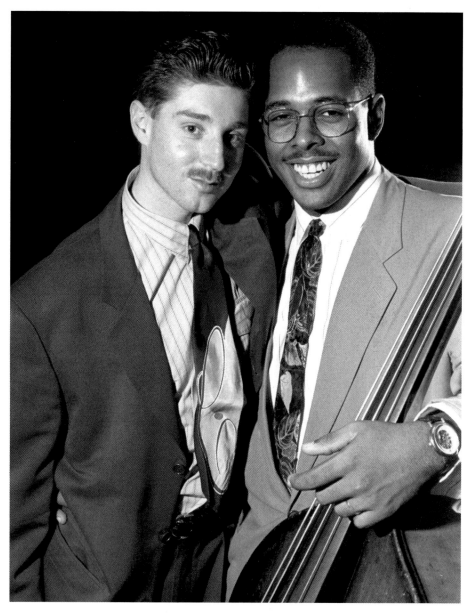

BENNY GREEN AND CHRISTIAN McBRIDE, 1991

It's not always necessary to carry extensive lighting equipment to get good studio-style portraits. All I had were two Vivitar 283s when I decided I wanted a shot of these two young lions of jazz in their dressing room. I aimed one flash from above and left of the camera, while the other was hand-held by a friend and aimed at the side and back of McBride's head to pull it off the black background. The second flash unit was triggered by a photoelectric "eye."

flash is probably a better choice than hot lights. Its short, high-powered bursts are color-balanced for daylight film, which allows the choice of a couple of dozen films. Combine brief flash duration (which virtually eliminates camera shake and subject movement) with high light output (which permits small lens apertures for extended depth of field), and you are all but certain of sharp photographs—even if your focus is slightly off. And electronic flash is a much cooler light source for your subject.

Manufacturers typically rate the power of their models in watt-seconds (ws), which is somewhat misleading. Watt-seconds is a measure of energy storage capacity, not light output, and the output of one manufacturer's 400ws unit is not necessarily the same as another's. A truer measure for comparing lighting power is stated in beam candle power seconds (bcps), a measure of the amount of light that strikes the subject at a given distance. Unfortunately, few manufacturers provide bcps ratings. Lately, more manufacturers are providing guide numbers, which makes comparisons easier. The best way to compare, however, is to test with a flash meter, which measures a momentary burst of light falling on a subject. Stand 10' away from the flash head with the flash meter set for ISO 100. Point it directly at the flash head and have someone fire the unit manually. The meter will respond with an f/stop reading, leaving no room for ambiguity when comparing one unit with another.

Assembling a location lighting kit

Equipping a professional location studio can be very expensive. For instance, both Jay Blakesberg and Lynn Goldsmith pack up to four Dyna-Lite 1000 power packs and five flash heads for a location shoot. Throw in accessories such as light stands, backgrounds, umbrellas or soft boxes, reflectors, clips, clamps, and cords, and we're talking close to five figures. Fortunately, you don't need to spend anywhere near that much to produce professional results. But just as in the rest of life, money provides more options and greater flexibility.

Electronic studio lighting comes in two configurations: component *power packs* with output jacks for multiple flash heads, and *monolights*, which combine the power source, flash tube, modeling lamp, and reflector in a self-contained unit. Of the two, professionals tend to favor power packs, which have traditionally out-powered monolights. That's because the size and weight of the electronics necessary for high-powered performance once made monolights too top-heavy to mount on a light stand. Now, however, shrinking electronics

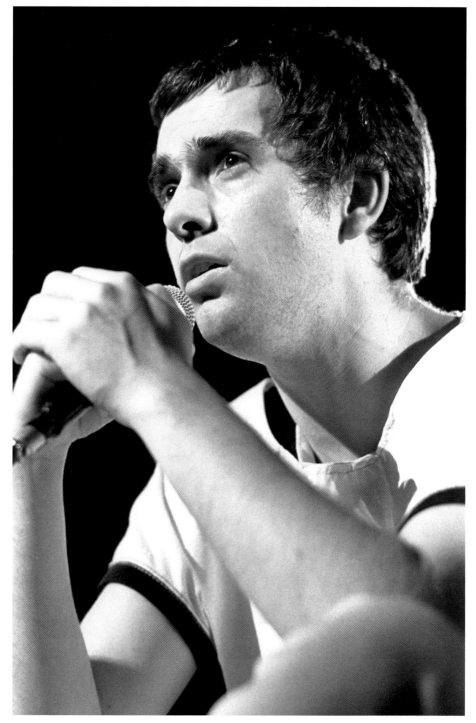

PETER GABRIEL, 1978

have made monolight performance comparable to all but the most powerful component power packs. The monolight's compact, lightweight, all-in-one construction makes it particularly suitable for location work.

Thoroughly examine the many options. Leading power-pack manufacturers include Balcar, Broncolor, Comet, Dyna-Lite, Elinchrom, Norman, Novatron, and Speedotron. Each offers a broad line of packs, flash heads, and related accessories. Prices vary dramatically based on power, perceived quality, and brand name. Among music-business photographers I know, the most common choices are Dyna-Lite, Balcar, and Norman. Dyna-Lite is particularly favored for its light weight and compact size, making it easier to tote on location. Leading monolight manufacturers include Broncolor, Elinchrom, Photogenic, and White Lightning. The latter company offers good savings because its products are sold directly to the customer only, which eliminates the middleman profit.

How much lighting equipment do I really need?

The answer depends largely on what you're trying to light. If portraits are your primary interest, you can get by with surprisingly little—maybe two lights and 400ws of power. Less, if you're willing to put up with very limited lighting options. On the other hand, if you want to make a living shooting six-piece bands on large sets, you'll need a lot more. That's the kind of shoot where Blakesberg and Goldsmith carry four power packs and five flash heads. Obviously, there's a lot of room in between, and a talented photographer who understands lighting can always squeeze more out of a setup than any novice can. I won't go on a location shoot with anything less than 800ws and two heads, and that is still very limiting. A more ideal minimum is 2000ws and three heads. That doesn't mean you can't do an excellent job with less. You'll just have to use larger f/stops (which affects sharpness and limits depth of field) and will have fewer options for backlighting your subjects and lighting your backdrops.

In addition to your power pack(s) and flash heads (or monolights), you'll need a number of accessories, including a flash meter, light stands, umbrellas or soft boxes to soften the light, sync cords, and various reflectors for specialized tasks. All of these items can add up to a lot of dollars, pounds, and bulk, but they are necessary tools of the trade if you hope to attract jobs from the best-paying and highest-visibility employers. Before you buy, thoroughly research the possibilities. Read photo magazines and talk to professionals who have studios. Then get to the camera store and ask a lot of questions. If you invest in a system with

potential for expansion, you'll make your money go a lot farther.

Finally, understand that having $5,000 worth of lighting equipment won't make you a better photographer any more than having a $2,000 camera and a bag of lenses will. Excellence flows from the heart and the brain that understands the nuances of the art and science of lighting. That comes only from reading, examining the work of the masters, asking questions, and exposing a lot of film.

APPENDIX ONE
MUSIC PUBLICATIONS

This list of publications was compiled over a period of three years, and some of them have no doubt disappeared by now. But new ones are being created every day. They are sorted by the styles of music predominantly featured in the publication. Corrections, deletions, and additions are encouraged. Contact the author at P.O. Box 4322, Daly City, CA 94016 or through our web site (http://www.humblepress.com).

MULTIPLE STYLES

20th Century Guitar
135 Oser Ave.
Hauppauge, NY 11788
(516) 273-1674
FAX (516) 434-9057

Acoustic Guitar
P.O. Box 767
San Anselmo, CA 94979
(415) 485-6946
FAX (415) 485-0831

Acoustic Musician
P.O. Box 1349
New Market, VA 22844
(703) 740-4005
FAX (703) 740-4006

American Music
1325 S. Oak St.
Champaign, IL 61820
(217) 244-6488
FAX (217) 244-8082

American Songwriter
121 17th Ave. South
Nashville, TN 37203
(615) 244-6065
FAX (615) 742-1123

Bass Player
411 Borel Ave., Ste. 100
San Mateo, CA 94402
(415) 358-9500
FAX (415) 358-8728

Bassics
6855 Glen Erin Dr., Unit 45
Mississauga, Ontario,
Canada L5N 1P6,

Best of Guitar Player
411 Borel Ave., Ste.100
San Mateo, CA 94402
(415)358-9500
FAX (415) 358-8729

Billboard
1515 Broadway, 15th Fl.
New York, NY 10036
(212) 764-7300

Canadian Musician
25 Hannover Dr., Ste. 7
St. Catharines, Ontario,
Canada L2W 1A3
(905) 641-3471
FAX (905) 641-1648

Cash Box
6464 Sunset Blvd, Ste. 605
Los Angeles, CA 90028
(213) 464-8241

Drum!
1275 Lincoln Ave., #13
San Jose, CA 95125
(408) 971-9794
FAX (408) 971-0382

Electronic Musician
6400 Hollis St., #12
Emeryville, CA 94608
(415) 653-3307
FAX (415) 563-5142

Fender Frontline
11999 San Vicente Blvd,
Ste. 401
Los Angeles, CA 90049

Flute Talk
200 Northfield Rd.
Northfield, IL 60093
(708) 446-5000

Gig
17042 Devonshire St., Ste. 209
Northridge, CA 91325

Goldmine
700 East State St.
Iola, WI 54990
(715) 445-2214
FAX (715) 445-4087

Gray Areas
P.O. Box 808
Broomhill, PA 19008
(610) 353-8238
FAX (610) 353-7693

Guitar Extra
10 Midland Ave.
Port Chester, NY 10573-5976

Guitar International
Manor Rd., Mere
Wiltshire A12 6H2, UK
0747 861051

Guitar Player
411 Borel Ave., Ste. 100
San Mateo, CA 94402
(415) 358-9500
FAX (415) 358-9216

Hi Folks! Alternative Musicali
Res. Sagittario
133-Milano 2
20090 Segrate (MI) Italy
FAX (02) 2532340

HIP-Harmonica Information
Publication
203 14th Ave.
San Francisco, CA 94118
(415) 751-0212

Hot Wire: Journal
Of Women's Music
5210 N. Wayne
Chicago, IL 60640
(312) 769-9009

International Society
Of Bassists
School of Music,
Northwestern University
Evanston, IL 60208
(708) 491-4764

International Musician
1501 Broadway, Ste. 600
New York, NY 10036
(212) 869-1330

Keyboard
411 Borel Ave, Ste. 100
San Mateo, CA 94402
(415) 358-9500
FAX (415) 358-9527

me-Music Express Magazine
219 Dufferin St., Ste. 100
Toronto, Ontario,
Canada M6K 1Y9
(416) 538-7500
FAX (416) 538-7503

Mix Magazine
6400 Hollis St., #12
Emeryville, CA 94608
(415) 653-3307
FAX (415) 653-5142

Modern Drummer
870 Pompton Ave.
Cedar Grove, NJ 07009
(201) 239-4140

Mojo
Mappin House 4 Winsley St.
London W1N 7AR UK
0171 436-1515
FAX 0171 637-4925

Mondo 2000
P.O. Box 10171
Berkeley, CA 94709
(415) 845-9018

Music Collector
6 Chapel St.
Cambridge CB4 1 DY, UK
(0223) 462466

Music Technology
22024 Lassen St., Ste. 118
Chatsworth, CA 91311
(818) 407-0744
FAX (818) 407-0882

Musician
1515 Broadway
New York, NY 10036
(212) 536-5208
FAX (212) 536-6616

Musik
Kings Reach Tower
Stamford St.
London SE1 9LS, UK

Peavey Monitor
711 A St.
Meridian, MS 39301
(601) 483-5365
FAX (601) 483-1172

Percussion Source
P.O. Box 391894
Cambridge, MA 02139

Performing Songwriter
P.O. Box 158159
Nashville, TN 37215
(615) 297-6972
FAX (615) 383-4812

Pollstar
4333 N. West Ave.
Fresno, CA 93705
(209) 224-2631
FAX (209) 224-2674

Rhythm
22024 Lassen St., Ste. 118
Chatsworth, CA 91311
(818) 407-0744
FAX (818) 407-0882

Saxophone Journal
P.O. Box 206
Medfield, MA 02052
(508) 278-7559
FAX (508) 359-7988

Sheet Music Magazine
223 Katonah Ave.
Katonah, NY 10536-2139
(914) 232-8108
FAX (914) 232-1205

Songtalk Magazine
6831 Hollywood Blvd., Ste. 780
Hollywood, CA 90028
(213) 463-7178
FAX (213) 463-2146

Studio Sound
Link House, Dingwell Ave.
Croydon CR9 2TA England
(081) 686-2599

The Harmonizer
6315 3rd Ave
Kenosha, Wl 53143-5101
(414) 653-8440
FAX (414) 654-4048

The Secret Guide To Music
70 Route 202 N
Peterborough, NH 03458

The Wire
45-46 Poland St.
London W1V 3DF, UK
0171-439-6422
FAX 0171-287-4767

Tower Records Pulse
2500 Del Monte St., Bldg. C
West Sacramento, CA 95691
(916) 373-2450

Trax Music Guide
111 North La Cienega Blvd.
Beverly Hills, CA 90211
(310) 659-7852
FAX (310) 659-7856

Vintage Guitar
P.O. Box 7301
Bismarck, ND 58507
(701) 255-1197
FAX (701) 255-0250

Windplayer
8127 Melrose Ave.
Los Angeles, CA 90046

BLUEGRASS/FOLK

Banjo Newsletter
P.O. Box 289, RR #1
Chilmark,MA 02535
(508) 645-3648

Bluegrass Canada
#106-147 Victoria St.
Kamloops, British Columbia,
Canada V2C 1Z4

Bluegrass Now
P.O. Box 2020
Rolla, MO 65401
(314) 341-7336

Bluegrass Unlimited
Box 111
Broad Run, VA 22014
(540) 349-8181
FAX (540) 341-0011

Dirty Linen
18-1/2 Cedar Ave
Baltimore, MD 21286-7843
(410) 583-7973
FAX (410) 337-6735

Fast Folk
Village Station
New York, NY 10014-0701
(212) 274-1636

¡Flamenco!
943 Fifth St., Suite #6
Santa Monica, CA 90403
(310) 394-2317

Fiddler
P.O. Box 125
Los Altos, CA 94022
(415) 948-4383

FIGA
2344 So. Oakley Ave.
Chicago, IL 60608

Folk Roots
P.O. Box 337
London N4 1TW, UK
081-340 9651
FAX 081-348 5626

Sing Out
P.O. Box 5253
Bethlehem, PA 18015-0253
(215) 865-5366

The Old-Time Herald
1812 House Ave.
Durham, NC 27707

BLUES

Blues Access
1455 Chestnut Place
Boulder, CO 80304-3153
303-443-7245
FAX 303-939-9729

Blues Revue
Rt 2, Box 118
West Union, WV 26456-9520
(304) 782-1971
FAX (304) 782-1993

Blues Connection
121 Everingham Rd.
Syracuse, NY 13205
(315) 469-5821

Blues Gazette
22 Franciscuslaan
B.9112 Sinaai
Belgium

Blues & Rhythm—
The Gospel Truth
82 Quenby Way
Bronham Mk 43 8QP Beds., UK
(023)482-6158
FAX (023) 482-6180

Blues & Soul
153 Praed St.
London W2 1RL, UK
0171-402-6869
FAX 0171-224-8227

Juke Blues
P.O. Box 148
London WY 1DY, UK
FAX 071-286-2993

Living Blues
Hill Hall, Rm 301
University, MS 38667
(601) 232-5742
FAX (601) 232-7842

Southland Blues Magazine
6475 E. Pacific Coast Hwy.
Long Beach, CA 90803
(310) 498-6942
FAX (310) 498-7793

The Blues News
P.O. Box 1263
Riverside, CA 92502
(909) 369-8635
The Blues Rag
37124 McKinley Ct, #662
Farmington Hills, MI 48335
(810) 471-3539

Westcoast Blues Review
302-655 Herald St.
Victoria, BC
Canada V8W 3L6
(604) 384-2088

CLASSICAL/OPERA

Chorus
P.O. Box 2318
Duluth. GA 30136-8451
(770) 242-8698

Classical Guitar
Olsover House,
43 Sackville Rd.
Newcastle on Tyme, NE6 5TA,
United Kingdom

Classical Music Magazine
106 Lakeshore Rd. E., #212
Mississauga, Ontario,
Canada L5G 1E3
(905) 271-0339
FAX (905) 271-9748

Classical Pulse
2500 Del Monte St., Bldg. C
West Sacramento,
CA 95691-3820
(916) 373-2450

Clavier
200 Northfield Rd.
Northfield, IL 60093
(708) 446-5000

Guitar Review
40 West 25th St.
New York, NY 10010

Musical Times
Bank House, 7 St. John's Rd.
Harrow HAI 2EE, UK

Opera News
70 Lincoln Center Plaza
New York, NY 10023-6548
(212) 769-7080
FAX (212) 769-7007

Opera Quarterly
P.O. Box 90660
Durham, NC 27708-0660
(919) 687-3601

Piano and Keyboard
412 Red Hill Ave., Ste. 16
San Anselmo, CA 94960
(415) 485-6946

Piano Today
223 Katonah Ave.
Katonah, NY 10536
(914) 232-8108
FAX (914) 232-1205

Strings
412 Redhill Ave.
San Anselmo, CA 94960
(415) 485-6946

Symphony Magazine
777 14th St. N.W.
Washington, DC 20005-3201
(202) 628-0099
FAX (202) 783-7228

The American Organist
475 Riverside Dr., Ste 1260
New York, NY 10115-0122
(212) 870-2310
FAX (212) 870-2163

COUNTRY

American Country
1424 Lake Dr. S.E.
Grand Rapids, MI 49506-1710
(616) 458-1011
FAX (616) 458-2285

CMA Close Up
1 Music Circle South
Nashville, TN 37203
(615) 244-2840

Country
RR1
Holstein, Ontario,
Canada N0G 2A0
(519) 334-3246

Country America
1716 Locust St.
Des Moines, IA 50336

Country Beat
7002 West Butler Pike
Ambler, PA 19002-5147
(215) 643-6385
FAX (215) 540-0146

Country Music
329 Riverside Ave.
Westport, CT 06880-4810
(203) 222-5800

Country Music News
Box 7323, Varnier Post Term.
Ottawa, Ontario
K1L 8E4, Canada
(613) 745-6006
FAX (613) 745-0576

Country Music People
225A Lewisham Way
London SE4 1UY, UK
081-692-1106
FAX 081 -469-3091

Country Song Roundup
210 Route 4 East, Ste. 401
Paramus, NJ 07652-5103
(201) 843-4004
FAX (201) 843-8636

Country Wave
9780-197 B. St., Ste. 101
Langley, British Columbia,
Canada V3A 4P8
(604) 888-8491

Country Weekly
600 South East Coast Ave.
Lake Worth, FL 33464-0001
(407) 540-1005
FAX (407) 540-1008

Journal of Country Music
4 Music Square East
Nashville, TN 37203-4321
(615) 256-1639
FAX (615) 255-2245

Music City News
50 Music Square West, Ste. 601
Nashville, TN 37203-3212
(615) 329-2200

Music Row
Box 158542
Nashville, TN 37215
(615) 321-3617
FAX (615) 329-0852

New Country
181 Suzanne Dr.
Antioch, TN 37013
(615) 781-2214

New Country Music
86 Elm St.
Peterborough, NH 03458-1052
(603) 924-7271

No Depression
1321 N. 44th St.
Seattle, WA 98103

Old Time Country
Univ. of Mississippi
University, MS 38677

FANZINES

Fanzines are devoted to a
single artist. Here are a few
we've encountered. There
are certainly many more.

Allman Brothers
Hittin' The Note
1345 West Fletcher
Chicago, IL 60657

Tori Amos
Really Deep Thoughts
P.O. Box 328606
Columbus, OH 43232
(614) 792-8836

Bob Dylan
On the Tracks
398 N. Dale Ct.
Grand Junction, CO 81503
(970) 245-4315
FAX (970) 243-8025

Grateful Dead
Dupree's Diamond News
P.O. Box 148
Purdys, NY 10578

Relix
P.O. Box 94
Brooklyn, NY 11229
(718) 258-0009

Spiral Light
Flat 3, 22 Chester Rd.
Glouster, GL4 7AY, UK

Unbroken Chain
P.O. Box 8726
Richmond. VA 23226

Elton John
East End Lights
Box 760
New Baltimore, MI 48047
(810) 949-7900
FAX (810) 949-2217

Led Zeppelin
The Ocean
46 Briarwood Dr.
Westwood. MA 02090

Zoso
1390 Market St., Ste. 2623
San Francisco, CA 94102

Morrissey
A Chance To Shine
66c Loampit Hill
Lewisham,
London SE13 7SX, UK

Vice
11011 Belton St.
Upper Marlboro, MD 20774

Pearl Jam
Release
410 Gilbert St., Apt. A
Bryan, TX 77801-3407

Pink Floyd
Brain Damage
P.O. Box 109
Westmont, IL 60559
(708) 968-4900
FAX (708) 968-4944

Prince
Uptown
P.O. Box 142
SE-45323 Lysekil, Sweden

R E M
Dead Letter Office
729 West Second Ave., #2
Chico, CA 95926

Rush
A Show of Fans
5411 E. State St., Ste. 309
Rockford, IL 61108
(815) 398-1258

Van Halen
The Inside
784 N. 114th St., Ste. 200
Omaha, NE 68154

Neil Young
Broken Arrow
2A Llynfi St. Bridgend,
Mid Glamorgan, CF31 1 SY, UK

Frank Zappa
Society Pages
Box 395
Deer Park, NY 11729

GOSPEL/CHRISTIAN

7-Ball Magazine
P.O. Box 24925
Nashville, TN 37202
(615) 872-8080
FAX (615) 227-6044

CCM-Contemporary
107 Kenner Ave.
Nashville, TN 37205-2207
(615) 386-3011
FAX (615) 386-3380

Gospel Music Exclusive
P.O. Box 6
Riverside, CA 92502
(909) 875-7404
FAX (909) 875-1346

Gospel Today
P.O. Box 292494
Nashville, TN 37229

Gospel Voice
P.O. Box 22975
Nashville, TN 37202-2975
(615) 329-2200

Heaven's Metal
902 Romeria Dr. #107
Austin, TX 78757
FAX (512) 454-0083

Precious Memories
Rt.1, Box 1876
Young Harris, GA 30582
(404) 379-2315

Release
404 BNA Drive, #508
Nashville, TN 37217
(615) 872-8080
FAX (615) 889-0437

Score
P.O. Box 292494
Nashville, TN 37229-2494
(615) 360-9444

Syndicate Magazine
P.O. Box 24633
Nashville, TN 37202
(615) 646-1506
FAX (615) 646-6011

The Singing News
P.O. Box 2810
Boone, NC 28607-2810
(704) 264-3700

True Tunes News
210 West Front St.
Wheaton, IL 60187-5111
(708) 665-3866

JAZZ

Cadence
Rte.1, Box 345
Redwood, NY 13679
(315) 287-2852

Coda
P.O. Box 1002, Station O
Toronto Ontario M4A Canada
(416) 593-7320

Down Beat
102 North Haven
Elmhurst, IL 60126
(708) 941-2030
FAX (708) 941-3210

Jazz Educator's Journal
P.O. Box 724
Manhatten, KS 66505-0724
(913) 776-8744
FAX (913) 776-6190

Jazz Journal International
1-5 Clerkenwell Rd.
London EC1M 5PA England
(071) 608-1348
FAX (071) 608-1292

Jazz Now
P.O. Box 19266
Oakland, CA 94619
(510) 531-2839
FAX (510) 531-8875

Jazz On CD
81 South Audley St.
London W1Y 5TA England
071-495-8637
FAX 071-495-8627

Jazz Player
P.O. Box 206
Medfield, MA 02052
(508) 359-7004

Jazziz
3620 N.W. 43rd St., Ste. D
Gainesville, FL 32606
(904) 375-3705

JazzTimes
7961 Eastern Ave, Ste. 303
Silver Spring, MD 20910-4898
(301) 588-4114
FAX (301) 588-5531

Mississippi Rag
6500 Nicollet Ave. South
Richfield, MN 55423-1673
(612) 861-2446

On The One—Jazzmopolitan
3288 21st St., Ste. 130
San Francisco, CA 94110

Straight No Chaser
41 Coronet St.
London N1 6HD England
071-613-1594
FAX 071-613-1703

The Jazz Report
22 Helena Ave.
Toronto, Ontario, Canada
(416) 656-7366

The Jazz Review
2005 Palo Verde Ave., Ste 158
Long Beach, CA 90815
(213) 493-6136

LATIN

Latin Beat Magazine
15900 Crenshaw Blvd, Ste. 223
Gardena, CA 90249
(310) 516-6767
FAX (310) 532-6784

Latin Style
P.O. Box 2669
Venice, CA 90294
(310) 452-8452

ROCK/METAL/ALTERNATIVE

Alternative Press
6516 Detroit Ave, Ste. 5
Cleveland, OH 44102
(216) 631-1212
FAX (216) 631-1016

Arena Rock Magazine
P.O. Box 423
Snowdon Station
Montreal, Quebec,
Canada H3X 3T6

Axcess
P.O. Box 9309
San Diego, CA 92169
(619) 270-2054
FAX (619) 270-2159

B-Side Magazine
Box 1860
Burlington City, NJ 08016
(619) 270-2054
FAX (619) 561-9027

Baby Sue Music Review
818 Courtenay Dr, N.E.
Atlanta, GA 30306
(404) 875-8951

Bad Trip
4325 John Wesley Dr.
Dallas, GA 30132-2762
(770) 445-3086

Ben is Dead
P.0. Box 3166
Hollywood, CA 90028
(213) 960-7674
FAX (213) 936-3323

Big O
P.O. Box 784
Marine Parade,
Singapore 914410

Big Takeover
249 Eldridge St., Ste. 14
New York, NY 10002-1345
(212) 533-6057

Bikini
2110 Main St., Ste. 100
Santa Monica, CA 90405

Black Market Magazine
405 West Washington, Ste. 212
San Diego, CA 92103-1932
(619) 521-9985
FAX (619) 521-9986

Blue Juice
14 Spencer Ave.
Earlsdon CV5 6NP,
Coventry, England
(020) 367-7692

Blue Suede News
Box 25
Duvall, WA 98019
(206) 788-2776

Blur Magazine
P.O. Box 484
Salem. OR 97308-0484
(503) 873-6402

Burrn
2-1 Ogawa-Machi Kanda
Tokyo 101 Japan

Circus
6 West 18th St.
New York, NY 10011
(212) 242-4902

CMJ-New Music Monthly
11 Middle Neck Rd., Ste. 400
Great Neck, NY 11021-2301
(516) 466-6000
FAX (516) 466-7159

Crash
25 West 39th St.
New York, NY 10018
(212) 302-2626

Creem
4375 Sepulveda Blvd, Ste 249
Sherman Oaks, CA 94103
(818) 905-5274
FAX (818) 905-8048

Dark Angel
P.O. Box 383
Richmond 3121,
Victoria, Australia
(03) 578 0344

DMR
636 Broadway, Ste. 804
New York, NY 10012

Ear
131 Varick St., Room 905
New York, NY 10013
(212) 807-7944

Entertainment Weekly
1675 Broadway
New York, NY 10019

Faces
63 Grand Ave., Ste. #115
River Edge, NJ 07661
(201) 487-6124
FAX (201) 487-9360

Fi-The Magazine of
Music and Sound
60 Federal St., Ste. 500
San Francisco, CA 94107
(415) 243-4434
FAX (415) 243-4449

Fizz
1509 Ocean Anne Ave. N, #276
Seattle, WA 98109
(206) 283-7042
FAX (206) 285-4399

Forced Exposure
Box 9102
Waltham, MA 02254

Genetic Disorder
P.O. Box 151362
San Diego, CA 92175-1362
(619) 461-3624

Guitar For The
Practicing Musician
10 Midland Ave.
Port Chester, NY 10573
(914) 935-5200
FAX (914) 937-0614

Guitar School
1115 Broadway
New York, NY 10010
(212) 807-7100
FAX (212) 627-4678

Guitar Shop
P.O. Box 87
Wallingford, PA 19086
(914) 935-5269
FAX (914) 937-0614

Guitar World
1115 Broadway, 8th Fl.
New York, NY 10010
(212) 807-7100
FAX (212) 627-4678

Guitarist
Alexander House, Forehill
Ely, Cambs CB7 4AF
England (0353) 665577

Hit Parader
210 Rt. 4 East, Ste. 401
Paramus , NJ 07652
(201) 843-4004
FAX (201) 843-8636

Hits
14958 Ventura Blvd
Sherman Oaks, CA 91403
(818) 501-7900
FAX (818) 883-1097

Hot Press
13 Trinity St.
Dublin 2 Ireland

Huh
2812 Santa Monica Blvd,
Santa Monica, CA 90404

Hypno Magazine
624 Broadway, Third Fl.
San Diego, CA 92101
(619) 239-9746
FAX (619) 696-1417

i-D Magazine
134/146 Curtain Rd.
London EC24 3AR England
071-729-7305
FAX 071-729-7266

I/E
2300 N. Yucca
Chandler, AZ
602-821- 1061
FAX 602-821- 1624

Industrial Metal
P.O. Box 565
Valley Stream, NY 11582

Industrial Nation
614 W. Belmont
Chicago, IL 60657-4529

Jet Lag
10252 Lackland
St. Louis, MO 63114

Kerrang!
Ludgate House, 245
Blackfriars
London SE1 9UZ England
(071) 921-5900

Lime Lizard
24 Highbury Grove
London N5 3EA England
071-704-9767

Livewire Magazine
28 West 25th St.,7th Fl.
New York, NY 10010
(212) 647-0222

Loud
Box 56425
Phoenix, AZ 85079
(602) 484-7697

Magnet
1020 N. Delaware Ave.
Philadelphia, PA 19125-4334
(215) 426-1163
FAX (212) 427-0881

Making Music
20 Bowling Green Lane
London EC1R OBD England
071-251-1900
FAX 071-278-4003

MAXIMUMROCKNROLL
P.O. Box 460760
San Francisco, CA 94146

Melody Maker
26th Fl, King's Reach Tower
London SE1 9LS England

Metal Edge/TV Picture Life
233 Park Ave. South
New York, NY 10003
(212) 780-3500
FAX (212) 780-3555

Metal Forces
46-48 Osnaburgh St., Ste 16
London NW 1 3ND England
01 388 5425 FAX 01 383 5354

Metal Hammer
3rd Fl., 59 Queens Gardens
London W2 3HF England
01-258 0206 FAX 01-724-4099

Metal Madness
63 Grand Ave., Ste. #115
River Edge, NJ 07661
(201) 487-3255

Metal Mania
475 Park Ave. So., Ste. 2201
New York, NY 10016

Metal Masters
5101 E. Busch
Tampa, FL 33617
(813) 852-9355
FAX (813) 985-3728

Metallix
25 West 39 St.
New York, NY 10018
(212) 302-2626

Metalshop
355 Lexington Ave.
New York, NY 10017

Music Confidential
900 Avenida Acasa, #N
Camarillo, CA 93012
(805) 445-8310
FAX (805) 445-8314

Music Life
Shinki Music Annex, 1-14
Tokyo 101 Japan

Musicworks—The Journal of
Sound Exploration
179 Richmond St. West
Toronto M5V 1V3
Ontario, Canada
(416) 977-3546
FAX (416) 204-1084

New Music Express
25th Fl, King's Reach Tower,
London SE19LS England

Option
1522B Cloverfield Blvd
Santa Monica, CA 90404-3502
(213) 474-2600

Performance
1101 University Dr., Ste. 108
Fort Worth, TX 76102
(817) 338-9444
FAX (817) 877-4273

Powerline
P.O. Box 4426
Stamford, CT 06907

Propaganda
Box 296
New York, NY 11040

Puncture
4020 Grant St., S.E.
Portland, OR 97214-5935

Q
42 Great Portland St.
London WlN 5AH England
071 436-5430
FAX 071 323-0680

Ray Gun
2110 Main St., #100
Santa Monica, CA 90405
(310) 452-6222
FAX (310) 452-8076

Reflex
211 E. 43rd St., Ste. 2001
New York, NY 10017

Request
7500 Excelsior Blvd
Minneapolis, MN 55426
(612) 932-7740
FAX (612) 942-7797

RIP
9171 Wilshire Blvd.
Los Angeles, CA 90210
(310) 858-7100
FAX (310) 247-1708

RIP
420 Lexington Ave.
New York, NY 10170
(212) 297-6184
FAX (212) 856-0870

ROC (Rock Out Censorship)
P.O. Box 147
Jewett, OH 44663
(614) 946-6535

Rockbeat
9171 Wilshire Blvd, Ste. 300
Los Angeles, CA 90210

Rock Flash
5660 E. Virginia Beach Blvd.
Norfolk, VA 23502-2428
(804) 425-6260
FAX (804) 425-9340

Rolling Stone
1290 Ave. of the Americas
New York, NY 10104
(212) 484-1616
FAX (212) 767-8203

Scram
P .O. Box 461626
Hollywood, CA 90046-1626

Screamer
774 S. Placentia Ave.
Placentia, CA 92670
(714) 572-2255
FAX (714) 572-3819

Seconds
24 5th Ave., Ste. 405
New York, NY 10011
(212) 260-0481

Select
1st Fl., Mappin House
London W1 N 7AR England

Shift
174 Spadina Ave., Ste. 407
Toronto, Ontario,
Canada M5T 2C2
(416) 504-1887
FAX (416) 504-1889

Shout Magazine
28 West 25th St.
New York, NY 10010

Siren
Bradford Court, Bradford St.
Birmingham B12 ONS England

Snipehunt
P.O. Box 3975
Portland, OR 97208
(503) 331-0771

Sound Of Death (SOD)
1069 Pinegate DrIve
Kirkwood. MO 63122
(314) 966-0976
FAX (314) 822-2721

Spin
6 W. 18th St.
New York, NY 10011
(212) 633-8200 (212) 633-2668

Spinzo
7056 Grasswood Dr.
Las Vegas, NV 89117
(702) 594-3981
FAX (702) 221-9295

Spiral Scratch
6 Chapel St.
Cambridge CB4 1DY England
(0223) 462 466
FAX (0223) 358 038

Strobe
P.O. Box 48558
Los Angeles, CA 90048
(213) 938-1243

Stubble Musiczine
P.O. Box 1420
Attleboro, MA 02703
(508) 396-4270

Tall Spins Magazine
234 Lee St., Ste. 3
Evanston,IL 60202-1487
(312) 935-0666
FAX (312) 642-1262

The Music Paper
P.O. Box 304
Manhasset, NY 11030
(516) 883-8898
FAX (516) 883-2577

The Record
4211 Yonge St. Ste. 410
Toronto M2P 2A9,
Ontario, Canada
(416) 221-3366
FAX (416) 221-3324

The Village Noize
48-54 213th St.
Bayside, NY 11364
(718) 229-0380

Thoro-zine
P.O. Box 49390
Austin, TX 78765
(512) 453-6747

Top Forty Focus
17317-107 Ave.
Edmonton T5S 1E5,
Alberta, Canada
(403) 486-5802
FAX (403) 481-9276

Tough Tracks Magazine
82 North St.
Foxboro, MA 02035
(508) 698-3938

Tribe
2042 Magazine St.
New Orleans, LA 70130
(504) 524-5200

Uno Mas
P.O. Box 1832
Silver Spring, MD 20915
(301) 770-3250

U.S. Rocker
6370 York Rd. #281
Cleveland, OH 44130
(216) 262-8387

Virtuallyalternative
120 N. Victory Blvd.
Burbank, CA 91502-1852
(818) 955-4000
FAX (818) 955-8048

Vox
27th Fl., Kings Reach Tower,
London SE1 9LS England
071 261-6312
FAX 071 261-5627

Yeah, Yeah, Yeah
89 Grant St.
Boonton, NJ 07005

Young Guitar
2-1 Ogawa-Machi Kanda
Tokyo 101 Japan

Your Flesh
P.O. Box 25146
Minneapolis, MN 55468
(612) 822-9152

URBAN/RAP/HIP HOP/REGGAE

40 Magazine
199-10 Linden Blvd.
Saint Albans, NY 11412
(718) 527-7151

4080 Hip-Hop Magazine
2550 Shattuck, Ste. 107
Berkeley, CA 94704
(510) 644-0333
FAX (510) 848-2425

Beat Down
P.O. Box 1266
New York, NY 10274
(212) 642-5306

Black Beat
35 Wilber St.
Lynbrook, NY 11563

BRE
6922 Hollywood Blvd., Ste. 110
Hollywood, CA 90028
(213) 469-7262

Dub Catcher
14 E. 4th St., 3rd Floor
New York, NY 10012
(212) 477-9149
FAX (212) 477-2159

Dub Missive
P.O. Box 677850
Orlando, FL 32867
(401) 381-9907

Hip-Hop Connection
Alexander House, Forehill, Ely
Cambs CB7 4AF England
0353 665577 FAX 0353 662489

Organized Rhyme
J-93 Tenbytown
Delran, NJ 08075
(609) 763-5068

Rap Masters
63 Grand Ave., Ste. 230
River Edge, NJ 07661
(201) 487-6124

Rappages
8484 Wilshire Blvd.
Los Angeles, CA 90211
(213) 651-5400
FAX (213) 651-1289

RapSheet
2601 Ocean Park Blvd.
Santa Monica, CA 90405
(301) 399-9000

Reggae Directory
P.O. Box 18115
Cleveland, OH 44118

Reggae Report
21300 N.E. 24th Court
Miami, FL 33180
(305) 933-1178
FAX (305) 933-1077

Reggae World
P.O. Box 74
Bronx, NY 10472
(718) 842-0428

Right On!
233 Park Ave.
New York, NY 10003

RMM-Rhythm Music
872 Mass Ave., 2-7
Cambridge, MA 02139
(617) 497 0955
FAX (617) 497-0675

Serious Hip Hop
Box 838
Philadelphia, PA 19105
(215) 629-9992
FAX (215) 625-9719

Street Beat
P.O. Box 648
Walnut, CA 91788
(909) 598-2300

StreetSound Magazine
333 W. 52nd St.
New York, NY
(212) 397-6203
FAX (212) 315-4601

Strong Sounds Magazine
5760 Owensmouth Ave.
Woodland Hills, CA 91367
(818) 884-2130

Subculture
25381 G Alicia Parkway,
Ste. 381
Laguna Hills, CA 92653
(714) 362-0399

The Art Farm
J-93 Tenbytown
Delran, NJ 08075
(609) 764-8023

The Beat
P.O. Box 65856
Los Angeles, CA 90065

The Bomb Hip-Hop
4104 24th St., Ste. 105
San Francisco, CA 94114
(415) 826-9479
FAX (415) 285-3518

The Flavor
1314 NE 43rd, #201
Seattle, WA 98105
(206) 547-6133
FAX (206) 632-4101

The Source
594 Broadway, Ste. 510
New York, NY 10012
(212) 274-0464
FAX (212) 274-8334

URB
1680 North Vine, Ste. 1012
Los Angeles, CA 90028
(213) 993-0291
FAX (213) 466-1207

Vibe
205 Lexington Ave., 3rd Fl.
New York, NY 10016
(212) 522-7092
FAX (212) 522-4578

Word Up
63 Grand Ave., Ste. 230
River Edge, NJ 07661
(201) 487-6124

World Music
P.O. Box 177
Cheltenham GL51 OYF
England
0242-252934

Yo!
P.O. Box 88427
Los Angeles, CA 90009

REGIONAL PUBLICATIONS

The following publications
are primarily targeted to
specific regions of the
United States.

Aquarian Weekly
7 Oak Place
Montclair, NJ 07042-3824
(201) 783-4346
FAX (201) 783-5057

All Blues to Do's
P.O. Box 22950
Seattle, WA 98122-0950
(206) 328-0662

American Music Press
325 10th St.
San Francisco, CA 94103-3804
(415) 864-4512
FAX (415) 864-3807

Angle
P.O. Box 7770
Flushing, NY 11352-7770
(718) 460-9428

Arizona Music Beat
726 E. Monroe Ave.
Buckeye, AZ 85326
(602) 86-7077
FAX (602) 386-2459

Athens News
14 N. Court St.
Athens, OH 45701
(614) 594-8219
FAX (614) 592-5695

Bad Newz
Box 28, 2336 Market St.
San Francisco, CA 94114

Baltimore City Paper
812 Park Ave.
Baltimore, MD 21201
(410) 523-2300
FAX (410) 523-2222

BAM
3470 Buskirk Ave
Pleasant Hill, CA 94523
(510) 934-3700
FAX (510) 934-3958

Bay City Nights
444-1/2 E. 12th St.
Erie, PA 16503-1226
(814) 453-6888

Big Shout
1120 North West St.
Wilmington, DE 19801
(302) 888-2929
FAX (302) 888-2925

Bloomington Voice
3902B Old South State Rd.
Bloomington, IN 47401
(812) 331-0963
FAX (812) 331-0863
FAX (415) 864-3807

Bone Music Magazine
131 Second Ave. North
Nashville, TN 37201 -1917
(615) 248-2663
FAX (615) 242-9877

Boston Phoenix
126 Brookline Ave.
Boston, MA 02215
(617) 536-5390

Boston Rock
131 Charlesbank Rd
Newton, MA 02158-1738
(617) 244-6803

Buddy
11258 Goodnight Lane
Dallas, TX 75229-3395
(214) 484-9010
FAX (214) 484-8785

Buzz
P.O. Box 1331
Johnstown, PA 15907
(814) 288-5825

Buzzz
910 Myrtle Ave.
Albany, NY 12208-2220
(518) 489-0658

Cake
2401 University Ave. NE
Minneapolis, MN 55418-3458
(612) 781-9178
FAX (612) 781-9181

California Country Music
P.O. Box 9602
San Jose, CA 95157
(408) 370-7005
FAX (408) 379-1063

Casoo Bay Weekly
551 A Congress St.
Portland, ME 04104
(207) 775-6601
FAX (207) 775-1615

Chicago Country Magazine
12 Park Ave.
Grayslake, IL 60030-2335
(708) 223-0661
FAX (708) 223-6855

Chicago Music Magazine
3711 N. Ashland, 2nd Fl.
Chicago, IL 60613

Chicago's Subnation
734 N. Lasalle St., Ste 1162
Chicago, IL 60610

Country Plus
6933 Westhampton Dr.
Alexandria, VA 22307
(703) 765-8838

Country Star
2509 Walmer Ave.
Norfolk, VA 23513-2604
(804) 857-1212
FAX (804) 853-1634

Dumpster Dive Fanzine
P.O. Box 426
Norwalk, CT 06856-0426
(203) 840-1138

East Bay Express
931 Ashby Ave.
Berkeley, CA 94710
(510) 540-7400
FAX (510) 540-7700

East Coast Rocker
7 Oak Place
Montclair, NJ 07042
(201) 783-4346

Everybody's News
1310 Pendleton St, Ste. 700
Cincinnati, OH 45210
(513) 381-2606

Face
19 Commercial St.
Portland, ME 04101
(207) 774-9703
FAX (207) 767-4379

Flagpole Magazine
P.O. Box 1027
Athens, GA 30601
(706) 549-9523
FAX (706) 548-8981

Flash Magazine
1110 Atlantic Ave., Ste 203
Virginia Beach, VA 23451
(804) 425-0280
FAX (804) 425-9340

Flipside
P.O. Box 363
Whittier, CA 90608

Florida Xposure
P.O. Box 950760
Lake Mary, FL 32795-0760
(407) 332-3119
FAX (407) 645-1172

Focus
P.O. Box 36480
Richmond, VA 23235
(804) 560-1898

Good Times
Box 33
Westbury, NY 11590

Illinois Entertainer
2250 E. Devon, Ste. 150
Des Plaines, IL 60018-4507
(708) 298-9333
FAX (708) 298-7973

IMpress-Independent
9 North Beverwyck Rd.
Lake Hiawatha, NJ 07034-2501
(201) 331-9001
FAX (201) 331-9003

Indie File
1711 Central Ave.
Charlotte, NC 28205-5107
(704) 377-6500

Ink Nineteen
P.O. Box 1947
Melbourne, FL 32902-1947
(407) 253-0290
FAX (407) 259-8880

Jam Entertainment News
112-D Longwood Ave.
Altamonte Springs, FL 32701
(407) 767-8377

Jazz Notes
P.O. Box 4487
Saint Paul, MN 55104
(612) 633-0329

Jersey Beat
418 Gregory Ave.
Weehauken, NJ 07087-5602
(201) 864-9054

Jersey Jazz
P.O. Box 173
Brookside, NJ 07926
(201) 543-2039

Just Rock
808 E. 6th St.
Rolla. MO 65401
(314) 364-2564

L.A. Jazz Scene
12439 Magnolia Blvd
North Hollywood,
CA 91607-2450
(818) 504-2115

Lollipop Magazine
7 Davis Square, Ste. 1
Somerville, MA 02144-2917
(617) 623-5319

Maryland Musician Magazine
14 W. Seminary Ave.
Lutherville, MD 21093
(410) 494-0566
FAX (410) 495-0565

Modern Screen Country
233 Park South, 5th Floor
New York, NY 10003
(212) 780-3500

Music Connection
6640 Sunset Blvd.
Hollywood, CA 90028
(213) 462-5772
FAX (213) 462-3123

Music Forum
1801 10th St. S., Studio B
Safety Harbor, FL 34695
(813) 791-6300
FAX (813) 791-6063

Music Monthly
7510 Hartford Rd, 2nd Fl
Baltimore, MD 21234
(410) 444-3776
FAX (410) 444-1807

Music News
1506 Pearl
League City, TX 77573
(713) 480-6397
FAX (713) 332-7540

Music Players Magazine
P.O. Box 1867
Pinellas Park, FL 34664
(813) 578-1400
FAX (813) 578-1414

Music Revue
P.O. Box 68052
Grand Rapids, Ml 49516
(616) 458-1011

Nashville Scene
301 Broadway
Nashville, TN 37201
(615) 244-7989
FAX (615) 244-8578

New England Performer
38 Montvale Ave, Ste. 345
Stoneham, MA 02180
(617) 279-1200

New Times
1201East Jefferson
Phoenix, AZ 85034

Nightflying
P.O. Box 250276
Little Rock, AR 72225
(501) 664-5099

Offbeat
333 St. Charles Ave., Ste. 614
New Orleans, LA 70130

Oll-The Music Magazine
1720 5th Ave.
Moline, IL 61265
(309) 764-0451
FAX (309) 764-8128

Overture
1212 Cathedral St.
Baltimore. MD 21201
(410) 783-8100
FAX (410) 783-8077

Pandemonium
917 Pacific Ave., Ste. 209
Tacoma, WA 98402-4433
(206) 272-3319
FAX (206) 272-8824

Performer Magazine
350 Queens Quay West
Toronto, Ontario,
Canada M5V 3A7
(406) 345-9643
FAX (416) 260-3499

Pittsburgh City Paper
911 Penn Ave.
Pittsburgh, PA 15222
(412) 469-3080

Public News
1540 W. Alabama
Houston, TX 77006
(713) 520-1520
FAX (713) 520-9390

Pulp Magazine
P.O. Box 480027
Denver, CO 80248-0027
(303) 830-7857
FAX (303) 830-0174

Pure Magazine
1608 N. Milwaukee, Ste. 404
Chicago, IL 60647
(312) 772-5570
FAX (312) 772-5570

Q-ME
8820 S. Sepulveda Blvd.
Los Angeles, CA 90045
(310) 337-7771

Rag
P.O Box 24308
Ft. Lauderdale, FL 33307
(305) 463-5799

Rock City News
7030 De Long Pre Ave.
Los Angeles, CA 90028
(213) 461-6600

Rock N' Roll Reporter
P.O. Box 575
McKees Rocks, PA 15136
(412) 771-1974

Rockstar
Box 343
Beverly Hills, CA 90213
(213) 271-4818

Smug
155 E. 23rd St., Ste. 303
New York, NY 10010
(212) 505-0119

Sound Attitude
P.O. Box 350037 Bay Station
Brooklyn, NY 11235
(716) 769-4871
FAX (716) 648-1533

Spotlight
Box 63423
St. Louis, MO 63163
(314) 725-7734

Subculture Magazine
1449 119th St. East
Whiting, IN 60633-1508
(219) 473-1742
FAX (219) 473-1748

Suburban Voice
P.O. Box 1605
Lynn, MA 01903
(617) 596-1570

Texas Beat
P.O. Box 4429
Austin, TX 78765-4429
(512) 441-2422
FAX (512) 441-7072

The Aquarian
P.O. Box 137/7 Oak Place
Montclair, NJ 07042
(201) 783-4346
FAX (201) 783-5057

The Country Post
721 South Blvd.
Oak Park, IL 60302-2903
(708) 848-0019

The Frogbelly Local
P.O. Box 1372
Gastonbury, CT 06033
(203) 586-7035

The Glass Eye
P.O. Box 2507
Toledo, OH 43606

The Island-Ear
P.O. Box 309
Island Park,NY 11558
(516) 889-6045

The Loafer
P.O. Box 3596
Johnson City, TN 37602
(615) 283-4324
FAX (615) 283-4369

The Metro
P.O. Box 24486
Nashville, TN 37202
(615) 320-5150
FAX (615) 320-0013

The New England Beat
8a Glenville Ave.
Allston, MA 02134
(617) 782-7625

The Rocket
2028 5th Ave.
Seattle, WA 98121
(206) 728-7625
FAX (206) 728-8827

The Splatter Effect
P.O. Box 7
New Brunswick, NJ 08903
(908) 249-7883
FAX (908) 249-4305

Thrust
12467 62nd St. N. #103
Largo, FL 34643
(813) 536-4100
FAX (813) 530-9573

Tune-In
9800 Richmond, Ste. 300
Houston, TX 77042
(713) 781 -0781
FAX (713) 789-8167

Tunes Magazine
1210 Levee
Dallas, TX 75207
(214) 741 -3463
FAX (214) 720-4471

Wavelength
Box 15667
New Orleans, LA 70175
(504) 895-2342

APPENDIX TWO
MUSIC BOOK PUBLISHERS

These publishers specialize in books about music, including photo books, song books, instruction books, music business, and biographies. A visit to a local chain bookstore will give you an idea of their specialties. A few large general-interest publishers also produce biographies of particularly famous musicians and music-business figures.

2.13.61
P.O. Box 1910
Los Angeles, CA 90078

Alfred Publishing Co.
P.O. Box 10003
Van Nuys, CA 91410-0003
(818) 891-5999
FAX (818) 893-5560

Billboard Publications
1515 Broadway
New York, NY 10036

Centerstream Publications
P.O. Box 5450
Fullerton, CA 92635
(714) 779-9390

Chartwell Books
110 Enterprise Ave.
Secaucus, NJ 07094

Chesbro Music Co.
Box 2009
Idaho Falls, ID 83403-2009
(208) 522-8691
FAX (208) 522-8712

Chronicle Books
One Hallide Plaza
San Francisco, CA 94102

Da Capo Press
233 Spring St.
New York, NY 10010

Miller-Freeman Books
600 Harrison St.
San Francisco, CA 94107

Hal Leonard Publishing
7777 West Bluemound Rd.
Milwaukee, WI 53213
(414) 774-3630
FAX (414) 774-3259

Mel Bay Publications
#4 Industrial Dr.
Pacific, MO 63069-0066
(314) 257-3970
FAX (314) 282-7163

Music Sales Corporation
225 Park Ave. South
New York, NY 10003
(212) 254-2100
FAX (212) 254-2013

Omnibus Press
6/9 First St.
London W1V 5T2 UK

Pomegranate Artbooks
Box 6099
Rohnert Park, CA 94927

Rough Guides, Ltd.
1 Mercer St.
London WC2H 9QJ, UK

Schirmer Books (Macmillan)
866 Third Ave.
New York, NY 10022

St. Martin's Press
175 Fifth Ave.
New York, NY 10010

The Bold Strummer, Ltd
Box 2037/20 Turkey Hill Cir.
Westport, CT 06880
(203) 259-3021
FAX (203) 259-7369

Twelvetrees Press
P.O. Box 188
Pasadena, CA 91102

Viking Penguin
40 West 23rd St.
New York, NY 10010

Warner Brothers Publications
15800 NW 48th Ave.
Miami, FL 33014
(800) 468-5010
FAX (305) 621-4869

Brockum
111 George St., 3rd Fl.
Toronto, Ontario,
Canada M5A 2N4
(416) 777-1811
FAX (416) 307-5131

Brockum
729 Seventh Ave., 16th Fl.
New York, NY 10019
(212) 254-5560
FAX (212) 354-5574

Crom Tidwell Merchandising
1208 Nichol Lane
Nashville, TN 32705
(615) 292-9193
FAX (615) 383-1290

Facility Merchandising, Inc
80 Universal City Plaza
Universal City. CA 91608
(818) 777-5100
FAX (818) 733-1593

Giant Merchandising
5605/5655 Union Pacific
Commerce, CA 90022
(213) 887-3300
FAX (213) 887-3345

Good Swag Merchandising
575 East 71st St., 9th Fl.
New York, NY 10021
(212) 722-0283
FAX (212) 722-0297

Grateful Dead Merchandising
P.O. Box X
Novato, CA 94948
(415) 898-4999
FAX (415) 898-9592

Great Entertainment
400 Lafeyette St., 5th Fl.
New York, NY 10003
(212) 995-7888
FAX (212) 995-7890

Ktema
4278 Noble Ave.
Sherman Oaks, CA 91403
(818) 788-7859
FAX (818) 788-2933

Mo-Tex Inc
1525 Neely's Band Rd.
Madison, TN 37115
(615) 865-8404
FAX (615) 860-4156

Nice Man Merchandising
8752 Monticello Lane
Maple Grove, MN 55369
(612) 493-2200
FAX (612) 493-2204

Sony Signatures
Two Bryant St., 3rd Fl.
San Francisco, CA 94105
(415) 247-7400
FAX (415) 957-1591

St. Rage and Company
746 E.12th St., Studio 5
Los Angeles, CA 90021
(213) 746-3593

Winterland Productions
100 Harrison St.
San Francisco, CA 94105
(415) 597-9700
FAX (415) 597-9862

A&I Color Lab (*, U)
933 North Highland Ave.
Los Angeles, CA 90038
(213) 856-5255
(800) 883-9088

Kodalux Plus
Processing Services
Lerner Processing Labs
1 Choke Cherry Road
Rockville,MD 20850
(301) 670-8626
(800) 345-6974

Rocky Mountain Film Lab
560 Geneva St.
Aurora, CO 80010
(303) 364-6444

Kodalux Processing Services
Lerner Processing Lab
1201 West Broadway
Minneapolis, MN 55411
(612) 588-7861

BWC Chrome Lab (*, P)
233 11th St.
Miami Beach, FL 33139
(305) 534-4454
(800) 292-3664

Kodak Premium
Processing (*, P)
Qualex, Inc.
16-31 Route 208
Fair Lawn, NJ 07410
(201) 797-0600
(800) 661-3456

Dwayne's Photo
415 S. 32nd St.
Parsons, KS 67357
(316) 421-3940
(800) 522-3940

Kodak Premium
Processing (P, M)
Qualex, Inc.
3131 Manor Way
Dallas, TX 75235
(214) 352-5900
(800) 661-3456

Kodalux Plus Processing
Lerner Processing Labs
3520 W. Warner Ave.
Santa Ana, CA 92704-7374
(800) 587-5227

AUSTRALIA
Vision Graphics Pty Ltd.
88 Pitt St.
Redfern,
New South Wales 2016
Australia
Tel. (61)(2) 319-3300
Fax (61)(2) 699-8801

SWITZERLAND
Kodak SA
Processing Laboratories
Case Postale Ch-1001
Lausanne, Switzerland
Tel: (41)(21) 631-0111
Fax: (41)(21) 631-0150

JAPAN
Horiuchi Color Lab, Co. Ltd.
1-6-7, Wada Suginami-Ku
Tokyo 166 Japan
Tel: (81) 03-3383-3321
Fax: (81) 03-3382-7493

KR Center
1320 Nishibori, Urawa
Saitama 338 Japan
Tel: (81) 048-864-5572
Fax: (81) 048-864-5575

UNITED KINGDOM
Kodak Ltd.
Kodachrome
Professional Film
Processing Laboratory
29 Deer Park Rd.
Wimbledon, London
SW193UG, England
Tel: (44)(081) 544-0055
Fax: (44)(081) 544-1493

(*) offers 120 film processing
(P) offers 135 push/pull processing
(U) offers 135 & 120 push/pull processing
(M) offers movie processing

BIBLIOGRAPHY

PHOTOGRAPHY BUSINESS

If you're going to sell your photos, you can use the information found in these books.

1997 Photographer's Market
Michael Willins, Editor
Writer's Digest Books
Annual listing of publications that buy freelance photography, including details of many music-oriented markets. Also interviews with photographers and photo buyers. A tremendous aid for anyone who wants to sell photos.

ASMP Photographer's Guide to Negotiating
Richard Weisgrau
ASMP

ASMP Stock Photography Handbook
ASMP
An excellent overview of the business of marketing stock photography by the American Society of Media Photographers.

Business & Legal Forms For Photographers
Tad Crawford
Allworth Press
All the basic forms you need to establish the terms of selling your photographs.

Legal Guide for the Visual Artist
Tad Crawford
Allworth Press
A definitive legal guide for protecting for your rights.

Pricing Photography: The Complete Guide to Assignment & Stock Prices
M. Heron and D. MacTavish
Allworth Press

Professional Photographer's Survival Guide
Charles Rotkin
Writer's Digest Books
How to conduct yourself as a professional and a guide to survival. Includes interviews with a dozen legendary photographers.

Sell & Re-sell Your Photos
Ron Engh
Writer's Digest Books
A classic that emphasizes techniques for selling stock photos through the mail.

Small-Time Operator
Bernard Kamoroff
Bell Springs Publishing
How to start your own small business, keep your books, pay your taxes, and stay out of trouble.

The Law [in Plain English] for Photographers
Leonard DuBoff
Allworth Press
Complete coverage of copyright, contracts, defamation, censorship, agents, taxes, estate planning, privacy and releases.

INSTRUCTION

The Darkroom Handbook
Michael Langford
Alfred Knopf
Outstanding, well-illustrated primer on basic darkroom techniques.

Existing Light Photography
Eastman Kodak Editors
Kodak
An excellent text for techniques of working with existing light.

How to Look at Photographs: Reflections on the Art of Seeing
David Finn
Harry Abrams

Lighting Secrets for Professional Photographers
A. Brown, T. Grondin, J. Braun
Writer's Digest Books

People in Focus: How to Photograph Anyone
Bryan Peterson
Amphoto Books

Photography: 5th Edition
John Upton/Barbara London
HarperCollins
A classic textbook, drawn from the legendary *Life Library of Photography* series. Covers all topics, illustrated with classic images from the history of photography.

Photography
Bruce Warren
West Publishing
A brilliant, all-encompassing textbook.

The Photographer's Guide To Using Light
T. Schwartz and B. Stoppes
Amphoto Books
Details the principles and properties of natural and artificial light. Step-by-step lessons.

Pro Lighting: Portraits
R. Hicks and F. Schultz
Amphoto Books

MUSIC PHOTO BOOKS

BLUES

Bay Area Blues
Michelle Vignes
Pomegranate Artbooks

Black and White Blues
Marc Norberg
Billboard Books

Going To Chicago: A Year On The Chicago Blues Scene
Stephen Green
Woodford Publishing

The Blues: A Book of Postcards
Multiple photographers
Pomegranate Artbooks

FOLK

The Festival Songbook
David Gahr
Amsco
B&W photos from Newport, Woodstock, etc. Text by Paul Nelson & Tony Glover. Sheet music and words for 24 songs.

The Face Of Folk Music
David Gahr
Citadal Press
A brilliant collection of more than 500 photographs of the principle participants in the folk revival spanning 1958 to 1968. Includes the musicians, fans, freedom fighters, and all the others that led the movement. Unfortunately, it is long out of print. Worth finding.

JAZZ

Bass Line: The Stories and Photographs of Milt Hinton
Milt Hinton/David G. Berger
Temple Univ. Press
The legendary bassist is also a remarkable photographer. An intimate inside look of some of the genre's greatest musicians.

Dizzy, Duke, The Count and Me
Jimmy Lyons
California Living
Jimmy Lyon's history of the Monterey Jazz Festival. Illustrated with dozens of B&W concert and location photos by Peter Breinig, Tom Copi, George Hall, Jim Marshall, Veryl Oakland, Seymour Rosen, Grover Sales, Jon Sievert, and Baron Wolman.

Images of Jazz:
Photographs by Lee Tanner
Friedman/Fairfax Publishers

Jazz
William Claxton
Twelvetrees Press

Jazz
David D. Spitzer
Woodford Press
Key players from 1970-1990.

Jazz People
Ole Brack and Dan Morganstern
Da Capo Press

Jazz Photographs of the Masters
Jacques Lowe
Artisan

Jazz Veterans: A Portrait Gallery
Nancy M. Elliott, John and Andreas Johnson
Cypress House

Overtime
Milt Hinton
Pomegranate Artbooks

Swing Era New York:
The Jazz Photographs
of Charles Peterson
Charles Peterson
Temple Univ. Press

The Blue Note Years:
The Jazz Photography of Francis Wolff (1941-1965)
Francis Wolff
Rizzoli International

The Eye Of Jazz
Herman Leonard
Viking
Leonard's magnificent concert photos from the '40s and '50s.

The Face Of Black Music
Valerie Wilmar
Da Capo Press
Jazz portraits-1962-75.

The Golden Age of Jazz
William Gottlieb
Pomegranate Artbooks

Young Chet: The Young Chet Baker Photographed
William Claxton
Schrimer Books

ROCK, POP, ALTERNATIVE

And God Created Punk
Photos by Erica Echenberg
Virgin Books

Annie Leibovitz: 1970-1990
Annie Leibovitz
HarperPerennial

Annie Leibovitz: Photographs
Annie Leibovitz
Pantheon/Rolling Stone

Candids of the King:
Rare Photos of Elvis Presley
by His Friends and Family
Jim E. Curtin Collection
Bulfinch Press/Little, Brown

Festival!
Jim Marshall/Baron Wolman
Straight Arrow/McMillian Text by Jerry Hopkins. Photos and text of several key early music festivals, including Woodstock, Altamont, and Sky River.

Fish in a Barrel-Nick Cave
& The Bad Seeds On Tour
Peter Milne
2-1 3-61

Fuck You Heroes
Glen E. Friedman
Burning Flags Press

It was Thirty Years Ago Today
Terence Spencer
Henry Holt
Early '60s candids of the Beatles backstage, onstage, and in the dressing room and hotel.

Led Zeppelin Portraits
Neal Preston
Perrenial
Preston was Zeppelin's personal photographer for several years. He traveled with the band and had almost unlimited access.

Led Zeppelin-Live Dreams
Laurence Ratner
Margeaux Publishing

Linda McCartney's Sixties
Linda McCartney
Bulfinch Press
Excellent concert and backstage photos of many of the key players of the '60s.

*Madonna: The Girlie
Show World Tour*
Many photographers
Callaway Editions

*Metallica: The Photographs
of Ross Halfin*
Ross Halfin
2.13.61

Monterey Pop
Jim Marshall and Joel Selvin
Chronicle Books
A look at the legendary 1967
Monterey Pop Festival. Many
classic Marshall photos.

*Photo Pass: The Rock & Roll
Photography of Randy Bachman*
Randy Bachman and Joel Selvin
SLG Books

Photo Past 1966-1986
Ray Stevenson
Symbiosis
B&W photos of London's
seminal folk and rock scene.

PhotoDiary
Lynn Goldsmith
Rizzoli International
A collection of Goldsmith's most
memorable images of musicians
and celebrities.

Rock Archives
Michael Ochs
Doubleday/Dolphin
Historical photos of rock
and roll from the Michael
Ochs Archives.

Rock Images 1970/90
Claude Gassian
Paul Putti Editeur
Extraordinary color and B&W
portraits of the cream of rock
and roll icons.

*Rolling Stone Images of Rock
and Roll*
Many photographers
Little, Brown and Company

Satisfaction. The Rolling Stones
Gered Mankowitz
Sidgwick & Jackson Ltd.
Black & white photos of the
Stones from 1965-67.

*Screaming Life-A Chronicle
of the Seattle Music Scene*
Charles Peterson
HarperCollins West

Sessions
Norman Seeff
WhaleSong Collection

*Sex & Drugs & Rock & Roll:
The Complete Pictorial History*
Multiple photographers
Bobcat Books
The title says it all. Cool
photos and hot poses.

The Clash: Before & After
Pennie Smith
Plexus

*The Photographer's
Led Zeppelin*
compiled by Ross Halfin
2.13.61
A compilation of photos by the
best photographers to shoot
Led Zeppelin, including Halfin,
Neal Preston, Jim Marshall, Bob
Gruen, Robert Knight, Pennie
Smith, and Michael Zagaris.

*The Rolling Stones:
Black and White Blues, 1963*
Gus Coral
Turner Publishing

U2: The Early Days
Brocklebank, Mahon,
and McGuiness
Delta
Photos of the early days of U2
by three photographers.

*With The Beatles: The Historic
Photographs of Dezo Hoffman*
Dezo Hoffman
Omnibus Press
Candid shots of the Fab
Four in the early '60s.

*Woodstock 1969:
The First Festival
3 Days of Peace & Music*
Many photographers
Square Books

Hot Shots
Norman Seeff
Flash Books

*Shooting Stars:The Rolling
Stone Book Of Portraits*
Annie Leibovitz, Editor
Straight Arrow
Includes the work of the genre's
greatest photographers through
1973, including Leibovitz, Jim
Marshall, and Baron Wolman.
Long out of print, but worth
looking for in used book stores.

*The Rolling Stone Illustrated
History Of Rock & Roll*
Jim Miller, Editor
Rolling Stone/Random House
A quintessential history of rock
and roll. Many brilliant photos,
largely supplied by the Michael
Ochs Archives. James Kriegs-
mann's studio shots of old doo-
wop and rock groups are worth
the price alone for his ideas.
Look for a copy of the 1973 over-
size edition. The photos are
huge and well reproduced.

INDEX

Italicized numbers indicate information in caption.

Down Beat, 37

E

earplugs, 282
electronic flash
 accessories, 298–99
 auxiliary battery packs, 297–98
 in performance, *78–79*, 95–98
 measuring light output of, 304
 mixed with ambient light, *5, 52*
 portable units, 292–97
 dedicated, 294
 dedicated autofocus, 294–95
 desirable characteristics, 292
 Nikon SB–26, 294
 non–dedicated, 293–94
 Quantum Qflash, 296
 S.A.I. NVS–1, 295–96, *297*
 Sunpak, 295, 296, 297
 Vivitar, 293–94, *303*
 studio units, 302–07
 Dyna–Lite UNI400 JR, *299*
 power packs, 304
 monolights, 304
 vs. ambient light, *87*
Eveleigh, Laura, 186
exposure
 18% gray, concept of, 108
 autoexposure, 246
 compensation dial, 245
 fundamentals, 106, 108
 meters
 center–weighted, 112
 incident, 108
 reflected, 110
 segmented, 112
 spot, 112, 245
 modes, 114
 multiple, *109)*

F

f/stops, 106
festival seating, 12
fill flash, *74,76*, 86, *97*, 99–100
film, 221–40
 black & white, 228–36
 advantages & disadvantages, 230
 choosing, 231
 Agfapan APX 400, 235
 Fuji Neopan 400, 235

 Fuji Neopan 1600, 234, 235
 Ilford Delta 100, 233
 Ilford Delta 400, 235
 Ilford FP–4 Plus, 233
 Ilford HP–5 Plus, 234–35
 Ilford XP2 400, 235
 Kodak Plus–X, 233
 Kodak T–Max 100, 233
 Kodak T–Max 400, 234
 Kodak T–Max 3200, 234
 Kodak Tri–X, 233–34
 color negative, 236–39
 Fujicolor Reala, 239
 Fujicolor Super G Plus 400, 239
 Fujicolor Super HG 1600, 239
 Fujicolor 400 Professional NPH, 239
 Kodak Ektapress Professional 400, 239
 Kodak Ektapress Professional1600, 239
 Kodak Royal Gold, 239
 Konica SR–G 3200, 239
 to shoot or not to shoot, 238
 versatility of, 236
 color transparencies 223–28
 color balance, 148, 223
 color temperature, 223
 daylight–balanced
 3M ScotchChrome, 226, 228
 Ektachrome, 226, 228
 Fujichrome, *52*, 226
 Kodachrome 226–27
 duplicating, 216–18
 E–6 processing, 227
 K–14 processing, 227
 labeling, 18
 shipping, 219–20
 storing and cataloging, 16
 tungsten vs. daylight, 224
 tungsten–balanced
 Ektachrome 320, 228
 ScotchChrome 640, 228
 DX coding of, *243*
 push–processing, 222, 227
 speed, 221
Film–Stor boxes, 284
filters, 98, 280, 282
finding places to shoot, 4–16
fine art prints, 184–87
flare, lens, 86
focusing, 124–139
 aids, 129

A northwestern Ohio native, Jon Sievert briefly worked as a staff photographer for the *Toledo Blade* newspaper following graduation from Bowling Green State University. He moved to San Francisco in 1969, where he began taking his camera to concerts and selling the photos to magazines and local music newspapers. His 1972 John Cipollina cover story and photographs for *Guitar Player* began a 19-year relationship with that magazine and its sister publications, *Keyboard* and *Frets*. During his tenure as a writer, editor, and staff photographer, he interviewed and/or photographed hundreds of world-class musicians. His photos have appeared on more than a hundred magazine covers, dozens of album/CD packages, and in countless books and publications worldwide, including *Rolling Stone*, *Musician*, *People*, *Acoustic Guitar*, *The New York Times*, *Entertainment Weekly*, *Guitar World*, *Newsweek*, and *Fachblatt*.

O R D E R F O R M

Want another copy of this book? Check with your favorite camera store, music store, or bookstore. If you can't find it, you may order from the publisher by toll-free telephone, fax, mail, or online.

Telephone orders:
Call toll free 1(800) 306-7168. We are open Monday through Friday from 9 A.M. to 6 P.M. Pacific time. Have your Visa, Mastercard, or American Express card ready.

Fax orders: (415) 333-9351

Postal orders: humble press, P.O. Box 4322-2, Daly City, CA 94016-4322

Online orders: order@humblepress.com

Web site: http://www.humblepress.com

Please send _____ copies of *Concert Photography* at $29.95 each.
I understand that I may return any books for a full refund if I am not satisfied.

Name: _____

Address: _____

City: _____ State: _____ Zip: _____

Sales Tax: Please add 8.5% ($2.55 each) for books shipped to California addresses.

Shipping:
U.S. Priority Mail (2-3 days): $3.50 for up to two books to same address, $3.00 for each additional book. **Book rate (3-4 weeks):** $2.00 for first book and 75 cents for each additional book to same address.

Payment:
❏ Check (payable to humble press)
❏ Credit card: ❏ Visa ❏ Mastercard ❏ American Express

Card number: _____

Name on card: _____ Exp. date: _____

Signature: _____

Call 1(800) 306-7168 toll free, and order now.